❧ SILENT HISTORY ❧

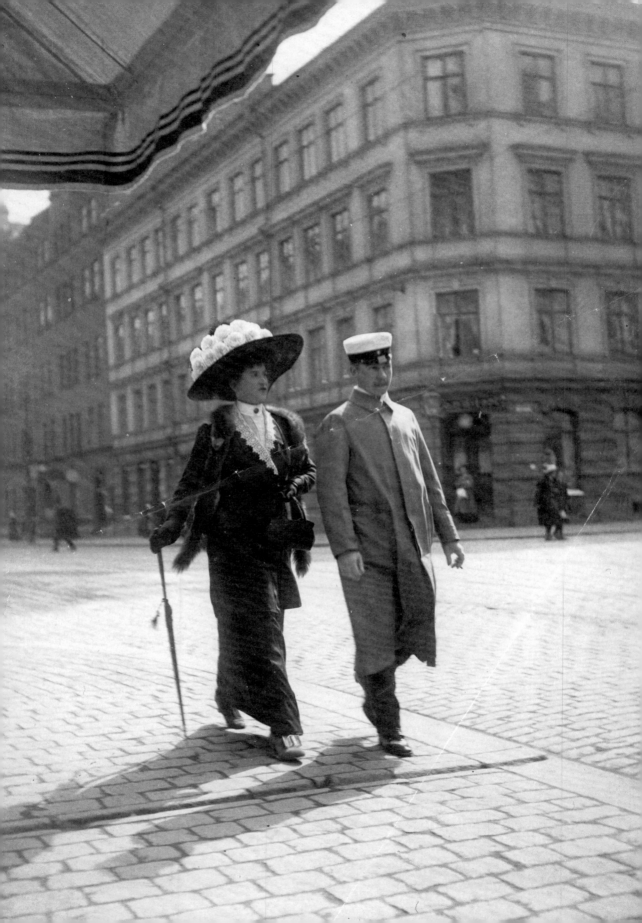

Silent History

Body Language and Nonverbal Identity, 1860–1914

Peter K. Andersson

McGill-Queen's University Press

Montreal & Kingston · London · Chicago

ISBN 978-0-7735-5475-7 (cloth)
ISBN 978-0-7735-5547-1 (ePDF)
ISBN 978-0-7735-5548-8 (ePUB)

Legal deposit third quarter 2018
Bibliothèque nationale du Québec

Printed in Canada on acid-free paper

We acknowledge the support of the Canada Council for the Arts,
which last year invested $153 million to bring the arts to Canadians
throughout the country.

Nous remercions le Conseil des arts du Canada de son soutien. L'an
dernier, le Conseil a investi 153 millions de dollars pour mettre de
l'art dans la vie des Canadiennes et des Canadiens de tout le pays.

LIBRARY AND ARCHIVES CANADA CATALOGUING IN PUBLICATION

Andersson, Peter K., 1982–, author
Silent history : body language and nonverbal identity, 1860–1914 /
Peter K. Andersson.

Includes bibliographical references and index.
Issued in print and electronic formats.
ISBN 978-0-7735-5475-7 (cloth). – ISBN 978-0-7735-5547-1 (ePDF). –
ISBN 978-0-7735-5548-8 (ePUB)

1. Body language – Europe – History – 19th century. 2. Body
language – Europe – History – 20th century. 3. Nonverbal
communication – Europe – History – 19th century.
4. Nonverbal communication – Europe – History – 20th
century. 5. Europe – Social life and customs – 19th century.
6. Europe – Social life and customs – 20th century. I. Title.

BF637.N66A53 2018 302.2'22 C2018-902953-6
 C2018-902954-4

Set in 10/14 Baskerville 10 Pro with Engravers, Helvetica
Neue, Bodoni Old Face, and Adobe Wood Type Ornaments
Book design & typesetting by Garet Markvoort, zijn digital

Contents

Acknowledgments vii

Introduction 3

PART ONE

⊰ 1 ⊱
The Culture of Nonverbal Communication in the
Nineteenth and Early Twentieth Centuries 21

⊰ 2 ⊱
Posing for Portraits:
Conventions and Aberrations 35

PART TWO

Introduction to the
Case Studies 65

⊰ 3 ⊱
Case Study 1:
Posing with a Walking-Stick 69

❧ 4 ❦
Case Study 2:
"Licensed Withdrawal" 105

❧ 5 ❦
Case Study 3:
The Female Akimbo Pose 131

❧ 6 ❦
Case Study 4:
The Waistcoat Pose 162

❧ 7 ❦
Case Study 5:
Hands in Trouser Pockets 180

PART THREE

❧ 8 ❦
Observations on Urban Body Language I:
Street Types in the Periodical Press 211

❧ 9 ❦
Observations on Urban Body Language II:
Stage-Comedy Stock Characters 234

❧ 10 ❦
Everyday Body Language and Its Contexts:
Concluding Remarks 247

Coda:
The Decline of the Graceful Ideal,
or How Hitler Became Ridiculous 262

APPENDIX
Biographical Notes on Photographers 267

Notes 269

Index 301

Acknowledgments

Writing a historical study of body language is a lonesome venture. The reaction one normally gets from colleagues is one of bafflement or mild amusement. But this risky endeavour has of course also benefited from some helpful and enthusiastic reactions – first and foremost, from the committee of the Swedish Foundation for Humanities and Social Sciences (Riksbankens jubileumsfond), whose generous three-year grant made my research possible, and whose printing grant contributed to the production of this book. The Foundation decided to believe in my idea, and agreed with me that studying nonverbal culture historically was a fruitful path. I am extremely grateful for their support and hope that I have lived up to their expectations.

During the years I worked on this project I also found support in the editors of *Journal of Victorian Culture* (Trev Broughton, Lucinda Matthews-Jones, and Alastair Owens), the historians working at the Department of History at the University of Gothenburg, and the friendly environment of the Department of History at Lund University, where my closest colleagues and friends assisted me in my work both at seminars and through informal discussions. I would also like to thank Claudia Pancino at the Dipartimento di Storia Culture Civiltà at the University of Bologna, who accepted me as a guest researcher during a crucial time in my research, and Eveliina Pulkki of the Nordic Network at The Oxford Research Centre in the Humanities, University of Oxford, who made me feel welcome during my brief stay there.

A work like this would not have been possible without assistance from the many archivists and librarians who helped me acquire material both for my research and for the finished book. My thanks go especially to Lund University Library, the Royal Library in Stockholm, Stockholm City

Museum, Wien Museum, Deutsches Museum in Munich, the Museum of English Rural Life in Reading, the Linley Sambourne Collection at the RBKC Archives in London, Manchester Archives, and the British Library. In the last stages of this project, Kyla Madden at McGill-Queen's University Press suddenly appeared as an editor who actually appreciated and understood what I was trying to do, and her assistance and support have been pivotal in making this book possible. Thank you, Kyla!

My final word of thanks goes as always to my wife, Charlotte Nilsson, whose companionship in conversation and in life certainly means that she contributed more than all the above put together to the research process. Thank you, my love, for showing me what is important in life and for your unwavering encouragement.

❧ Silent History ❧

Introduction

⸺

⫷ THERE ARE MANY WAYS TO WRITE the history of the human body. Much depends on the emphases created by the chosen focus and the source materials used. Typically, histories of the body produce stories of civilizing discipline, especially when they take into account the social institutions and discourse patterns that have strived to control physical urges and desires.[1] This attention to processes of restraint has led some historians to direct their gaze at the antitheses: decadence and frivolity, carnival culture, and indulgence in substances that move the body, as it were, beyond the limits of control.[2] One problem with much of this research, however, is that it relies quite often on the study of texts rather than bodies.

A historical study of the body and, more specifically, of body language, is a contradiction in terms, for the historian cannot observe the subject directly. And yet any history that leaves out the way people carry themselves, or dress or devote themselves to various physical activities, is bound to be incomplete. The human body is, in perhaps the most obvious way, at the mercy of the forces of nature at the same time as it is a tool of social identification and cultural adaptation. The fact that these two aspects of the body are very difficult to distinguish from each other is what makes their study so fascinating. Moreover, the human body as a tool of cultural adaptation is an essential thing for a historian to study. Not all humans have access to the written word. Not all humans have access to art, or teaching, or political thinking. But all humans, in all historical periods, have had access to a body. Therefore the body is the first and perhaps most vital instrument of expression, which makes it an inescapable subject for historians interested in communication, behaviour, social life, or the self.

The history of the body as a means of personal expression is not completely unwritten,[3] but it has been side-stepped to some extent in favour of histories of bodily discipline or bodily oppression. Although that history will be important for the present study, my main focus will be the bodily practices that were the object of discipline, rather than the discipline itself. If we want to make a historical study of body language in spite of our inability to directly observe its manifestations in the past, we do have one rich source of evidence: photography. We need to ask ourselves: To what extent can photography be used to write the history of the photographed rather than of the photographer? An advantage of such an approach is that, not being limited to written source material, we do not have to limit our scope to those sectors of a past society that were literate or at least textually documented. The disadvantage, of course, is that the body language we see "captured" in photographs is mediated through the subjective agency of the photographer. The potential for images from the early days of photography to provide a window into the everyday lives and body language of people in the past is highly problematic, and yet I believe it needs to be explored further. Before photography, there was no way of documenting people's everyday behaviour with such immediacy or directness. Photography was from the very beginning used with specific hidden agendas, but it was also used to document the world, and as long as we apply adequate source criticism it might provide us with a valuable window into the everyday lives of ordinary people in a time bridging the premodern and the modern. This book aims at investigating the eventuality of such a window through what is in essence an experiment in historical methodology. By studying early photographs and their surrounding visual culture, I wish to test the possibility of uncovering the nonverbal messages and cultural patterns of public body language in the nineteenth and early twentieth centuries.

"The history of the Victorian age will never be written: we know too much about it. For ignorance is the first requisite of the historian," Lytton Strachey famously stated a century ago.[4] Since then, his maxim has been both proved and disproved, for the history of the Victorian age has been written again and again, from varying viewpoints, with the result that it might seem impossible for anything about the period to have escaped historians. But knowing too much about a historical period – or *thinking* that one knows too much about it – is a dangerous starting point. It gives way to laziness, or an unwillingness to question the foundations of that knowledge. For what we know about the Victorian age, or about the late nineteenth and early twentieth centuries (usually seen as a coherent period), is based to a large extent on the written record. A wealth of written material from this period is available for us to interpret. But this can obscure the

fact that much of life goes on outside the verbal sphere, and, furthermore, that many people in this period were still either illiterate, semi-literate, or generally uninterested in books or magazines. The latter is still true in many contexts. Therefore, a history that bases its conclusions on novels, newspapers, legal records, politics, or science is, in a manner of speaking, the history of only half the people, or of all people half the time. What we have is, in other words, the "verbal history."[5]

This book is about the "silent history" of the late nineteenth and early twentieth centuries. The word "silent" can mean a lot of things. If by it we mean "nonverbal," our study can encompass art or architecture, but the histories of art and architecture have many parallels with the verbal history in general and so are not particularly unexplored. The silent history that I want to write here is silent also in the sense that very few historians have paid attention to it. It is the history of nonverbal communication, of the minute gestures and poses that people perform daily in their tasks and interactions but are seldom if ever documented in writing. In short, the history of body language.

There is only one way to study the body language of a historical period, and that is to consider its pictorial remains. In older periods, paintings, sculptures, or drawings must suffice, but from the nineteenth century onward we have a much more reliable source in photography. The advent of photography constitutes the very first time in history when people could document themselves and be documented just as they would have looked to their contemporaries, and thus it constitutes a fascinating insight into the way people dressed, acted, behaved, and carried themselves and allows us to feel a tangible closeness to them. This is especially true for the people of modest means of whom we, before the nineteenth century, had only been allowed glimpses in idyllic paintings or crude caricatures. By looking at early photography as a source of evidence on the lifestyles of "ordinary people" we can open up a whole new arena for historical study.

Here, the experienced photographic historian is sure to take a wary stance. It is a modern naïveté, she will say, to think that photography can objectively document the world around it. Photography, just like painting or writing, is shaped by the techniques and choices of subject matter of the photographer and can only be used as a source for the world of the photographer, not the photographed.[6] This is true, of course, but scholars have missed out, perhaps, in their overreliance on these critical approaches to photography. Poststructuralist readings of photography have the ambition to connect the motif of a photograph with the forces that shaped the creation of the image. This is exactly what I want to do, but when choosing to focus on everyday body language and its documentation in photography, it has been necessary to base my research on a

different and more neglected theoretical tradition that puts the emphasis on the agency of individuals and on social practice rather than the place of photography in an administering field of discourses. A few recent scholars working with photography as a historical source have begun to look more upon the photographed subject, using portrait photography especially as a gateway into both the culture of decorum and the culture of resistance among colonized peoples.[7]

Since the emergence of visual studies as a discipline in its own right in the late 1990s, the issue of visual culture and "the gaze" as a social and historical problem has been increasingly theorized, primarily in tandem with postmodernist lines of thought.[8] This has led the assumption concerning the objective accuracy of photography as a direct representation of reality to be questioned more and more. Although views of the photograph as an "indexical emanation of the reality to which it refer[s]" were reiterated as late as the 1980s by Roland Barthes, the theorization of the so-called "visual turn" means that now very few scholars of visuality maintain such an outlook uncritically. As summed up by Martin Jay, "the image as a natural sign, a straightforward analogue of its object, is an assumption whose time, it seems, has clearly gone. The new doxa is hostile to any claim that the eye can be innocent ... Instead of trusting in the integrity of the visual, we now comfortably talk about 'the hermeneutics of seeing,' 'iconic utterances,' 'the rhetoric of images,' 'imagistic signifiers,' 'visual narratives,' 'the language of films' and the like."[9]

There is a slightly scathing undertone in Jay's characterization of this development, and his attitude is perhaps symptomatic of how scholars have started to wonder whether it is possible to move beyond this stance. At the same time as postmodernist theory began to establish its hegemony within visual studies, a general disillusionment with its inherent scepticism ensured the persistence of a tug of war between postmodernist critical theory and an acknowledgment of human "aesthetic and spiritual needs."[10] This striving toward something more material in the wake of abstraction has given rise in recent years to efforts to study history from less abstract viewpoints, such as the so-called spatial and material turns, which attempt to incorporate more palpable sources into their analyses while still acknowledging the critical notions of postmodernism.[11] Postmodernist theories have had an enormous impact on the historical disciplines, but at the same time as that impact has become embedded in the methodology, it has been counterbalanced by a rekindled attention to source criticism and contextualization, showing that some aspects of the critical theories have all the time been accounted for by these approaches.[12] In the words of historian Jennifer Tucker, photographs as a historical source are as problematic as any other source material. "By exposing the questions

we ought to raise about all historical evidence, in other words, photographs reveal not simply the potential and limits of *photography* as a historical source, but the potential and limits of *all* historical sources and historical inquiry as an intellectual project."[13]

The debate surrounding the potential of photography as a historical source has proved strangely enduring, probably, at least in part, because of what Geoffrey Batchen has identified as the persistent faith in the transcendent quality of photography.[14] This faith might be naive – a clear sign of a fear of death or of an emotionally charged desire to feel close to the past – but at least its durability has ensured that the debate is kept alive. The most poignant discussion of the way photographs can be used in historical inquiry is perhaps found in the vibrant field of research on ethnographic photography in the nineteenth century. In her book on the role of photography in Victorian anthropology, Elizabeth Edwards has pointed to the way "the viewer participates in the creative process of representing" when responding to a photograph.[15] The performative act that is intrinsic to being photographed assumes the involvement of an audience. Developing this notion, Julia Peck has studied how Australian colonial subjects "performed" their aboriginality in photographs, thereby demonstrating the impossibility and even ineffectuality of distinguishing between "authentic" and "performed" acts in front of a camera. Building on Edwards, Peck stresses that "all photographs capture a heightened moment of performativity."[16] No one who is photographed can avoid playing the part of herself or himself. Thus, any attempt to use photographs as clues to the people in them will inevitably be a study of the "point of fracture" between the photographer and the photographed where "natural" behaviour turns into an act for the camera.

But all types of public behaviour have an audience, whether that audience is a photographer or other pedestrians. All observations of public behaviour contain a degree of theatricality. Ruth Rosengarten recently stressed "the [historical] continuity of the notion of identity as a performance that is intensified in its address to the camera, rather than the avidly embraced notion that it is a contemporary invention."[17] And yet the age of photography surely changed the culture of everyday practice and public behaviour, not only through the implementation of photography but also through the concurrent explosion of new media forms, the growth of urban culture, and the reformation of notions of collectivity and individuality of the late nineteenth and early twentieth centuries. Early photography might thus constitute an important source for a period of change in public and mundane behaviour, but the potential of this can be evaluated only by enlisting the photographic record in a study of performativity at the turn of the twentieth century.

It is possible to move beyond the conclusion that a photograph is merely a subjective representation of reality by carefully separating, through a process of source criticism, its instances of documentation from its embodiment of external influences.[18] We must accept the photographer's choice of directing the camera as an unavoidable bias that the photograph really has in common with most historical sources; the following study will undoubtedly be influenced by that bias, but in a wish to oppose the scepticism, I have taken inspiration from the way Marianne Hirsch pinpoints Roland Barthes's conception of old photographs as not simply "a 'copy' of reality, but [as] an emanation of *past reality* ... The important thing is that the photograph possesses an evidential force ... the power of authentication exceeds the power of representation" (emphasis in original).[19] This stance has been taken up by Beth Muellner in a study of female cyclists' self-presentations in photographs in the 1890s, in which the phenomenological attitude to photography allows it to be used as evidence for the existence and possibility of certain gestures at a certain time.[20]

The insights that photography can provide into the world of body language in the nineteenth century are largely unexplored, however, and I wish to delve into this question here by testing the ability of historical photographs to provide knowledge about the behaviour of photographed individuals. Taking our cue from source criticism, then, what types of photographs – if any – could be used in such an endeavour? The ideal of a photographic image that would tell us something about the object it represents would be a photograph that has not been biased or directed by a photographing agent – in other words, a photograph without a photographer. This we cannot muster – unless, perhaps, we consider using images from surveillance cameras. But how close to this ideal can we get in historical photographs? I would say that the instances of photography in which the photographer has the least possible influence on the behaviour of the photographed are those taken from a long way away or with a hidden camera. Neither of these types of photographs is unproblematic. The former type, often used to make postcards, is useful in that its purpose is to show a landmark or a street scene, and the individuals who happen to be caught in the picture have not been choreographed by the photographer and are in most cases unaware of the camera. The latter type is more problematic in that it might be manipulated by the photographer, depending on where he points the camera, how close he gets to the people he photographs, and how much of the actual scene we see in the resulting image.[21]

But a surprisingly large number of such photographs exist from around the turn of the twentieth century, and they provide a rare and uninvestigated insight into public behaviour of the time. Within the study of

photography, the term "street photography" has emerged to denote images produced in an interaction between the photographer and bustling street life. Given the prominent French practitioners of this genre, such as Eugène Atget and Henri Cartier-Bresson, street photography has typically been associated with Parisian artistic life in the early twentieth century and described as developing out of the realist interests of the Impressionist school and the culture of *flânerie* described by Charles Baudelaire and Walter Benjamin. Given this pedigree, street photography has been studied mainly as an art form, and most of the photographers who first explored the possibilities of catching moments of everyday life with a camera were connected to the artistic world.[22] What research on street photography as art has demonstrated, however, is that in order to acquire the sense of immediacy and transience that is its appeal, street photography needs to exclude the context of what is going on. The images are thought-provoking because they are mysterious and do not give us information about who is depicted or exactly what is happening.[23] During the twentieth century, however, an increasing scholarly interest in street photography has obscured the rather inartistic and unprofessional origins of the practice. Cartier-Bresson defined the art as that of catching a "decisive moment" in the depicted subjects' psychology or expressions, but the attention to such aspects means that the earliest street photographers have been somewhat disregarded, since the value of their output is more historical than artistic.[24]

Street photographs are inevitably one of the first ports of call for anyone who wishes to learn about street life in the late nineteenth century, but in order to stabilize the unavoidably capricious observations that we can make from such photographs, we will need a large number of pictorial and textual sources to contextualize our conclusions. In her examination of how historians may use photographs, Penny Tinkler emphasizes that any historical investigation using photographs to "provide insights into the people depicted" must consider how the photographs have been produced and how this may have affected the motif.[25] On the point of street photography, she remarks that one cannot, for example, draw conclusions about the absence of men in a certain area from photographs that have been taken in that area only at a certain time of day, but that, selecting one's questions with care, the images can surely tell us something. Consequently, it is vital to reflect on what questions can be posed to the photographs, and on what points the photographs are liable to deceive us.[26] I would argue that one area in which photographs are less likely to deceive us are details in body language, particularly poses made in public and momentary gestures. If coupled with theoretical works in the field of performativity and everyday life, street photography might, as argued

by Meir Wigoder, allow us to "concentrate on the subject itself" – "the anonymous pedestrian."[27]

⊰ THE HISTORY OF THE HUMAN BODY as it has been written has many parallels with the history of the Victorian age. It is often the story of civilization and inhibition, but paradoxically it coincides with the development of modernity and the evolution of the ideas of freedom and naturalness that govern our conduct today. A recent article by Sander Gilman charts the origins of the upright posture and its importance in nineteenth-century culture, especially in the military and in Darwinian notions of the separation of humans from apes. Gilman especially stresses the way posture was used to distinguish between "primitive" and "advanced" human races.[28] Specialist studies on sports with a focus on how athletes were portrayed also contribute valuable information on bodily discourses.[29] Photo historians have also occasionally taken an interest in the way photographic portraiture reproduced civilizing ideas about identity.[30] A pioneering piece by the art historian Kenneth L. Ames on the symbolism of Victorian seating posture has attempted to balance the one-sided picture of bodily discipline by drawing attention to the way defiantly lounging postures became increasingly accepted, as evidenced for example by how the back legs of Victorian chairs show signs of tilting.[31]

Most research on the history of body language has focused on premodern periods, in which material such as sculptures, religious paintings, or portraiture provides clues to the rituals of the medieval or early modern church or royal court.[32] When it comes to the modern period, the study has been carried out mainly by sociologists and anthropologists, and the field is dominated by the formative work of Marcel Mauss, Maurice Merleau-Ponty, and Pierre Bourdieu, who gradually increased awareness of body practices as socially inscribed and as incorporations of social imperatives. Mauss's 1934 article "Techniques of the Body" speaks of an "education of composure" wherein emotions and "disorderly movements" were systematically suppressed through the internalization of various social norms in order to achieve a "domination of the conscious over emotion and unconsciousness."[33] This was a few years before the publication of Norbert Elias's great work on the civilizing process, which has many corresponding notions, although Elias did not apply his ideas to the modern age.

The ideas introduced by Mauss were eventually taken up by Merleau-Ponty, who proposed the integration of mind and body on a philosophical level, challenging Cartesian dualism and stressing the importance of the body in human experience. He drew attention to the way "prereflective" lived experience in our bodies plays a vital role in perception, thus paving

the way for the work of Bourdieu on his "theory of practice," in which the latter emphasized the role of unreflected bodily dispositions rather than rational reasoning in the decisions of individuals.[34] Using Mauss's term *habitus* to denote "dispositions" or "inclinations" toward choosing a road of action, Bourdieu set the scene for decades of offshoot studies in the humanities.[35] In its formation, Bourdieu's work on practice and habitus provided a vital bridge between the abstractions of French structuralism and the attention to agency represented by advances in ethnomethodology.[36] However, in an investigation such as the present one, which will look at everyday bodily practice and social interaction on a micro level, Bourdieu's work must play a secondary role to the more helpful incentive of Erving Goffman.

Goffman's work on the self-fashioning that goes on in situational social encounters has been related to the body theories of Mauss and Merleau-Ponty in that it provides the contextual focus that they were aiming at but never achieved. In their work, the integration of past, present, and future in body techniques is activated through the appropriation of culturally acquired habits in the circumstantial conditions of the current situation. Goffman pursues this line of reasoning by drawing attention to the importance of the situational in social encounters and the adoption of an inscribed repertoire of cultural codes in public appearances. He also develops Merleau-Ponty's notion of intersubjectivity by underlining the fact that physical action derives its meaning from dialogical situations in which it is directed toward other people.[37] The incorporated dispositions that Merleau-Ponty talks about can thus be studied alongside culturally contingent "costumes" of self-presentation by paying attention to transient social scenes.

In my previous work, I have made use of Goffman's theories more fully, but here I will limit myself to his notion of the situational and of performativity – or "display," as he calls it in *Gender Advertisements*. This book deals exclusively with body language in advertising photographs, and serves as a helpful inspiration when considering the demonstrative aspects of body language. Goffman identifies display as the type of body language that has become culturally formalized and stereotyped so as to more effectively convey signals concerning social identity, mood, intent, and so on.[38] Several tropes in nonverbal communication are thus cultural artifacts, formed to communicate the performer's aspired social type. Goffman looks specifically at gender displays and identifies the "conventionalized portrayals" of masculinity and femininity. Here, we will try to cast our net wider, but will partly land in observations on the formalized displays of gendered, class-based, and subcultural identities.

The imperative to look upon body language as a topic of cultural history can also be derived from Paul Connerton, who like some of the scholars mentioned considers body practices as a site of memory by which people may distinguish between various bodily signals. By acquiring habits in our body language, we adopt the bodily preconceptions of previous generations, learning them until they become unconscious.[39] This remark has been inventively picked up by historian Herman Roodenburg, who has studied how bodily memory was essential in shaping the behavioural ideals adhered to by early-modern courtiers, allowing them to speak in terms of both something natural and something acquired.[40] Connerton notes that the human repertoire of postures and poses is limited, which is exactly what makes it potent in public communication, and the positive charging of upright posture versus the negative view of slouching that Gilman observed is deeply embedded in the moral aspects of most cultures. Body language, then, is always about using and interpreting ways of being that have been handed down from the past.

We learn from the examples of such historians as Roodenburg and Ames that body language can be a topic for cultural history, considering posture or gesture as a cultural artifact, and it is apparent by now from work on the cultural history of the body that at various times in history the body was disciplined by imposed ideals and norms. But this is hardly the whole picture. What about the ways in which these norms have been adapted by various groups in everyday practice – or avoided in favour of other ideals? Here I want to take the discussion one step further by looking at historical body language not from its discursive or prescriptive aspect but as a tool in everyday social interaction. Bodily practices will be scrutinized for what they can tell us about the cultural patterns and ideals that governed the nonverbal interactional part of the age rather than its verbal and literate sphere. These cultural patterns might be seen as subcultures of practice differing from or challenging the hegemonic or written discourses permeating the textual record. Thus, examining *how body language was used in everyday life to communicate identities and ideals of conduct* will hopefully provide us with an altered view of the history of the body in the modern period. It will, at least, redress the imbalance in historical research on the nineteenth century that is based on written or literary material. Such approaches have contributed to a picture of this period coloured by stereotyped middle-class perceptions, even when the goal is to shed light on the lower strata. In that way we have often been given, in the words of Gareth Williams, "a history of popular culture that approaches it through the censorious eyes of its policemen [and that] shows the people as not so much *doing* as having things *done* to them."[41] In this book, if nothing else, I hope to show people doing things.

◄ IN THIS STUDY, I use the term "body language" to refer primarily to body poses and gestures. The study of body language in this form is a large field, taken up by semioticians, psychologists, and anthropologists. Semioticians discern between communicative and expressive body language, the former being conscious and the latter spontaneous and unintentional, betraying emotions. Anthropologist Christoph Wulf distinguishes, similarly, between iconic gestures, basic signs that change very little over time, and symbolic gestures, which have different meanings depending on time and culture. Gestures are generally understood by scholars of nonverbal communication as functioning as either "speech illustrators" or "emblems," i.e., culturally specific gestures such as the "peace sign" or "thumbs-up." Poses or postures convey "attitudinal states and general affect," meaning expressions of partiality, attention, and tolerance.[42] The study of gestures in particular has been established mainly by Adam Kendon in the research on "visible actions" as "utterances," highlighting the way people manage their actions with deliberation. However, Kendon's contribution focuses mainly on hand gestures.[43]

The study of body language across cultures has in some instances brought to the fore a conceived difference between "expressive" and "reserved" cultures, in which the former is characterized by a forthright and "loud" body language while the latter is perceived as subdued and discreet.[44] Such cultural divides were earlier seen as empirical proofs of the perceived division between archetypal northern European behaviour and more gesticulating southern European or Middle-Eastern behaviour, but this thesis has been heavily criticized, not least for confirming ethnic stereotypes, and latter-day systematic investigations into such discrepancies have found little evidence to support the notion of a cultural dualism. These studies have consisted mainly of examinations into the frequency of touch between strangers in public places and the degree of proximity between strangers who sit on park benches, and their conclusions have suggested that the influence of cultural factors should be toned down in preference for "situational variables" such as conversation topic, emotional state, personality, and so forth.[45]

The study of poses and gestures, however, has not been as explicitly related to the expressive/reserved division. The most relevant work, carried out by David Matsumoto and Hyi Sung Hwang, indicates that there is indeed a distinction between expressive and reserved cultures with respect to their influence on nonverbal behaviour such as facial expression, eye contact, posture, and gesture. This division is also identified as a common cause of misunderstanding between representatives of the respective cultures, easily leading to irritation.[46] But instead of seeing this division as absolute and translatable to specific countries, as in those few studies that

have appropriated it, we may see it as a continuum in which cultures can be placed both close to the middle or further out from it, and it may be more practical to view the expressive and reserved cultures, in conjunction with the conclusion mentioned above, as coexisting, divided by social factors or situational variables rather than by nationality or gender.

The body language that meets us in old photographs is, nine times out of ten, influenced by the presence of a camera and a photographer. In many cases, this means that the body language we encounter is shaped by contemporary standards of conduct and expectations concerning how to pose for a photograph. But it is also an appropriation of such standards by the individual in the photograph, and every such appropriation is affected by factors stemming both from the individual and from her surroundings. It is this situationally contingent appropriation that will interest us in this book. Therefore, the types of photographs considered will mainly be those in which the individual agency is greater, although in order to detect this agency we will begin by briefly considering the conditions of the most ritualized photographic images. The body language that we may observe in the types of photographs studied here lies close to the "everyday practices" described by Michel de Certeau as "tactics," the vernacular reappropriation of the cultural commodities imposed on everyday life by authorities or institutions. This reappropriation connotes the way "ordinary people" adapt or consciously misuse products and services available to them. The creativity of everyday life lies not in the production of commodities but the ways in which commodities are used.[47] For example, architects decide how houses and flats will look, but it is the people who move into them who decide how they will be furnished and decorated. This basic idea is similar to Umberto Eco's notion of "semiotic guerrilla warfare" and has inspired John Fiske in his theorization of popular culture as a constant micropolitical tug of war.[48] I will refrain from using words such as "resistance" or "guerrilla tactics" when the actual intention of the individual is unknown. The practice Certeau spoke of is sometimes conscious and meant as resistance, but often it is not, being instead the willing consumption of commodities that are then inadvertently used in ways that differ from those intended. How many of the people who buy the latest fashion wear it in absolute accordance with the combinations that the designers had in mind?

Certeau's theory of tactics is useful mainly because it articulates something quite elementary: that culture is not just created "from above," and that deviant or alternative action among ordinary people – what folklorists once called "folk culture" – lives on in the modern age. The established picture of the *belle époque* puts much emphasis on the disciplined and formal nature of the age, but many excursions into sources that

originate from the "backstage" regions of the age, revealing the informal and undisciplined life that went on in back streets, parlours, dance halls, public houses, brothels, sports venues, and the like, repeatedly cast doubt on the comprehensiveness of such a picture.[49] Although it has long been an implicit assumption that this period in history was divided between the life and culture of the well-to-do and that of the impecunious, the observations on Victorian or *belle époque* unrestraint indicates that the division between civility and abandon is not translatable to class divisions. This warrants a new picture of the everyday culture of this age that pays closer attention to the testimony of the silent history.

The outline of this book follows a journey of discovery from a civilized and verbal picture of the age to an uninhibited and nonverbal version of it. This is motivated not only by a wish to demonstrate the one-sided nature of the verbal history, but also to emphasize the interrelatedness of decorum and abandon that existed in the period. Therefore, we begin the study by looking at the nineteenth-century culture of civility and manners from a bodily perspective (chapter 1), continue by examining more specifically the age of early photographic portraiture and the body ideals it contained, and contrast the conventional portraiture with portraits that do not fit into the framework (chapter 2). This second chapter acts as a bridge to the central part of the investigation: five case studies focusing on individual body poses that have been chosen as particularly typical and prominent in this period (chapters 3 to 7). The poses are examined in street photography and thus provide insight into the everyday practice of people in public urban spaces and the body language they indulged in in this context. After these case studies, a contextualization of the body language detected in them is made through a survey of its representations in newspaper accounts and the stereotypical connotations that the various poses had in public discourse (chapters 8 and 9). From this, we try to identify the contours of the nonverbal cultures that flowed through the streets and what subcultural identifications or roles the examined poses carried within them. The decorous context of the beginning of the book is thus balanced by a look at the uninhibited context of everyday practice at the end of it. The concluding chapter attempts to place this time-limited study into a larger context of the development of behavioural ideals and the question of a civilizing process in the entrance to the modern age.

I cannot claim to study the entirety of vernacular body language in this period, nor do I believe that a historical investigation of nonverbal communication can ever claim to cover a full range. The photographic material is scattered and biased, but its relative wealth and a juxtaposition of dispersed samples will prevent impressionistic observations. The case studies I make are highly specific microhistories of a situated practice

conditioned by local contexts and varying identities. At the same time, I pick my examples from the urban cultures of three different regions: England, Sweden, and Austria (with some outlooks on southern Germany). I have chosen these regions to ensure a varied array of responses to the cultural and social developments of the time, considering the range from the industrialized environment of England, to the still rural and only partly urbanized world of Sweden, via the rapidly and suddenly industrializing and modernizing Germanic countries. These transnational comparisons will show both local variations and cross-cultural circulation, and I shall try to disentangle these with the help of pictorial and other productions of popular culture. A study of the nonverbal cannot reach conclusions that are as verbally exact as a study of texts, and I ask my readers to keep this in mind.

The poses analyzed here, then, are tactical uses of the photographic medium. At least such is the case for conscious poses, where the camera was visible to its subject. In the final part of the study, I will focus on the body language that is visible in hidden-camera photographs or snapshots whose subjects were not given time to pose, and compare this unmanaged behaviour with conscious posing first to gauge to what extent the popular culture was allowed to shape the body language of portrait photography and then to make observations on the nature and principles of cultures of practice around the turn of the twentieth century. A photographic study also requires sufficient contextualization, and in this case it will be provided by comparing poses seen in photographs with the exaggerated versions depicted in contemporary cartoons and magazine illustrations. The criticism surrounding the use of illustrations and cartoons to gain insight into everyday practice is valid, but there is an approach that can make such material useful. Taking our inspiration from Carlo Ginzburg and close reading of inquisition protocols to detect places in the texts where the interrogators were baffled by their victims and misinterpreted their words, we may similarly use some instances in cartoons and the like to detect a rift between the cartoonist's perception of a popular practice and the practice itself when the cartoonist's depiction of it appears strange or nonsensical.[50]

◄ BUT WHY IS THE PERIOD in focus here, roughly from around 1860 to the First World War, important to the history of the human body? It is hardly more relevant than others, but it plays a key role both in the way the historical imagination of the twentieth and twenty-first centuries has identified this period as the threshold of the modern age, and in the way historians of the body have drawn a diffuse border between the premodern and modern periods around this time. The civilizing process described by

Norbert Elias stops short at the modern period, Michel Foucault locates the main changes in the way we view madness and criminality in this age, and Thomas Laqueur postulates that a shift in the perception of human anatomy brought about the idea of the male and female sex in the late eighteenth and nineteenth century. So, as you can see, the community of historians mistaking the history of the body for the history of discourses is getting quite crowded. How would this history be different if we looked at it from the point of view not of doctors, policemen, and politicians, but of the man on the street?

In hindsight, the civilizing of the human body that aimed at straight backs and graceful movements reached its pinnacle in the late nineteenth century. Much of the strict and upright body language that we associate with this period had earlier origins, but several key expressions of nineteenth-century culture consolidated or spread it: conventions of theatre and opera acting, ballet, militarism, and even Spanish bull-fighting posture.[51] This means that much of the free and liberal ways that have become increasingly dominant in the twentieth century are often seen in contrast to the "stuffy" nineteenth century. The investigation carried out in this book may serve to encourage a different outlook. For if we assume that Lytton Strachey was wrong, and we devote as much attention to the culture of practice and everyday interaction as has been devoted to the disciplined culture of textual sources, then the cultural history of the nineteenth and early twentieth centuries will be seen not as the disciplined age that the late twentieth century rebelled against but as an age holding the genesis of much of the unruly and "liberated" behaviour of the late twentieth century. And, with this perspective, I hope to take a few steps away from the concept of a divided world of elite and popular culture in the nineteenth century toward a more integrative picture. For while the period from the mid-nineteenth century to the First World War covered in this book was a time of vast social and economic divisions, its culture was not as divided as we have come to believe.

Part One

1

The Culture of Nonverbal Communication in the Nineteenth and Early Twentieth Centuries

HOMO ERECTUS: NINETEENTH-CENTURY BODY IDEALS AND THEIR LEGACY

A much-reprinted etiquette manual, first published in 1859, offers very particular advice on the physical carriage of men and women. When it comes to women, "the graces of an upright form, of elegant and gentle movements, and of the desirable medium between stiffness and lounging, are desirable both for married and single." This striving for a balance between stiffness and a "lounging" appearance seems to be the most vital lesson in this section of the book, and it concerns both men and women. "A certain dignity is the first requisite," the author informs us, but we must not overdo it. "Dignity can never go along with a slouching gait, and uprightness should be acquired in childhood by gymnastics and ample exercise. This uprightness, however, should not go to the extent of curving the back inwards." In the end, however, the perpetual insistence on both adhering to strict rules and being natural turns into a paradox. "Avoid stiffness on the one hand, lounging on the other," the book instructs, while adding, "Be natural and perfectly at your ease."[1]

It is evident in the etiquette and advice manuals of the mid-nineteenth century that the writers wished to convey a sense of order and decency, and that their advice was founded on the belief that appearances were indicative of one's nature or breeding. "A noble and attractive every-day bearing comes of goodness, of sincerity, of refinement," writes John H. Young in a book entitled *Our Deportment*. "And these are bred in years, not moments. The principle that rules our life is the sure posture-master."[2] Historians

like to suggest, however, that the ideology behind nineteenth-century etiquette books was not one of pious morality. This may have been the chord struck, but beneath the surface was the crass ambition of the burgeoning middle classes, who wished to complement their financial prosperity with an emulation of "high culture" as they climbed the social ladder. Manners and etiquette were simply a means of achieving profitable ends: acquiring influential acquaintances or landing a good marriage partner.[3] This is an established picture of the middle class that shaped much of nineteenth-century society in Western Europe, but is it the whole truth?

Even a scholar such as Michael Curtin, who supports this picture, introduces nuances that imply a variation in attitudes. He takes Samuel Smiles's highly popular *Self-Help* as an example of an advice book that promoted virtuous traits such as diligence and intelligence rather than simply instructing the reader on how to behave. The above-quoted etiquette books are representative of the genre, and they invoke characteristics such as dignity, nobility, and spontaneity, but it is quite clear that their emphasis is on practical rather than spiritual advice. On the other hand, the writers seem compelled to say a few words on just why one type of behaviour is preferable to another. They use words such as "grace" and "sincerity" to claim adherence to indisputable ideals. Certainly, these books were instruments in social climbing, and their popularity reflected the contemporary mentality of careerism, but how typical were they? This question lies at the heart of this book. For now, however, we will limit ourselves to a discussion of the relevance of conduct ideals within the culture of sociability.

A more concrete glimpse of nineteenth-century decorum can be found in other literary genres, such as novels and autobiographies. When Swedish author Emilie Flygare-Carlén wanted to introduce the confident and admirable hero of one of her romantic novels, she wrote that "he carried his considerable height with a good posture, and his broad shoulders, muscular contours and weather-beaten cheeks, framed by bright curly hair, were reminiscent of the ancient vikings."[4] Similarly nationalistic is a description of the typical inhabitant of a particular northern Swedish village in an annual from the Swedish tourist association: "The Dalby man is tall and powerful and he wore his local costume with a good posture and conspicuous dignity."[5] A corresponding picture of an English labourer is painted by Richard Jefferies: "I looked at the modern charcoal-burner with interest. He was brown, good-looking, upright, and distinctly superior in general style to the common run of working men. He spoke without broad accent and used correct language; he was well educated and up to the age. He knew his own mind, and had an independent expression; a very civil, intelligent, and straightforward man. No rude charcoal-burner of old days this."[6] Although, apparently, there was a clear picture of a

disreputable and ill-mannered working man in Jefferies's mind, these quotes exemplify the way bodily and behavioural ideals in the nineteenth century were not bound up in matters of restrained etiquette. Men and women of the manual labour groups or from the farming culture were not expected to behave like people at a garden party. However, the ideals of dignity and grace that formed the basis for the etiquette manuals' advice are present here as well, although expressed differently.

Historians of nineteenth-century culture like to stress the dominance of middle- and upper-class etiquette,[7] but in doing so tend to forget its limitations in relation to gender and to class. Men of considerable or moderate means often had access to spheres of life where the rules of propriety were different or suspended. Prostitution was substantial and unofficially sanctioned, and involved a relationship between men and women that turned the rules of conduct manuals topsy-turvy. Here men were allowed to be forthright and physical – and so, it should not be forgotten, were women, who as prostitutes had the ability to behave publicly in ways that alarmed those who were unaccustomed to it, or who believed in the separation of the private and public sphere.[8] One pornographic work of the late Victorian period, the eleven-volume erotic diary *My Secret Life* published under the pseudonym "Walter," gives a credible account of how a middle-class gentleman could lead a double life in which he completely discarded his well-behaved persona when walking the back streets in search of licentious women.[9]

There were also exclusively male arenas, such as gentlemen's clubs, cafés, and student associations, where rules of conduct were eased.[10] Finding corresponding arenas for women is much more difficult, at least among the middle and upper classes. Female interaction without men was limited mainly to visits in the home or other social gatherings that were more restrained than male congregations. Although masculine ideals allowed for a certain degree of outwardness or overlooked lapses of self-discipline – provided these were limited to the proper arenas, of course – female ideals were much more informed by discourses of fragility and passivity.[11] Possible exceptions were women who occupied certain social roles not embraced by the narrow bourgeois ideals. Widows had more legal rights than married women, and women who remained unmarried throughout adulthood, although they might be sneered at on account of this deviance, could allow themselves a more unrestrained, and even manly, behaviour.

This discrepancy between male and female ideals became apparent in the outraged reactions to late nineteenth-century phenomena that threatened the division of the sexes, such as the popularity of cycling among women or critiques of the institution of marriage. Textual expressions of outrage are often our window into "alternative" codes of conduct in

nineteenth-century culture. The indignation apparent in periodicals of the time in the face of hooliganism, larrikinism, free-spoken cab-drivers, street-corner gangs, "street Arabs," or the "monkey parade" are clear suggestions that this period was rife with other conceptions of public behaviour than that represented by etiquette manuals and moralizing letters to newspaper editors.[12] In 1864, the German-American jurist Francis Lieber defined a gentleman as a character "distinguished by strict honour, self-possession, forbearance, generous as well as refined feelings, and polished deportment." He continued: "Its antagonistic characters are the clown, the gossip, the backbiter, the dullard, coward, braggart, fretter, swaggerer, and bully."[13] This is a clear indication that it would be difficult to distinguish a gentleman if there were not contrasting characters.

This profusion of types and ideals of behaviour should be kept in mind when we talk about nineteenth-century Western culture. There is a distinct antagonism between various ideals, but the belief in straight backs and good posture was expressed in more than the etiquette books. At the same time as advice books promulgated the "upright form," posture became a focus of interest in the worlds of orthopaedic medicine and athleticism. Although before the nineteenth century poor relief had done little to remedy the causes of poverty, there were moves in the nineteenth century toward the institutionalized care of the crippled and deformed poor. Orthopaedic medicine became a way of extracting those who could be made into able-bodied workers from the ranks of the crippled, by treating, among other things, their bad posture. Correspondingly, the emergence of the gymnastics movement in the early nineteenth century, promoted especially in the German-speaking regions of Europe by Johann Christoph Friedrich GutsMuths and in Sweden by Per Henrik Ling, established the notion of physical exercise and the cultivation of a healthy and robust body as a foundation for able citizens and a strong character.[14] Bad posture was also one of the physical attributes noted in the diagnosis of insanity, and the emphasis on posture crept into child-rearing and education, where a slack posture was deemed to signal laziness and degeneracy.[15]

For men, the connection between character and posture was made apparent early in life through schooling and military training. Military codes had encouraged a straight posture since a few centuries back, but this type of bodily discipline was strengthened in the nineteenth century, partly by its dissemination into civilian life but also by the adoption of new types of uniforms and new thoughts on military organization.[16] During the European wars in the eighteenth century, Prussian and French armies augmented their insistence on discipline and self-control by making erect posture a key ingredient in military conduct and emphasizing the importance of standing to attention.[17] Women, meanwhile, learned the necessity

of good posture in other ways. The popularity of the nineteenth-century corset is infamous, although its excessiveness and health risks have been somewhat overblown. Corsets first appeared in the sixteenth century, when bodices of the medieval period became more rigid, incorporating whalebone or other sturdy materials to ensure an erect posture. The corset was part of a culture of self-discipline widespread in early modern aristocracy that originated in the Spanish and Italian courts. As refined and civil behaviour became increasingly codified, physical appearances were expected to mirror these ideals.[18] Tight-laced stays or corsets then came in and out of fashion in the ensuing centuries, but enjoyed their height of popularity in the second half of the nineteenth, not as a result of increasing female oppression but because the democratization of fashion in the wake of the Industrial Revolution gave more women access to corsets. Thus, corsetry became linked to ideals of beauty and femininity on a wide front. Historians have interpreted this as a transferral of old aristocratic ideals of the disciplined body to notions of feminine beauty in the modern period.[19] However, although it would always be crucially linked to female fashion and appearance, the corset was also introduced into male fashion at the same time.[20] The bodily ideals inherent in the corset and related fashions corresponded to male ideals, and the ideals of both the gentleman and the lady contained ideas of refinement and dignity that permeated nineteenth-century Western culture.

THE MODERN CULTURE OF DIGNITY AND CIVILIZATION

The three countries under scrutiny in this book – Austria, Sweden, and Great Britain – all formed discourses of the human body that were both different from and similar to each other. In the German-speaking countries, athletic ideals would be intimately linked with an inherent culture of militarism. In Sweden, the gymnastics movement became a tool in the social engineering of industrious workers. In Great Britain, the image of the immaculate youth was linked to the culture of gentlemanliness, "fair play," and courage that was pivotal to the country's imperial aspirations.[21] While both Germany and Britain had colonial motives, Swedish culture was directed inward. Britain had long been a nation of industry, Germany and Austria became so very rapidly and suddenly, resulting in a more tangled identity, and Sweden was very slowly becoming industrialized, retaining the rural agrarian undercurrent of its national culture well into the twentieth century. And yet all three regions shared cultural currents and discourses that typified the era.

The nineteenth-century culture of bodily ideals touches on many of the phenomena of the age, including imperialism, nationalism, and social

class structures. Most of these are clusters of ideas resting on notions of hierarchy, whether between Western nations and their "uncivilized" colonial subjects, or between men and women, compatriots and foreigners, or rich and poor. Even industrialism, with its consequent social divisions, urbanization, and market competition, contributed to the modern notion of "us and them." According to this perhaps somewhat rigid picture, nineteenth-century culture has been purported to be the product of a consolidation of discourses long in circulation. In an influential study, Dror Wahrman asserts that early eighteenth-century England was characterized by unstable, malleable identities, allowing gender identities, for example, to be tweaked in masquerade, or race to be modified if a "savage" switched climate or was initiated into Western social customs. With the approaching threat of an American revolution, however, England was stricken by a deep identity crisis, after which monolithic, essentialized identities started to become emphasized.[22] Wahrman claims that similar shifts in perceptions of self took place as well in other countries such as France, which after its Revolution was afflicted by a "collective uncertainty about identity" that led to more personalized notions of self and a belief in the communication of delineated individuality and social roles through outward appearances.[23]

This solidification of social categories was ultimately a consequence of profound modern changes that created a sense of bewilderment and instability. European encounters with non-European cultures and peoples – encounters that were repeatedly related and communicated in popular culture – and the increasing complexity of Western society as a result of industrialization, capitalism, and notions of progress may be extracted as contributing factors. The natural way for Europeans to react to meeting colonials was to see them as lacking things that Westerners had started to see as ubiquitous. Their lack of factories, large cities, and efficient long-distance transport were viewed by Europeans as evidence of inferiority. It was simply not on the agenda to wonder whether they were less happy without these modern conveniences. The same attitude was applied to the impecunious strata of Western society, and the discourse of "poverty" became more disseminated. This unequal outlook also formed attempts at compassion, such that the implict goal of poor relief was to make the recipients of aid more like those who provided it.[24]

The watchwords behind this emerging discourse were "civilization" and "culture," concepts that during the eighteenth and early nineteenth centuries were increasingly seen as essentialized and hereditary. The discourse of civilization is related to the process described by Norbert Elias, who claimed that the state formations of the early modern period made societal functions more differentiated and interdependent, thus forcing people to

abandon old expressive and violent means of social advancement in favour of a more restrained and strictly organized adjustment of their conduct to the various social arenas on which they now depended.[25] Although Elias's streamlined depiction of this process has been criticized, it has been extremely influential in shaping the picture of emergent modern modes of conduct, and historians of the eighteenth and nineteenth centuries generally agree that Europeans at this time defined themselves in opposition to peoples they saw as "uncivilized" simply because they did not strictly adhere to the ideal of self-restraint and civility.

That this tenet of civilization was not an invention purely of the post-medieval period becomes apparent when we consider the invocation of antique ideals by eighteenth- and nineteenth-century thinkers. This is especially prominent in discussions of the notion of dignity, which was closely associated with the European self-image at this time. In his book *On Grace and Dignity* (1793), Friedrich Schiller defined dignity as "tranquility in suffering," thus tapping into a belief that seems to have been widespread at the time. Political scientist Michael Rosen traces this definition to art historian Johann Joachim Winckelmann, who a few decades earlier had published a book on ancient Greek sculpture in which he described the famous *Laocoön Group*, which depicts the tragic hero and his sons struggling with two sea serpents. Winckelmann points particularly to Laocoön's dignity in this scene, "a noble simplicity and tranquil grandeur, both in posture and expression," which sustains the viewer's respect for him, and though he evidently feels excruciating pain, it "causes no violent distortion either to his face or to his general posture." Winckelmann's words became influential in the following years and was related to Immanuel Kant's characterization of dignity as being defined by human acts of morality and the ability of humans to choose their own actions.[26] The connection of moral action to a cult of heroism and self-reliance reflected in outward appearances has been seen as a modern figure of thought. In his examination of modern notions of identity, Charles Taylor identifies the replacement of the older culture of honour with a modern concept of dignity that links dignity to individuality. The struggle for respect in the public sphere, he says, is "woven into our very comportment. The very way we walk, move, gesture, speak is shaped from the very earliest moments by our awareness that we appear before others, that we stand in public space, and that this space is potentially one of respect or contempt, of pride or shame."[27] The recognition of the self depends on the recognition of others, but according to Taylor this dimension is neglected in modern individuality, which is conditioned by defining oneself in opposition to others.[28]

The culture of dignity and posture was also becoming foundational in political life around the turn of the nineteenth century. As political

credibility and status became linked with emerging notions of masculinity, comprising ideals of heroism, defiance, and character, public appearances and speeches became more and more theatrical, informed by newly established ideas of expression in which certain emotions or states of mind were seen as directly translatable to certain poses or gestures. This body language was set down in manuals of acting and rhetoric and was to become influential in the public image-making of late nineteenth-century politicians.[29] For any public figure in the late nineteenth century and the period before the invention of radio, a command of rhetoric and the ability to make a lasting impression in public appearances were crucial, thus further establishing a connection in public between dignity and a certain comportment.[30]

Noble, refined, dignified, self-possessed. We may extract many such adjectives from the descriptions of the ideals of conduct quoted above. They correspond to ideals of physical appearance that valued a slim body, sober dress, and, not least, erect posture. The most explicit expression of these ideals can be found in the military culture of Europe before the First World War, which stressed self-discipline and fitness in a more extreme way than in earlier times. Such a military culture has most often been linked to German culture at this time, and was well established there, but it is also related to the colonial culture of Great Britain and the racially infused nationalism of Scandinavia.[31] It was fed by a widespread belief in European superiority and a hierarchical, stratified view of humanity inspired by popular ideas of social Darwinism. But was this stress on the straight-backed European sovereign unchallenged?

The opposition to the restrained culture of the nineteenth century comes in two shapes. First, the omnipresence of subcultures of more rowdy and forthright behaviour, exemplified by the hooliganism and larrikinism mentioned in the previous section. Second, the derision of "Victorian values" that emerged in different guises from the modernist circles of the early twentieth century. This latter form of opposition is one that has shaped much of later views of the nineteenth century. In Britain it is connected to the Bloomsbury group of writers, especially Lytton Strachey, whose revisionist histories of the preceding century paved the way for a fashionable sneering among liberals at the prudery of the Victorians. In the late twentieth century, this view – along with a contrasting one, which started to point to the comfort and security of "Victorian values" as a reliable alternative to the sway of cynical postmodernism – became the basis for a political opposition.[32] Continental equivalents to the Bloomsbury group were found in the movements of Expressionism, Dadaism, and Surrealism, as well as in intellectual circles within news media that were influenced by liberal or Marxist trends. This avant-garde also had

an influence on popular culture, such as in cabaret songs and cartoons.[33] In Scandinavia, popular movements such as the workers' movement, the temperance movement, and the free church movement contributed to an integration of the culture of decency and conservatism of the nineteenth century with progressive liberal or socialist ideas. The establishment in Sweden of social democracy was a step toward balancing conservative and socialist forces in order to comply with the demands of workers for emancipation and revolution, while at the same time preserving capitalistic systems for the good of the domestic economy. This seems to have engendered a curious mutation of the ideals of proper conduct, spreading the cult of respectability and decency to the lower orders, but also undermining the lifestyles of the peasant population by implicitly propagating such values as good hygiene and polite manners.[34]

But this picture of a shift from conservatism to democratic liberalism is somewhat simplistic. In an attempt to complement Elias's work on the civilizing process, Dutch sociologist Cas Wouters speaks of an "informalization" of manners and an "emancipation of emotions" during the twentieth century. Wouters contends that the nineteenth century saw the creation of "an elaborate and increasingly formalized regime of manners" that comprised a "complicated system of introductions, invitations, calls, leaving calling cards, 'at homes,' receptions, dinners, and so on."[35] This image of the nineteenth century as the age of courtesy and good manners is certainly not inaccurate, but it is inadequate, and it leaves out large sections of the social hierarchy as well as most occasions of everyday life in order to paint a picture of visitations and hat-tippings. Recently, historians have begun to emphasize the more rowdy and licentious aspects of this period. The general picture is one of a widespread discourse connecting physical carriage, especially posture, with civility, confidence, moral and cultural superiority, and social (including both racial and class) hierarchies.[36] But this culture was far from hegemonic, and the worlds of, for instance, working-class masculinity, sports, and gambling fostered quite different ideals. The dichotomy between civility and licentiousness was not necessarily a division between the upper and lower classes, as the cultures of public-school and university rowdyism and the class-transgressive indulgence in prostitution suggest.[37]

THE DEMOCRATIZATION OF THE PORTRAIT AND THE DISSEMINATION OF PERFORMATIVITY

Although we will not be concerned exclusively with portrait photography in this book, that is where we must start, for the invention and popularization of photography in the mid-nineteenth century offered a new way

of looking at the portrait and the depiction of the individual, and, consequently, led to new notions of identity. The history of portrait photography ultimately starts with Louis Jacques-Mandé Daguerre, who is most often credited with the invention of photography around 1839 (although the honour should not go exclusively to him), but the popularization and dissemination of photographed portraits was mainly the work of André-Adolphe-Eugène Disdéri, who in 1854 patented the *carte de visite* photograph, so called because of its similarity in size to a calling card. These photos were studio portraits, depicting the subject sitting or standing, alone or in a group, against a backdrop either of a painted landscape or a feigned domestic interior, created with the help of a curtain or a pedestal. Daguerreotype portraiture had many restrictions, given the imperfections of the technique, which was to be improved by various hands over the years. Daguerreotypes generally presented the sitter in half-length and were on completion framed in red morocco cases; given their dimensions (4 × 6 cm), they were comparable to miniature portraits.[38]

In the earliest days, the time of exposure could be up to five or ten minutes, making the process of being photographed quite excruciating for the sitter, who had to keep still during this time. Quite rapidly, however, exposure times were reduced to a couple of minutes, although this was still long enough to make a stand with a headrest an obligatory part of the photographer's studio until the turn of the century. Considering these technical complications, it is understandable that special conventions concerning posture and posing emerged and were set down in photographic manuals. An early example demonstrates how the limitations of the daguerreotype technique were largely responsible for the conformity of early portrait photographs. To prevent a strained expression on the part of the sitter – who naturally was affected by the length of exposure – a comfortable and natural seating position was required, with hands and legs placed so as not to be distorted by the lens. Disdéri eventually wrote several manuals, likewise expressing a desire for a natural pose in the sitter. This naturalness was supposed to counteract the mechanical feel of the apparatus and the photographing process, and Disdéri instructed photographers to make their sitter "forget any posture that he has prepared in advance and lead him to a natural pose."[39]

Interestingly, the introduction of portrait photography was met with criticism for its failure to achieve likenesses. For several centuries, painted portraiture had strived to achieve an ideal image of the subject, a composite drawn from a "careful generalization," while a photograph could convey only a momentary impression.[40] The general notion of the art of portraiture in the early modern period contends that portraits predominantly had the function of presenting the individual as the representative

of a social category, an office, or an estate. Close studies of portraits from this era demonstrate how, despite a growing interest in great individuals and personalities in comparison with the Middle Ages, a portrait reproduced in books would often be used to represent different people. A certain type of Western individualism emerged in Europe at the time of the Renaissance, putting more emphasis on the individual and realistic representations of illustrious people, but at the same time the premodern era did not have the modern expectation that realism should be the order of the day, containing a culture of types wherein individuals were presented as part of collective identities, and portraits of bishops or kings were frequently hung in groups.[41]

Viewed from this longer perspective, then, negative reactions to the portrait photograph were understandable, and recent research on *carte de visite* photography stresses the importance of studying albums of such photographs in their entirety, since albums constituted a way of situating individual portraits in a collective context where they communicated the sitter's relation to his or her social or occupational surroundings, thus reflecting social ambitions. Individual images were often sold as parts of a set, and the importance of albums show that they were also consumed this way – both those of private persons and those of celebrities (a type of photo that became incredibly popular). The prevalence of albums, and the practice of producing a series of photographs of a sitter, taken in slightly different poses, rather than just one photo, has been taken to imply that a likeness in the mid-nineteenth century was read in ways related to the premodern conception of the individual. If a photograph could not be made into the composite that a painted portrait was, then a series of images had that effect, and placing images together also emphasized the close connection between the individual and the collective.[42]

On a deeper level, scholars have claimed that the introduction of photography brought about a fundamental change in the understanding of vision. Most influential among these is undoubtedly art historian Jonathan Crary, who has argued that a classical model of vision based on the assumption of a physiologically stable viewing subject was supplanted in the nineteenth century by notions of an inconsistent observer constantly shaped by external forces. This conceptual shift paved the way for more relativist and subjective perceptions of vision as the flux of modern life undermined the observer's attentiveness.[43] And yet the wealth of photographic images of the late nineteenth century renders it difficult to substantiate such a general theory of vision.[44] What can be claimed with more certainty, however, is simply that this plethora of images (resulting both from the invention of photography and from new technological means of reproduction) placed the individual – especially the urban individual –

within a flow of impressions, potentially facilitating states of distraction, and a cult of realism caused by the removal from the "real" that the re-produced image emphasizes.[45] Philosopher Giorgio Agamben has also claimed that the self-consciousness and image overload of the late nine-teenth century contributed to a loss of naturalness in body language, lead-ing to the jerks, tics, and frantic gesticulating pathologized in 1885 by psychologist Gilles de la Tourette.[46]

The visual culture of the latter half of the nineteenth century thus ushered in new visual experiences and new ways of perceiving the visual. Histor-ical studies of this situation have slowly begun to address what impact this had on ordinary people, as we will see in chapter 10, but little attention has been devoted to the relation of the lower orders to the spread of portrait photography. Having your picture taken was an expensive business, and when it started to become possible for poorer people to do so, they hardly had the means to have ten pictures taken, or to collect them in albums. Did the nineteenth century constitute a "democratization period" for the portrait, or did this not happen until well into the twentieth century? As the century wore on, portrait photography became more inexpensive and available to a greater variety of people, but many historians deny that the working classes had the time or money to have their photos taken. And, in cases where more impecunious people could afford a *carte de visite*, the pictures are seen to be virtually indistinguishable from upper-middle-class portraits, since it was generally accepted for lower-class sitters to conform to and emulate bourgeois ideals and appearances.[47]

Such an account is of course a simplification. In the earliest decades of photography, labourers and the poor encountered the camera only when photographers ventured to make anthropological studies of beggars for commercial use or to document a team of workers at the construction of some important building. In the 1870s and '80s, however, technological development made cameras cheaper and easier to use, and travelling photographers and local studio photographers offered to make portraits of rural dwellers and the inhabitants of poor urban neighbourhoods. Un-fortunately, most studies of nineteenth-century photography in relation to the lower orders are studies of photos of prisoners, mental patients, and the like, exploring the way people from the lower classes, or from various outsider groups, became the object of the photographic eye in a derogatory and prejudiced way. The use of photography in mental institu-tions, correctional facilities, or police work reflected preconceptions that classified the poor, criminal, or deviant as "other" – as social categories that needed to be civilized or put right.[48] This mentality was of course especially apparent in the attitude to colonial subjects, and photos of the

indigenous peoples of colonized countries in the nineteenth century show the inherent discrimination in the way the sitters are posed or depicted.

Very few attempts have been made to comprehend the way the members of these divergent categories made use of photography themselves, and what identities and cultural notions can be reflected through photographic depictions of them. A brief study of American tintypes from the third quarter of the nineteenth century, a special type of photograph that was very cheap to make and thus became popular among manual labourers and manufacturers, illuminates how unskilled tintype photographers and their customers ignored the conventions of posing and artfully creating a likeness that had emerged among professional photographers. Whereas those who visited an illustrious photographic studio could expect to be instructed to pose in a certain way so as to conform to ideals and norms, tintype sitters chose their own poses and are generally seen proudly presenting the tools of their trades, dressed in their work clothes as if they have just wandered in from work. Art historian Michael Carlebach interprets this way of presenting oneself as reflecting a work pride emanating from the increasing rarity of independent, self-sufficient manufacturers and craftsmen in a rapidly industrializing country.[49] The worker's relation to photography was naturally more pragmatic and less aimed at artistic stylization than that of the middle class, reflecting a difference in cultural contexts and attitudes to art. The carpenter and the seamstress were not as exposed to theories of fine art or debates on photographic depiction in specialized journals as the bank manager and the solicitor. But to simply conclude that their self-presentations merely expressed pride in their work seems to reflect an unwillingness to thoroughly interact with such photos.

In his book on companionship as reflected in male studio portrait photographs, John Ibson contends that the increasing theatricality and performativity of nineteenth-century life resulted in a culture of photographic pageantry among men from the lower-middle and lower classes. Gender historians have spoken of a "masculinity crisis" toward the end of the century in response to the strictures of modern life. Ibson assumes a hesitant attitude to this now-discarded theory, but the evidence of male performativity still suggests a will among men to present themselves in rugged or rustic poses indicative of what he calls an "anti-modern spirit."[50] In other contexts, labour historians have interpreted the body language of plebeian men in situations of workers' protests and demonstrations as oppositional and subversive, combining older carnivalesque behaviours with the political endeavours of the moment.[51] Observations like these are most commonly found in works on the history of dress, in which the alternative and assertive clothing of the lower classes is often seen as a type

of "nonverbal resistance" to the dominant styles of dress. Other fashion historians have, however, noted the adaptability of working-class men to the nature of the situation they were in, gladly shedding their rough work clothes in favour of a suit after a hard day's work.[52]

In a similar vein, portrait photographs of the indigenous peoples of European colonies – generally interpreted as pacifying the sitter and exposing him or her to the prejudiced view of Western culture – have also been credited with giving the colonized subject a tool for self-presentation, a tool that, despite being shaped mainly by Western imperialist conventions, could not be controlled to the extent that the sitter's influence was completely subverted.[53] The complexity of the relationship between photographer and colonial subject in the situation of photographing has also recently been paid more attention, thus revealing interesting nuances. For instance, James Faris has shown in a case concerning photographs of the Navajo people of the American Southwest how photographers made portraits that deviated greatly from the norm of colonial portraiture, but that these were suppressed and more conventional images publicized in favour of those that give an alternative picture of the relationship between native and photographer.[54] Although the self-presentations in photos of this type often express indigenous people's attempt at gaining pride and dignity by appropriating Western dress and appearances, they would probably also be a valuable source for the hybrid popular cultures emerging among colonized subjects.

What studies of portrait photography suggest, then, is a culture of performativity that presumably differs from potential premodern counterparts by virtue of their new medium. The performativity of the lower strata or of semi-public and private spheres is different from that of the most public and hegemonic. Many historians paint a picture of a dualism or even conflict between the dominant bourgeois cultural expressions and the plebeian expressions. Although this notion fits in with the conventional way of portraying this period, we must not make any preliminary assumptions, as the vernacular body language that this study seeks to uncover is defined by situation rather than class. Consequently, it will become relevant to focus on points where the presumed hegemonic discourse of civility and good posture is challenged or suspended, in order to see more clearly what patterns and logics these challenges are signs of, and thus perhaps to tone down the notion of a hegemony of one at the expense of the other.

Posing for Portraits

CONVENTIONS AND ABERRATIONS

⊰ NOW THAT WE HAVE BRIEFLY CHARTED the culture surrounding behaviour and body ideals in the late nineteenth and early twentieth centuries, we turn more specifically to the question of body language in photography. When photography was a new medium, it was closely associated with the world of the portrait photographer, whose studio one visited to have one's likeness taken. At the outset, this was a matter for a select and wealthy few, but toward the end of the nineteenth century the number of photographers grew rapidly and cheaper alternatives made it possible for most people to visit the photographer.[1] In this chapter, I will start by looking at the norms of posing that emerged in studio photography and how portrait photographers worked to get their customers to pose according to stylistic ideals. This will give us an idea of the notions of bodily self-presentation that were disseminated from the world of portrait photography into late nineteenth-century culture at large. Continuing from these observations, I will roughly sketch the basic characteristics of the portrait-posing conventions that were used in photography and then consider the various challenges to and deviations from these conventions that can be seen both in the art of the period and in portrait photographs from various spheres.

GETTING THE SITTER TO POSE RIGHT

The first journals for professional photographers started to appear in the mid-nineteenth century, beginning with *La lumière* in France in 1851. In

Great Britain, the first photographic societies and, simultaneously, journals, were founded in the wake of the Great Exhibition of that same year, where photographs were displayed. In 1853, the *Journal of the Photographic Society of London* (later the *Photographic Journal*) appeared. In Germany, a photographic society was founded in Berlin in 1863, and its periodical, *Photographische Mitteilungen*, was first published in 1864. In the German-speaking world, *Photographische Correspondenz*, the journal published by the photographic society of Vienna, was one of the most renowned periodicals. Sweden founded its first photographic society in 1888, when its publication, *Fotografisk tidskrift*, began appearing. Alongside these journals, manuals for photographers helped to shape the routine of professional photography, and several included instructions on how to pose clients for their portraits.[2]

Although the manuals were generally more scientifically inclined, the journals became a forum where the growing number of professional photographers could discuss their methods, admire one another's work, and dwell on the identity problems of the new technique and its claims to be acknowledged as an art form. Many of the photographers who read and contributed to these periodicals earned their living in the most common and lucrative form of their craft – portrait photography – and consequently much of the discussion in these journals concerned this type of work. By looking at a few of these articles from three of the most well-established journals, and relating them to instructions found in the most widespread manuals, we may acquire a picture of what ideals portrait photographers adhered to when posing their sitters and how, as professionals, they responded to the sitters' requirements.

The photographic journals were quickly embraced by both professional and amateur photographers as an outlet for their frustrations – not least with their clients. In some articles, the tastes of the photographers and the sitters are described as completely at odds. The author of one article notes that his sitters invariably choose the worst of the portraits he offers them at the end of the session, and credits his customers with "an absolute incapability of appreciating that which is better."[3] Even Disdéri, in one of his manuals, acknowledges that sitters come to the studio with poses prepared in advance, and that it is the job of the photographer to thwart such affected behaviour and strive for a natural pose.[4] The aim of producing a natural appearance in the sitter recurs frequently in these writings. The ideals reflected in this advice are connected to a conveyance of the sitter's true character. As mentioned before, a likeness was still conceived as something reached through a generalization of the sitter's attributes and traits, and professional photographers believed they were able to translate this ideal to photography by adapting the ideals of classical art to a

formulation of the basic rules of photographic composition. In the discussion surrounding this, there is a distinct clash between classical notions of beauty and a contemporary appreciation of realism.

If we look at a few of the more extensive pieces on poses, we will soon notice that the imperative we saw in etiquette manuals to follow strict rules and be natural at the same time is expressed here too. An elaborate article on photographic posing in the Swedish photographic journal lays down rules with a concern for aestheticism and character. The basic principle of the pose, according to the article's author, Herman Hamnqvist, is that it should not represent movement so much as the immobility after a movement, an ideal reached by asking the sitter to look in a certain direction, and then take the photograph just after he has adjusted his body, his head, and then his eyes. What Hamnqvist appears to want is a sense of animation rather than stiffness, and to capture movements that are natural instead of arranged. The position of the head can also be manipulated in various ways. "You may make the sitter look sprightly by letting him point his nose upwards, and if he is allowed to hang his head, he might either look pensive or stupid, and in these ways one might lend character to the portrait." When it comes to the pose of the rest of the body when photographed in full figure, Hamnqvist stresses the importance of the leg position for the appearance of the whole, claiming that an equal distribution of body weight on both feet conveys the sense of immobility that one wishes to avoid, but if the sitter transfers the weight to one foot, he may attain "a pose that communicates a moment of rest without resorting to the aforementioned stiffness." He concludes by emphasizing that a pose should be a "pose" as little as possible, and that people should be allowed to be as natural and as simple as they are in reality.[5]

Some contributors to these journals approach the problem by becoming overly technical. Scottish photographer Hugh Brebner explains his theory of composition in portraiture by suggesting that the sitter be arranged along a line on which the photographer, by proposing various positions of the arms and legs, applies curves, so that "if the face is looking in one direction and the body is turned in another, the principal line of direction will suggest a curve like that of the letter S, and the entire head will again be brought nearer the centre to allow the principal line of direction (S) to occupy its true position in the enclosing space." Understandably, considering these technicalities, Brebner concedes that his theory "will not allow us to deal with the position of a man as a thing of legs and arms."[6] Slightly more modest, but just as technical, is Hermann Vogel, who in his photographic manual gives several meticulous instructions for posing a sitter. The basic criterion is that the hip line and shoulder line should not be held evenly, meaning that it is preferable to pose a person with his or her body

resting on one foot, making one hip and one shoulder higher than the other. "Above everything else a parallel position of the arms, or of the legs, should be avoided." The goal here, then, is the same as for Brebner – to make the person appear rounded and aesthetically posed rather than stiff and square. Vogel's hints on achieving this are numerous, and yet he cannot transcend the inner contradiction of nature and discipline, ending in an admission that no two individuals are alike and that it is impossible to reconstruct in one sitter a pose that was successful in another. "It is, therefore, generally speaking, superfluous to give rules for making positions."[7]

But other instructors are more open to the pursuit of realism. German photographer Hans Spörl promotes the beauty of the regular line of the body in the same way as Brebner and Vogel, but also emphasizes that "the simpler the pose is, the more natural it will seem. Twisted postures smack too much of the theatrical."[8] In journal articles dating from the 1910s and '20s, it seems that this quest for naturalness is more accentuated. An article published in Sweden in 1918 adopts a sympathetic stance toward the sitters, explaining how the awkwardness and self-consciousness of being photographed make them assume an unnatural expression, while the key to a successful portrait is to capture the inner harmony that will ensure the likeness of character aspired to. Thus, the photographer must convey an air of relaxation and freedom, and above all not force a pose that is unnatural for the sitter. "'Profound' or 'relaxed' poses arranged by the photographer will generally give an untrue portrayal of character."[9] Correspondingly, Charles H. Davis, in an article from 1922, advises the portrait photographer to thwart the plague of strained poses by "watch[ing] people in public places, in carriages, tramcars, omnibuses, and particularly groups of people on the street or elsewhere engaged in conversation. They are at ease. They are not conscious of being observed. There are no squared shoulders, protruding chins and a military stiffness of neck and head – but, speak to a person, and notice the self-conscious rigidity and lack of reposeful grace that instantly follows."[10] As in the Swedish article, the main problem identified here is the nervousness and self-awareness of the sitter, and the photographer is encouraged to become something of a psychologist with the skill of distracting the sitter enough for a natural appearance to emerge. Another article-writer thinks the photographer should "explore the soul of his sitter and convey it."[11]

It is tempting to attribute this attention to the "natural" in these late pieces to an evolving preference for a relaxed appearance in opposition to the stiffness of the previous century, but naturalness is prominent even in the earliest manuals and articles. A Swedish pamphlet giving instructions to people who intend to have their picture taken, first published in 1859 but probably based on a German manual of 1857, is unambiguous on

the point of posture: "Nature! unaffected nature! no deliberate posture with the purpose of embellishing specific parts of the body."[12] What the different writers mean by "nature" changed, however. In his influential manual of 1868, English photographer William Lake Price similarly instructs his readers to make sitters at ease as much as possible, but goes on to describe how they should be placed against the head rest (an item that Price deems indispensible) and how the arrangement of the body should be such that any risk of movement is prevented.[13] All this is of course an adaptation to the lengthy exposure times needed in these early days of photography. Even though the 1859 manual promotes unaffected nature, it devotes most of its pages to advising on the sitter's clothes and appearance so that the colours or materials worn will not distort the image. As the technology improved, the headrest and the stiffness associated with it were dispensed with, but in the effort to ensure photography's status as an art form, those who wrote instructions on portrait photography kept borrowing their principles from premodern painting and sculpture. Thus, Hermann Vogel illustrates his lecture on how to pose a sitter with antique statues, as does Charles H. Davis, who stresses the importance of studying Michelangelo and Rembrandt in order to appreciate "the line of beauty."

That there was a perpetual conflict between those who tried to formulate rules of posing and those who thought this could not be taught, and that sitters should be allowed to be as natural as possible, is apparent when one reads through the journals.[14] And yet, in these articles and manuals, we mainly see one side of the picture, since articles that claim to lay down rules of posing may be found from the first days of photography all the way up to the 1920s. This is not the voice of the avant-garde, even though its presence can be vaguely felt. The 1904 *Fotografisk tidskrift* includes a translation of an American article on pose in portrait photography which, in its dogmatic attitude to the subject, advocates a pyramidal composition to ensure the graceful posture of the sitter while making the placement of the arms appear natural. The author also promotes a diagonal placement of the sitter, illustrated in the article by portraits of men leaning casually on a table or an armrest, and prescribes that the sitter place his or her weight on one foot and not on both, so as to convey an impression of relaxation. These principles go together to achieve the primary goal of portraiture – namely "likeness," according to this writer – so that the picture brings out what is characteristic in the sitter.[15]

Another article in the Swedish journal, this time borrowed from the *British Journal of Photography*, reiterates the principles of the previous one, proposing a circular, or elliptical, composition for group portraits and a triangular composition for single portraits.[16] Ideals borrowed from the world of classical art thus permeate these writings, and yet their authors

are slightly wary of overemphasizing them. These last two articles signal an awareness both that the compositional pyramid has been overused by portrait photographers, and that, to avoid a strained look, the pose should be adapted to the character of the individual sitter. This conflict comes to the fore quite clearly in the problem of the hands. Several articles agree that the hands are the most problematic part of posing, as they easily appear large in the resulting image, and the two recently quoted articles seem to connect this problem with female portraits, where prominent hands should be avoided. While one article suggests that the hands should be occupied with something, giving them a more natural appearance, the other focuses on the lighting of the hands, saying that they should be partly shaded so as to hide their full width.

It is in the notes on hands that the writers betray their social views most clearly. "If the sitter is a person of education and refinement, then we will find that the hands assume a graceful position of themselves."[17] Vogel thinks, in accordance with his colleagues, that the fingers should not be aligned, which makes them look "as if they were glued together," and suggests that the photographer place "a roll of paper in the hand of the sitter. The fingers will place themselves around this," in a way reminiscent of old portraits, and "by gently removing the roll, the fingers will remain in a tolerably graceful position." This trick is not to be applied to just anyone, however. "It would be ridiculous," says Vogel, "to bring the horny hand of a laboring man or a washerwoman into such a position."[18] Among the most renowned circles of photographers, it seems that members of the lower classes were never viewed as suitable subjects for portraiture. G.G. Mitchell, expounding on the difficulties inherent in creating an elegant and attractive portrait with sitters other than members of "the better classes," writes that "low caste or very unintelligent features do not attract the interest of any one, save it may be as a study of physiognomy." Such people may be required for photography, however, in "genre pictures, where, in the very excess of the homely, rags and dirt even may be made to look delightful."[19] A similar distinction is made in Price's manual, where a connection between difference in genre and difference in the class of the sitter is taken for granted. Price refers to lower-class sitters as "rustic and picturesque figures" and notes that they "differ from portraiture and subjects of refinement" in the way their faces should be lit, rustics generally benefiting from open sunlight. This also "allows the picture to be taken very rapidly, thereby avoiding the blemishes that it would show in a more prolonged exposure, with sitters often intractable and ignorant."[20]

The occasional impatience with the sitter that shines through many of these writings reflects not only the professional's irritation with the uninitiated, but also the practice of portraying people in accordance with their

social background. The frustration resulting from seeing a sitter depicted untruthfully in correspondence with his or her "character" discloses a desire to maintain boundaries. An article in an English weekly makes fun of portraits in which a person poses against a fake background that is inconsistent with her social standing. "There is Mrs. Jones, for instance, who does the honours of her little semi-detached villa so well: how does she come to stand in that park-like pleasure-ground, when we know that her belongings and surroundings don't warrant more than a little back-garden big enough to grow a few crocuses? ... Then there's Mr Robinson, standing in a library with a heap of books put within reach of his hand. Now, all Mr Robinson's little world know that he never looked into any book but a ledger in his life." The sardonic tone here is directed at the lower middle class, the clerks and suburbanites, who were so regularly scorned in this period, but behind it lies a fear of deception that ran through much of society in the nineteenth century. The article states the object of the fear clearly: "the love of appearing what we are not."[21]

A German manual makes a close connection between the posing of the portrait and the separation of social spheres. Stressing the need for the pose to be "discreet and yet piquant" and "casual but not daring," much like many others who gave advice on decorum during this period, the writer explains the reason for restraint in the portrait by noting how potential customers might take offence if it is not observed. "Older ladies might be deterred by the fear of encountering ladies of a certain kind in the reception room of the studio. Such a concern is of course very foolish, since the photographer will, in his own interest, keep the members of different classes separate as much as possible." The writer is referring to the common practice among photographers of displaying selections of their portraits in a showcase outside their studio, but implies that women who allow their portraits to be placed there are of a "certain kind."[22] The pose of the portrait thus hides a concern for the preservation of social boundaries, and it secures these boundaries by adhering to received rules of conduct.

One might easily get the impression from these writings that the rules were strict and that most photographers and sitters followed them. What they also illustrate, however, is an ongoing anxiety about these rules, resulting from a sense of threat coming from amateurism or conflicting ideals. Amateur photographers are often spoken of in these pages with a slight condescension, as are sitters of an inferior status, or, for that matter, those who are not fashionable. Mitchell notes that an inability to pose right is most evident in the "country cousin." Scholars have asserted that there was a general understanding in the nineteenth century of what was realistic, a positivist notion of a common attainable truth.[23] The challenge

for photographers as we have seen it here was to achieve the reproduction of truth. But this, as it transpired, was profoundly problematic. Portrait photography was by no means seen by its practitioners as something that could easily reproduce the likeness of a human being.[24] It took not only a camera, but also methods of lighting, the correct choice of lens and, not least, the right pose. In this mentality, we may identify traces of concepts from the time of pre-photographic portraiture, when the mere replication of the subject's outer features was not the goal but, rather, the revelation by means of a kind of composite or generalized rendering of his or her internal individuality and character. It seems that the action of freezing a moment in time was the main obstacle to the uncritical acceptance of photography as means of reproducing reality. This is an important reason why photographers write about working with the sitter so that his or her special gestures and quirks shine through in the staged moment of photography.

Photography's relationship to realism in the latter half of the nineteenth century is complex. On the one hand, an older, lingering definition of realism was expressed through traditional notions of portraiture and likeness. On the other hand, emerging notions of realism strengthened and gained strength from the establishment of photography as a mediator of objective truth, and these ideas conflicted with efforts to secure photography's position as an art form on classical grounds. As photography became more widespread and its practitioners more numerous, the principles and ideals with which it was associated became increasingly uncertain and contested. In its early years it had been the exclusive domain of a small number of cultivated practitioners, but as the vogue for photography grew, artistic paradigms became more heterogeneous and photographers experienced difficulties maintaining a sense of unity.[25] These difficulties are visible between the lines in the manuals and journals, but the world of photography was much larger than the voices heard there, and the observance of social boundaries that is apparent in many of the writings is a sign that social divisions were perceived as a threat to a harmony of photographic principle.

It is against this background that the rules of portrait posing should be read. The status of photography as an objective depiction was reached only through a long and ambiguous process, and portrait photographers well into the twentieth century felt a need to adopt strict rules in order to achieve a likeness.[26] This conception of "likeness" rested on social views. The pose that many of the writers quoted here aspired to guarded the sitter against being perceived as too boisterous and daring, too nonchalant, or too sombre and austere. Venturing into such appearances meant crossing social boundaries that would threaten the unity and respectability of photography. Everyone knew there were cheap photographers who

thwarted this adherence to certain dogmas, and the attitude to these was ambivalent. What the instructions on poses provide us with, however, is a language of social boundaries that describes attributes and appearances, giving us insight into superficial and practical guidelines of distinction that may be helpful to our study of the contemporaneous culture of appearances.

THE POSING CONVENTIONS OF THE STUDIO PORTRAIT

The conformism of the *carte de visite* portrait is repeatedly observed by historians of photography. In the words of Geoffrey Batchen, "the typical carte-de-visite photograph, with its self-consciously bourgeois subject leaning on a fake column or pretending to read at a small table" is commonly seen as "repetitive and predictable, popular and unabashedly commercial."[27] Undoubtedly, the archetypal portrait photograph of the nineteenth and early twentieth centuries follows a distinct template of poses. This makes it easy to jump to the conclusion that there was little variety in photographic poses and that all body language at the time was restrained and militaristic. Although I will oppose such a notion in the following discussion, I would first like to explore the conventional studio portrait in order to read its subtle messages and chart its social dissemination. The uniform character of *carte de visite* and cabinet photographs is apparent across Western culture (figure 2.1), and it is difficult to deny the frequency of standards concerning poses.[28] In many ways, these standards emerged from a focus on the face and the conception of the face as the mirror of the soul. Although the cult of physiognomy falls outside the scope of this study, it is nonetheless relevant that the face was, since the late eighteenth century, the centrepiece of the conventional portrait. Of course, this is obvious when we consider that portraits are most often taken from the chest up (rather than from, say, the knees down), but although the full body portrait that was very popular in the sixteenth and seventeenth centuries had lost its hegemony by the nineteenth century, we see during this century a preoccupation with the rest of the body that perhaps emanates from a general uncertainty of what to do with it, or from a desire to strengthen the impression made by the face, as if it were inadequate to convey sufficient expression.

In single portraits, the sitter is generally depicted in full length, half length, or in a head and shoulders view.[29] Half-length portraits cut off the body either above the waist or, if the subject is seated, below the knee. Occasionally, a standing subject is cut off below the knee, but this practice seems to have been frowned upon by some photographers as unaesthetic. A rough estimate of the distribution of portrait types would be an equal

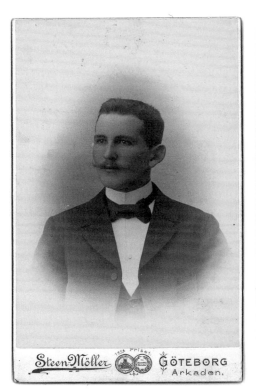
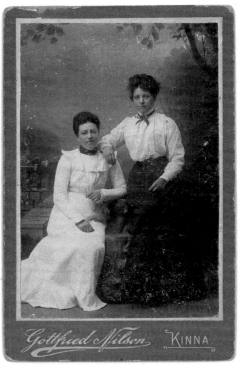
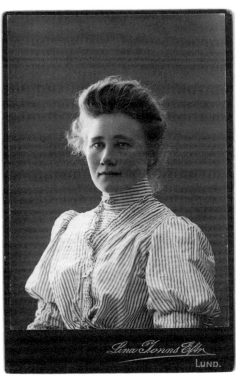
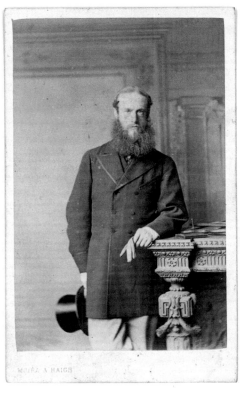

2.1 · EXAMPLES OF CONVENTIONAL *CARTE DE VISITE* PORTRAITS
FROM THE TURN OF THE CENTURY
(author's collection)

division between bust portraits and full- or half-length portraits. Head portraits were supposedly easier to produce successfully, running a relatively small risk of being marred by awkward poses, and printed portraits of statesmen or other such dignitaries often make use of this format, the subject generally being shown in half profile, a pose that might have been associated with antique busts. Early standing portraits tend to make quite obvious use of the headrest, as do many seated portraits, but this reliance diminishes toward the end of the nineteenth century. Since headrests were constantly criticized, another way of ensuring a more steady posture in the days of long exposure times was to make use of furniture, leaning the subject either back into an armchair or forward onto a table or pedestal. The laid-back position that armchairs created were more suitable for men, however, and women are more readily depicted with the head resting on the fist – a pose that ensured steadiness while at the same time communicating a desirable dreaminess or air of contemplation.[30]

Women were possibly shown seated more often than men, and the arms-akimbo pose (see chapter 5) is almost exclusively male. More revealing than the general poses themselves are the small variants within the overall portrait that communicate, more than anything else, gender roles. For instance, as touched on in the previous section, the position of the hands differed greatly between men and women. Women's hands are gently placed in their lap, on a book or on a table, barely touching these objects. Men's hands grasp things firmly, are held akimbo, or are crossed in front of the chest.[31]

Seated portraits were possibly preferable for women, as it would make them appear more elegant, passive, and dreamy. German art historian Ursula Peters distinguishes between the "posture of firm character" assumed by men and the "intrinsically adorning gestures" of female sitters.[32] The male presentation was more about expressing strength of character, while female appearances were focused on adornment and fashion. Men cross their arms or grasp their lapels, and their leg positions indicate solidity with the feet planted firmly on the ground. Women's arm positions – head resting in hand, hands in the lap, or arms hanging by the sides – suggest passivity or pensiveness, and long dresses naturally mean that the legs and feet are barely visible. But there are variants within the conventional gestures and poses that cannot so easily be fitted into this framework. Men occasionally have one hand in a the pocket, a gesture similar to the one-arm-akimbo pose, which conveys nonchalance. In some instances, the emphasis of the portrait may be the sitter's elegance rather than sternness, and in a way that can take on the character of a "feminine" pose. A man might be posed just as readily as a woman with his hand on a book or with his gaze fixed in the middle distance, looking dreamy

and gentle. Generally, however, the impression sought here is philosoph-ical contemplation rather than feminine adornment, but the complexity hinted at shows us that there were relevant dimensions other than gender.

The sitter's occupation lay the foundation for many portrait conven-tions, some of which are quite obvious. Writers or men with an artistic profession are often depicted in the company of books, some holding just one, others leaning over a tableful with their heads thoughtfully resting in the palm of the hand. Photographs of statesmen or members of the legal professions contain scrolls and documents, and these sitters are often shown in their hat and coat, suggesting proximity to the public and the real world. Many of the standards applied in the first decades of portrait photography were established by Disdéri and accommodated the tastes and attitudes of his circle of customers. What Disdéri developed was a method of portraiture that depicted individuals as types, or representatives of social groups. Gisèle Freund connects this procedure with a shifting of the focus away from the face toward the full body and the preoccupation with props that signify the status of the sitter.[33] The nineteenth-century need to sort people into definable categories and make sure they acted and appeared according to their social position has been linked by numerous historians to urbanization and population increases, which made it ever more difficult to keep track of people at the same time as opportunities for social mobility threatened the permanence of social boundaries.[34]

The preponderance of full-length portraits à la Disdéri seems to have waned somewhat, however. The forty-eight-volume work *Swedish Portait Gallery*, published between 1895 and 1913, shows hundreds of prominent Swedish citizens from various walks of life, all photographed in bust por-traits, and hence without props.[35] Perhaps it seemed unnecessary to in-clude the attributes of the profession when the profession was stated next to the picture. Anja Petersen notes how the use of props and decoration reached a climax in the 1880s and 90s, only to grow out of fashion in favour of more toned-down depictions.[36] It is difficult to note a prevalence of one type of portrait in one decade and another type in the next, but as we saw in the discussion among practitioners of the profession, embellishment was often frowned upon, and this may have been a reaction to exaggera-tions in the early days of the medium. The full-length portraits – common in the *carte de visite* photographs – were also frequently made to imitate the appearance of a person coming in from the outside to make a visit, a trope that eventually died out as the rituals of visiting disappeared.[37]

The logic of conventional poses was thus an affirmation of social cat-egories, and the impressions given by sitters were meant to support this role-playing. As indicated by the thoughts presented in journals and manu-als, there were differing ideals of posing, but the ideologies expressed

through conventional studio poses, as well as the poses themselves, conformed to certain basic notions. What they expressed first and foremost were conventional concepts of masculine dignity and pride or feminine delicateness and grace. The ideals of classical art were present at least until the turn of the century. Ursula Peters notes an appropriation of the portrait ideals of the Rococo period in the cultivated elegant poses of female aristocratic portraits of the late nineteenth century, but in conjunction with influences from widely disseminated portraits of popular actresses of the day.[38] Also, the frequent use of props in the studio portraits – mainly armchairs, draperies, pillars, and a painted sky in the background – were conventions that had been applied in portraiture for centuries.[39]

Photography historian Robert Pols indicates a clear difference between nineteenth- and twentieth-century photographic depiction, claiming that "photography in the 20th century was as obsessed with happiness as Victorian photography was concerned with dignity."[40] Many would agree with this contention on a basic level, but the question is when and how the shift occurred, and whether it was absolute. Literary scholar Fred Schroeder, in a brief study on the emergence of the teeth-baring smile in the twentieth century, identifies such things as the appearance of smiling children in advertisements and in amateur photographs that caught people in unguarded moments, smiling, as trends that helped to make broad smiles socially acceptable. In earlier times, toothy smiles were associated with the lower social strata.[41] However, this did not deter some of the photographers writing in journals in the nineteenth century from encouraging smiling in portraits. Reading the articles on posing, we see how the conformity of the *cartes de visite* that today strikes us as typical was highly contested at the time. And although most of the photographs that survive from this age follow strict templates, we can occasionally in them see individuals who, in the words of Batchen, are "still learning how to look like themselves."[42] The medium was new and confusing, and the rules of the photographers were invented to tame its narcissistic potential.

CHALLENGING CONVENTIONAL POSES

Despite the dominance of conventions in portraiture, discrepancies are visible. The problem is that in these discrepancies it is difficult to identify what comes down to the influence of the photographer and his or her notion of how different people should pose according to norms of behaviour and distinction, and what may be attributed to our own prejudiced gaze when we consider one photograph a successful reproduction of the norms of the time and another a "failure." This problem is most discernible when we compare portraits of urban people of some means to portraits of rural

dwellers of lesser means. The prejudice against the latter type of sitter and the "head-on stare" of their poses was widespread at the time.[43] This relationship will be probed further in the next section, but it is also necessary to contemplate how varied posing could become while still upholding the boundaries of convention. Most mainstream portrait photographers followed a set of norms that are quite apparent to the discerning eye of posterity, and the result is that we find most *carte de visite* portraits somewhat dull and conformist. This monotony was a goal in the late nineteenth century, but as implied by some photographers' writings, the artistically ambitious distanced themselves from the most run-of-the-mill portrait types.

The artistic ambition of portrait photographers makes itself known in portraits that go beyond the most conventional but still in some ways reproduce the same attitudes. Such portraits could arouse irritation and even anger. Napoleon Sarony, the American photographer who took the famous series of portraits of Oscar Wilde during his American tour in 1882, claimed that the sitter should surrender completely to the direction of the photographer. "The art of posing is not posing," he said in an interview, continuing: "Once conscious, the sitter begins to pose, and falsely … The moment a person is told to 'look natural,' at that moment he will look what he feels – perfectly idiotic. He feels he is posing – and posing is for professional models only." Sarony claimed that Wilde's poses in the famous photographs were entirely his (Sarony's) creation, thereby adding another – somewhat pretentious – twist to the complex debate about likeness and posing.[44] The unconventional poses of the late nineteenth century are to be found almost exclusively in portraits – photographic or painted – of writers and artists. Often, poses in art of this period follow the same conventions as seen in photographs, but attempts to vary and challenge what started to be seen as restricting norms has already begun around the middle of the nineteenth century.[45]

Unconventional poses in portrait paintings are most often seen in portraits of the artist's colleagues or friends, or in portraits of rustic or low-life characters.[46] Depictions such as these were still at this time connected mainly to images of people outside the well-mannered sphere. This naturally included people of low social status, such as workers or beggars, but even a middle-class person could be depicted in opposition to bodily norms if he or she was meant to appear in a less than favourable light.[47] This is particularly true of some of the paintings made by the members of the Pre-Raphaelite Brotherhood in England, whose explicit aim was to challenge established conventions of portraying the human body. Paintings such as John Everett Millais's *Christ in the House of His Parents* (1850) and William Holman Hunt's *The Awakening Conscience* (1854) are distinctive in the way their subjects are depicted in poses and with facial expressions

meant to look mundane, as if a scene were frozen in the middle of a gesture. Both paintings are examples of the Pre-Raphaelite striving for realistic expression, but this ambition was heavily criticized when the paintings were first exhibited.[48] An objective for the Pre-Raphaelites was also to capture "the ordinariness of ... physical movements" – a goal they shared with artists in other countries who strove for the literal documentation of everyday life in the late nineteenth century.[49] The portraits of such painters as Henri Fantin-Latour, Pierre-Auguste Renoir, and Edouard Manet, in their ambition to emulate the everydayness of the studio photograph, most often stressed the routine and ennui inherent in conventional body language. Eventually, however, the portrayal reached a different level of radicalism, and paintings such as Henri Rousseau's *Boy on the Rocks* (1895–97) and Edvard Munch's *Anxiety* (1894) or *The Scream* (1893) derive from a will to revolutionize the technique of depiction, while the ambition to find new ways of representing the human body in a realist way had declined with the waning of naturalism.

When bad posture was invoked in painting, it was based mainly on the identity of the subject. Edgar Degas, for instance, painted numerous pictures of people leaning forward or slumped lifelessly in furniture – examples are *The Collector of Prints* (1866) and *L'Absinthe* (1876) – but altered his manner of depiction when the subject has a higher station in life. The emphasis of mainstream art in nineteenth-century Europe was on beauty. "The artist is the creator of beautiful things," wrote Oscar Wilde in his preface to *The Picture of Dorian Gray* (1890), a novel that was itself a critique of the contemporary tendency to sever ties between artistic beauty and reason. Wilde's novel challenges established notions of aestheticism, but was at the time of publication not an anomaly. Robert Louis Stevenson's *Strange Case of Dr Jekyll and Mr Hyde*, published four years earlier, explicitly depicted the conflicts of the late nineteenth-century middle class as a split personality between refinement and civilization on the one hand and primitive urges on the other. The fact that this conflict was brought to the fore has been interpreted as sign of an intensifying anxiety concerning waning idealism and notions of degeneracy and an effort to preserve boundaries – between male and female, civilized and degenerate, natural and unnatural, etc. – that were seen as under threat.[50]

When artists started to challenge the conventions of depicting individuals, then, they were seen as radical. Although we may identify forerunners, it was only toward the turn of the century that this became a more widespread practice in art. If we want to find photographic portraiture that truly deviated from the studio conventions, then we need to search outside of the culture of metropolitan aestheticism. What we have seen so far, though, is undoubtedly that portrait conventions became so

entrenched that it was almost commonplace to remark on their monotony, and that the conscious challenging of these conventions by painters and photographers were something different from the unconscious departures from convention made by amateur and marginal photographers.

DEVIATING FROM CONVENTIONAL POSES

Despite the emergence of conventions of portrait photography in the latter part of the nineteenth century, many surviving portrait photographs from this period diverge palpably from these norms. The studio conventions are easy to illustrate using the *carte de visite* portraits made by photographers who catered to urban and well-off populations, but when one shifts one's gaze toward the countryside and the lower strata of society, it becomes apparent that these conventions were not omnipresent. One may find many portraits – especially by itinerant photographers and from fringe areas of Western culture – where the conventions have either been unsuccessfully imitated, or else tweaked to suit the divergent tastes of the photographer and his subjects.[51] Looking closer at such photographs, it might be possible for us to see beyond the conventions of restrained, graceful, and dignified conduct that dominated the discourse of portrait photography, and glimpse the plebeian or vernacular conceptions of conduct that seeped through when the conventions of portrait posing were suspended.

Photographic journals and many of the collections of *carte de visite* portraits in the most illustrious archives and museums might give the researcher the impression that portrait photography in the nineteenth and early twentieth centuries was an exclusive business. If we widen our scope, however, and look at collections in smaller provincial archives, not to mention the portrait photographs on offer by the shoebox-full at fleamarkets and junk shops, we will have cause to alter this assessment. A great majority of the photographers of this period were mediocre local entrepreneurs who did not write instructive articles in the periodicals or take pictures of royalty and nobility.[52] Their output is only partly preserved: some prints may be found in the pages of contemporary photo albums, but many others have been scattered to time. Those that might be salvaged from the junk shops are difficult, if not impossible, to connect to a specific author, and the identity of the sitters is lost unless – as in some cases – someone had the foresight to write it on the back.

When we analyze the pose in a portrait photograph it is important to consider what Ulrich Keller has called "the portrait dialogue," namely the negotiation that goes on between the photographer and his model on the posing and arrangement of the portrait. The concept is used by Keller in connection with the celebrated German photographer August Sander,

whose project to document the social categories of early twentieth-century Germany demanded that he come up with a way to portray the individuality of each model beyond their own self-conscious ways of acting. This meant that Sander would try to ignore the model's wishes about how to be portrayed, and instead attempt to capture the unconsious gestures and poses that revealed something about the model. Therefore, Sander's portraits shun the standardized poses of studio photography and show us something that appears more momentary. At the same time, however, Sander's method was consciously mechanical, and it aimed at creating a degree of alienation between the picture and its viewer.[53] But this concept of a dialogue can be transferred to other photographers whose methods may have been less deliberate or sophisticated. In such contexts it becomes a way of describing what the photographer creates out of the body language and personality that the model brings to the photo session.

We must assume that the photographer's hand is always present in posed portraits, but that does not make the model invisible. The model has his or her own body language to begin with, and then this is altered according to the photographer's instructions, but we may sometimes detect a friction between those instructions and the model's execution of them. So how do we detect this? There is probably no specific way of proceding, but it is possible to juxtapose the poses and expressions of sitters in different portraits as the basis for a discussion of the negotiation. Sitting for a portrait constitutes, as witnessed by vexed articles in photographic journals, a clash between the ambitions of the sitter and the ambitions of the photographer. In provincial or plebeian portraits, the discrepancy from conventional studio portraits might be explained by the photographer's ignorance of ideals expressed among prominent urban photographers, or the sitter's stern reluctance to conform to these ideals as expressed by the photographer, or the photographer's acceptance of the "rough" posing of the sitter as a way of adhering to idyllic conceptions of "rustic subjects" concurrent with established photographic discourse. All three cases might give us material to extract a more peripheral photographic practice, but it is important to be conscious of these factors in order to distinguish the influence of the photographer from that of the sitter.

Three portrait types common to the period around the turn of the century may be used to discern the negotiation between sitter and photographer. First, the studio portraits of itinerant, village, or small-town photographers often differ from the upper-middle-class or urban *cartes de visite* in their execution – showing signs of cheap or non-existent background screens, or compositions that do not follow the "artistic" rules set down by the more illustrious practitioners – and in the elegance or confidence of the sitter's pose. For instance, the portrait of a young man

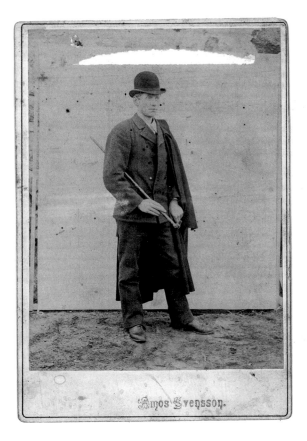

2.2 · CABINET PHOTOGRAPH, CA 1900,
SMÅLAND COUNTY, SWEDEN
(*author's collection*)

2.3 · TINTYPE PHOTOGRAPH, ENGLAND
(*author's collection*)

with a cane under his arm and a cape flung over his shoulder (figure 2.2), by Swedish provincial photographer Amos Svensson, probably attempts to bestow a sense of elegance or urbanity on the subject, but the inadequacy of the screen behind him and the unassuming nature of the man's clothes make it clear that this was not taken by a big-city photographer catering to the rich and famous. The pose is more revealing in an English tintype portrait of three young men (figure 2.3), who have, presumably, come into the makeshift studio of an itinerant photographer. None seems to have dressed up for the occasion, which makes one think it was a spur-of-the-moment decision. Apart from the triangular placing of the boys, there seems to be no attempt by the photographer to arrange their poses in accordance with posing norms. The boy on the right sits in a relaxed

and ungainly way, while the one on the left stares into the lens expectantly. They wear their hats far back on the head, exposing their fringes (bangs) in the style of late-Victorian street gangs.[54]

In some of these nameless photographs one might detect an attempted imitation of received notions of portraiture that does not quite come off; in others, portrait conventions seem deliberately discarded, and in such cases one is tempted to believe that the sitters have been allowed a greater freedom when posing. On the other hand, it is easy to draw the conclusion that portraits like these provide a "truer" documentation of the sitter's self-presentation, and we must keep in mind that it is not possible to verify our speculations about the influence on the poses. We can only rely on the cumulative suggestions that the great mass of portraits with similar poses give concerning farmers' or labourers' self-identities. In many cases, the photographic situation creates an appearance of awkwardness in the subject, especially in his or her confrontation with the photographer's studio, given the unnatural aura of its paraphernalia and the uncomfortable clothes one would be forced to wear when having one's picture taken. However, around the turn of the century, advances in photography made it possible for photographers to move about more freely and for people to take pictures themselves.

A great number of Swedish postcards from the first years of the twentieth century consist of portraits taken at people's homes or in front of their houses, reflecting the popularity of the portrait postcard, the next stage in the development of portraits from the *carte de visite* and the cabinet photograph. New possibilities for such vernacular image-making emerged thanks to the introduction of the hand-held Kodak camera, which could be returned to the factory for developing and from which the owner could choose to receive the photographs as printed postcards. Around the turn of the century, itinerant photographers started to offer customers the photos they took as postcards.[55] In the situations depicted in these photographs, the subjects generally appear much more at ease than in *cartes de visite*: they smile to a greater extent and allow themselves a looser and more expansive body language. Two examples are the man standing in front of his cottage with a child in figure 2.4, smiling confidently at the camera, whose only concession to gentility seems to be the donning of a hat, and the lady in figure 2.5 who poses in a grove of trees, leaning languidly on a cane while looking straight at the camera with a bemused expression. Although they don't tell us much about the identities or self-conceptions of these individuals, these portraits are certainly unlike the average *carte de visite*, and the depiction of their subjects as closer to their own environment makes them appear more at ease. We can only guess whether this is the result of the photographer's soothing or sociable conduct, or whether

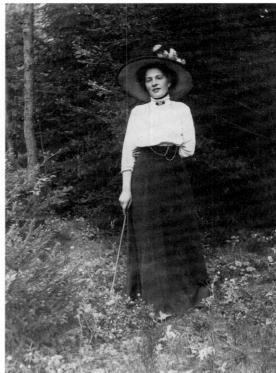

2.4 · POSTCARD, UNDATED, PROBABLY 1900S,
SKÅNE COUNTY, SWEDEN (*author's collection*)

2.5 · POSTCARD, UNDATED, CA 1900, SWEDEN
(*author's collection*)

the subjects were in fact more comfortable with this situation themselves, but the sometimes marked difference between portraits like these and *cartes de visite* suggest that the subject's own behaviour is allowed to shape the posed picture more here.

The second type of portrait photograph that gives us a different picture are portraits of work groups. Within this genre, the images that perhaps most systematically illustrate cultures of performativity in the lower classes are group portraits of labourers or farm hands. Much has been written about working-class identities at the turn of the century and the gender roles inherent in labouring life, but few commentators have paid attention to what must be one of the most illustrative sources of the labourer's performative masculinity.[56] An extensive study of such photographs could be a book-length investigation in itself, but by considering a few of the more general and representative elements of the genre we can bring their essential characteristics to light. Looking, for instance, at a typical example

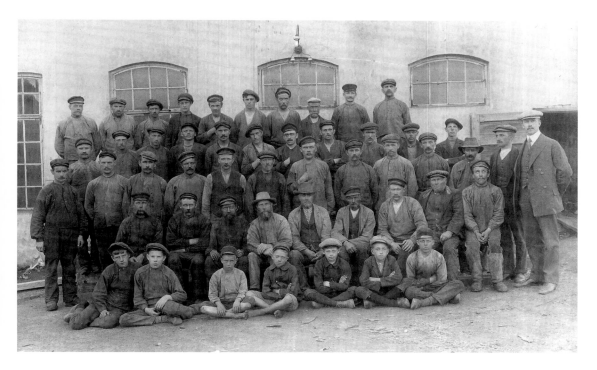

2.6 · FARM LABOURERS, SOUTHERN SWEDEN, 1910S
(*author's collection*)

from the south of Sweden that can be approximately dated to the 1910s, we see a team of what appear to be farm labourers at some large estate (figure 2.6). At first sight, it is a very typical workers' group portrait. The men stand straight in "rigid frontality" poses, looking stern and masculine but at the same time obedient in the presence of their superior at the far right, whose suit and clean shoes suggest that he is the lord of the manor. The poses are generally quite conformist, and most men stand in a straight but wary posture with their arms either hanging down by their sides or behind their back. Apart from the boys, only three men have their arms crossed. But the main distinguishing gesture is performed by four men in the middle – one in the back row, two in the central standing row, and one in the first standing row. They have stuck their right hands inside their shirts. This gesture is random and diffuse enough not to be considered an instruction from the photographer, but it is a clear and conscious gesture, and the men that perform it seem to have a slightly more brash facial expression than many of the others. This expression might just be coincidental, so let us not make too much of it. The most concrete bit of agency on the part of these workers is the hand-in-the-shirt gesture, which clarifies an assertiveness that one might detect in some of the other men as well.

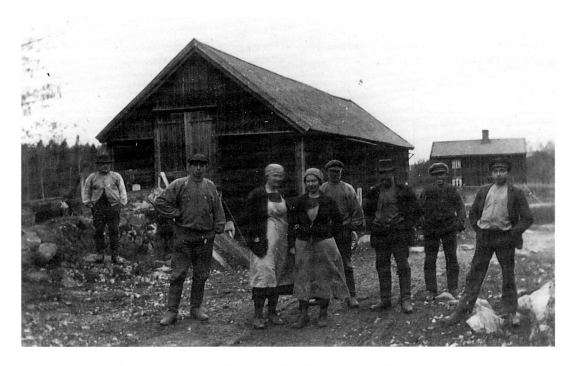

2.7 · FARM LABOURERS, NORTHERN SWEDEN, CA 1910S
(*author's collection*)

Studying a larger quantity of similar group photos, it is possible to dis-
cern certain gestures and general postures that seem to have been part of
Swedish labourers' formalized self-presentation in situations like these.
These group portraits come in different varieties that are important to
keep in mind. Some, like the one examined above, are highly arranged,
probably for the benefit of a visiting itinerant photographer, and strive to
show the complete workforce, including foremen and executives. Others
have a more impromptu look – which might be deceptive, as it is clear that
photographers habitually arranged their subjects to look casual. But there
are differences here as well. A stray group portrait from northern Sweden
(figure 2.7) illustrates how, although photographers might have encour-
aged rough and slouching poses in labourers, rough and slouching poses
were what labourers had to offer even when they were not arranged by the
photographer. Basically, then, the poses that we see here might be inter-
preted as a specific subcultural reaction to the situation of photography,
which makes it a potential gateway to a vernacular nonverbal language.

There is little to suggest that the portraits of workers represent the
workers' own preference for being portrayed in working clothes. Numer-
ous studio portraits of men and women with a likely background in the

labouring strata of society suggest that people from these classes were also prepared to don a collar and tie and pose in front of a painted backdrop. More likely, the photographer himself went out to places of work in order to document workers, either on his own authority or on behalf of a land or factory owner. At this time, there was a certain fascination among photographers for the rough ways of the lower strata, as evidenced by the popularity of such motifs in picturesque photography.[57] But there is no reason to assume that the photographer's visit to the workplace was simple exploitation. Through their sheer repetitiveness, the pose of stern resolution and others like it emerge as indicative of a culture of self-presentation among working men rather than a romantic conception of the rugged worker, even though the two may have occasionally overlapped or underpinned each other. The body language of the men in such photos is along the same lines: composure, togetherness, relaxation. Their arms are hanging – freely or impeded by whatever pocket they encounter along the way down – and their legs are heavy and anchored to the ground. The direction of their gestures and poses is downward.

I have conducted a more systematic study of work-group photographs using a collection from the work of railway photographer S.W.A. Newton held at the Leicestershire Record Office.[58] Although it is only an example of how labourers could pose in a certain context, this collection is substantial enough to corroborate the observations I have made on this genre of photographs. Most of the images show navvies in the middle of their work, stopping to indulge the photographer. In some cases they pose with their tools in their hands, the only concession to the situation of photography being a slightly awkward and not very stiff standing-to-attention pose, but in most of the pictures there are workers who pose in a completely opposite way. As in the photograph considered above, most photos contain a mixture of rigid frontality poses and slouching poses, but the emphasis is on the latter type.[59] These poses are conspicuous, but they are not completely different from some of the poses included in the studio portrait conventions. An elegant leaning posture, sometimes with a hand in a pocket or a thumb hooked somewhere on the clothing, could be the preferred self-presentation of the most established of bourgeois males.

A number of details stand out when the worker's poses are compared with conventional studio poses. First, the gaze is directed straight at the camera, which is seldom if ever done in studio portraits apart from the most provincial ones. Second, a prominent pelvis, which is never seen in studio portraits, is a recurring feature of these portraits of workers. Third, the leg positions are divided between the *contrapposto* position and the straddle-legged stance, both positions assuming a more forthright appearance in the workers' body language. Fourth, the workers often have both

hands in their pockets, which is rare in studio portraits. In general, then, several aspects of the worker poses also occur in studio portraits, but the way they are carried out sets them apart. The main factors that distinguish the worker poses are eye contact with the camera and the more extreme protrusions of the pelvis. In the case of the latter, the pelvis seems to be a fundamental instrument in the generally expansive poses that are assumed. It is either pushed to the side, as in a number of poses where the legs are crossed or the body is leaning on something, or pushed forward in slouching poses, sometimes in combination with both hands in the trouser pockets, which draws further attention to the pelvis.

Portrait photographs of labourers show us how certain aspects of studio portrait conventions had seemingly crept into the posing of labourers, at the same time as the performativity culture inherent in the labourer subculture must be credited with much of the body language. But it would be unwise to assume vast differences between various social groups. Masculine display in group portraiture was not limited to portraits of work groups, as evidenced by the poses of public-school boys in late-Victorian and Edwardian school photos, which show performances of rugged masculinity within a context more or less completely separated from that of labourers.[60] Contemporary testimonies of public-school culture report a subculture reminiscent of street gangs or manual labourers, visible both in the haughty "swagger" of their gait and in their ritual fights with labourers, including navvies.[61] So what these images indicate to us is not so much the presence of social identities as of gender display and how it is reinforced by peer pressure. Displays of masculinity were common to all classes, but the difference between school boys and navvies was that the latter incorporated this display into most of their public behaviour; further up the social hierarchy, overt masculinity was consigned to certain situations and times of life.

The final type of portrait photograph that needs to be considered here is perhaps the one that most lives up to the requirements of the historical photograph as a primary source, namely the photobooth portrait, in which the agency of the photographer is virtually absent. Experiments with automated photographic machines started to occur in the late 1880s, but it was not until 1890 that the first fully operational photo booth was patented. This was the so-called "Bosco," named after an Italian magician and patented by German inventor Conrad Bernitt in Hamburg. The machine was put up in several locations over the following years, in department stores and at fun fairs, and produced a simple ferrotype photograph on a glass plate that was distributed by the automat in a small paper case. The Bosco photobooth seems to have rapidly spread to other countries, and there are records of a Bosco standing at the Art and Industry Fair in Stockholm in 1897.[62]

Photobooth portraits are helpful to us in that they constitute, as mentioned, a portrait that has not been produced under the influence of a photographer. The pose and expression are the creation of the sitter, who exerts a certain freedom in putting on a jocular or rude appearance. As many of the Bosco booths were placed at fairs and in close proximity to places of entertainment, a frivolous attitude in the sitters is to be expected. However, the situation of being photographed in a photobooth is an unnatural one, and even today people do not do it often enough to work up a routine or become familiar with how to sit and where to look when the photograph is taken. This awkward situation must have been present in the 1890s as well, and since the situation of sitting in a photobooth has similarities with sitting in a photographer's studio, the expectation that the sitter follow the posing norms of the studio portrait might have affected the photobooth portraits. The few extant Bosco photographs scattered in various archives confirm this assertion, and constitute in most cases a meeting of lightheartedness and discomfiture.

In many cases, however, the lightheartedness is revealing about the culture of frivolity and joviality current at the time, and in some examples the sense of fun and lightheartedness of the situation outside of the booth has been transported into the booth. Two photos from Munich show us groups of people looking more cheerful than most people in late nineteenth-century portrait photography. One depicts three men, two of whom are standing in the foreground looking straight at each other in a pose that seems planned, while the third is standing between and behind them, resting his arms on their shoulders (figure 2.8). The arrangement is explicit in its message of male companionship and frivolity. The way the two men in the foreground look at each other is quite an unorthodox composition, striking a note comparable to the male physicality present in some photographs that other historians have called attention to. Similar but slightly more orthodox is the other photograph from Munich, in which no fewer than five people have crammed into the booth to pose for a festive and jolly picture (figure 2.9). Here, three of the individuals look at each other instead of the camera, as if they are in the middle of a conversation. The man at the front seems to be struggling to fit into the frame, while the man at the far back leans toward the man next to him in a mock-romantic pose.

In the photo booth pictures, we encounter physical intimacy and an overt display of companionship among people who would probably not have posed in quite the same way at the photographer's studio, and we encounter them in a situation that is more relaxed than a visit to the studio.[63] These pictures were not for displaying in the drawing room or sending to one's aunt. They were meant as mementos from a good night out with friends. Thus, the expression of friendship and togetherness is important,

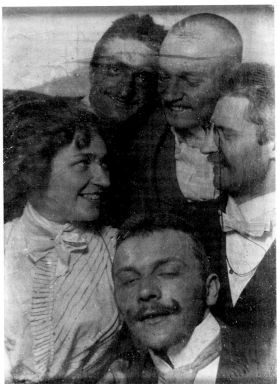

2.8 AND 2.9 · BOSCO PHOTOBOOTH PORTRAIT, MUNICH, 1890S
(*Deutsches Museum*)

and we get a glimpse of how people of moderate means conceived of their relationships. The act of looking into each other's eyes, even between men, or the arm slung around the other's shoulders, tells of an easy-going type of companionship that was not wary of physicality or public shows of affection.

CONCLUSIONS

What we have observed in the second half of this chapter should not be taken as evidence of of a homogeneous culture, but as signs of everyday body languages that emerge when the rules of portraiture are loosened. Consequently, this overview serves only to draw attention to little details in the body language of this time that indicate ways in which people revealed their identities, while the poses themselves might be considered as adaptations of vernacular body language to the situation of conscious portrait posing. This is, then, something between the "conventional"

portrait body language dealt with in the first half of this chapter, and the everyday vernacular body language that will be extensively studied in the following chapters. What I have tried to demonstrate is, first, how the context of photographic portraiture of the late nineteenth century created notions and conventions of bodily posing that would have had an impact on body language and self-consciousness broadly and, second, that the influence of the photographer on the portrait image, although considerable, was limited, and that the habitual behaviour of the sitter can often be glimpsed, especially in such portraits that avoided or did not abide by the rules established in conventional *carte de visite* portraiture.

The portraits of provincial or commercial photographers either attempt to cast the sitter in the mould of studio portrait conventions, showing the clash between these and the sitter's personality, or allow the sitter to pose as he or she likes, showing the sitter's everyday performativity, albeit possibly influenced by how the sitter thinks one should pose when being photographed. We never see behaviour that is completely unaffected by the photographic situation, but we see a different variety of performative behaviour than in studio *cartes de visite*. Even in cases where the photographer has an ethnographic agenda, we might catch sight of something inherent to the sitter. Photo historian Alan Trachtenberg states that if the photographer sees the model as an archetype, he will probably only "document" him or her, thus leaving the model a certain freedom to express something of him or herself.[64] However, the ethnographic photographer will want to portray the peasant in his traditional costume, while the peasant himself might want to be portrayed as an urban dandy in his Sunday suit. When we juxtapose examples of both types of portraits, the collision of urban and provincial cultural tropes is visible.

In the following chapters I will, for reasons of space and coherence, focus my attention on the urban context. The rural culture of performativity that we have glimpsed here, however, has provided us with subtle but evident signs that the portrait conventions observed at the beginning of this chapter should not be seen as representative of the body language of the turn of the century. As we move on, this is the notion that we need to keep in mind: the traces of alternative, everyday cultures of practice that can be glimpsed only in snapshot photographs that document the fleeting moment.

PART TWO

Introduction to
the Case Studies

THE NEXT FIVE CHAPTERS will follow a consistent form. They are shaped in the way of case studies that take as their point of departure a single individual in a photograph or the comparison between two individuals in two photographs who strike similar poses. The discussion will strive to identify the intention of the pose, its concrete significance or how it was used to convey a subcultural identity, and the border between the concrete role-playing aspect and the diffuse everyday performance of the pose. Building on this analysis, I will compare the initial example with other instances of the same or similar poses in other street photographs, and then examine the occurrence of the pose in magazine illustrations, especially cartoons and caricatures, wherein, it is presumed, an effort has been made to ridicule a contemporary phenomenon or social type that readers would recognize. These illustrations thereby provide us with a reflection of the meanings of the nonverbal communication that we are looking for. By examining the specific type or character that the caricature claims to be mocking, we acquire insight not only into how that type was viewed, but also into how the actual people that it referred to presented themselves and, by comparing several illustrations, how the conduct and appearance associated with a type was seldom limited to a specific subculture or group. We thus gain insight into certain subcultures as well as how nonverbal culture spread, and how people from various backgrounds related to one another in the nonverbal sphere of practice.

The English, Swedish, and Germanic focus will be continued, using street photography from urban areas in England, Sweden, and Austria (with some excursions into Germany) and satirical journals published in London, Stockholm, Vienna, and Munich. A number of photographic collections and portfolios of specific photographers have been consulted, but for the sake of simplicity and copyright restrictions, the arguments are illustrated with the output of a limited number of photographers:[1] in England, the street snapshots of Linley Sambourne and Paul Martin of London and Samuel Coulthurst of Manchester; in Sweden, the work of Erik Tryggelin of Stockholm and Per Bagge of Lund; and in Austria, the photographs of Emil Mayer and August Stauda. (For biographical notes on these photographers, see Appendix.) A majority of these photographers' output is from the 1890s, some portfolios stretching back to the 1880s and some forward to the 1900s. Moving images cannot be ignored in a study of this period, but the availability of sufficient material on which to base conclusions is highly variable. I have, however, endeavoured to make use of some street films of the 1890s and 1900s, as they are often more illustrative than still images of the way people went from one way of acting to another depending on the situation. The most helpful film source comes from the work of Mitchell and Kenyon, two Englishmen who documented many aspects of life around 1900.[2] From the other countries the material is more scattered, and film footage from various sources have been used. The main satirical journals used are, from England, the renowned and middle-class *Punch* (founded in 1841) as well as more subversive and pioneering comic-strip magazines such as *Funny Wonder* (published between 1892 and 1901) and *Illustrated Chips* (founded in 1890); from Sweden, the most well-known *Söndags-Nisse* (founded in 1862), *Kasper* (founded in 1869), and, to some extent, the later *Strix* (founded in 1897); from Munich, *Fliegende Blätter* (founded in 1845); and from Vienna, *Simplicissimus* (founded in 1896).[3]

The points that will be taken into consideration in these case studies include the obvious ones of degree of wealth, sex, age group, and type of situation. As my research progressed, it became clear that age and type of situation (or "definition of situation," as Goffman calls it) need to be reflected upon in relation to the social life of the turn of the century to a larger extent than it has been by historians. Therefore, I have endeavoured to show how these aspects played a role that was just as large, if not larger, than class or sex in the business of social role-playing in this period.

As Robert Muchembled has pointed out, there is no well-defined pool of sources for the historical study of body language, which calls for the identification of what he calls "fields of coherence": the pursuit of cultural expressions that may be joined up into links that illustrate a unified cultural morphology.[4] That is why the following chapters focus more specifically on the urban arena and on the photographic record of certain cities. The photographs discussed illustrate various urban contexts, but to concretize the observations, particular attention has been paid to two urban arenas that were vital to the public life of the city in this period: the promenade and the marketplace. These contexts are useful in that they allow us glimpses of people from various walks of life, while at the same time being situations that men and women from quite a wide social range engaged in.

The five poses that provide the focus of the following case studies have been selected after an extensive review of the extant visual material for their frequency and potential to illustrate a temporal body language that is simultaneously universal and specific. By this I mean that all the poses can be and are performed in some form in other historical periods as well, while at the same time, in their execution and connotations, they contained something typical of the body language of Western urban culture around the turn of the twentieth century. These poses pertain to the uses of the walking-stick; the restrained poses of coyness used by young women; the significance of arms held akimbo; the time-specific use of the male waistcoat; and the connotations of trouser-pocket use. The widespread and emblematic nature of these five particular posing practices has been estimated in part on the basis of a survey of a large corpus of images from the period, which lays the basis for the selection of source images used in the book, but also in part on my own familiarity with the culture of behaviour and visual representation of the period.[5]

Since most poses that will be studied were either mainly masculine or mainly feminine, each case study will focus on either men or women in order to make the investigation more concentrated. However, almost all of the poses discussed here could be adopted by both men and women, and so in each chapter some attention will be devoted to the opposite sex. Besides this, I have tried not to discriminate between various social categories in extracting individuals, focusing instead on certain places, and the array of poses examined, although naturally not exhaustive, aims at showing a wide social variety of people. These considerations will make the

study initially eclectic, but I consider this wide scope to be necessary, as body language in most periods – but especially during the decades under study – does not contain the clear social divisions found on other levels in society. It is crucial, therefore, to illustrate the class-transgressive nature of this body language in public life.

We must keep in mind that none of the poses studied can be definitively pinned to a specific or explicit meaning. The messages and interpretations of bodily tropes are constantly fleeting and heterogeneous, but their associations and the uses they are put to reveal more clearly than other sources how conceptions and attitudes are negotiated in the flux of public interaction. Particular poses and gestures were connected to certain roles or identities more than others, and therefore they illustrate the identity games and fluctuating connotations of public life at a certain point in history. In the case studies, the poses will be connected to stereotypes that were brought to the fore whenever the pose was referenced in the media, in order to gauge the identities and roles that the "audience" associated them with and thus also that the performers themselves might have associated them with. The identification of types in nineteenth-century visual culture has been observed by art historian Mary Cowling, who points out that "instantly recognisable types" were routinely used in narrative painting, illustration, and literature both as documentations of contemporary daily life and as strategies for stirring recognition in the audience.[6] Cowling's study is limited to physiognomical types, however, while the more extensive discourse of "city types" has been examined in the context of urban folklore as an expression of how individual practice is intermingled with mediated identities in an urban context. This aspect will be considered in each of the case studies, and is discussed more fully in the conclusions on page 247.

3

Case Study 1

POSING WITH A WALKING-STICK

⊰ THE MAN ENTERS THE FRAME in the upper right-hand corner, strolls unobstructed along the pier, and disappears at the bottom left within five seconds. His walk is steady and purposeful, and he goes along without altering his body language or raising his eyes from the ground in front of him. And yet there is something decidedly self-conscious about his appearance. His attire is sober and unassuming: a bowler hat, a dark three-piece suit, a bow tie.

And the walking-stick.

The walking-stick holds the key to the impression of self-consciousness and showiness that he projects. The way he swings it as he walks along, as if it were a third leg, but a leg with no real use, there only to be decorative and to instill an air of elegance about his movements. Keeping his left hand firmly behind his back only serves to support this impression of elegance (figure 3.1). Yes, he knows exactly what he is doing, even if he might be doing it half-consciously sometimes. In this instance, though, he is undoubtedly conscious, for he is being filmed, and, like most of the other people visible in this film, he is aware of the camera. The others strolling along on the same stretch of the pier on a summer's day in the Swedish town of Jönköping in 1911 try to move along as confidently and as gracefully as they know how. We might pick out any one of them and use him or her as a gateway to the body language and culture of self-presentation abounding at this time. But I choose the stout man with the walking-stick. Why? Because, as we will see, his little saunter across the stage, as it were,

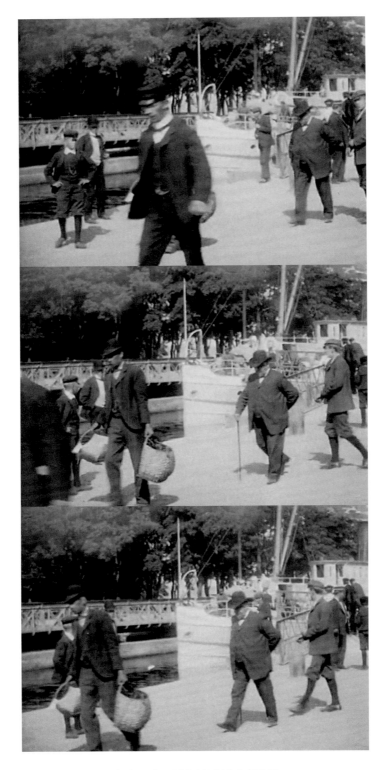

3.1 · STILLS FROM A FILM
MADE IN JÖNKÖPING, SWEDEN, 1911
(*with the kind permission of Swedish Television*)

contains so much, and connects with a whole world of nonverbal communication and impression management current at the time.[1]

The suave way of walking that makes use of both the walking-stick and the hand behind the back emerges as probably one of the most overtly conscious displays of elegance in public streets around the turn of the century. In few other movements or poses is the self-consciousness of the performer so apparent. But, starting with this system of movements, we are not in the land of still poses but in the land of motion. This is a way of making the act of propulsion more attractive and of conveying how the performer wishes to be perceived in his surroundings. In this first instance, it is a male way of walking, but later in this chapter we will question whether it is exclusively so. Until then, however, we will satisfy ourselves by observing similar ways of walking in other sources. Those who carry a walking stick do not necessarily walk elegantly. A brief piece of film made by the Lumière company in Vienna in 1896 gives examples of gentlemen like the Swedish one, who swing their canes back and forth as they walk, and of other men, who seem to be in more of a hurry and have grabbed the stick by the middle, carrying it horizontally and putting the stick to no practical use.[2] To many men, then, the stick has the function only of a decoration or an extension of the arm, and the free arm swings as it would normally. In some instances, though, exemplified by the gentlemen mentioned, the movements contain a sort of heightened grace. In this chapter, we will try to gain an understanding of this body language and the messages it contains by tracing its constituents to various cultural spheres during the same period.

Our starting-point is not strictly speaking a pose, since it is mobile, but as we will become aware this way of walking is connected to several ways of standing still that make elaborate use of the walking-stick. The stout man in Jönköping, as well as the men in the Lumière film, are illustrative because they perform this way of walking in a more exaggerated way by placing one hand behind the back. This gesture – deliberately or not – draws attention to the hand holding the stick and the way the stick is moved back and forth while the owner walks. This way of moving a walking-stick has become emblematic of the pompous, haughty conduct of yore so often parodied in the latter half of the twentieth century. There is something of a Pythonesque "silly walk" about the way we perceive it today. As mentioned, other men visible in the film clips swing their walking-sticks in similar fashion, but the gesture is less conspicuous when the free arm is swinging too, thus making the walking-stick a less noticeable extension of the arm.

In the ensuing discussion, I will connect this way of walking with various still walking-stick poses that constitute attempts at exuding elegance.

Although the aspirations of such poses might be clear and simple enough, small discrepancies between various types of walking-stick poses reveal interesting cultural ruptures in the perception and performance of elegance. By analyzing this body language we approach nonverbal ways of conveying certain identities in public self-presentation as defined by certain qualities. However, it is difficult to translate these qualities or the "message" behind the nonverbal communication into words without imposing our own preconceived notions on the interpretation. This is why we will have to try to extract as much information as we can without making assumptions about the intentions or messages of poses, and instead trace the relationship between everyday practice and popular culture. The structure of this chapter is the same as that of the subsequent case studies: we begin with examples of the pose in street photography, compare these with cartoons and caricatures depicting exaggerated versions of the pose, and then try to identify the contemporary stereotypes to which the caricatures referred. This will return us to the world of everyday practice and allow us to discern the quotidian roles that the caricatures refer to.

The walking-stick evolved in the early modern period from the sturdy and practical staff used by wayfarers since ancient times. Although this forerunner also carried its weight of symbolism – especially a Christian one – the walking-stick became a fashion accessory as it grew smaller and thinner, indicating that the people who used it negotiated a smooth terrain, or did not walk very much. Already in the seventeenth century it was well established as a decorative artifact, and it cannot have been seriously disguised as a support for the infirm in aristocratic circles. But it did not stay an upper-class accessory for long – if indeed it ever was only that. Depictions of artisans, merchants, and peasants – especially elderly ones – from at least the eighteenth century onward show them with walking-sticks. In rural environments – that is so say, in most environments – the stick would have come in handy for getting over puddles or testing the consistency of a muddy road surface. It may still have had such uses in the late nineteenth century, but when it is seen carried in photographs of that period, it seldom seems to be very functional.[3]

How widespread was the use of walking-sticks across the social scale? Although the stereotypical conception of the man with the walking-stick is tinged with an aristocratic or bourgeois flair, the culture that such an accessory signalled was not necessarily connected to economical divisions. The man in the Swedish film footage has the appearance of a gentleman of some means, but this way of dressing and behaving was widespread, and it is vital in these case studies that our analysis of body language is not skewed by preconceived notions about social divisions. There are indications, however, that the walking-stick was infused with gentility and

symbolized a very specific social belonging to some people.[4] Data on the diffusion of such accessories in various social strata is difficult to come by, but Diana Crane, in her study of French working-class dress in the late nineteenth century, states that the attributes of cane and gloves were non-existent lower down the social scale.[5] It has also been suggested that the introduction of reed grasses such as bamboo and cane into the manufacture of sticks, giving rise to the term "cane," caused a division between walking-sticks and canes. The maxim "one strolls with a walking-stick, and swaggers with a cane," is sometimes quoted in reference to this.[6]

The walking-stick, then, is connected to various walking styles, and the terms "stroll" and "swagger" denote two related ways of walking to which varying qualities seem to have been ascribed. The word "swagger," in its noun form, denoting a superior or insolent behaviour, can be traced as far back as the early eighteenth century, although it is used as a verb by Shakespeare.[7] Strolling and swaggering are both very masculine ways of moving, and we shall observe how these could be performed in the period in focus, but the body language dealt with in this chapter is not exclusively male. Although walking-sticks were uncommon among women, a corresponding gender-transgressive accessory grew popular in the nineteenth century: the umbrella. In poses, the umbrella was used in much the same way as a walking-stick, but its basic functionality might have made it less conspicuous or showy, as a practical item carried against the possibility of rain rather than as an elegant affectation. It was this sensible quality that made umbrellas popular among English gentlemen in the late eighteenth century; originating in the Asian parasol, they were used as such until their usefulness as protection from the rain became apparent to Westerners. Historian Ariel Beaujot has identified the gendered dimensions of umbrella use in the nineteenth century, noting that women used parasols to protect their complexions from the sun and that the various intricate ways of putting them up and down contained a secret language of flirtation. For men, the umbrella worked chiefly as a symbol of social distinction, and writers at the time distinguished between the tightly furled umbrella of the aristocratic gentleman – furled so tightly that it was almost impossible to distinguish it from a walking-stick – and the clumsily furled working-class umbrella, its whalebone ribs sticking out and a rope twirled around it, resembling "the cinched waist of a woman rather than the strait [sic], tight figure of a gentleman."[8]

The umbrella was not exclusive to a certain social class, and the social associations of the walking-stick were contradictory, if we consider what sociologist Thorstein Veblen wrote in his 1899 treatise *The Theory of the Leisure Class*. Here he states that those in the habit of carrying a walking-stick include both men of the "leisure class" and "lower-class delinquents."

Veblen curiously connects the "pecuniary upper-class man" with the lower-class delinquent in that both types share certain characteristics: both are unscrupulously engaged in profitable activities, both disregard "the feelings and wishes of others," and both have a taste for gambling and "aimless emulation" that provides a further sign of their "predatory human nature." In both these classes, idleness is praised, and so "the walking stick serves the purpose of an advertisement that the bearer's hands are employed otherwise than in useful effort, and it therefore has utility as an evidence of leisure."[9] Veblen's writing is strictly categorical, and he tends to see races where there are only diffuse social groupings, but his observation of the use of the walking-stick in groups across the social scale is suggestive and deserves closer inspection.

The body language that the walking-stick encouraged was not new to the nineteenth century. It was closely modelled on early-modern aristocratic portrait paintings in which antique posing ideals had been adopted for the depiction of prominent people in a way that conveyed their greatness through the arrangement of their bodies. In such portraits, the "hand-in-waistcoat" pose was, for instance, one of many conventionalized ways of presenting the balance between modesty and boldness that men wished to exude in the seventeenth and eighteenth centuries. The portrait that emphasized the sitter's "glamour" lived on into the nineteenth century, when the flamboyance of the portrait was toned down but the grand manner of the poses lived on, an effect that has been interpreted by art historians as a conjunction of the idealism and hero worship of the age with strains of realism and the influence of middle-class norms.[10] Most of the poses that we will study had already existed for several centuries in one form or another, but new meanings were ascribed to them, and they were placed in different contexts. Whether the poses of early-modern portraits were picked up by people in the nineteenth century and influenced their everyday body language is difficult to confirm, but a striking resemblance coupled with an undeniable self-awareness in the pictures we will look at suggests a dissemination of grand ideals into everyday practice – along with reactions against these ideals and conflicting interpretations of them. As noted, the spread of studio portrait photography might have contributed to this dissemination, as well as the growth of print media and the diffusion of images of the rich and famous.

THE OCCURRENCE OF THE POSE IN
STREET PHOTOGRAPHY AND FILMS

Men with walking-sticks are everywhere in street photographs from this period. Mostly their walk is unassuming, caught in midstep, but often

they add little dashing gestures to the regular movements. It seems that carrying a walking-stick encourages these little adorning gestures, as if the cane makes the walker feel like he is dancing or prompts a lighter step.[11] This glee is also present in immobile body language. In many street photos we see men standing about in parks or squares or on street corners. The social status of such men is often mixed; these groupings bring together labourers in collarless shirts, suited office workers, and elderly men in both worn and neat clothes. The practice of standing in this way, looking at passersby and having a chat with whoever else happens to be standing close by, seems to have been widespread and common at the turn of the century, and it is one of the most important sources for the study of male body language of the time.[12] Standing idly in this way, the men need to adopt poses that are both comfortable and make them look good in the eyes of others. A large proportion of these men assume a slouching pose in which both hands are thrust deep into the trouser pockets, a pose associated with a working-class or labourer identity. This pose will be further probed in chapter 7, but it is interesting to note the wide array of poses: slouching men can often be seen next to men who try to make themselves comfortable in more upright positions. The most elegant poses seem to have been reserved for the most public of spaces. One can see men of varied social positions posing with their hands in their pockets in less visible arenas such as back streets, or in places dominated by men, such as dock areas or other workplaces, but the most performative poses of elegance are most commonly seen in the city centres, along high streets and boulevards, and, especially, in the presence of women.

In the output of street photographers, the social life of street corners and squares is extensively documented, showing how the nature of the place and of the audience affects the performance of the lounging men. One of the most emblematic varieties of walking-stick poses can be found in a photograph from a Viennese suburb taken by August Stauda in 1901 (figure 3.2). The area looks quite worn and rough, and most of the people assembled in the cobbled alleyway are labourers and street children. The lack of blurred edges and the fact that most gazes are directed at the camera are clear indications that the whole scene is staged, which is further corroborated by the slightly stiff pose of the two street sweepers. There is no reason to doubt that the people in the photograph were posed by the photographer before he made this exposure – as suggested by the curious stance of some of the children – but the image is strange nonetheless, particularly because of the unexpected presence of the man with the walking-stick in the centre of the group. The context renders it doubtful whether this man differs in any considerable way from the others in terms of class, but his appearance is striking in that it explicitly aims at elegance.

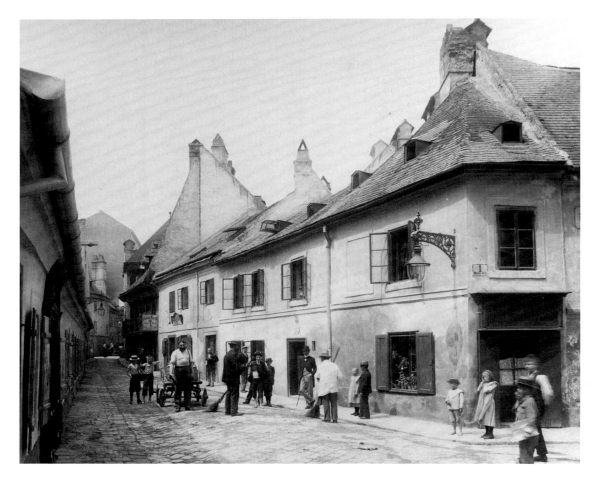

3.2 · FECHTERGASSE, VIENNA, 1901
(*Wien Museum*)

His clothes are those of the typical urban office-working gentleman, and we cannot really judge from this distance whether it is an expensive or a cheap version of a respectable garb, but his pose conveys more clearly his aspirations toward looking dapper and stylish among his rougher-looking fellow posers.

This man's self-conscious pose constitutes a very explicit way of using a cane to project grace or elegance, and perhaps this explicitness is also what might have revealed his performance as that of a parvenu rather than a true man of sophistication to the audience of his time. Other photographs document other, slightly more subtle, ways of playing essentially the same role. When we glimpse the conscious performance of such poses aimed at an audience of other pedestrians rather than the camera, they appear more relaxed and less elaborate. Per Bagge has caught many in-

stances in which men playing the part of respectable gentleman pose in public view. An image from the Per Bagge Collection shows a man in the far background standing still, possibly talking to another man who is not visible. He leans on his walking-stick in a spontaneous but manifest way. His elegant pose appears to be adapted to the very exposed nature of the situation (figure 3.3).[13] Several photographs in which men take the most elegant walking-stick poses in the presence of women indicate that some forms of all-male congregations allowed an alleviation of the etiquette that was held up chiefly when women were nearby. In such situations, we see how the context of leisurely walking, or strolling, especially in parks, or the act of observing some public ceremony, bring certain ritualized modes of conduct to the fore. This conduct is not limited to situations where a concrete audience is present, but also to situations that are generally public and defined by a mode of polite congregation.

In the background of another Bagge image, we see a man standing in the middle of the road, slightly out of focus, posing in a graceful contrapposto leg position with one arm akimbo and the walking-stick planted in the ground. There is no apparent audience here, nor does the man seem aware of the camera, but he is still playing his sophisticated role (figure 3.4). His leg position is emblematic and is reminiscent of statues from the period. Nineteenth-century street photography shows that it was common for men to assume leg positions that have since become almost extinct. One of these is demonstrated by this man, who stands with one leg bent so as to form a convex curve while the other is bent slightly at the knee; another, even more common, pose bends both legs in a backward curve with one foot put forward quite a long way.[14] These contrapposto leg positions demonstrate how it was possible to perform, without a walking-stick, poses that gave an impression similar to walking-stick poses. In some cases, it was accompanied by hands put into pockets up to the knuckles, and sometimes with hands deep in trouser pockets.[15] The thrusting forward of one leg occurs frequently, especially in the poses of labourers and young boys, and vacillates between a semi-conscious resting pose and a fully conscious recalcitrant pose. In some cases, it is clearly meant to be elegant, but in others only suave and relaxed, which sets it apart somewhat from the explicitly elegant walking-stick poses. Both types of poses are conscious and performative, but indicative of slightly varying identifications. What is interesting is the way they often blend into one another, not seldom across the social scale.

Apart from its ritualized aspect, the walking-stick pose is designed to excuse immobility by being decorative and looking imperturbable, as if to stave off any impressions of awkwardness that might arise from standing still. The courting ritual seems to be taking place chiefly between men

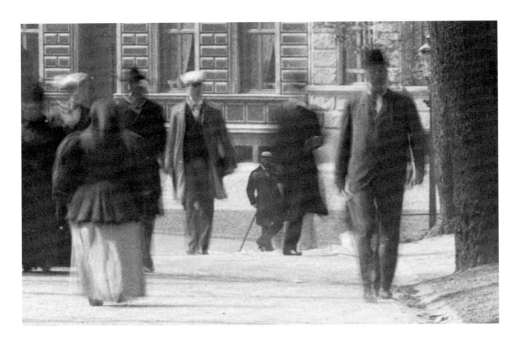

3.3 · STREET SCENE, CENTRAL LUND, 1904
(*Lund University Library*)

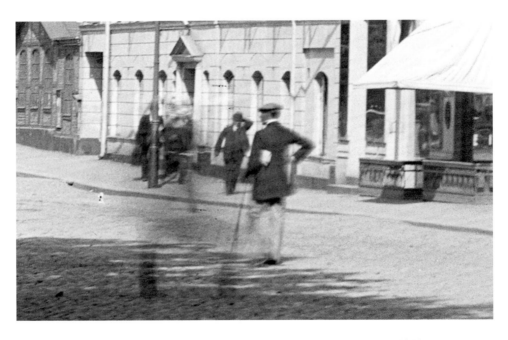

3.4 · A STREET BY THE RAILWAY STATION, LUND, 1912
(*Lund University Library*)

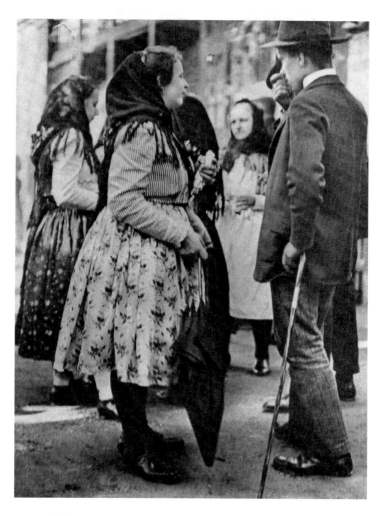

3.5 · BOHEMIAN GIRLS WITH THEIR SUITORS,
VIENNA, 1900S (*Wikimedia Commons*)

and women of some means, indulging in dressing up and strolling, but in some cases it encompasses youths of the lower classes, as evidenced by some of Vienna photographer Emil Mayer's snapshots of young people presumably from the servant class congregating in the street on their evening off. In several of these pictures, the young men strike elegant poses, but in one in particular the suave usage of the cane together with the dandyism of the hat and starched collar suggests a culture of plebeian ostentation (figure 3.5).

The most elegant walking-stick poses are mainly found in pictures in which the man is consciously performing for the camera, although a mild elegance worked into habitual body movements in all public places is also

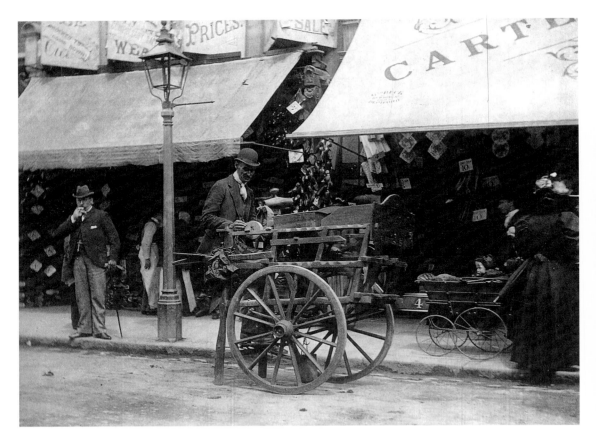

3.6 · A CUTLER AT WORK, LONDON, 1893
(*with permission from the Harry Ransom Center*)

visible in photographs where the subject is unaware of the camera.[16] A
Paul Martin photograph dated 1893 depicts a man at work sharpening
cutlery on his mobile grinder temporarily stationed near the curb of a
busy London shopping street (figure 3.6). It is not this itinerant crafts-
man – the centrepiece of the picture – that should occupy our attention,
however, but the man standing to the left of him, looking on. Unlike the
cutler, this man has noticed the camera and has posed himself in order to
look good in the photograph. His self-consciousness is visible in his pose.
The walking-stick plays a different role here than in the previous poses:
it is not leaned on or swung but simply placed parallel with the legs at a
slight angle, mirroring their straightness. Here we see how even the most
inconspicuous standing pose could involve some amount of conscious
self-presentation, especially when the subject is making use of a cane. In
this case, the leg pose is also eye-catching for being so straight and sol-
dierly, the curiously spread feet adding to this impression. A similar pose

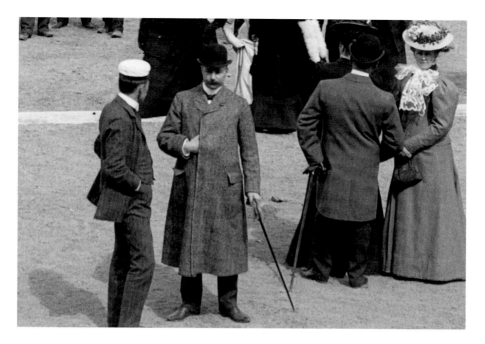

3.7 · CITY PARK, LUND, 1907
(*Lund University Library*)

is made by a gentleman in a Bagge photograph, who is also pausing, facing away from the camera, and almost unconsciously puts some graceful finishes to his immobile pose, resting his hand in his coat pocket and placing the cane at a slight angle from the body (figure 3.7). Even in less striking versions, these poses seem to have been arranged to make the individual appear dignified when indulging in activities that could easily give the impression of unease – stopping to think, deciding which way to go, or simply stopping to look at the scenery.

The suave "caneless" poses we have seen often seem to represent men from a lower-class background, and the impressions they give are somewhat different from the most elegant walking-stick poses, but the boundary between these poses is far from definite. By the late nineteenth century, the walking-stick had become such a common accessory that it could be found in the hands of both women and impecunious men. An example of the latter comes from the portfolio of Manchester photographer Samuel Coulthurst, who in one of his exposures caught a man standing in front of a used-clothes stall, looking about himself (figure 3.8).[17] Since his back is turned to the camera, we cannot make out his facial expression, and his clothes are plain to the point of almost total social anonymity. His pose is much like the other ones described here. He has paused in his strolling,

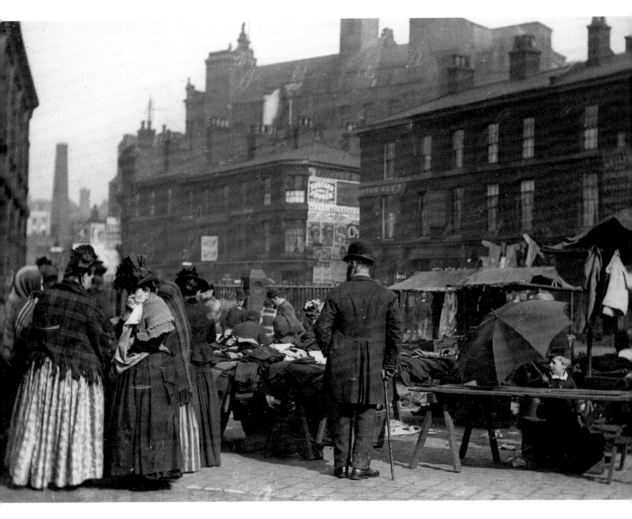

3.8 · MANCHESTER STREET MARKET, 1890S
(*Manchester Archives*)

leaning slightly on his bamboo cane with his left hand in his pocket. The
pose is not explicitly self-assertive. Instead he is caught in this pose as if
he assumes it only half-consciously as part of the regular pattern of move-
ment of a man with a walking-stick, like the man in the Paul Martin photo-
graph. There is nothing in the worn character of his boots or frock coat
to suggest poverty, but perhaps the too-long sleeves of the coat, making
no room for shirt cuffs, rule out the possibility of his being a gentleman of
means. His pose, however, is identical to that easy and not too assertive
walking-stick pose that we can see hundreds of men in dark suits strike
in the streets of European cities at this time. And perhaps it is in this, its
most subtle and half-conscious form, that the walking-stick pose is best

studied? For it is here that the symbol of the walking-stick becomes wholly enmeshed in the unconscious conduct of the late nineteenth-century man. As noted, it conveys relaxation, ease, and licensed immobility – signalling to others in the surroundings that this man allows himself to pause and relax, and communicating a self-containment and self-mastery that was the aim of much of body language at this time. Allowing oneself to pause was an important message in a time when movement and diligence was an ideal. Thus the pose did not contradict the ideal, but was designed to state that the performer had good cause to rest in his diligence, and that he was master of himself enough to decide when this was to be.

This type of pose is therefore closely associated with the man in the suit, the "bourgeois gentleman" if you will, but rather than being the symptom of a class, it is an expression of an ideal that was dispersed throughout Western society at this time. It was translated into the similar poses of men further down the social scale, and it could even be performed, although in slightly more discreet ways, by women, as some examples show.[18] The documentation of female umbrella-carriers illustrates a certain graceful bearing induced by the accessory. Although it is very difficult to find images of women carrying walking-sticks, it is relatively easy to find women of respectable appearance brandishing rolled-up umbrellas and holding them much the same way as men do their canes. Interestingly, however, the upright and somewhat regal bearing created by the umbrella is more often found among middle-aged or elderly women rather than young women. Young women embarking on a promenade would have kept to more restrained gestures (see chapter 4), whereas advancing years seemed to have fostered increasing confidence. A woman of some years was a character of dignity in a different way than an adolescent. Thus, the women we see in photos by Erik Tryggelin, for example, are in late middle age and indulge in a different display of confidence (figure 3.9). The performance of immobile poses typical for elegant men is not as common among women, but the umbrella encouraged much the same type of movements for women strolling down the street. The absence of the immobile pose among women is probably attributable to the style of dress. Genteel women seen in the streets are busy holding up their skirts, making sure they do not trip or step in a puddle, and the bulky skirts and bustles make a certain type of elegant gesture difficult to perform.

The occurrence of elegant leaning poses in street photography suggests that they could be adopted by men from various social backgrounds when they wished to demonstrate a relaxed attitude to their surroundings, either when just lounging about observing or when chatting with a passerby. As we shall see, the walking-stick pose was just one of a wide array of leaning poses with varied but fluctuating connotations. A study

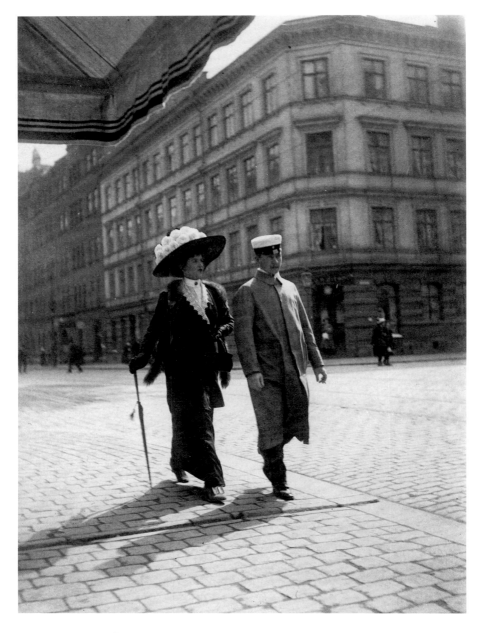

3.9 · STOCKHOLM STREET SCENE, CA 1900
(*Stockholm City Museum*)

of the most stereotypical walking-stick poses might lead one to think that the elegant ideal of the time was fairly straightforward and homogeneous, but men could strike many attitudes with their walking-sticks, some of which did not seem to aspire to the same impression of elegance as others.

Occasionally, one sees a man carrying his walking-stick by the middle, so that it becomes horizontal, or even upside down. This seems to be a sign of nonchalance or demonstrative indifference, as it is mainly connected with men of fashion.[19] The rare occurrence of this practice in street photography is not enough to allow us to draw any definite conclusions, but the habit of carrying sticks horizontally was often commented on in the press at the time. Often, this criticism concerned the potential risk of hitting or poking other pedestrians or fellow omnibus passengers.[20] "One of the most careless and dangerous habits in which some people indulge to a great extent," wrote one magazine, "is that of tucking their umbrellas or walking-sticks under their arms, letting them stick out almost, if not quite, horizontally, and thereby endangering, as well as incommoding, people who are so unfortunate as to be behind them in the street."[21]

To many observers, the way a man carried his stick also signified who he was. A Swedish article complaining about the superior manners of snobs laments the spread of such practices down the social scale, where "carrying the walking-stick or furled umbrella horizontally" is seen as a sign of being "a man of the world."[22] An English article mourns the passing of the "good old-fashioned style" of using a cane by pressing it to the ground "in a sort of rhythmic accompaniment to the feet," which has been superseded by a more performative practice: "In masher-land it is inelegant to employ a cane as a walking-stick. You must expose the ornamental handle to full view, and the ferrule should seldom or never touch the side-walk. It is necessary hence for the wearer to grasp the cane a foot or so below the handle, and hold it in a slanting position, with the handle forward. A good effect is produced if you walk with strides that suggest to the passers-by that you are wearing knee-caps beneath your nether garments after the manner of a horse."[23]

THE OCCURRENCE OF THE POSE IN CARICATURE

We have now observed the way walking-sticks were used in performative body language in the urban streets of turn-of-the-century England, Austria, and Sweden, suggesting a type of behaviour based on graceful gestures that conveyed a lightness of touch and a delicacy and could sometimes be transposed into a more masculine slouch. We will now compare the photographic evidence with images from the popular culture of the three respective countries, focusing on caricatures in satirical journals and portraits of variety entertainers in character. These sources offer insight into the array and nature of contemporary cultural stereotypes that were created as distortions of ways of acting in real life but could not depart too much from it, since they needed to strike a chord with their audiences. By

3.10 · *PUNCH* CARTOON BY PHIL MAY
(*archive.org*)

3.11 · CARTOON IN *SÖNDAGS-NISSE*, 1896
(*Lund University Library*)

working out the current meanings of the stereotypes, we can see the back-drop against which people acted in everyday life, the impressions they wanted to give, and those that they wanted to avoid.

In satirical journals of the decades around the turn of the century, a slightly stylized and highly codified version of the walking-stick pose is recurrent. It is depicted most commonly from the side, the cane held out either in front of the body or to the side, the hand holding it pushed back so that the cane creates a diagonal from the waist down to the ground. This is seen quite clearly in a *Punch* cartoon by Phil May (figure 3.10), which shows two distinguished gentlemen facing each other in conversation.[24] The large man on the left assumes the described pose in its most clear and confident way, the straight back and exaggerated contrapposto leg position accentuated by the right hand placed on the waist. The short man to the right exudes waning self-confidence, and though his leg pose is the same, his lowered face and less assertive brandishing of the walking-stick support this impression. An almost identical version is found in an 1896 cartoon from *Söndags-Nisse* (figure 3.11). The variations on the pose are numerous, but they all have a few things in common. The contrapposto

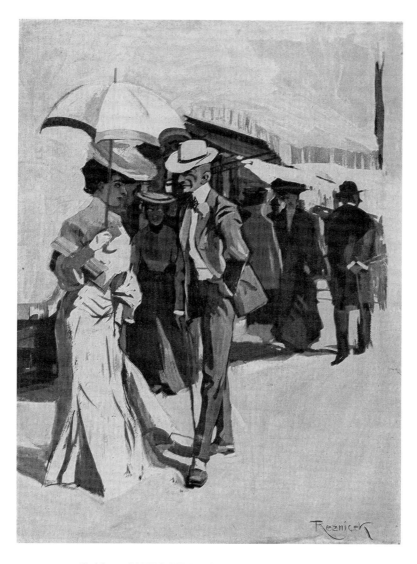

3.12 · CARTOON IN *SIMPLICISSIMUS*, 1903
(*Lund University Library*)

leg position is its main characteristic, and in caricatures it is often exaggerated. The version of contrapposto in the Phil May cartoon is a parody, making the performers look slightly ridiculous. But, as we have seen, it corresponds in some way to poses that could be assumed in the Victorian streets. Other versions of it, however, are more exaggerated.

A watercolour drawing published in *Simplicissimus* in 1903 (figure 3.12) is of the habitual street encounter between an elegant gentleman and lady, allowing the joke writer to add whatever amusing line of dialogue he

wishes to provide for either character. In this case, the cartoon has been given the title "Eine Mutter," and the caption reads: "What do you say, Baron, after our divorce my husband received custody of the children – and not one of them is his." The connection between the dialogue and the image suggests that the woman is supposed to be viewed as flirtatious and promiscuous, trying to lure the eligible aristocrat, but indeliberately hinting at her lasciviousness while signalling her availability. The joke appears tasteless and deeply misogynous to a twenty-first-century reader, but is an example of the type of misanthropy common in humorous publications of the time. Our main attention here should be devoted to the way the characters are depicted, though, and one of the most striking aspects of this is the embellished pose of the baron. It is not the most common type of depiction of the walking-stick pose, but the position of the legs are characteristic of the extreme contrapposto that tends to go with it. In this case, it connects to eighteenth-century rituals of greeting and the courtly bow depicted in many eighteenth-century illustrations, wherein a backward step makes the corresponding leg straight, with the heel in the ground.[25] The man in the picture does just this, at the same time putting his cane into the ground and sticking his vacant hand in his trouser pocket in a way that is almost identical to an akimbo position.

When the pose is performed in this way, it gives a more refined impression than in the depictions of two droll gentlemen in the street. The baron's conduct does not seem quite at home in the street, and his comportment indicates that he is engaged in a totally different activity than the conversing gentlemen. When we look at cartoons showing street encounters, it is relevant to compare pictures of two men with pictures of a man and a woman. The object of nineteenth-century cartoons is often to reveal the embarrassing intentions of human interaction hidden under layers of etiquette that become transparent when observed from outside. In this endeavour, it is worthwhile to present encounters between flirtatious men and women, and this seems to have been particularly pertinent in the period studied here.[26] The poses depicted signify the pose of the charmer, and are especially used in representations of male-female encounters. The reason for this is probably that it expresses in a suitably overstated way the efforts of men to appear elegant and assertive in the presence of women. The key aspects of this body language – the swinging of the cane, the contrapposto leg position and protruding hip – recur frequently enough for us to assume that they were codified attributes for mocking the performance of the street peacock. As we will see in the next section, they connected to a broader context of depictions of the dandy and the swell, and were used to signal a certain type of masculinity and subculture that emphasized refinement and delicacy rather than ruggedness and directness. But,

interestingly, the contents of this body language were not used exclusively to connote upper-class characters.

The assertive leg positions observed so far can be seen in caricatures of both failed charmers and low-lifes. Another recurring situation in cartoons of this period is the encounter between a well-dressed gentleman and a shabby-looking labourer or tramp. This is often used as an excuse for an amusing clash between an uptight outlook and the more easy-going attitude represented by the lower classes.[27] In such encounters, the slouching posture of the impecunious man and the upright posture of the wealthy man are emphasized, but it is also common for the former to be portrayed striking a suave pose, sometimes leaning elegantly on something, and sometimes execcuting the contrapposto position in where one knee is bent, similarly to the Phil May cartoon above. We seem to return to this leg position, partly because it is often accompanied by a walking-stick, but mainly because it crops up in rather disparate contexts.

Regular *Söndags-Nisse* cartoonist Albert Engström uses the contrapposto stance in several depictions of the cheeky tramps that populate his drawings. When he founded his own magazine, *Strix*, such characters abounded, and Engström's most popular character, "Kolingen," was established. The name Kolingen has an obscure etymology connected to the nicknames given to the casual labourers working in Stockholm harbour, and it emerged as the nickname of such an itinerant worker that Engström claimed to have met in real life. Kolingen habitually confronts his surroundings with a rebellious humour, often implicitly commenting on the social divisions of the age by presuming equality with the gentlemen and women he meets. For this reason, his body language often emulates the straight-backed and snobbish poses of his counterparts, as when he bows deeply and gracefully before a top-hatted, monocle-wearing, and walking-stick-wielding gentleman and greets him with the words, "Excuse my bluntness, but a certain similarity in dress encourages me to inquire as to the possibility of a loan." The character's cheekiness means that his urbane poses are not reserved for confrontations with other classes, however. A cover drawing for *Strix* in 1913 (figure 3.13) shows Kolingen in conversation with another low-life. Kolingen is dressed in his usual combination of extremely shabby apparel and the odd remnant of an illustrious past. In this drawing, as in many others, he is seen wearing a starched shirt front and matching cuffs together with his worn coat and baggy trousers. But it is his pose that is of interest to us. His leg pose especially mirrors that of the gentlemen in the Phil May cartoon. Considering Kolingen's complex character, it would not be strange to see him with a walking-stick. His social position does not allow him to own one, but, interestingly, his character matches the elegance of it.

3.13 · CARTOON IN *STRIX*, 1913
(*Lund University Library*)

Engström was inspired in his drawings by caricatures of vagabonds from other European countries as well as America, which makes his characters something of an amalgam of domestic and transnational observations.[28] What Kolingen exemplifies is the tramp trying to fit into civil society. He does not assume the dress of the gentleman in full, probably because his failure to do so was seen as more humorous, and the character himself never seems to be in doubt concerning his actual social position. Therefore, his attempts to infiltrate the respectable classes work as a tool for the anarchist and socialist viewpoints of the artist. To what extent he had counterparts in reality we cannot say, even though Engström himself claimed to have based the character on a drunkard he invited into his home one night and gave one of his old suits to wear.[29] Kolingen's social climbing is exaggerated, and perhaps this is attributable to the still-rural quality of Stockholm life in the early 1900s. Rural vagrants were indistinguishable in appearance from inner-city down-and-outs, which might explain why the rural tramps of Engström's sources of inspiration could be transported to the urban milieu of his cartoons. The characteristics of Kolingen reappear in different forms in more urbanized countries, where the lower classes of the inner cities had developed more distinct subcultures. But oftentimes the connections between various characters striking identical poses are obscure.

3.14 · COVER OF SHEET MUSIC FOR "THE AFTERNOON CRAWL,"
DEPICTING ALFRED VANCE, 1870S
(*Spellman Collection of Victorian Music Covers, University of Reading*)

A common character in English music hall at the same time was the *lion comique*, a caricatured and overblown version of an upper-class idler, who used to step onto the stage and perform songs that paid tribute to champagne and other luxuries. The most famous performers of this stock character were George Leybourne, popularly known as "Champagne Charlie," and Alfred Peck Stevens, performing as "The Great Vance."[30] Illustrations of these characters can be found on the covers of contemporary music sheets, depicting them in characteristic poses, sometimes reproduced after photographs of the singers. For instance, an image of Vance on the cover of the song "The Afternoon Crawl" (figure 3.14) subtly parodies the

perceived body language of the upper-class fop. Vance holds the arched leg position in a way that pushes his pelvis backward, making him look slightly silly. In the background is another fop, his pose so straight that his behind protrudes all the same, and his waist tapered like a woman's.[31] The exaggerated body language of the dandy was a common ingredient in the mockery of this figure, being almost more important than his dress, which was often similar to that of an "acceptable" gentleman.[32] The ridiculing of various types of affected body language in the public streets of the late nineteenth century gave rise to a number of terms created to describe them. The "Grecian Bend" emerged as a critical description of women in high heels and tightly laced corsets, and the "Alexandra Limp" denotes a fad for limping that appeared when Princess Alexandra, bride of the Prince of Wales, developed a limp as a consequence of rheumatic fever. Among men, the "Roman Fall" signified the pompous style of walking affected by swells and similar types. In a music-hall song commenting on the fashion it is described as "Head back, the chest well out, / A walk between a shuffle and a crawl."[33]

The quite specific leg poses seen here were reproduced in very disparate characters, ranging from the tramps of Stockholm to the dandies of London. This visual language could also be employed in the racist depictions of blackface minstrelsy, a genre in which the stereotype of the "dandy coon," an especially derogatory caricature, developed during the 1890s. What these characters had in common, apart from being the butt of a joke, was their social ambition, and this is what is mocked in the dandies as well. The most vicious mocking was that to which the black dandy was subjected. The "coon" songs, especially those of the English performer Eugene Stratton, combined a scepticism concerning the corruption of the lower classes by urban life with an established racist notion of the "backwardness" of the black slave; the black dandy thus constituted the most extreme expression of the dimness and vulgarity of the snob that typified caricatures of white dandies.[34] But the ridiculing of their white counterparts had nuances lacking in these racist portrayals. When it came to tramps, the comedy derived from the utter hopelessness of their aspirations, as if they lived in a fantasy world where they were the aristocracy. And perhaps this topsy-turvy world was part of the caricaturist's social criticism. When the joke was on the swell, then the prosperity was in some ways achieved, but the derision was founded on their licentious way of life; thus the laughs that music-hall swells elicited were mixed with rage against the social injustice presented. The caricatures of these social types were not exclusively mocking. Engström presented his tramps as idealized, free-living, truth-tellers, men who step into polite society to point out its fallacies and deceptions. The swell, with all his social ambiguity, could be

3.15 · CARTOON IN *FARBROR MÅRTEN*, 1891

3.16 · JOKE POSTCARD, SWEDEN, 1890S
(*author's collection*)

a model of masculinity for male members of the audience, but the mixture of aristocratic manners and popular appeal reflected the lower-class nature of the audience, for whom a swell was never just a hero.[35] The affection for the caricatures of the late nineteenth century always carried some vital reservations with it.

The self-conscious and elegant use of the walking-stick in everyday life was obviously less exaggerated than in cartoons. The main parallel between photographs and cartoons is that the walking-stick was not needed to strike an elegant pose in either case. Thus it may be that the stick itself was a sign of social status, but the body language that went along with it could be adopted by people across the social scale. But neither did the walking-stick, when present, guarantee an elegant pose. The horizontal carrying of walking-sticks, as noted above, was ridiculed in cartoons of mashers and swells, and whenever a true snob was to be portrayed, he held his walking-stick by the middle or under his arm, to underline his pretentiousness.[36] A decent and sensible gentleman would never indulge in such ostentation. A Swedish cartoon showing an elderly man telling off his wayward son shows the father with his cane to the ground and the son with his cane held aloft under the handle (figure 3.15).[37] But an even more

specific practice that became the object of scorn was carrying the walking-stick in the coat pocket. This phenomenon is really only found in cartoons, but it is so explicitly connected to certain urban types – particularly in Stockholm – that it must have been a comment on something observed by the artists in the street and recognizable to readers.[38] In these caricatures, we encounter the character of the *grilljanne*, the swell unique to 1890s Stockholm characterized by a very distinct fashion (see below). The joke postcard reproduced here shows two boys dressed up as *grilljannar*, and the cane placed in the coat pocket here emerges as one of their most conspicuous trademarks (figure 3.16).

Deconstructing the walking-stick pose thus demonstrates that the role played by leaning on the cane could be played without it, which would then signify something of of a "sham" performance of elegance, and that walking-sticks and elegant poses could be "misused," in the eyes of arbiters, by those who carried sticks in conspicuous ways that broke the rules of propriety. But these "tactical" uses of walking-sticks were not meant to appear inelegant. They were simply performances of other conceptions of elegance, and the walking-stick – which a respectable gentleman could not do without – was creatively used to convey subcultural signals, messages both of conformity to the general rules of gentlemanliness and of a culturally specific nonconformity.

STRIKING THE WALKING-STICK POSE

The elegant poses can be connected to certain characters or types that were regularly ridiculed in satirical journals and variety theatres of the time. The reason to relate conceptions of body language to types is that it will provide us with a more specific context in which to view the attitude toward certain poses. The pose and its variants focused on in this chapter appeared, as we have seen, in the characterization of many different types of people. It was not even limited to men. Several cartoons in which women pose with umbrellas verge on the elegance that was mainly reserved for depictions of men, and this is especially true in images where a group of women is portrayed in intimate interaction.[39] Women are drawn holding the umbrella out from the body, the point of it close by the foot so that it creates an angle, a pose often seen in images of men but then generally accompanied by a different and more garish leg posture. That flamboyant poses with walking-sticks were associated mainly with a male performance is apparent, however. One cartoon depicts a woman dressed in the new suit for "emancipated ladies," and she is standing with a straight back, a cigar in her mouth, and a cane in her hand (figure 3.17).[40]

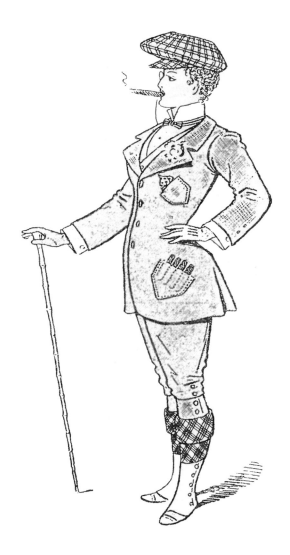

This emancipated woman is made to look quite dandyish, and it is apparent from several cartoons in which the poses dealt with in the previous section occur, that the walking-stick pose and the elegant arched leg position were associated with dandy characters. The interesting thing about the types we will consider here and in the following chapters is that there were relatively closely related equivalents in all three regions of our study. This is perhaps most apparent in the character that described the dandy or snob, which was associated with various designations in the various

countries. In England, the word "swell" was most commonly used, alongside the word "masher," which, however, did not correlate exactly with swell. In the German-speaking countries, the term *Gigerl* was established as the name for a corresponding urban clothes-snob, and in Sweden, the closest equivalent was probably the grilljanne. I will describe these three variations and their cryptic labels in turn, focusing on the way their body language was used to say things about their characteristics.

The character of the swell emerged in the latter half of the nineteenth century as a blurred variation of the early nineteenth-century character of the dandy. The focus for the dandy lay on appearance and clothing, and in a time when it became increasingly possible for larger sections of society to afford cheap imitations of the latest fashions, some of the ideals of dandyism were disseminated. The dandy, as associated with men such as Beau Brummell and Charles Baudelaire, was a very limited social phenomenon, focused on by latter-day scholars to an extent that hardly corresponds to the spread of the culture at the time. Toward the close of the century, however, a surge of synonyms for the dandy implies that the practice of dressing up became more widespread, and, inevitably, was less of a status-marker. The discourse of the swell is thus intimately linked with attempts to deride him for his overdressing or lack of refinement.

In English, terms like "masher," "gent," and "dude," although with differing etymologies, could all be used to denote a flashy dandy. The "gent" emerged early in the century as a word for the "young men at the very bottom of the respectable class, the scrubby clerks, apprentices and medical students who scraped along in the backwaters of London on less than £50 a year, calling themselves (hopefully) 'gents' and their betters (admiringly) 'swells.'"[41] The term "swell," then, was originally used for a well-dressed upper-class man, but as it became associated with the music-hall swell songs and the "swell mob," the gang of neatly dressed pickpockets infiltrating urban crowds, the word seems to have been increasingly stained with the condescension of showiness. "Masher" was used of the ladies' man, and crops up in newspaper accounts deriding the flirtatious and flamboyant behaviour of young upstarts.

In German, the most common term at the time was *der Gigerl*, which originated in south-German and Austrian slang in the 1880s and became the label for a special type of dandy in the cities of these regions adhering to certain codes of dress.[42] Just as in England, the Gigerl became a common character in both caricature and stage entertainment and was the subject of several popular songs, including composer Josef Franz Wagner's *Gigerl-Marsch*. The term was used by Georg Simmel as an example of a slave of fashion who paradoxically obeys the current collective norms as he aspires to individuality. Simmel considered the Gigerl the apotheosis

of trend-following, overstating every fashion in the extreme. "If pointed shoes are in style, then he wears shoes that resemble spear tips; if pointed collars are all the rage, he wears collars that reach up to his ears."[43] A contemporary of Simmel, social commentator Adolf Loos, made a slightly different appraisal of the Gigerl, considering him profoundly unmodern in his attempt to express individuality through his clothing, as opposed to just disappearing in the crowd.[44]

The Swedish counterpart derives both from the indigenous subcultures and from foreign influence. In the 1880s and '90s, the word "grilljanne" was established as a derisory denomination for a type of young lower-class dandy that used to congregate at the newly opened restaurant Jones Grill at Norrmalmstorg in central Stockholm. From this institution the prefix *grill* came, and the word *janne* derived from a given name commonly associated with the working classes or with young rascals. The term was popularized by the editor of the weekly journal *Figaro*, who in his column frequently complained about the superficial and decadent existence of dapper young men often seen in the mentioned establishment. However, the grilljanne was also famous as a character on the Swedish variety stage, popularized by the short-lived entertainer Sigge Wulff, who died in 1893 when he was only twenty-two, but whose characterization lived on in numerous impersonations in the years after his demise.[45] According to a contemporary impresario, Wulff saw a Gigerl character being performed by the German comedian Littke-Carlsen and strived to emulate it. "The type that Wulff created," it is further explained, "never became exactly what Littke Carlsen had played, but what was then called a 'janne character,' that caught on immensely, and was imitated everywhere."[46]

These characters were fictional to the extent that their dress and manners were exaggerated and turned into something perhaps more homogeneous than in reality, but neither could they stray too far from reality lest they lose recognizability for the audience. In Stockholm, especially, the subculture of the grilljanne seems to have been real, and the high frequency of cartoons referring to the character in satirical journals of the early 1890s is a sign that readers would know who they were making fun of. The outfit of the grilljanne is also made up of a very specific set of clothes that was both described in writing and ridiculed in illustration. It consisted of a very short jacket, preferably in some loud colour such as yellow, a high stiff collar and wide shirtfront, a brightly coloured scarf, and wide striped trousers folded up at the feet. The most characteristic attribute, however, was the walking-stick, which was supposed to be short and thick: too short, in fact, to be used for leaning or putting into the ground while walking.[47] Looking at the caricatures of the grilljanne, we may add to this assembly a monocle, a small bowler hat, a large cigar, a gemstone

in the shirtfront, and long pointed shoes. Although this is evidently a parody, it seems that there was a fashion for these items among young urban men at the time, which indicates that the grilljanne was the caricature of an existing local subculture.

Although caricatures of pompous or over-zealous dandies in the public street often made use of the walking-stick and the performances of elegance that it brought about, it is interesting to note that the more refined the caricatures of these late nineteenth-century dandy subcultures became, the less elegantly were they portrayed. The idea of an elegant gentleman that conformed with the contemporary ideals of deportment included the use of modest but graceful poses, represented by some of the images examined at the beginning of this chapter. But when cartoons commented on emerging subcultures that deviated more and more from these ideals, the poses that were used to mock them digressed even more from these conventions. An early grilljanne caricature illustrates the lyrics of a music-hall song sung by a character labelled as "Young Mr Stockholm" (figure 3.18). The song comments on current events and begins with a lament on behalf of the grilljanne, who complains that the scorn he has been dealt by the editor of *Figaro* has made people laugh at him in the street. The character is depicted in a male variant of the Grecian bend, his body tilted forward at the waist, one hand delicately adjusting his monocle, the other holding the trademark walking-stick, which, given its shortness, does not reach the ground. Here, the grilljanne is still portrayed as upright and suave, but in later portrayals he is seen as straddle-legged and with bad posture.

The *Fliegende Blätter* caricatures of the Gigerl generally depict this character in rather unrefined poses, most often standing with equal weight on both feet, knees slightly bent, and the walking-stick planted squarely on the ground. It is as if the cartoonists wish to undermine the elegance that the Gigerl so desperately tries to attain by hinting at a lack of dignity and a ruggedness that hides behind his façade. The main focus of the derision is the distinctive fashion of the Gigerl, which shows that the grilljanne outfit was closely modelled on its Continental counterpart. The high collar, small bowler, short jacket, pointed shoes, and thick walking-stick signal the presence of a Gigerl in these cartoons, and the humour is derived from these items. "What a pretty collar one could wear with a neck like that!" says one Gigerl as he admires the giraffes at the zoo. "Would you like some help with that walking-stick, sir?" says the commissionaire to the Gigerl grasping his knobbly cane.[48] Just like the incarnations of the English swell, the Gigerl is ambiguous, often characterized as a lower-class wolf in respectable sheep's clothing, but portrayed as just a snobbish gentleman often enough to destabilize that impression. In the English context, the terminology of the dandy is more heterogeneous, but

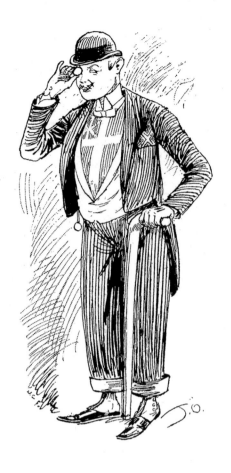

3.18 · "YOUNG MR STOCKHOLM." CARTOON IN
SÖNDAGS-NISSE, 1891 (*Lund University Library*)

the words that were used seem to have been almost synonymous, even though they may have derived from different conceptions. "Masher, swell, or dude," says the satirical journal *Fun* in 1887, as if they all denoted the same type of person, and looking at cartoons in which the caption describes the character in it as a "swell" or a "masher" ("dude" is not as common) the types appear to overlap. Although these terms were applied to types of a greater heterogeneity than in Austria and Sweden, the distinguishing dress of short coat, folded-up trousers, short cane, high collar, and too-small bowler recurs here, too (figure 3.19). The more sophisticated journals of the *Punch* type do not seem to have taken much notice of this stereotype, but in more run-of-the-mill publications, such as the journal *Larks!*, it is to be seen here and there, at least during the early 1890s.[49] His

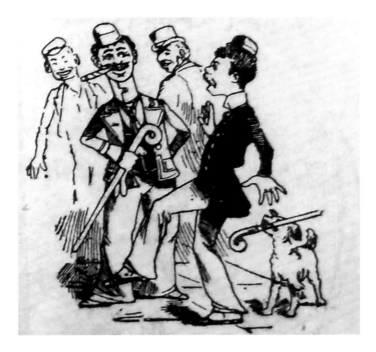

3.19 · CARTOON IN *THE FUNNY WONDER*, 1893

appearance must have been recognizable enough for Munich-based car-
toonist Lothar Meggendorfer to publish a picture book on the Gigerl in
England under the title *Scenes in the Life of a Masher*.[50]

But the connotations of the masher/swell terminology remained am-
biguous in England, thus hindering the efforts of caricaturists to portray
this type devoid of all elegance. The masher would be constantly derided
for the way he took elegance and respectability to the level of exaggerated
and obvious performance, thereby revealing an aspect of the character
that the Victorian mentality preferred not to acknowledge. But the pass-
ing of the times worked against this reluctance, and the masher became
the ideal man of a younger generation of women, as demonstrated by a
cartoon commenting on the suggestion of giving women a right to vote, in
which the snob that the journal is sure will be their candidate, simply for
being handsome, is presented under the title "The Masher Candidate of
the Future" (figure 3.20). This masher is nothing more than a decorative
and elegant man, his trousers so tight as to look like stockings, his hair
and beard neatly trimmed, and his walking-stick pose so exaggerated that
its elegance is transmuted into effeminacy. This is most likely the inten-
tion of the cartoonist, who flanks his caricature with young women hold-
ing banners with slogans such as "Fitznoodle for ever" and "Vote for the
Ladies' Candidate. High Collars and Principles."

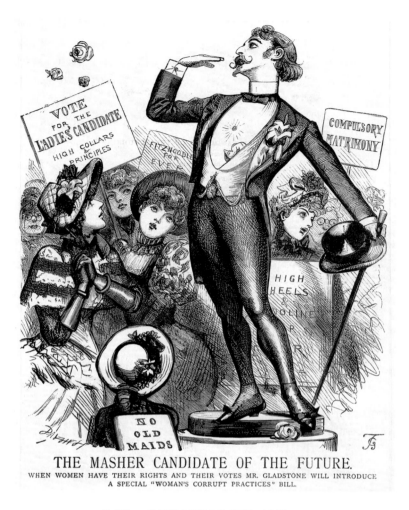

THE MASHER CANDIDATE OF THE FUTURE.

WHEN WOMEN HAVE THEIR RIGHTS AND THEIR VOTES MR. GLADSTONE WILL INTRODUCE
A SPECIAL "WOMAN'S CORRUPT PRACTICES" BILL.

3.20 · CARTOON IN *FUN*, 1883

High Collars and Principles. The tone struck here connects dandyism with male desirability, but the perspective of the journal is sceptical of the impressionable nature of young women (all the women in the picture are young and swooning) and their baffling preference for a man who is too feminine. At the same time, the word "masher" derives from the term "to mash," which refers to flirting, thus undercutting the suggestion of effeminacy. But just how masculine was the swell/masher character supposed to be? In cartoons where the joke is not as much on the swell, his body language is still not exactly what one would call rugged.[51] The essence of this character lies in his excessive attention to his appearance, which in itself overstepped the boundaries of some contemporary values. The man who cared too much about his clothes always had a dash of femininity about

him.[52] The caricature is a warning against overindulgence or overacting, and by using poses from reality that readers could relate to, the comedy (laughing in the face of fear) makes the reader sure of his own adherence to the rules. The cartoonists create a type that fails in his ambitions, and allow the readers to laugh at him. But the type, as I have tried to demonstrate here, derives from reality and refers to some extent to subcultures or counterinitiatives from everyday practice.

In recent years, fashion historians have conceded that dandyism among young men in the lower social strata of the nineteenth century was widespread and should not be seen only as a culture of emulation. It had its own logic, guided by rules of conduct that may have had some aspects of imitating upper-class behaviour but that was also formed within the frames of reference relevant to labourers, servants, or junior clerks.[53] At the same time, the culture of elegance and delicacy that emerges in the poses examined in this chapter has been traced by historians mainly to the formation of middle-class masculine ideals that promoted "noble simplicity and quiet grandeur."[54] Seldom, if ever, have the ideals of refined and restrained conduct been ascribed to men in the lower classes.[55] The evidence of nineteenth and early twentieth-century illustration partly corroborates this notion, in its incessant subtle association of transgressions in public body language with a discourse of social divisions. The evidence of documentary photography, however, when given the proper attention, suggests a culture of practice in which boundaries were more fluid than we might suppose. This might impel us to look at the printed discourse with new eyes.

It is interesting to note in the street photos the proximity between elegance and nonchalance in body language, and the way one type of pose could so easily mutate into another. When this body language is referred to in writings from this period, it is often in the same breath as the moralistic attitude toward laziness current in the time. In England, the relationship to work and rest was complex, to the point where work was not always good and laziness not always bad. To some extent, as in most things at this time, it had to do with who you were, of course. No one would dream of accusing the Queen of being a layabout! But it also, and perhaps mainly, had to do with how you were lazy. There was an array of terms for different types of indolent people. An idler, for instance, was not the same as a loafer, and a loafer had little reason to mix with a lounger in the streets.

The haziness in the distinction between various poses and the simplicity with which one pose could change into another, as the evidence of street photography and film shows, implies a deeper complexity. The associations that dandies could awaken linked them, at least to men of letters,

with just the "lower-class delinquents" mentioned by Veblen. A contemporary Swedish article on the subject of arrogance connects the grilljanne with the rowdy behaviour of young men. "In the world of boys, the bully is often a weak and cowardly soul, exercising his strength in words, chewing tobacco, smoking, spitting, drinking, cursing etc. And when you encounter childish arrogance in people who are not children, such as in the so-called 'grilljanne,' it is generally something similar that prompts the arrogance."[56] Another article writer warns the youth of the day against "playing at gentlemen and imitating the bad role models found at restaurants, hotels, and steamships." The writer warns that "boys with bad sense and a tendency towards snobbishness" might become self-important snobs if spoiled by their parents with money to buy "clothes, gloves, a walking-stick, and other fancy accessories."[57] Not everyone was as harsh in their outlook, however. Realist fiction of the period sometimes made mention of the culture of dandyism among lower-middle class men and women without judgment, as in a magazine short story of 1864, which opens with a description of the quayside of central Stockholm on a Sunday, when the faces seen during the week behind the counters of the shops suddenly emerge, like butterflies from their coccoons, in the form of "elegant young men, with their hair neatly dressed, sporting a pince-nez and walking-stick with a silver knob, side by side with the daintiest of creatures, smelling of Eau de Portugal and strutting in silk, lace, and gauze."[58]

The "mock-dandy" of the lower middle class was a common victim of satire and social criticism in the mid-nineteenth century, when the ability and ambition of shop assistants and clerks to dress up became possible to a larger extent.[59] Toward the end of the century, the satirical gaze persists, but through the baffled perspective of the newspapermen we can glimpse the contours of a subculture barely perceived given its lack of verbal spokespersons. What the small details of body language, such as a new way of carrying the cane or a new type of gait, reveal when systematically examined are instances of a performative body language designed to convey alternative conceptions of the role of public gentleman. The conventions concerning the role that men of a certain standing should play in the public gaze were widely known and characterized by the "noble simplicity and quiet grandeur" that cultural historians have identified as a governing discourse of the nineteenth century. But in the customs that evolved in everyday practice, different ways of playing that role started to take hold, and tactical uses of the walking-stick, together with subculturally affiliated standards of body language, became emblems of new and subversive portrayals of the role.

Both the more conventional walking-stick poses and the subculturally influenced ones were used in rituals of public strolling and male-female

courtship, and though the derision of the latter could be fierce, it seems that the border between them was diffuse. A cult of elegance permeated the masculine displays of most classes, and the presence of the walking-stick and related poses is a symptom of a widely disseminated ideal of comportment designed to convey a combination of confidence and masculine delicacy, especially when explicitly addressed to members of the opposite sex or to a camera. The contemporary culture of strolling or promenading seems to have shaped and created the need for an elegant body language in men. The promenade, as identified by historians David Scobey and Cameron White, consisted of a ritualized stroll along a main boulevard or through a park, displaying gender and respectability to the opposite sex. It encouraged a "casual, straight-legged walk" distinct from the slouching conduct that signalled "idleness, laziness, vice and moral degeneracy."[60] But flirting was a more widespread practice than that, and other practices, as we will see, formed part of the interaction between the sexes.

4

Case Study 2

"LICENSED WITHDRAWAL"

⊰ IN MODERN TIMES, stereotypically male and female body languages have been associated with expansive and submissive poses respectively, and the contention that women are subordinated by virtue of the smaller space taken up by female behaviour relative to male behaviour is difficult to contradict.[1] That being said, and while the patriarchal discourses of the modern age need to be considered, it is still possible to add nuances to the history of nonverbal gender relations, especially by looking at the earlier parts of the modern period, when the foundations of our time were laid but had not yet been solidified.

In this chapter, we will be concerned with poses assumed by women that appear shrinking or constricted as opposed to the rather more expansive poses associated with men that were in focus in the previous chapter. This body language encompasses a varied array of poses, and it is easy to stop at the conclusion that they are all expressions of submission, but a closer study reveals other facets of nonverbal female practice. Let us start with a few specific examples that illustrate the type of poses most commonly seen in the source material. In a corner of one of the pictures taken by local photographer Per Bagge in a park in Lund in 1907, we see a group of women walking away from the camera, their backs turned to us (figure 4.1).[2] They are all dressed neatly, in accordance with the fashion of the time, some in overcoats, others only in a blouse and long skirt, all of them in hats. It is probably safe to say that these women belong to the well-off section of the town dwellers, although we might also be dealing with members of the growing class of women engaged in office

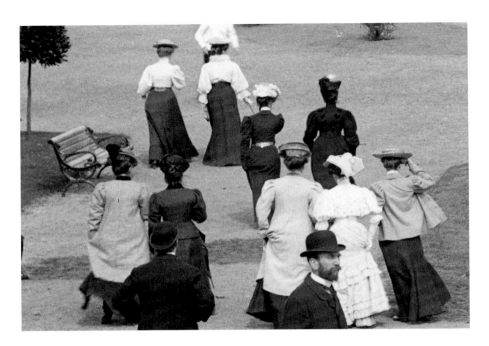

work. Their movements are graceful and placid and are little more than the regular movements of a walking human. Some of the hand positions are dictated by the clothing, especially the holding of the skirt and of the hat. Other gestures are slightly more relaxed. The woman on the far left seems to have one hand in the pocket of her coat, and the woman strolling with a cane appears quite unhampered in her movements. The overall impression is one of decency and moderation, and the performative dashes often seen in pictures of men are virtually nonexistent. And yet we see a certain variety of gestures within these limitations.

Bagge's output is valuable for its documentation of various facets of small-town life at the turn of the century, and the pictures of genteel strolling in the city parks can be compared with life at the market squares. In such photos, the congregation and fraternizing of women from the lower classes around the market stalls provide a rare glimpse of mundane female behaviour. The women seen in images from a cattle market in 1896 have a very distinctive appearance, their shawls arranged so that they hang down over their brows, their bodies bundled up by more shawls, and even a blanket under the arm. Almost all are carrying a basket on their arm to hold groceries, the folded arm held close to the upper body in the same way as the women who keep their hands clasped together in front of the stomach (figure 4.2).[3] In part, these subtle gestures are caused by the nature of

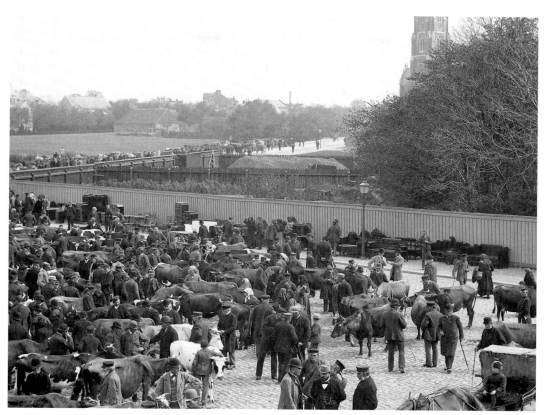

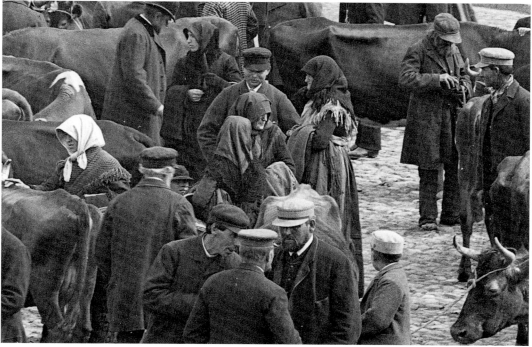

4.2 · CATTLE MARKET, LUND, 1896
(*Lund University Library*)

their clothes, which they sometimes need to hold to keep in place or allow them to move unhindered, but there is a discretion here that reminds one of the wary poses of women in portrait photography of the time.

In both the graceful walking styles of the women in the park and the restrained movements of the women at the market, then, there is an indication of a moderation that, while detectable in male body language as well, seems less taken for granted among men. The two photographs referenced constitute illustrations of the most common contexts of such body language – the elegant stroll and the grocery market – and contain two related gestures that will be the focus of this chapter: the holding of the skirt and the hand on the stomach. The most influential and fervent analysis of this body language probably comes from Goffman's study of late twentieth-century advertisement imagery, wherein he labels it with the term "licensed withdrawal," denoting the customary habit of portraying women as weaker or distant in the situation of the picture – by averting the gaze, biting a finger, caressing themselves, and so on – as a stylized version of a body language current in everyday life as well.[4] Should the poses detected in this context be considered as expressions of such licensed withdrawal? Although there is certainly an aspect of female submission in this body language, there must be more to it that becomes apparent upon closer inspection, and we need to be aware of the discrepancy between situations in which men and women congregate and all-female gatherings.

The gesture patterns of women from all walks of life have been shaped by subtle ideals since the early modern period. A study of aristocratic portraiture shows how the akimbo poses of prominent men were seldom if ever mirrored in depictions of women. Female portraits had a predilection for more delicate hand poses, gently touching the fabric of the dress or leaning the head on the knuckles of a limp hand.[5] A hand on the waist was used, with the exception of some portraits of noble women, to suggest a louche or proud character, and even in male portraiture it was restricted to secular portraits, it being deemed too self-assertive a pose for religious dignitaries. A woman displaying such self-possession was considered improper.[6] There is a distinction, though, between the comparatively expansive poses of early modern noblewomen's portraits and the hands-in-lap pose of the nineteenth-century housewife. Although the former displays a familiarity with the nature of posing, the latter is a sign of awkwardness and estrangement. We simply have no sources for the body language of poor people in the centuries before the invention of photography, but it is interesting to note that the restrained poses occur even in pre-nineteenth-century portraiture. Gainsborough's portrait of Mr and Mrs Andrews, for instance, shows the woman with her hands in her lap. The same is true for Gainsborough's portrait of Mrs Andrews' parents, Mr and Mrs Carter.[7]

The model woman of the nineteenth century was passive and still in contrast to the active man.[8] Even though this ideal emerged mainly from the literary and propriety-governed discourses that permeated the upper middle classes, it was widely distributed and affected most social groups of the time. Even peasant women portrayed in painting are habitually depicted with their hands together or occupied with some household task such as sowing or cooking. This represents an ideal, of course, but such an ideal is surely related to the way women posed in studio portrait photography. What is noteworthy is that a similar body language should be found in snapshots from the public street, and the question we need to ask is whether this is a sign that the ideals current in the photographer's or artist's studio corresponded to ideals in everyday life, or whether the body language that we see in everyday life should be interpreted in other ways. We need to look at more examples of such poses and set them against their contemporary background.

THE OCCURRENCE OF THE POSE
IN STREET PHOTOGRAPHY

Unlike some of the poses we will deal with in later chapters, the elegant and moderate female movements are not difficult to trace either in photography or illustration, and they constitute the stereotypical patterns of movement that we associate with this period in history. They are there in nearly every photograph – the wary and subtle gestures, the constant avoidance of sudden movements – and they correlate with the discourse that has become the stereotype of the Victorian feminine ideal: the delicate and fragile woman. Linley Sambourne's snapshots of women in English seaside towns contain many such gestures, as do the hidden-camera snapshots of Oslo photographer Carl Størmer from the 1890s.[9] Both collections exemplify the mannered conduct of bourgeois public interaction in spaces where this took place: the seaside promenade and the urban boulevard. The hands placed on the stomach or against the skirt and the arms creating a straight line in contrast to the waving contour of the corseted waist characterize the female body language. These are movements designed to appear sensible, decent, and respectable.

But to what extent did the norms of respectable female body language contain variations? Could there be any subcultural or individual messages behind it, besides the obvious one about patriarchal structures so ingrained into individuals that they show in their body language too? I do believe that closer inspection will reveal to us that there is a difference between simply acting submissively and consciously performing a discreet body language. The poses and gestures that I want to draw your attention

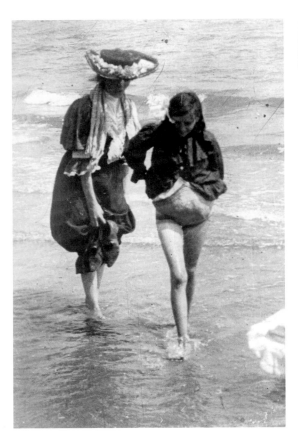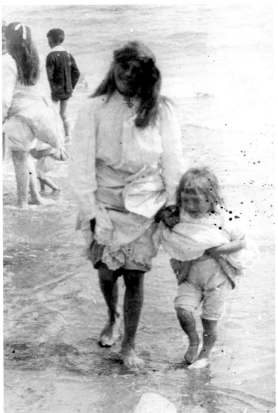

4.3 · WEYMOUTH, 1906
(*Royal Borough of Kensington and Chelsea Archives*)

to have a performative side to them, which discloses a discourse operating within the strictures of restricted female practice. A slight discrepancy can be noticed between the more performative delicacy of women in public or social situations and the unaffected movements of everyday practice and moments of solitude. These observations can be drawn from a full study of the photographs of Linley Sambourne, whose hidden-camera photos of women in public were taken in both the streets of London and the leisure areas of English seaside towns. A comparison of the material from the two contexts shows a difference in dress and behaviour in women from roughly the same social backgrounds. When caught on camera in the seaside towns of Brighton or Folkestone, the conduct is either prim and gentle when strolling elegantly on the promenade, or self-consciously playful when sunbathing or dipping the toes in the water. We cannot of course be certain that the elegant women seen on the promenade, grasping skirts and parasols, are the same as or correspond to the relaxed young

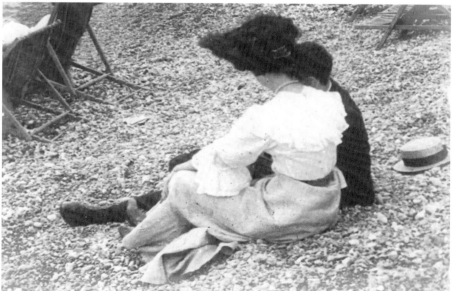

4.4 · BRIGHTON, 1906
(*Royal Borough of Kensington and Chelsea Archives*)

women resting or playing on the beach (figures 4.3 and 4.4), but details in dress and the proximity of the images both in place and time suggest a discrepancy in mindset rather than class. The London pictures show a comparable unselfconsciousness or attempts at lightheartedness. When the women notice the camera on the beach, they tend to smile or flirt

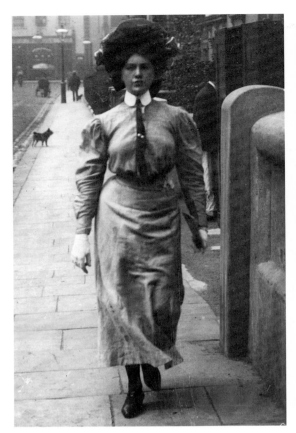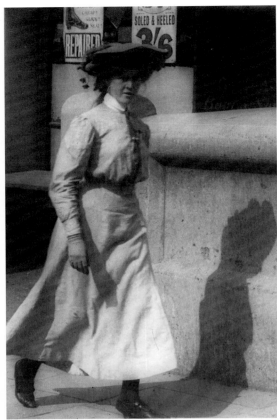

4.5 · KENSINGTON, 1906
(*Royal Borough of Kensington and Chelsea Archives*)

with it. When they notice it on the sea front, they hardly know whether to smile or maintain their dignified elegance. When they notice it while on an errand in the city, they only glance at it awkwardly, their hurry and mind-set not allowing them the indulgence of altering their behaviour.

The amount of material in the Sambourne portfolio is not enough to warrant decisive conclusions, but the pictures make an interesting suggestion: that the prim and subdued patterns of movement of the elegant seaside stroll reflect performance and leisure more than the unadorned body language of everyday practice. The girls photographed by Sambourne in the streets surrounding his Holland Park home move neither graciously nor submissively (figure 4.5). They swing their arms as they walk, make gestures while talking to one another, and are not afraid of meeting the photographer with a challenging rather than a shy gaze. Most of them are quite young, some dressed in school uniforms and others with books under their arms. Others appear to be nannies out on a stroll with their

charges, and several have been labelled "shop girls" by Sambourne in the album in which they are meticulously catalogued. By the seaside, we see women walking around aimlessly, presumably engaged in the act of "promenading" referred to in the previous chapter. These women are more elaborately dressed and so their movements are impaired, but the nature of the situation and the ritual of the promenade also seem to affect their body language. This body language corresponds in some ways to the elegant poses of men analyzed in the previous chapter.

The holding of the skirt as seen in figure 4.1 above does not appear very self-conscious or performative, and in that case it probably is not, but skirt-holding had clear and explicit connotations depending on how it was done. Since it was often necessary for women to raise the hems of their skirts in order to be able to walk more freely, rules of propriety emerged in connection with it. According to Ariel Beaujot, women of refinement were supposed to avoid getting rough elbows, which suggests that protruding elbows were also viewed with disregard.[10] The various means for raising the skirt without raising the arm too much by means of a "dress holder" accessory or a loop of cord attached to the side of the skirt similarly implies the existence of a concern. "No doubt a lady who possesses the art of holding up her train coquettishly in her hand shows a great deal of elegance and grace; but when she has to hold a parcel or umbrella, what is one to do?" asks an American periodical in 1878.[11] Some periodicals jokingly made distinctions between how various types of women lifted their skirts while walking in cities, from the clumsy and awkward way of the rural girl to the elegant and suave gestures of the urban middle-class lady.[12]

These notions were part of a whole array of rules for walking in the public street that were set down in etiquette manuals. The fastidious tone of these manuals makes going out of the house sound as dangerous as traversing a jungle. The dangers of this jungle were of course men and, to some extent, the looks of others. One of the most frequently occurring pieces of advice for women with regard to walking in the street was not to look into the eyes of others and not to look around. It was up to the lady to acknowledge a male acquaintance when she met him, but only by a discreet look, upon which the man would raise his hat and start walking beside the lady. "Upon no consideration should a young lady stop to speak in a crowded thoroughfare."[13] This set of rules placed quite large demands on a young woman's ability to shut out her surroundings and retain her dignity, as suggested by this passage from a contemporary etiquette manual:

The true lady walks the street, wrapped in a mantle of proper reserve, so impenetrable that insult and coarse familiarity shrink

from her, while she, at the same time, carries with her a congenial atmosphere which attracts all, and puts all at their ease. A lady walks quietly through the streets, seeing and hearing nothing that she ought not to see and hear, recognizing acquaintances with a courteous bow, and friends with words of greeting. She is always unobtrusive, never talks loudly, or laughs boisterously, or does anything to attract the attention of the passers-by. She walks along in her own quiet, lady-like way, and by her pre-occupation is secure from any annoyance to which a person of less perfect breeding might be subjected.[14]

It is important to refer to this culture of etiquette partly because it reflects some aspects of the time, and partly because it has played a vital role in shaping posterity's view of the era. Many historians have made use of these manuals as a way of gaining insight into the behaviour of the period, although it is perilous to use them as anything other than a reliable source to the ideals within a limited social sphere. The source material used here certainly calls for an adjusted perspective on Victorian etiquette, which is why a comparison of the different photographs of Sambourne is pertinent. In the London street series of photos, the women seem quite unmindful of any rules of etiquette or of what gestures are suitable for a young lady. On the promenade, however, the impression is quite different, although it adds nuances to the established notion of etiquette.

Promenading women, as those seen in the first picture from Lund, display an array of motions and poses that shows both the impediments to expansive movements created mainly by clothes, and the variety of gestures that evolved as adaptations to those impediments. A photograph from the portfolio of Emil Mayer depicts another leisurely walk, this one at the Prater in Vienna (figure 4.6). Two young ladies are seen strolling in the company of a young man. One can just make out the silhouettes of the other people assembled in the park, who appear to be less prosperous, dressed up but congregating in a rather relaxed and unorganized fashion. The three individuals in focus, although well dressed, are no aristocrats. The girls appear dressed for the office or shopping more than for an evening out, and the picture might have been taken in mid-day. The man is dressed in ordinary clerk attire and might come from just about any social stratum, but the baggy overcoat and worn shoes suggest that he is at the same level of affluence as his companions, despite his trying to look suave by adding a walking-stick to his getup. The body language of all three is that of politeness, discretion, and ceremonial interaction.

The ladies might be strangers to the man but, whatever the case, the situation is one of civil and respectable courtship or, more innocently, male-

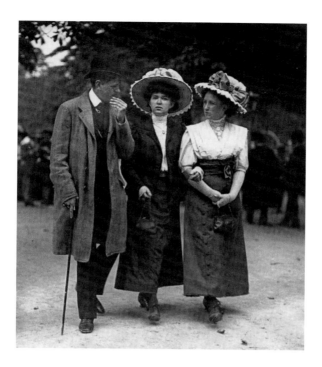

4.6 · PROMENADING IN THE
PRATER, VIENNA, 1900S
(*Wikimedia Commons*)

female interaction directed by civility, and perhaps accentuated by the subjects' awareness of the camera. It is the hand poses of the women that are of interest to us in this instance. Walking arm in arm was common for women venturing forth together, as it was usually necessary to go out in company. A lone woman was an easy target for wooers, and it was generally not considered respectable for a woman to go out on her own, especially in a park like this. To walk arm in arm was common even for men in some contexts, but here the gesture goes together with the inwardly directed positions of the other arms to paint a picture of coquetry and prudishness. The hands clasped in front of the body, as done by the woman on the right, is a very common pose that can be found in photographs from all areas of study, and the way the woman on the left holds her handbag is reminiscent of the types of gestures seen by the basket-wielding women in the marketplace photos.[15]

The movement patterns of promenading women is decidedly constricted, then, even if, when observed in action, they do not slavishly follow the rules set down in manuals. The skirt-raising gesture, for instance, is seen in numerous variations. Some women hold the skirt with both hands, some only with one, some raise it gently at the front, others grab onto the fabric

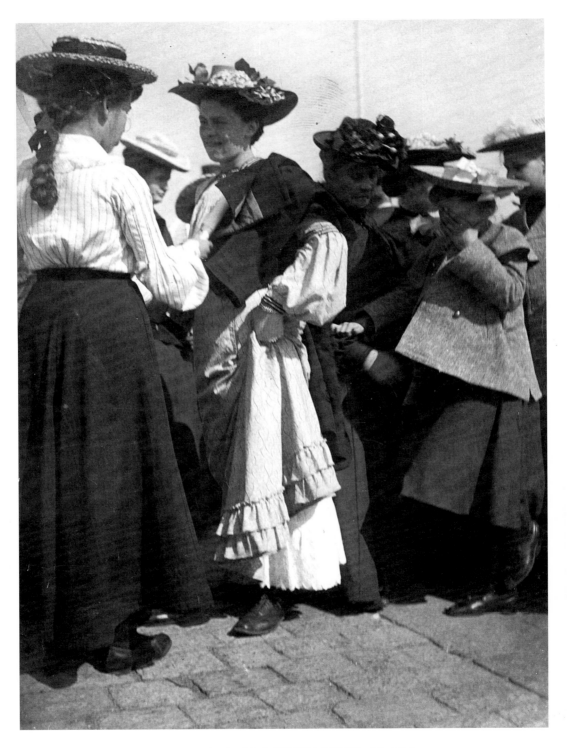

4.7 · STOCKHOLM STREET SCENE, CA 1900
(*Stockholm City Museum*)

at the side and raise it in a gesture reminiscent of an akimbo pose.[16] The main dividing line seems to be between those who hold the skirt by the side and those who hold it by the front. The latter way is the one advised by manuals, but the former is the method that most frequently occurs in the pictorial evidence. Clearly, this way of holding the skirt was the more practical one when out on errands, and perhaps the more graceful way of holding the front was reserved for the promenade. In a couple of the Sambourne images, we see a woman holding her skirt in a fashion that makes her look quite bothered by its presence, and there is no attempt at gracefulness in her movements at all. Her right hand is holding the dress firmly while the left hand swings fiercely. The same gesture can be seen in a few of the Tryggelin photos, especially one of a crowd of young women in which the girl in the middle, dressed neatly in a white dress and hat, grabs a large piece of the skirt and holds it up while talking to a friend. This situation of interaction between acquaintances, although carried out in public, seems to instill a more indecorous and careless deportment in this woman (figure 4.7).

The gentle holding of the skirt is clearly a sign of a certain ritual state associated with the culture of promenading and leisurely strolling, an activity that was not just for the upper classes, but that might not have been very common among the lower classes. So how do the poses of ceremony and elegance relate to the body language of housewives and servants at work? A discretion of conduct is discernible in the images of women in markets, but does it aspire to the same impression? In photographs of impecunious women, two arm poses are common: clasped hands hanging in front of the stomach, and one or both arms bent at a right angle with the forearm held across the waist. These gestures are mostly seen in street photos where the people are aware of the camera and are directed toward it. In this way it correlates with the submissive poses of studio portraits that we studied previously. When we move out into the street, however, the use of such poses is intermingled with other expressions.

The girl in the street door caught in a relaxed moment by Erik Tryggelin holds her arms in front of her body as an expression of semi-conscious shyness, and her gesture follows the pattern of lower-class women confronted by male photographers from a more comfortable background (figure 4.8). But this is not restricted to encounters across class divides, which indicates that the restraint of the female party in such meetings is occasioned by the gender divide rather than anything else. This is illustrated by several of Emil Mayer's Prater images, where the masculine and expansive poses of the male suitors are accompanied by the constricted poses of the young women. We see them holding their furled parasols in front of them, holding their hands together in front of the stomach and even

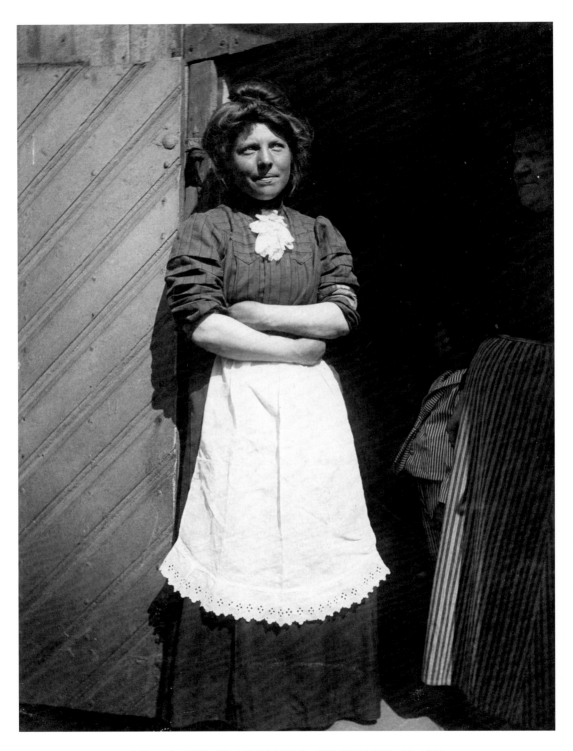

4.8 · A MAID IN A DOORWAY, STOCKHOLM, CA 1900
(*Stockholm City Museum*)

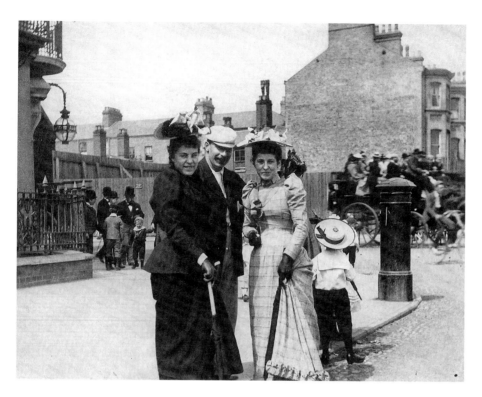

4.9 · LONDON STREET, 1890S
(*with permission from the Harry Ransom Center*)

crossing their legs, as if to make themselves as tiny as possible. In some of these photos, the female body language is not quite as constricted, incorporating akimbo and other expansive arm gestures (see chapter 5), which shows that the constricted poses are only one facet of a complicated ritual of male-female courting, defined both by a sense of play and provocation and by a conscious display of traditional masculine and feminine bodily tropes. The men and the women act in ways that are expected of them, but the male-female congregation has various stages, some only friendly and companionable, some provocatively flirtatious, and some mannered and coquettish.

The movements and poses here are free and easy, but they stay within the limits of a slightly more restrictive norm than that of men in similar situations. A Paul Martin photograph from an unidentified working-class street depicts two women and a man dressed in their Sunday best, posing for the camera in the midst of the bustle (figure 4.9). The man is in the middle, holding the women with a confident and domineering gesture, while the women comply, performing an act of coquetry by turning one shoulder to the camera and placing the parasol before their bodies. The

girl on the right also holds up her skirt, emphasizing the constrained pose. The body language of women in these situations is shaped by the tacit rules of the ritual. The relatively public nature of the situation also restrains the body language, but when men are absent it is altogether more relaxed. The ease is conveyed mainly through akimbo poses, a key aspect of female body language that we will return to in the next chapter. The more removed from public life the situation is, the more expansive is the female body language; even in photographs of back streets and poor people on their doorsteps, where the presumptuousness of the photographer might have made people wary, the poses are more assertive (see chapter 5). But, even in frivolous moments such as those documented in the bank holiday or seaside photos of Paul Martin, the presence of men and women together ensures the subtlety of female body language.[17]

The women with the most striking body language in the market photos are the female stallkeepers. Examples from Per Bagge, Paul Martin, and Erik Tryggelin show women, generally of a more advanced age than their customers, leaning languidly against their stalls and allowing their already generous frames to sprawl with the use of akimbo and leaning poses.[18] The distinction between the shopping women and the stallkeepers is one of a ritual state, naturally, as the latter are set on actively interacting with customers, shouting out their wares to passersby and getting ready to haggle about prices. The customers need to perform a more wary body language, both because they are running errands, thus being in a dutiful mindset, and because they are carrying heavy loads. To what extent the poses of the stallkeepers can be attributed to a certain subculture is the subject of chapter 8, but a wide study of women in these situations indicates that their frequently restrained body language is not completely set apart from the expressive body language of the stallkeepers.

The poses that we identified above, in which the hands are held close to the stomach and waist, sometimes appear submissive, but sometimes they have a self-confident air, traversing the division between the shy hands-behind-the-back pose and the cocky akimbo pose. The evidence of the "licensed withdrawal" in the photographs examined here indicates that factors of situation and age played a role that was at least as vital as class. Women lower down the social scale, most easily exemplified by market stallkeepers and domestic servants, were allowed a more expansive body language, and their subcultures encouraged it, but a closer examination of these photographs reveals two other determining factors. First, we need to consider the age of the performer: more matronly women of advanced years were expected to act in more robust and manly ways, while young girls indulged in acts of flirting, playfulness, and coquetry, and middle-aged or married women were the most restrained. Second, the

situation in which the photograph captures a performance needs to be identified with respect to the public-private continuum. Are the people in the picture among friends, close to home, out promenading, running errands, or what? This condition is illustrated by one of the backyard photographs of Vienna photographer August Stauda (see figure 5.3).[19] In photos such as this we are closer to the domestic sphere, and the women in them appear more confident, more "at home," both literally and symbolically. The mild amusement that is playing in their faces, and the challenging look that seems to say, "Well, now that you're here, do your thing and then let us get on with our day," demonstrates how women from the lower classes created an expressive body language within the strictures conditioned by their gender. But an older woman will not be as shy as the young girl in the door photographed by Tryggelin. Female body language in this age is never completely submissive, and yet it does not quite reach the expansiveness of men, which is why looking at it can be quite bewildering.

THE OCCURRENCE OF THE POSE IN CARICATURE

So far, we have identified two strands within the subtle variants of female body poses at the turn of the twentieth century. One of these was more derided in popular culture than the other. The skirt-lifting poses of women in the street was used to signal both elegance and arrogance. In earlier depictions of women in the street, this pose is rare, and it seems that its introduction into the world of caricature was a consequence of the entrance of wealthy women into the public street, a sphere that wealthy women in earlier centuries may not have been able to avoid completely, but with which they were not as closely associated.[20] The increase of well-dressed women in the street, as well as the growing ability of poor women to dress in clothes similar to those worn by wealthy women, would have affected body language by creating a need for a practical way of walking quickly without being hindered by the long skirt. Before the nineteenth century, dresses often reached down to the ground, but it seems that the fashionable attire that one might associate with the seventeenth and eighteenth centuries from paintings and court circles were dissimilar to the more practical clothes worn by the lower strata in the street. So while it would not of course have been impossible for a woman to raise her skirt before the nineteenth century, this gesture and its related poses would have become more common and more pragmatic versions of it emerged.

The standard way of portraying a respectable woman walking on the street in turn-of-the-century cartoons is to show her leaning slightly forward so that her movement is apparent despite her legs being hidden, one arm occupied by an umbrella, and the other hand gently holding the

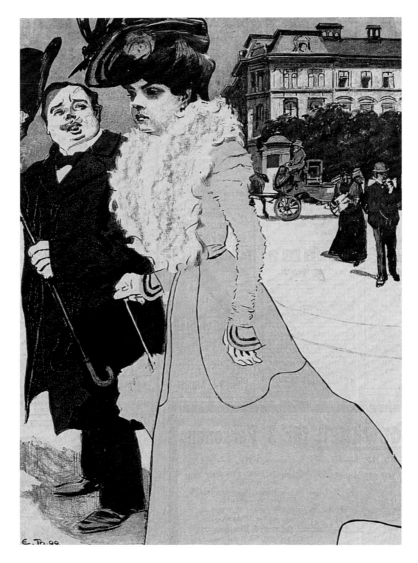

4.10 · CARTOON IN *SIMPLICISSIMUS*, 1899

skirt so that the arm creates a gentle S-curve (figure 4.10).[21] In almost all of the cartoons where such a woman is depicted, the theme is that of a man approaching her with some feeble excuse for chatting her up, such as sheltering her under her umbrella (when she already has one), while the woman walks away or ignores him. This motif was particularly recognizable for the urban readership of satirical journals, as lone women venturing into the street at this time were often approached and harassed by men with dishonourable intentions (in spite of the rules of etiquette

manuals!) – a subject that was regularly debated in the media.[22] When such scenes are depicted, then, it is the man who is the butt of the joke, and the women in these pictures are always portrayed as elegant and delicate, providing a picture of an ideal rather than an object of derision. In some cartoons, however, the situation is more exaggerated, and the behaviour of the woman is such that humour is derived from that as well. The behaviour that is mocked in such depictions is either the affected elegance of a stuck-up lady or the flirtatiousness of a woman who is not as shy as she pretends to be. In the former case, the woman is portrayed as a caricature, and her delicate gestures and upright posture are exaggerated.[23] In the latter case, the woman is generally not made to look silly or stupid, but a hinted association with prostitution looms large.

A *Simplicissimus* cartoon shows an attractive woman wearing a striped skirt, wide hat, and fox-fur boa walking down the Friedrichstrasse (figure 4.11). She is lifting up her skirts a little too high to be respectable, while another woman, walking away from the viewer, displays the rounded backside of her dress, accentuated by her firm grip on the side of the skirt. The portrayal of the two women is highly sexualized, and yet it differs from the way prostitutes are usually represented in these periodicals (which is not sexualized at all). The caption reads, "We would very much like to strike, but then there are only too many respectable ladies who would be willing to work." The picture is quite a forthright reference to the well-known prostitution of Berlin's Friedrichstrasse, and the portrayal of this particular prostitute puts the emphasis on sexuality rather than, as is more common, on ugliness or poverty (see chapter 5). There is nothing comical in the picture itself, which might lead one to assume that this is a picture of an ordinary woman. Elegant men and women who are suave and moderate in their conduct are seldom ridiculed in these cartoons.[24] They are more likely to be portrayed as the neutral bystanders to the real silliness going on elsewhere in the picture.[25] The inappropriate behaviour of this woman, however, is there in spite of its subtleness – it is in the slight vulgarity of her clothes, combining a loud skirt with an ostentatious hat and a boa, and in the way she lifts her skirt.[26]

But flirting is not exclusively tied to indecency, even though it is almost always condemned when performed by women. Men are depicted as flirting by approaching women, while women flirt through coquetry, and the restrained gestures of women in public are used to illustrate this. In a cartoon in *Fliegende Blätter*, a woman in a cloak and feathered hat is seen walking away from a flamboyant man in a monocle, displaying an ostentatious buttonhole and a Kaiser Wilhelm moustache. The caption reads: "Gentleman, who has unsuccessfully attempted to flirt with a lady:

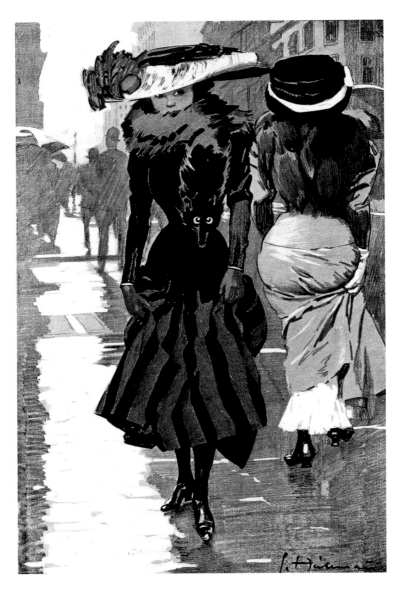

4.11 · CARTOON IN *SIMPLICISSIMUS*, 1909

'Unbelievable shortsightedness!'" The woman, who is evidently too fast even for the predatory dandy, glances back at him with a coy expression, and the artist makes use both of her sensual lips and the way her delicate gloved hands lift up her skirt for walking to get across how her outward innocence hides a voracious nature.[27] A cartoon from *Söndags-Nisse* that portrays basically the same scene but in a cruder way, shows the man leaning forward and raising his hat, while the woman demonstrates her flattered

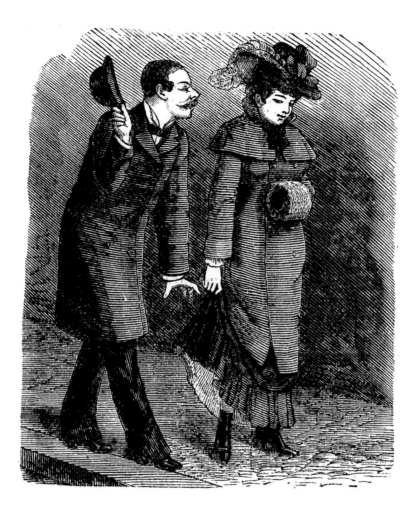

4.12 · CARTOON IN *SÖNDAGS-NISSE*, 1883
(*Lund University Library*)

interest despite gestures of retreat as she pulls the hem of her skirt toward her, lowers her face shyly, and holds her other hand toward her stomach, hidden in a muff. "Do you intend on walking alone, Miss?" asks the man. "That depends on you," replies the woman (figure 4.12). The message behind such illustrations is clear. Should the performance of delicacy and restraint become too exaggerated, it slides into coquettish flirting.

Just as the case with men, then, the derision is directed at both flamboyant ostentation and indecency. Somewhere in the middle is a sensible and temperate ideal meant to represent the readership. The delicate poses of women are sometimes the subject of mockery, although seldom through

pictorial representations that make them look grotesque or unrealistic. The comedy is mostly in the caption, while the picture itself shows ordinary-looking individuals. The satire is in the details, and is therefore difficult to extract a century later, but in the subtleties of a cartoonist's depictions – a woman raising her skirt a bit too high, or making a restrained gesture in the presence of a man that would have been quite acceptable were it not for the look she gives him – we glimpse both a stern condemnation of female behavioural excess and a subtle nonverbal practice designed to express liberty within social strictures.

This conflict is further illustrated when we try to find depictions of the more domestic hand-on-stomach poses seen in photographs. Such poses are quite rare, and when women from the lower classes are depicted their body language is more assertive, which will become clear from the next chapter. When this type of pose is used in cartoons, it seems mostly to signify the identity of the housewife, as depictions of women talking to their servants or standing in the door of the house generally pose with their hands close to the waist or stomach.[28] In street scenes, similar hand poses recur, but the addition of accessories such as umbrellas or the holding of the dress change the gestures. The most similar hand poses in street scenes are those in which the woman is seen carrying a muff, which gives her hands the same prim and protective sense as when they are held against her stomach (figure 4.13).[29] Muffs had been around for centuries, but it is possible to see changes in the way they were used. In eighteenth-century portraits, for instance, they are seldom carried with both hands in the prudish way seen in the late nineteenth century, and in earlier times muffs were worn by both men and women.[30] The way of carrying muffs in the late nineteenth century fits well within the general picture of women as expressed in cartoons and other illustrations.

Notwithstanding the examples discussed, it is clear that the body language identified in this chapter did not lend itself as readily to caricature as did other types. Taken by themselves, the cartoons mentioned might give the impression that women were rarely ridiculed in satirical journals in comparison with men, but this notion will be eradicated when we look at the various associations of female akimbo poses, which could be used in the mockery of both the wealthy and the poor. What this survey demonstrates is, rather, that even when subtlety in behaviour was presented as an ideal in the satirical journals, the wariness of exaggeration seen in etiquette manuals was still present. A woman's discreet behaviour ran the risk of being seen as overly coquettish, suggesting that female bodily discretion, while undeniably submissive, could also be a tool in a self-conscious performance, one that betrayed a coy nonverbal identity. But here we frequently see it from the outside. Can it be viewed from within?

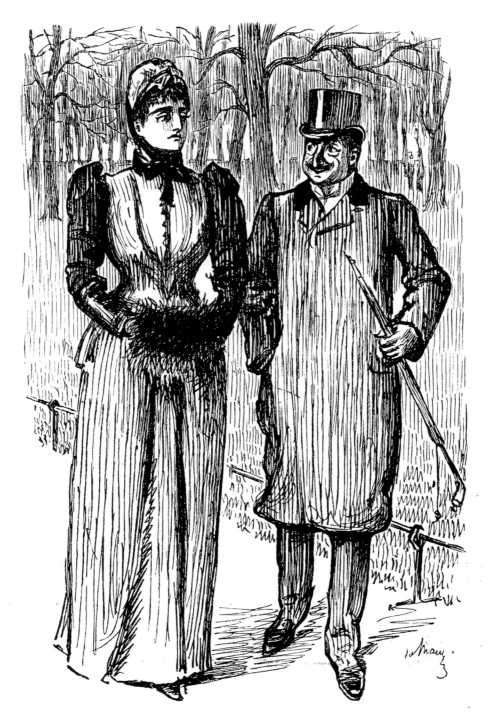

4.13 · CARTOON IN *PUNCH*, 1890
(*Lund University Library*)

In an influential lecture, feminist scholar Iris Marion Young contends that a woman's body modality is caught in the tension between the business of acting independently as an individual subject and the restrictions attached to the feminine identity in a patriarchal society that defines women as "the inessential correlate to man." Young mentions the example of "throwing like a girl" that other scholars of body language have studied, which shows that young girls throw a ball simply by raising their arm and throwing it, while boys use their whole bodies, thereby taking up much more space in the process. Young attributes this to what she calls an "inhibited intentionality" that undermines women's confidence in carrying out physical actions, leaving the space of action open for men.[31] This resignation correlates to the situations seen in the photographic material examined in this chapter, in which women are meant to be elegant and ladylike, especially when they interact with men. The ritual of the promenade certainly contains something akin to the patriarchal gender contract that Young is talking about, but a closer study of body language shows that there are other sides to it. The body language of women in situations when men are not present and when women are carrying out tasks on their own has a completely different logic, but there is also a sense of agency in the coy gestures some women make in front of men. Patriarchy may serve to explain a basic difference between male and female body language, but women do other things besides expressing their subservience to men.

There is a clear difference in the photographic and cartoon material consulted here, and it consists in the more sprawling body language of women in photographs as compared to the very prim and submissive ideal suggested by cartoons. One has to look to the details to discern this difference in full, but it is there. Linley Sambourne's portfolio of women photographed more or less candidly in the London streets demonstrate how female body language – in this case, of women from the middle sections of society – although decidedly less expansive than the male equivalent, was not characterized by its submissiveness but rather by the development of a freedom of movement within its patriarchal confinement. When women were portrayed in cartoons, their restraint, although mirroring actual practice, was exaggerated, and the expansiveness of everyday practice was toned down in favour of a stereotype. So how are we to understand this "confined freedom of movement"? Well, the main point to be made in this chapter is that, in spite of gender hierarchy, the message conveyed by the poses of these women is not one of oppression or dependency, but of an autonomous identity. This identity can be connected to various social

categories that emerged at the time, perhaps most pertinently that of the "shop girl." Sambourne himself uses this term, which was invented to label the young women employed in shops of turn-of-the-century English cities and was carelessly applied to young women in many lines of work. The term was the subject of heated discussion in the media concerning whether the lifestyles of such women were a threat to their innocence and femininity, but we know little of the internal subcultures of the women who actually led such lives.[32]

Only by looking at the criticism of alternative female lifestyles and the periodicals and novels that these women consumed may we acquire something resembling a relevant context for the nonverbal identity gleaned here. In 1860s England, the term "the Girl of the Period" preceeded "the New Woman" as a label for young women who indulged in unrestricted behaviour, devoting their time to unproductive pursuits such as fashion and parties.[33] The fact that this phenomenon was publicly derided, and that the subculture was supplied with its own publications, including *The Girl of the Period Miscellany*, is a clear indication that young women were able to live more freely than rules of conduct suggested. The articles of the miscellany celebrated girls who were active outside the home, hunting, travelling, working, smoking, and playing croquet. But, interestingly, as Kristine Moruzi has noticed, the accompanying illustrations in the magazine seldom depicted the women in very unorthodox poses. This discrepancy corroborates the observation made here, that a relative freedom of movement in everyday life, which could even be expressed in writing, did not receive a corresponding pictorial representation within the contemporary norms of depiction.

Sally Mitchell has suggested that the late nineteenth and early twentieth centuries saw the development of a separate "girl culture" among both middle- and working-class girls in the stage between childhood and married life. This culture was expressed in girls' periodicals, novels, clothing styles, and sports, and although it did not constitute a dramatic change in how girls lived, it introduced new ideals of behaviour and modes of living that influenced the female emancipation of later periods.[34] The Girl of the Period stereotype, together with later equivalents encompassing shop girls, office girls, and so on, demonstrate that the female youth culture of the late nineteenth century contained many aspects beyond the proto-feminist ones that have been the focus of latter-day research.[35] It also shows the importance of age in evaluating social differences in this period. The relative freedom inherent in girls' culture was compromised when a young woman entered married life, and the bodily cues of coyness and coquetry were chiefly relevant to the age of courtship and marital

introduction. Women from some walks of life might even have regained their bodily liberty later in life, when the desexualized notion of the old woman brought her closer to male templates.

The independent subculture of lower-class women is mainly visible through their reading matter – profusely criticized, of course, by moralists at the time – which included romance and adventure novels, and publications that, while not opposed to or critical of the conventions of domesticity and marriage, placed more emphasis on heated emotions, glamour, and adventure than on household economy and the plight of being a good wife and mother.[36] This context is relevant to the body language studied here, as what we have distinguished are indications that female poses and gestures contained an outspoken and playful agency intent on expressing confidence, control, and charm. To some extent, women displayed a more subtle body language than men, but only insofar as no grand gestures can be seen in the sources. Their restrained body language was generally used in the presence of men and was to a large extent an adaptation to the nature of their clothing, but was mainly dependent on the definition of the situation. For women, expansive body language was reserved for more private situations than it was for men, but, as the next chapter will show, it certainly existed.

5

Case Study 3

THE FEMALE AKIMBO POSE

═══════════

◁ A SUNNY DAY ON Maximiliansbrücke in central Munich in the sum-mer of 1896. A traffic of horse-drawn carts and carriages, elegant stroll-ers, and labourers on their way to and from work pay little attention to the boundary between street and pavement. A group of ladies sheltered by the shade of large parasols walk along the railing of the bridge. One lady in a light-coloured dress and a flower-bedecked hat decides to follow the example of her fellow pedestrians and puts up her parasol just as she passes the camera. In the same second, two other women come walking in the opposite direction, away from the camera. They are identifiable as chambermaids by the crossed white bands of their aprons shining against the blackness of their dresses. The woman on the left looks slightly older than the other. She holds her hands in front of her stomach. The young woman on the right, however, keeps both her hands held firmly on the high waist of her dress. Her arms create almost horizontal lines jutting out from the silhouette of her torso. A few paces later, she drops her right arm, only to lift it to the waist once more, a few seconds after (figure 5.1).[1]

Is there anything to this? At first glance, it is really just people walking. No one stops or does anything out of the ordinary. It is impossible to say where any of them are going – not even the two maids, who might be out on a break, running an errand, or going from one place of work to another. The striking thing is, I suppose, that the young maid is the only one in the entire thirty seconds or so of pedestrian traffic who is seen grasping her waist in this somewhat conspicuous manner. The absence of

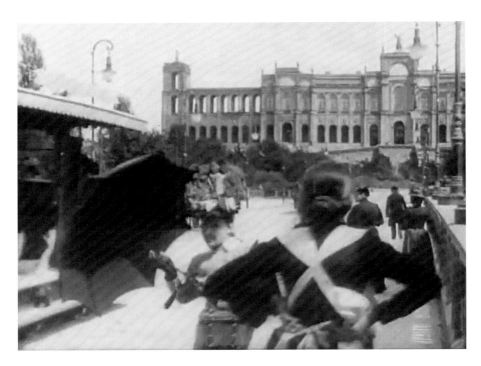

5.1 · STILL FROM LUMIÈRE FILM MADE IN MUNICH, 1896

such gestures in the other people might be ascribed to the fact that their hands are occupied, in the case of the other women mainly by umbrellas or parasols. But this woman's hand is also occupied by what appears to be a loaf of bread. Her arm pose looks to be both a way of resting her arms and a semi-conscious style of walking.

Another summer's day, another time, another place. Among the dressed-up visitors to an agricultural show at Leeds in 1902, we see a group of women reappearing throughout the few minutes of footage. They are well-off society women congregating, chatting, and joking among the tents of the Great Yorkshire Show, where animals and farming implements are exhibited. The people seen in this film are from various walks of life, and it is difficult to pinpoint the social background of the women appearing, but despite being decidedly well-to-do, their conduct in front of the camera is silly and mischievous. Some of the women turn repeatedly to the camera, barely able to hold back their laughter. At one point, they make mock-flirtatious faces toward the camera. They hold up their skirts in a more firm and manifest way than the women we saw in the last chapter (figure 5.2). It is a display of cockiness and teasing. The hands that hold up the skirts are resting on the waist, creating an akimbo pose. One of the women looks to the camera, presenting her shoulder and bent arm in an assertive and

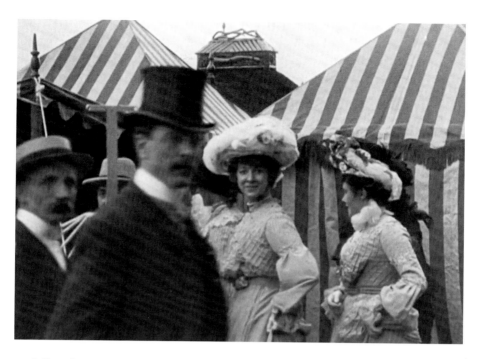

sprightly manner. For a brief moment, the lady of refinement turns into a raucous and mischievous girl.[2]

What are these two women – the chambermaid in Munich and the society lady in Leeds – up to when making these rather grand and eye-catching poses? In the previous chapter, we noticed how even in the submissive and restrained body language of women there was a hint of assertion and self-awareness. I refrained from touching on poses or gestures that might seem too expansive, so as not to brush aside the patriarchal aspect of female body language in this period. In this chapter, however, we will look more closely at poses and gestures that convey more directly a sense of independence and agency, to see what they meant and what room they were given in the behaviour of women at the time.

The pose of holding the arms akimbo, with hands on hips, the arms bent, and the elbows jutting out from the torso, is one of the most emblematic poses in the history of nonverbal communication. In art, it can be traced at least as far back as the sixteenth century, and it was used frequently in early modern secular portraiture to express the alertness and pride of aristocratic sitters.[3] In this way, we tend to interpret the arms-akimbo pose as a means of conscious distancing by the male aristocracy from their social inferiors, by stating their power over their own bodies,

as in the "Renaissance elbow" described by Joaneath Spicer.[4] The akimbo arm is not absent from female portraits, however, and it can even be found in antique sculptures of Greek goddesses.[5] The use of akimbo arms in art, then, mainly relates to one type of pose, but that pose can potentially communicate a number of emotions or states of being. Guillemette Bolens lists a few: relaxation, fatigue, satisfaction, anger, surprise, defensiveness, defiance, threat, bluff.[6] With such an insight, it is easy for us to distinguish between the maid in the Munich film, whose akimbo pose seems to be an expression of relaxation or fatigue, more unconscious than conscious, while the Leeds woman executes the pose in an act of flirtatious audacity. Looking through the sources, these two meanings are the most common ones, but the distinction between them is not always apparent, and we can tell a lot about this period from the way these meanings were intermingled.

In advice literature, violent gestures have always been associated with the lower orders.[7] This goes for both men and women, and there seems to be a point in most historical periods when body language strays so far from the ideal that social distinctions play a more vital role than gender-based distinctions. The ideal represented by advice literature, at least in the nineteenth century, is problematic, as its true source is difficult to pinpoint, and although there can be little doubt that ideals of respectability and discipline were widespread in the Western world among all social classes by the late nineteenth century, it cannot be said just how much they infiltrated the culture of everyday life.[8] The body language that we shall look at in this chapter would at first glance be a stereotypically working-class type of body language, but a broader look at its appearances suggests a more complicated relationship between body practices and social identities. As the akimbo pose is generally associated with men, and its male use has been more thoroughly explored, I will devote most attention to its female uses, to investigate female access to performances of power and spatial domination in the everyday situations of the period.

THE OCCURRENCE OF THE POSE IN STREET PHOTOGRAPHY

The distinction between the two main uses of the arms-akimbo pose as identified above – semiconscious fatigue and conscious effrontery – is detectable in most of the source material. The latter type is seen in photographs akin to portraits such as images of women standing in their doorways or otherwise posing explicitly for a photographer. In these cases, the pose is sometimes cocky and defiant, but often it is not, and it is difficult to draw a line between acts of effrontery and acts of awkwardness or rest. This is probably because the distance between effrontery and awkwardness is not

so vast. Illustrations of this can be found in numerous snapshot photographs, but is perhaps most evident in examples of the so-called "doorstep portrait." Doorstep portrait is the name usually given to photographs in which a photographer, with the explicit purpose of documenting at close hand the lives of poor people, has been allowed to portray the inhabitants of a slum dwelling by photographing them on their doorsteps or in front of their houses. Such photos constitute the most common occurrence of poor women in early photography, which in itself makes them a vital source, although their posed nature is problematic.

Didier Aubert claims that doorstep portraits are traces of a consensus between photographer and sitter, in which the former has been granted some access, albeit with reservations, as he is not admitted into the house, while the latter performs a "public presentation of privacy," a self-conscious self-presentation that balances the sitter's self-assumed role with the behaviour of a poor person that is expected by the middle-class audience of the reportage.[9] Using such images with the goal stated here, then, calls for some caution, and the problem of the genre is demonstrated in the awkwardness/effrontery divide that I have called attention to. Doorstep portraits from the production of Oscar Heimer, August Stauda, and Heinrich Zille are the most revealing in showing how the situation of being photographed in front of one's home was an experience that created both a vague awkwardness and a confident self-assertion in the people photographed. Thus we can see how gestures such as holding the arms akimbo could be used both when the individual wanted to express an unswerving confidence and when he or she wanted to disguise discomfort. An image by August Stauda of two working-class women standing in a Viennese backyard illustrates the occasional closeness between awkward arms-close-to-body poses like those seen in the previous chapter, and more assertive akimbo poses. The shyness and awkwardness of the young woman on the left prevents her from putting her hands at her sides, while the older woman appears more confident and unbothered by the presence of the photographer (figure 5.3). This is quite a typical example of the documentation of the lower classes that photographers around the turn of the century sometimes set out to do, resulting in stiff poses that suggest defensiveness. A slightly different version of a similar scene is found in a Per Bagge photograph of one of the humbler residential streets of central Lund. Here the photographer's objective was not to document a courtyard, and so the imposition is not as apparent, but the people in the picture are aware of that imposition nonetheless, particularly the young woman peering out from behind a garden gate in figure 5.4. Both she and the woman who can be glimpsed in the window next to her convey a sense of curiosity rather than defensiveness, and this defiant attitude – the

5.3 · SÄULENGASSE, VIENNA, 1904–05 (*Wien Museum*)

5.4 · DETAIL OF PHOTOGRAPH FROM VALLGATAN, LUND,
BEFORE 1911 (*Lund University Library*)

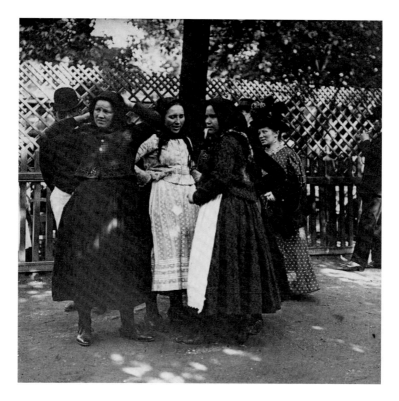

"What are you looking at?" pose – is mirrored in her akimbo gesture. This oscillation between awkwardness and defiance is a common theme in most doorstep portraits of this period, indicating a conflict between the unease of the unfamiliar situation and a will to hold one's own.[10]

Holding the arms akimbo was very much a part of female body language, then, to the extent that some women did not feel they needed to hide it. Among poor women, this pose might have given outsiders the impression that they were more masculine than the self-possessed members of wealthier classes, but, as we have seen, although some aspects of expansive body language could be associated with the lower classes in certain contexts, such movements and poses occurred across the social scale. Doorstep portraits might lead one to think that they were displayed mainly in encounters with photographers and other representatives of an "outside gaze," but the pose is also visible in photographs whose subjects do not seem to be consciously performing for the camera. Emil Mayer caught a group of young women in one of his photographs from the Prater park in Vienna (figure 5.5). The women are allegedly immigrants

from one of the outer provinces of the Austro-Hungarian Empire, who were in the habit of travelling to the capital in search of employment. A similar picture analyzed in connection to the walking-stick pose shows to some extent how these youths fused rural and urban cultural expressions, most visibly in the peasant dresses worn by the women and the hats and walking-sticks sported by the men. In the present photo, four girls are standing in the shade of a tree on a sunny summer's day, chatting and adjusting their clothes and shawls. The girl in the middle, wearing a light-coloured bodice and apron, is standing in an akimbo pose, as the girl to her left, who is hidden behind another girl, also seems to be. The girl on the far left stretches her arms up, apparently to fasten her scarf. Her leg pose, both feet firmly on the ground, accentuates the ease and straightforward-ness of her state of mind. It is not quite clear what they are doing, whether getting ready for a night out or simply enjoying a break from their work. Their clothes are provincial, and the presence of aprons on two of the girls suggests they are at work, but it might also be that their appearance has not yet been affected by urban fashions. Quite possibly, they are merely visitors to Vienna, rather than immigrants as Mayer's caption claims. Their surroundings contain clues that complicate the impression. From behind the left girl, a man in a bowler is peering out, and to the right a woman in more metropolitan-looking dress is talking to someone behind the girls. Further to the right, an elegant man is lighting a cigarette.

The Prater, as we have seen from the other Mayer photographs discussed here, was a place where people from all walks of life went in their leisure hours, and Mayer took the opportunity to photograph people from different classes for his collections of "Vienna types."[11] In many of these pictures, the people appear unmindful of the camera, to the point that we might assume only a small degree of intrusion from the photographer. The provincial girls allow us a glimpse of their relaxed body language, reserved for interaction among the closest friends, and the rare moments that have been caught on camera are revealing. The body language is confident and expansive without being self-consciously assertive or flirtatious. It resembles the movements of the two maids in the film footage from Munich in that it seems to be a way of resting the arms and body at the same time as the familiarity of the moment lends their gestures a certain informality.

The most frequent occurrence of the arms akimbo pose in women from the lower classes is otherwise seen among female market-stall holders. In the photographs of Paul Martin depicting street markets, at least one woman is seen leaning on her stall with one arm akimbo.[12] A Samuel Coulthurst picture from Manchester shows a stallkeeper standing with one foot on her barrow and her arms akimbo (figure 5.6). But the most extensive documentation of market-stall conduct comes from the Per Bagge

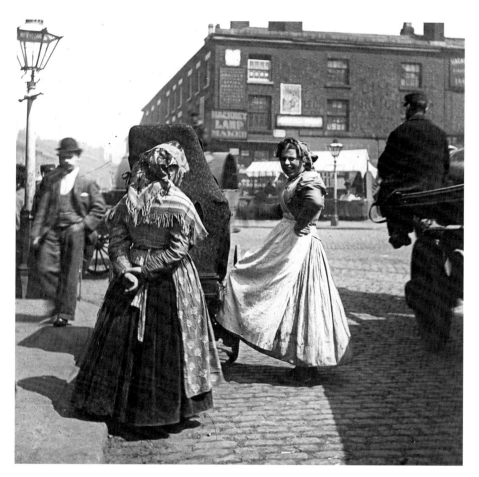

5.6 · MANCHESTER STREET SCENE, 1890S (*Salford Local History Library*)

5.7 · MARKET SQUARE, LUND, 1890S (*Lund University Library*)

collection of images from Lund. These photos show how the stallkeepers adjust their body language to some extent, depending on whether they are interacting among themselves or with their customers. When they are caught putting up their stalls or waiting for customers to arrive, the poses of the women hardly differ from that of the men. In one picture, a woman in a shawl and long black dress is seen from behind while leaning on a barrow chatting with two men who are leaning leisurely beside her (figure 5.7). Her clothes hide the position of her legs, but it is possible to conclude that she is leaning forward, resting her lower arms on the barrow. Another photo shows a similarly dressed woman in the far background of a market square talking to a man while erecting her stall. Holding the awning of the stall with one hand, she rests her vacant hand on her hip while turning to the man (figure 5.8).

The arms-akimbo pose in these contexts seems to be both about private backstage relaxation behaviour and an assertive claiming of space among equals. The one could easily turn into the other. When Linley Sambourne wanders about in London and on the Continent, directing his lens at young women, the response from the photographed women is often defiance or irritation, but while some women, looking awkward and uncomfortable, simply walk past him, others look into the camera with a provocative and challenging gaze, such as the woman in a dark plaid dress, whose gait is quite confident and sprawling and who looks at Sambourne and his camera inquisitively rather than self-consciously (figure 5.9). The cocky pose of the woman in the film from the agricultural show provides a window into the use of the akimbo pose among women who were of a different social standing or who made a more consistent display of respectability. Holding the arms akimbo was not as accepted in some social circles as in others, and so the restrained body language that we studied in the previous chapter was more closely associated with women higher up the social scale, at least in the more graceful rather than sheepish forms. But different situations meant different social rules, and there were situations when upper- or middle-class women made use of a more expansive body language. The akimbo pose in these situations appears somewhat different than when performed by market stallholders, and it is closely linked to the various strategies that emerged for raising long skirts when walking.

The late nineteenth-century city offered more public arenas for women at the same time as it became increasingly acceptable and necessary for women of the prosperous classes to negotiate the streets. This is reflected in the street photography of the time, in which elaborately and elegantly dressed women are quite a common sight. Several photos by Tryggelin focus on these elegant women, and as noted they illustrate some of the more expansive gestures that wealthy women could perform in public.

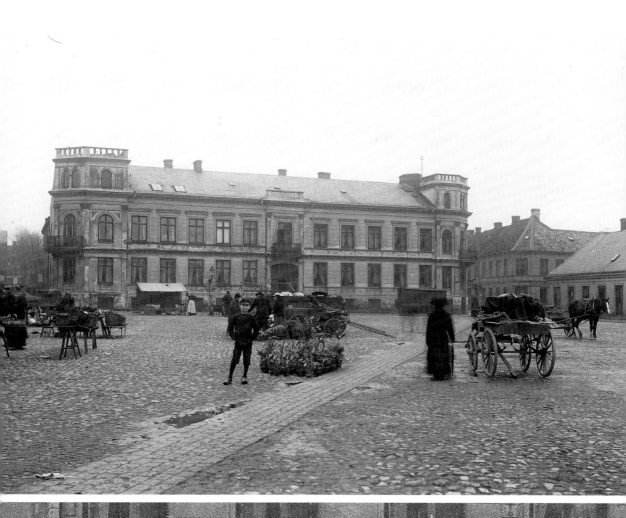

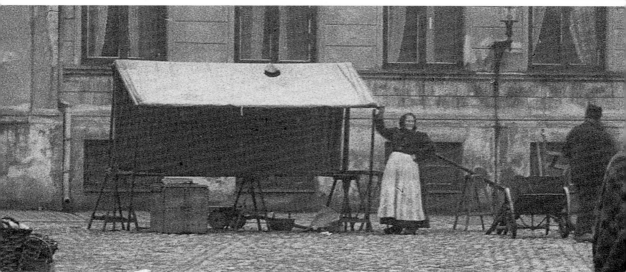

5.8 · MARKET SQUARE, LUND, 1890S
(*Lund University Library*)

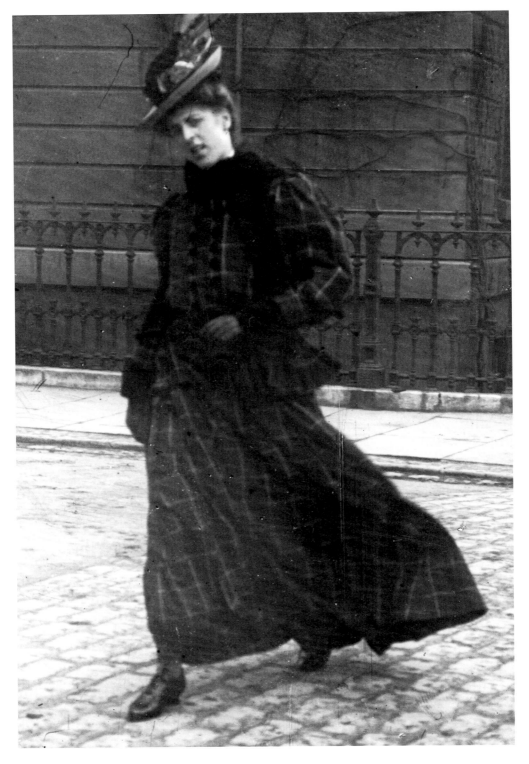

5.9 · CORNWALL GARDENS, LONDON, 1906
(*Royal Borough of Kensington and Chelsea Archives*)

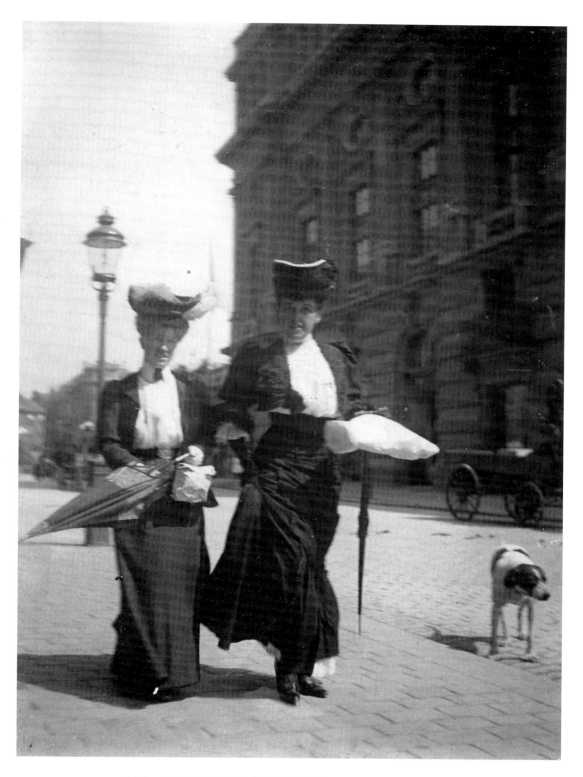

5.10 · STOCKHOLM, NEAR THE OPERA HOUSE, CA 1900
(*Stockholm City Museum*)

Besides the previously mentioned use of walking-sticks and umbrellas, many women are portrayed as walking with the skirts of their dresses held up by the hand to facilitate movement (figure 5.10). The advice literature of the time tried to establish the notion that the skirt held up with the elbow jutting out from the torso was unacceptable, and this rule may have been followed in more civilized situations, such as promenading or disembarking from a carriage, but in the more physically demanding practice of walking in the thoroughfares, this proscription seems to have been ignored. In the brief but busy films made by the Lumière company in Vienna in 1896, one might find several examples of how female pedestrians lifted their skirts while making their way through heavy traffic. A film showing the traffic on the Ringstrasse exhibits at least two individuals, one a middle-aged woman in a striped dress under a parasol looking quite distinguished, and the other a younger woman in a white blouse and black skirt. One does not need to study many photographs and film clips before realizing that it would have been quite impossible to walk in a late nineteenth-century city simply by raising the skirt at the front.

But how should this pose be interpreted? Is it anything other than a concession to necessity? A look at its inclusion in cartoons will elucidate the matter somewhat, but snapshot photography suggests that it was largely a matter of how relaxed and cheerful the situation was. Promenading women seldom allow themselves to make expansive movements. Respectable women in a hurry or on errands, however, move relatively unhindered or unmindful of manners. Their gestures are not, perhaps, as expansive as those of men generally, but if the situation requires swinging arms or raised skirts or large steps, then it is carried out, and such movements are often seen in the photos of Sambourne, Tryggelin, and Mayer.[13] Demonstrative, expansive poses are more easily found in private photos or photos in which the woman in front of the camera is acquainted with the photographer. There are, however, interesting exceptions. Sambourne captures some, and Tryggelin's output also manages to catch women of refinement in expansive poses, such as in the image of two women sharing a private moment on a bridge, one of them leaning effortlessly against the balustrade (figure 5.11).

It is evident that the akimbo pose in its most explicit form was still an ambiguous gesture by the turn of the twentieth century. Its use was spreading, perhaps, but it was still connected to very specific attitudes and situations, and was considered a faux pas in the most sophisticated contexts such as the promenade. But when we look at the media context of this age we see how the pose had very interesting connotations, allowing us to both understand why it was frowned upon and appreciate why, when it was performed, it was quite a big deal.

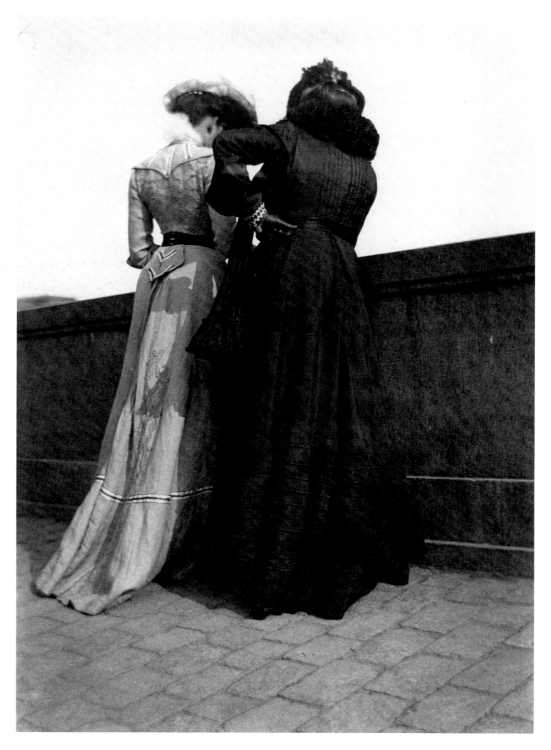

5.11 · STOCKHOLM, UNKNOWN LOCATION, CA 1900
(*Stockholm City Museum*)

The most important implication of the occurrence of the akimbo pose in so many different contexts is that it undermines the association that such body language had in the discourse of the period, and which thus has been formative of our perception of the period since then. It is difficult to find substantial collections of photographs of prostitutes from this early age. The best portrayals come from the American photographer E.J. Bellocq and, from a somewhat later period, the renowned French amateur photographer Eugène Atget.[14] These pictures corroborate somewhat the popular notion of the time that prostitutes acted more forthrightly than was acceptable for a respectable woman. An examination of early nude photography, however, would be even more unambiguous in connecting expansive body language in women with eroticism. The models for nude photos were often prostitutes, and the poses displayed in this genre exemplifies a ritualized body language shaped to accommodate male sexual fantasy.[15] Thus a study of nude photography would provide an insight into the secret corners of male sexual desire in a period when such things were hidden away, but it would probably not reflect a body language connected to everyday practice. The possible connection should not be dismissed, however, and as we compare the akimbo pose in street photography with its uses in illustration, we glimpse something of the interplay between female agency and male desire.

The most formulaic use of the akimbo pose in cartoon portrayals of women is the depiction of the working-class woman with an attitude, a type of figure that is something of a stock character in the satirical journals at the turn of the century. She crops up as either a maid or a waitress, or as a street woman or lower-class housewife, and the meaning of her pose depends to a large extent on her age. Regular *Punch* contributor Phil May was fond of drawing cockney women, and he appeared to have drawn his subjects from life, as suggested by a comparison of his cartoons with his preserved sketchbooks. One such sketchbook, now in the manuscript archive of Emory University in Atlanta, contains a number of drawings of impecunious women in akimbo poses.[16] May seems to have distilled his depiction of women to two basic stereotypes – one, the young Eliza Doolittle–type cockney girl, the other the coster woman, portrayed as stout and matronly (figure 5.12). The latter variety is shown in its purest form in the drawing entitled "The Language of Flower Girls," which jokingly has the line "Rude am I in my speech" from *Othello* accompanying the portrait of an extremely burly and masculine-looking woman, dressed in a long white apron, a cape and a straw hat with craggy wisps of hair jutting out from underneath (figure 5.13). Her face is virtually that of a man,

5.12 · SKETCHES OF COCKNEY WOMEN FROM THE SKETCHBOOK OF
PHIL MAY, CA 1896 (*Manuscript, Archives and Rare Book Library, Emory University*

5.13 · CARTOON BY PHIL MAY IN *PUNCH*, 1903 (*Lund University Library*)

5.14 · CARTOON IN *SÖNDAGS-NISSE*, 1897 (*Lund University Library*)

5.15 · CARTOON IN *KASPER*, 1896 (*Lund University Library*)

and her forearms are emphasized by the akimbo pose, making them look both dirty and strong.[17] May views the coster women that he most likely had observed himself in the London streets as deprived of the feminine delicacy that constituted an ideal in refined circles. Although his portrayal stems from direct observation, and the body language of the street women that he draws may correspond with what he saw, the pictures are coloured by his distanced perspective.

The depiction of the burly street woman is mainly conditioned by her age. Similar types of women are also seen in the pages of Swedish and German satirical journals. In some cases the London coster woman corresponds in characterization to the Stockholm working-class housewife, as in a cartoon from *Söndags-Nisse*, showing two worn and elderly women arguing in the street about whose husband is the worse drunkard (figure 5.14).[18] Here, the akimbo pose plays a role similar to that in the Phil May drawing, accentuating the burly and stout nature of the impecunious woman, rendering her as down to earth by means of the firm arm pose and wide-legged stance, but also as easily provoked and defiant in the confident pose that simultaneously wards off and eagerly awaits all attempts at insult. The German cartoons occasionally portray lower-class women, but seldom in the light-hearted and ebullient way that the English and Swedish examples do. When a matronly woman is shown, she is more

often a cook or a maid than a street seller, and the defiant pose of the Phil May "flower girl" changes somewhat in tone when the woman in this role is younger.[19] The nature of the stout and uglier woman is depicted as aggressive and pugnacious, as in case of the lower-class woman in the *Kasper* cartoon who dismisses another couple's attempt at gentility while that of her and her husband is equally feeble: "Well look at the Anderssons, trying to act like gentility! But they can't, cos they haven't got style like we!" (figure 5.15).[20]

The younger working woman is likewise often depicted in the akimbo pose, but she comes across in a different way. Her confidence and cockiness is more sexualized, and she is presented as a bit thick. In *Punch*, this type of woman is connected with the aforementioned stereotype of the cockney girl, and her body language exudes the carefree but stupid character that people like to sentimentalize in reference to the cockney.[21] Less locally associated is the maid character, who crops up with little variation in all three national contexts. In cartoons, she frequently has male suitors who come to her place of work to court her, while her mistress stands by, watching sternly. Time and again, her attitude toward both men and her female employers is expressed in an arrogant akimbo pose. Such is the case with the kitchen maid in a *Fliegende Blätter* cartoon, who is distracted by her enlisted suitor outside the window while her mistress calls to her from the other room. "I can't come, madam," she replies. "The fatherland

5.17 · CARTOON IN *SÖNDAGS-NISSE*, 1897 (*Lund University Library*)

beckons!" (figure 5.16).[22] The one-arm akimbo pose that she assumes is mirrored in a *Söndags-Nisse* cartoon in which a maid has been called into her mistress's parlour. The mistress sits in a chair reading a newspaper while the maid stands leaning on something with one arm akimbo in the foreground, demonstrating clearly to the viewer her brashness. "Does Lisa comprehend that we cannot have her fiancé here dining every night?" says the mistress. "Yes," replies the maid, "he has complained about it himself. Could I not send the food to him?" (figure 5.17).[23]

The humour in these depictions is premised on a stereotype of the sloppy and insubordinate servant, and the perspective is generally that of the employer's difficulty in getting servants to do their job properly. The maid figure can easily be replaced with a waitress in a restaurant or a receptionist in a cheap hotel, but the relationship between the servant and the patron is consistent.[24] The body language of the servant is employed here, then, in the communication of a comfortable household discourse

5.18 · CARTOON IN *FLIEGENDE BLÄTTER*, 1903

with a certain outlook on a specific class of people. But the akimbo pose was not used to depict servant women only, and it is the comparison of these caricatures with those that convey a more complex social picture that deepens their significance. Granted, the akimbo pose is often used in a formulaic fashion: several cartoons depict an akimbo-armed women merely to show that she is addressing someone, and the pose is often a device for representing a reaction to someone's comic line or the body language of someone who is saying something droll or sardonic.[25] But, in most cases, the female akimbo pose conveys something else too, something that hints at the cartoonist's view of female body language.

In several cartoons, the assertively posed woman is meant to be interpreted as a symbol of the unruly or modern woman. As previously mentioned, "emancipated" women were occasionally portrayed in deliberately male poses. A *Fliegende Blätter* illustration entitled "Inverted World" shows a woman in a one-arm-akimbo pose with a cigarette in her mouth gazing

5.19 · CARTOON IN *KASPER*, 1903
(*Lund University Library*)

at her husband, who sits in an armchair reading a newspaper, smoking as
well. "Well, I never!" exclaims the woman. "Do you also smoke, Eduard?"
(figure 5.18).[26] The illustration comments acerbically on the emerging fash-
ion for cigarette smoking among women, and in the process of depicting
the challenge of gender roles, portrays the woman in a pose that makes
her more manly and assertive than most depictions of women.[27] It should
be noted, however, that although I have little doubt this is how the read-
ers interpreted this cartoon, the akimbo pose was not uncommon in the
portrayal of women. As the initial reference to the film footage from Leeds
suggested, there were habitual female gestures that were quite reminiscent
of akimbo, and a non-akimbo pose could easily transcend into an akimbo

pose. This is especially the case with various skirt-holding poses, which make a respectable woman appear slightly flirtatious, and when a woman holds her skirt so that it is raised just a bit too much above the ground, revealing the boot, then it is a clear sign of raunchiness (figure 5.19).[28]

This raunchiness is embraced by the generally male perspective represented by the satirical journals, but is it just a male fantasy? In some instances, the representation of an akimbo-posed woman seems not to be expressly sexual, but simply shows her to be arrogant or assertive. It has been suggested by some historians that representations of women with assertive body language in this period were meant to portray them as unfeminine. The performances of female entertainers have especially been used to support this claim.[29] In some cartoons, the conduct of assertive women is certainly viewed as masculine, but in most examples there is little to suggest that this was the association the cartoonists primarily wanted to bring to the fore. Just as when the skirt-holding pose turns into an assertive akimbo arm position, there are numerous pictures of women lounging on park benches or in sofas, their hands resting decoratively but self-confidently, and often with akimbo poses.[30] A good example of a skirt-holding pose that becomes a sort of excuse for an akimbo pose is a *Punch* cartoon of an aristocratically dressed lady talking to a peasant woman.[31] There is nothing in this picture to suggest that the akimbo pose is anything special, other than that the lady is posed as a listener and the peasant woman, with her outstretched hand, is posed as a talker (figure 5.20). In cartoons deriding the fashionable new pastime of cycling, female cyclists are often depicted as brash and assertive, generally posing akimbo. Illustrations from both *Punch* and *Simplicissimus* show them leaning languidly on their bicycles, and they treat the men they are addressing arrogantly and derogatorily, but the joke is usually on the women – as in the *Simplicissimus* cartoon in which two female cyclists haughtily ask a road worker why the road surface is so uneven, and he replies that it is on order from the authorities to prevent people from cycling too fast through the province (figure 5.21).[32]

The representation of the two cyclists in this picture exaggerates their poses, one of them leaning listlessly on her vehicle, the other raising her head while addressing the man and standing in a broad-legged stance with her arms akimbo. The portrayal of female cyclists is seldom less than derisive, but the association of their pastime with assertive body language shows how the phenomenon was intimately linked to female aspirations of independence and confidence.[33] It is clear, then, that assertive body language was used in the portrayal of women who wished to claim an independent identity, but how synonymous were the body language and the various identities of the turn-of-the-century period labelled as the New

5.20 · CARTOON IN *PUNCH*, 1907
(*Lund University Library*)

Woman? As mentioned in the previous chapter, labels such as the New Wo-
man or the earlier Girl of the Period were created in journalistic discourse
to apply to a social movement that was perceived from a certain perspec-
tive. The labels' correspondence with everyday practice and subcultures
was weak. Such terms would at best carry an association for those who
encountered these phenomena in the press rather than in real life. Those
who have studied the occurrence of these labels have mainly noted the
opposition they met with in hegemonic discourse. In an article on the
New Woman, for instance, Susan Shapiro has shown how this stereotype
was portrayed in *Punch* as masculine, the joke often being that she was
mistaken for a man.[34] This is a telling observation on the strict gender

5.21 · CARTOON IN *SIMPLICISSIMUS*, 1897
(*Lund University Library*)

divisions of the period, but a narrow focus on the most striking expressions of derision tends to bias the picture. The New Woman could, as Shapiro asserts, be portrayed as masculine in cartoons, but oftentimes she was not, her "newness" expressed only by the cartoon's caption while she was otherwise represented in orthodox fashion.[35]

The main point to be made, then, is that some categories of women were depicted with assertive body language as a way of demonstrating and mocking their inappropriate breach of convention, but the assertive body language was also used to portray women who were well within the boundaries of the norms. Assertive female body language was not as unacceptable as might be expected. But, of course, this also had to do with who you were. The New Woman movement was essentially a phenomenon emerging from well-off sections of society, which might account for the inconsistency in the mockery of it. When it came to the assertive body language of the lower classes, however, the satirical journals were generally much more ruthless. This is hardly surprising, given their familiar outlook and the readership they were directed toward, but they were also often keen to provide a liberal and uncomfortable view of society, and many of their cartoonists tried to get up close to the people they caricatured. This means that some cartoons may give us a glimpse of social behaviour that has left few traces elsewhere.

As mentioned, the akimbo pose is often used in portrayals of women who are not meant to be perceived as deviant or unusual (see note 35). This fact blurs the issue when it comes to connecting the akimbo pose with representations of women perceived as masculine or unrespectable. When a cartoonist wanted to draw a rude or indecent woman, he habitually used assertive body language to convey her brash and expansive conduct. A good example is a picture by Thomas Theodor Heine in an 1898 issue of *Simplicissimus*, in which a "Professor of national economics" stands in the street lecturing a prostitute: "You have chosen a difficult and dangerous occupation, young lady!" (figure 5.22). The woman stands in a pose reminiscent of some of the poses of cockney women in *Punch*, her hands down to her knuckles in the pockets of her jacket, giving her an akimbo-style pose, and her legs planted wide apart, while a man – presumably meant to be her pimp – stands in a similarly cocky pose behind her. The most striking feature in this woman is her face, which is pale and skull-like, the sunken eyes framed with dark circles.[36] The elements of her pose are in themselves not intimately linked with the body language of the prostitute. The akimbo pose wherein the hands are half-hidden in pockets is also seen in depictions of respectable women.[37] Women standing with their legs apart is also not uncommon. The difference lies in the fact that respectable or "normal" women *could* assume assertive poses, but often

5.22 · CARTOON IN *SIMPLICISSIMUS*, 1898
(*Lund University Library*)

did not, whereas women who deviated from the norm, either by dressing or acting in a "modern" way, or by coming from a rough social background, were almost always shown in assertive poses. In cartoons, the stereotypes bred by the artists were in constant conflict with the realities that the artists sometimes wanted to portray. If we were to peel off the outer layer of cartoon conventions and stock characters that the cartoonists' work was steeped in, then we would see a continuum of assertive female body language across class boundaries. This continuum acquired the prejudiced association of different poses with different classes, but the pattern is broken often enough for us to see that the realities observed by the cartoonists and the conventions they fitted their drawings into differed from each other.

STRIKING THE AKIMBO POSE

Juxtaposing the cartoons with the photographs shows, then, how the akimbo and similar poses were widespread across the social scale, but in some discourses became associated with the lower classes or with the self-assertion of the New Woman and similar stereotypes. We see from some photographs that women would pose akimbo in situations that demanded a display of confidence. This is especially apparent from the encounter of lower-class women with the street photographer, suggesting that certain tenets of assertive self-presentation were current among groups of women in urban contexts who lived labouring or impecunious lives. But the evidence also suggests the occurrence of the same body language higher up the social scale. So should we instead consider the akimbo pose and the attitudes it conveyed as a body language that communicated a completely different identification? For example, many of the images we have considered represent young women in both well-off and impecunious social contexts. Upper middle-aged women posing akimbo are almost always either coster women or cooks. Images of older wealthy women posing akimbo are rare. In cartoons we might ascribe this to a need to get across their diminished freedom of movement in ways that are clear to the viewer, but it seems that the cartoonists also picked up on a widespread predilection for assertive poses among young women of the time. Female akimbo poses among the well-off are more easily seen in snapshot photography or in artists' sketchbooks, suggesting that the freer body language the pose was part of was strictly reserved for certain situations.[38]

The popular culture of the late nineteenth century increasingly presented female characters defined by an expansive body language. The emergence of the cancan dance in Paris is perhaps the most famous example. The dance first cropped up in the 1830s, but it was not until the

1880s and '90s that it was performed as a stage entertainment by scantily clad women.[39] In England, the stage stereotype of the flirtatious woman is closely associated with the song "Ta-ra-ra-boom-de-ay," made popular by music-hall entertainer Lottie Collins in 1891. The lyrics are put in the mouth of a girl who claims to be "fond of fun" and "Just the kind you'd like to hold / just the kind for sport I'm told." This was long seen by historians as a symptom of the "Naughty Nineties," a period of relative sexual liberation in the Victorian period, but has since been reinterpreted as only superficially liberal, simultaneously reinforcing a controlled feminine sexuality, as expressed by the lines "I'm not too young, I'm not too old / not too timid, not too bold," which balances the flirting with restraint.[40] It has also been noted, however, that less famous versions sung in smaller or seedier music-hall theatres were much more forthright, both in performance and lyrics.[41] Similarly, the popular Swedish music-hall singer Anna Hofmann was famous for songs crammed with *double entendres* while staying within the boundaries of decorum. Hofmann's routines were based on a number of established stage stereotypes, including the rude girl, the poor woman, and male impersonation.[42] Hofmann also sang a number entitled "Fröken Chic" ("Miss Chic"), which was an adaptation of the song "Die Gigerkönigin," made popular by Austrian variety singer Paula Menotti. Judging from the cover of the sheet music for "Die Gigerlkönigin," performing this song required the singer not to dress up as a man so much as to dress provocatively, in much the same manner as Lottie Collins did when performing her hit.[43]

The existence of such popular entertainments is not evidence of similar liberal female conduct in everyday life, but it is indicative of a culture of female conduct that these songs inspired and were inspired by. Such conduct is, unfortunately, available to us only in the outraged reactions they provoked in the press. The descriptions included in such reactions will be recounted and analysed in chapter 8. For now, we will content ourselves by noting the contemporary connotations of the body language described here, which referenced both eroticism and gender transgression. The former aspect is demonstrated by the popular songs mentioned above. Another cultural form that might be connected to this is the aforementioned phenomenon of pornographic pictures. However, the representations of nude women in such images more often made visual references to classical art than to modern cultures of licentiousness.[44] It seems, then, that not even in the culture of erotic imagery, which was often directed toward a well-off audience that could probably appreciate the fine-art connection, was the expansive female body language fully acceptable. A possible explanation for this is the supposed submissive position that the depicted women were meant to take, but on the other hand there are numerous

contemporary descriptions of the body language of street women being decidedly licentious and forthright.[45]

There is also a vital difference between the types of women whose lifestyles or work demanded a more expansive body language, and so influenced their body language when they paused from work. Among the photographs of Emil Mayer, Per Bagge, and Samuel Coulthurst, for instance, we find several working women caught in the midst of labour, whether erecting a market stall or carrying out buckets of waste to the garbage man, and these chores force them to behave differently from the ideal delicate maiden.[46] There is a vital difference, then, between those who pose akimbo because it is a natural part of their otherwise expansive and agile body language and those who pose akimbo as a conscious self-presentation. To the latter category we might of course assign women from any walk of life, but the labour of women lower down the social scale makes it more interesting to look at the poses of women who would presumably have been part of different subcultures. Looking at the evidence from the sources, the self-conscious performative akimbo pose is connected to situations of portraiture or male-female confrontation. This would suggest that the perception of the akimbo pose in such situations was quite different from the corresponding stance among matronly working women, who were often perceived as masculine.

The connection between the akimbo pose and the long dresses that were commonplace in the nineteenth and early twentieth centuries is an indication that the expansiveness of the gesture was both suppressed by discursive codes of conduct for women and subversively performed through gestures and poses that disguised this expansiveness as a concession to the nature of their clothing. Some instances of respectable women lifting up their hems are in reality akimbo poses. A study of cartoons from the 1900s and 1910s shows that women are depicted in much the same way until roughly the First World War, when jokes referring to the work of women on the home front portray them – derisively, of course – as more masculine and expansive in their body language. However, during this same period, changing fashions also contributed to a change in the poses of women that was not overtly mocked. For instance, in *Punch* cartoons from the last years of the 1910s the portrayal of women had definitely changed, even though the conventions of the nineteenth century lingered on until at least about 1910. From cartoons and commercial illustrations in the 1910s and 1920s, we see that the scope for akimbo and similar poses was considerably greater, even though skirts became shorter. Nevertheless, the skirt-holding poses of the 1890s and 1900s were crucial precursors to the sexualized and expansive body language of the twentieth-century female media image.

The most systematic documentation of women with a generally assertive body language is found in the photographs of Linley Sambourne and Emil Mayer, the former catching young women employed in urban types of work, whom he often labelled as "shopgirls," and the latter photographing young women who had moved into Vienna to work as servants, congregating in the Prater and outside dance halls.[47] The conclusions that may be drawn from this body of evidence indicate that certain more independent ways of life, especially in urban areas, fostered a more expansive body language, but also that this type of body language may have emerged from a situation of sexual exposure or vulnerability as much as from a sense of confidence. The display of confidence can be interpreted as a backstage behaviour when seen in all-female groups, for instance, and a relaxed attitude may well have characterized these women's conduct, but photographs such as Sambourne's especially indicate that these women also needed to make use of confident body language to answer or defy the ever-present male gaze. Whether this gaze was the main trigger for this expansiveness or not, the evolution of a separate – and perhaps predominantly nonverbal – female subculture of behaviour, and a tactical appropriation of the external aspects of female appearance, is detectable in the pictorial evidence.

6

Case Study 4

THE WAISTCOAT POSE

⇥ WE RETURN TO THE AGRICULTURAL FAIR in Leeds that we have visited before. In another section of the film, we see a group of men strolling around the area, moving toward the camera. Three of the men walk along inconspicuously, laughing at some unknown joke while their attention is directed toward the fourth man, on the far left (figure 6.1). He appears to be at the centre of attention, and he likes it. He smiles broadly and victoriously – perhaps he has just made a favourable purchase – and has a big cigar between his teeth. He is holding a walking-stick in one hand, but he is not leaning on it. Instead he holds both hands raised to his chest and the thumbs stuck into the armholes of his waistcoat. He does not change this position of the hands in the entire time he is seen. It is as if this pose is the clearest expression of his state of mind.[1]

This man's conduct corresponds with that of another man, filmed the year after, in 1903, but several miles away in London (figure 6.2). It is a Sunday morning in Petticoat Lane, and the used-clothes market is in full swing. The camera pans across the thronged street from a tripod, and as the people become aware of being in its view they immediately adjust their behaviour, becoming noticeably self-conscious. The hawkers' gestures become exaggerated and showy, children flock in front of the camera, and virtually no one who passes can avoid peering into the lens or pulling some sort of face in response to the unusual situation. But the man who is of interest to us is at first quite inconspicuous. He appears about thirty seconds into the film, standing still in the corner of the frame. He is wearing a neat, flat cap, a moustache barely visible in the poor quality of

6.1 · STILL FROM FOOTAGE MADE AT THE GREAT YORKSHIRE SHOW
IN LEEDS, 1902 (*courtesy of the British Film Institute*)

the footage, a pipe clenched between his teeth, and a neckerchief. There
is nothing special about this getup among the cockney men of Edward-
ian east London, but the interesting thing is that he appears again a few
seconds later, when the camera is filming another section of the market.
Then he is standing there in the exact same pose, all ready for his close-up
when the camera pans past him. And the same thing happens again. And
again. This man seems hell bent on being caught by the camera, and he
deals with it as if he were being photographed for a portrait, standing
completely still in a carefully arranged pose. (Meanwhile, the same ges-
ture is made by others, such as the man to his left in the upper frame and
the one circled in the lower frame.[2])

The pose is interesting. He grabs the lapels of his jacket firmly, the hands
high up so as to be visible on film. Judging by his immobility, he is posing
as if for a portrait, and yet this explicit pose is very rare in studio por-
traits. It would be easy to dismiss this man as slightly eccentric, if it were
not for the fact that several other men in the film assume the same pose.
These men do not reappear as much as the first man, but their posing is
highly conscious: they stand still, looking straight into the camera. Some
of them grab their lapels in the same way as the first man, but others

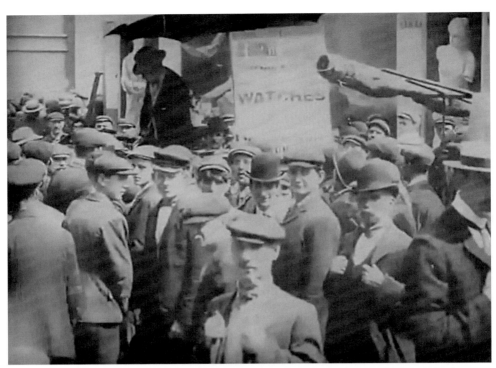

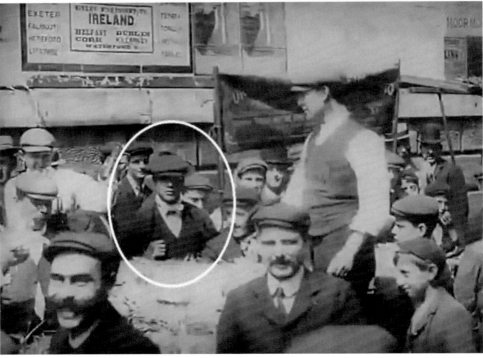

6.2 · STILLS FROM THE FILM *PETTICOAT LANE*, 1903
(*courtesy of the British Film Institute*)

adopt the same method as the man in Leeds, with thumbs hooked into their waistcoats.

The poses that we see in these films make up perhaps some of the clearest examples of poses that today appear outdated but were very common in the late nineteenth and early twentieth centuries. For reasons of clothing, this group of poses is limited to male performance, of course, and the placement of hands high up on the body is paralleled only by the akimbo pose in female body language. Around the turn of the twentieth century, riding jackets and similar items of clothing became popular among women, but I have not been able to find examples of women performing the lapel-grabbing pose. In the first half of the twentieth century, this pose and its connotations seem to have been increasingly evoked stereotypes connected to the "Old World" of the *belle époque*, and the pose was eventually used in parodies of cockney characters or pompous industrialists. There are signs that this parodic association stems from the period of its most affluent popularity, as we will see, but the films show that – in some circles at least – it was also popular as sincere self-presentation. The question is, of course, what men who performed this pose wanted to communicate by it.

The introduction of the waistcoat and overcoat into Western men's clothing dates to the early seventeenth century, when the first prototypes of what would become the three-piece suit came into fashion. However, the cut of these garments differed so much from their nineteenth-century counterparts that it is doubtful whether they encouraged the type of body language that we see in the modern period.[3] In portraits and caricatures from the seventeenth and eighteenth centuries, the high-handed poses are absent, and thumbs more often hooked in waistcoat pockets – a gesture that seems to have been associated with unreliable characters. It seems that the straight line of the coat, as opposed to the angled line with a prominent lapel that emerged in the nineteenth century, together with the relative inaccessibility of the waistcoat that resulted, effectively made the waistcoat-type pose unnatural. One reason for its eventual emergence, then, is partly to be found in the evolving cut of men's clothing, but although poses of this type may have been possible in many different periods, we need to find out what it meant in this particular period. Obscure traces of the emergence and reception of the pose can be detected, for instance in William Henry Merle's 1838 autobiographical novel of political intrigue at the turn of the nineteenth century, *Melton de Mowbray*, in which the statesman Charles Fox's manner is described as "inelegant; nay, he frequently indulged in the profane habit of poking his hands into his breeches or waistcoat pocket, and still more often committed the other vulgarity of thrusting his thumbs into the arm-holes of his waistcoat."[4] Journalists also

made use of this characterization, as in a piece deriding the latest fashions in which the writer observes various vulgar types at a ball, including a "haberdasher's apprentice" who is "bowing and smirking to a customer" and whose "favourite attitude" consists of having "his thumbs stuck in the arm-holes of his waistcoat."[5]

The perception of this pose is complex, however, as the vulgarity perceived in it is often coupled with positive qualities. In Frederick Marryat's short story "The Pirate," first published in 1836, a sea captain described as a "great personage" is first seen on deck, where "he walked with his coat flying open, his thumbs stuck into the arm-holes of his waistcoat, so as to throw his shoulders back and increase his horizontal dimensions. He also held his head well aft, which threw his chest and stomach well forward. He was the prototype of pomposity and good nature, and he strutted like an actor in a procession." The images here combine a sense of theatricality and affectation with dignity and heroism. Another Victorian writer who captured this pose was Charles Dickens, who describes it in at least two of his novels: *Great Expectations* and the unfinished *The Mystery of Edwin Drood*. In the former novel, a version is used in the portrayal of Herbert Pocket, who puts his thumbs in his waistcoat pockets as he boasts about the business affairs he plans to undertake in the West Indies. In *Edwin Drood*, we first encounter the conceited auctioneer Mr Sapsea as he paces his room "with his thumbs in the arm-holes of his waistcoat."[6] Dickens seems to connect this type of body language with greed or the pursuit of profit, and it is used in the descriptions of similar characters in fiction from other countries as well. German writer Fritz Reuter unflatteringly portrays the restaurateur Mr Kunst in his 1866 novel *Dörchläuchting* as a red-faced man "who had the custom of peering at people from below and wandering like the pendulum of a clock back and forth in his restaurant with his thumbs stuck into the arm-holes of his waistcoat."[7] The character is quite Dickensian in the delusions of grandeur that contrast with the small-mindedness of the man. Thomas Mann, in his 1901 novel *Buddenbrooks*, also allows the greedy banker Mr Kesselmeyer to "stick his thumbs in the armholes of his waistcoat while playing piano with his fingers on his shoulders."[8]

The pose continues to crop up in fiction from the early twentieth century. In the emerging Swedish workers' literature, it was especially apt as a tool for quickly establishing the figure of a fat and greedy capitalist, and perhaps became more of a caricature than a mirror of reality. By the 1940s, Nobel Prize winner Harry Martinson was one who aired the close affinity between the country squire and the thumbs in the waistcoat.[9] In one of Sigfrid Siwertz's late novels, in which reminiscences of the early twentieth century play a vital part, a comic actor who laments the latest

fashion of the two-piece suit exclaims: "How the hell do you want me to play farce without a waistcoat with armholes to stick my thumbs in!"[10] In silent films, the pose could also be a practical way of conveying the untrustworthiness of a character.[11] It appears, then, that this pose, being so assertive and forthright, quickly turned into a good way of establishing exaggerated characters, both in literature and on stage, at the same time as it was common in everyday practice. As the film examples reveal, the pose could also be associated with men from seemingly various social backgrounds, suggesting a socially transcendent dimension.

THE OCCURRENCE OF THE POSE IN STREET PHOTOGRAPHY AND FILMS

It is Sunday in the Rathbone Market area of the Canning Town district of east London. The year is 1906. A long row of carriages have been filled with excited young women dressed up for a day in the countryside. Arranged countryside outings for the children of the impecunious was a common ingredient in the charity work implemented in the slums of the metropolis. The organization behind this initiative is not apparent from the photograph, but judging from the people in the carriages the outing is reserved for young girls, while the male population of the area is left standing on the pavement (figure 6.3).[12] Just in front of the first carriage a group of young men and women have gathered, and it is difficult to say whether they have assembled out of curiosity about the excursion or because there is a photographer documenting the event. Whatever the case, the four boys who occupy the front of the group pose very consciously for the camera. The short one on the right, standing next to a woman holding a small child, has his hands deep in his trouser pockets, and the contrapposto position is assertive and cocky. To his right, three other boys pose with one or both hands grasping the lapels of their jackets. The purpose of these conscious poses seems to be to project toughness or arrogance, considering the way they look into the camera, one of them peering with his face slightly turned, another looking straight at the lens with his upper body bent slightly backward. The way the pose is performed, then, leads the viewer to interpret it similarly to the slouching pose of the boy on the right.

But in other pictures the same pose is used to convey something wholly different. The images we have examined so far show men who are fully aware of being caught on camera, and who have presumably altered their behaviour accordingly. This might lead us to think that the waistcoat pose was used only in such situations, but evidence from street photography suggests otherwise. Several men in the Lund photographs of Per Bagge,

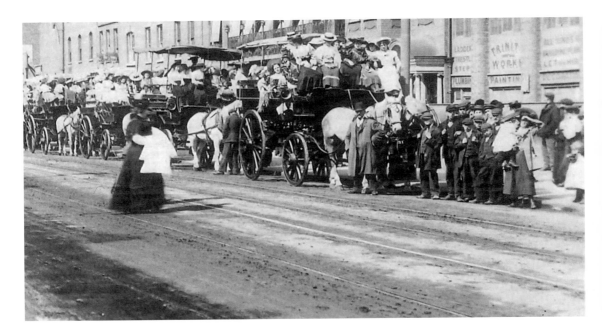

6.3 · CANNING TOWN, LONDON, 1906
(*with kind permission of Brian Girling*)

for instance, hook their thumbs in the armholes of their waistcoats when clearly unaware of the presence of a camera. In a picture showing men in a cattle market, a man wearing a peaked cap and strutting about looking like some sort of official has his thumbs hooked in this way while the rest of his fingers rest on the front of his waistcoat (figure 6.4). In a picture from another market square in the same town, we can see in the distance a man, dressed as a labourer, standing in the middle of the commotion looking about himself with his hands on his waistcoat in the same manner. Around him are other idle men strolling about between the stalls and glancing at the goods and the people. Most have their hands behind their backs, and it seems that, in this situation, the waistcoat pose shares a function with the hands-behind-the-back pose in that it signals idleness and staves off involvement in the business going on in the immediate surroundings (figure 6.5).

This use of the pose is akin to some of the uses of the walking-stick pose as a way of retaining dignity in moments of immobility. It signals a temporary ritual state at the same time as it is performative, and it appears in two types of contexts: when men stand still and look about themselves or into a camera, and when they stroll at a temperate pace. The two initial film examples illustrate this, as do many other Mitchell and Kenyon films. In their *Panoramic View of Morecambe Sea Front*, from 1901, at least

6.4 · CATTLE MARKET, LUND, 1896
(*Lund University Library*)

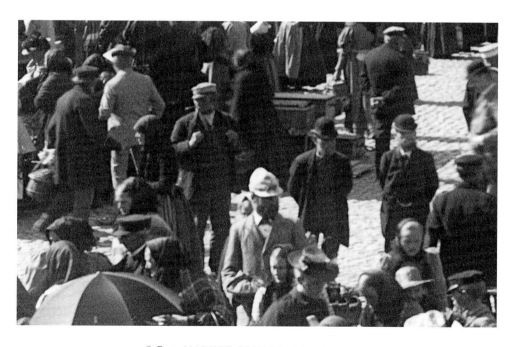

6.5 · MARKET SQUARE, LUND, 1890S
(*Lund University Library*)

three men display this pose. One is a cab driver waiting for customers and posing by the side of the road as the camera sweeps past on a tram (figure 6.6). Another is an elderly man with a long white beard strolling slowly along the promenade in the company of a woman (figure 6.7). The actions of these two men correspond somewhat to those of the two men described at the beginning of this chapter: one standing, the other strolling. The standing man might be compared to other standing men who are seen in the same footage. In the Morecambe film, we see several other cab drivers as well as other men and women who have taken their position on the promenade waiting for the camera to go by and take their picture. They assume a variety of poses. Some men hold their arms akimbo, others have one hand in a trouser pocket. Some have their hands behind their back, and others just let their arms hang at their sides. Are all these poses interchangeable? Do they mean roughly the same thing? Yes and no. This conscious posing behaviour is visible in the Petticoat Lane film as well, and there the poses – being caught close up – can be studied alongside facial expressions and other minute details of behaviour. This allows us to discern between, on the one hand, men who make distinctive poses consciously and with the intention of performing an expansive role, for the sake of appearing masculine or self-contained in the film, and, on the other hand, men who barely pose at all, either because they are surprised by the camera or because their conscious performance involves a restrained body language, similar to the "rigid frontality" of portrait photography.

What this suggests is that the poses differ in the message they are designed to send out, whether contact-seeking and frivolous, or dismissive and aggressive. The waistcoat pose certainly belongs to the former category, but as it frequently appears in situations together with the other category, the two must be related. Therefore, it is possible that the waistcoat pose also communicated some form of subcultural pride, a way of demonstrating a collective identity to the outside viewer represented by the photographer. And although the waistcoat pose is often accompanied by a smiling face, the performance that makes use of it has an assertively masculine aspect to it. Such, at least, is the case with the cigar-smoking man in Leeds, the group of boys in Canning Town, and some of the men in the Petticoat Lane film.

But then there are the other uses of this pose, exemplified by the strolling old man in Morecambe and the idle man in the market in Lund. Here the affinity with the walking-stick pose is perhaps most distinct, and it might be seen as a method of signalling the same things but without the advantage of possessing a walking-stick. This is at least the impression one gets by comparing the similar situations and locations of these two poses. But the body language is certainly very different, and it has none of the

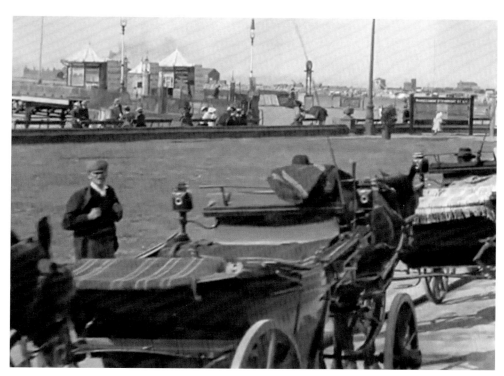

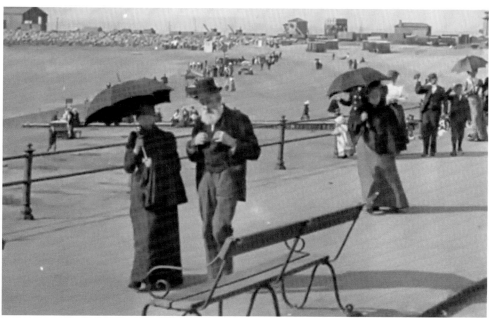

6.6 AND 6.7 · STILLS FROM THE FILM
PANORAMIC VIEW OF MORECAMBE SEA FRONT, 1901
(*courtesy of the British Film Institute*)

aspirations toward elegance that define the walking-stick pose. It comes across as decorous but desexualized, magisterial but slightly more comical than dignified. This is, of course, a constructed reaction that stems from the way the pose was represented in fiction, such as the novels mentioned earlier. In retrospect, it is easier for us to understand the mockery than that which was mocked, but of course the old man on the promenade is not consciously being silly. His self-presentation rests on an ambition to convey the respectability of old age and experience, the same message that his beard is meant to get across. The cultivation of the beard among late nineteenth-century men was often coupled in printed discourse with words such as strength, manliness, dignity, decision, and sternness, thus expressing contemporary ideals. The popularity of beards in Victorian England was widespread and transcended divisions of class, suggesting that large sections of society embraced the ideal of manliness and hard work.[13] Similar preconceptions seem to support the waistcoat pose, and although it is not only elderly men who perform it, its logic may derive from a will to be taken seriously or to be seen as superior to people in one's surroundings. Its occurrence in fiction supports this, and the frequency of its derision in novels may be taken as a sign of the pose's popularity just as much as of the scorn it provoked.

Thus, the waistcoat pose can be interpreted as a socially acceptable version of beating one's breast. The hands are held high, signalling alertness and a readiness to act, and for someone who wants to be associated with thrift and labour it is consequently more suitable than the walking-stick pose, in which the low and slumped position of the hands signals idleness and leisure. What is noteworthy is also the relative frequency of the pose in English photographs compared to Swedish and Austrian. Swedish examples can be found, and descriptions of the pose exist in both Swedish and German-language literature of the period, but the pose is exceedingly rare in German and Austrian photographic material.

Another side to the waistcoat pose is less self-presentational and more about being routinely self-conscious without having a distinct role to play. Most men in public view seem to have felt a need to dispose of their hands in some way, and those without a walking-stick put their hands behind their backs, on their hips, or in their pockets. And there were of course numerous ways of putting one's hands in one's pockets in the turn-of-the-century world. Trouser pockets will be dealt with in the next chapter, but waistcoat pockets encouraged gestures of their own, and there were different ways of putting the hands in the trouser pockets. Photographs of street scenes or other public areas where a group of people have assembled, curious about the event, often demonstrate the need to do something with one's hands when posing for a photograph. Here they cannot rely on

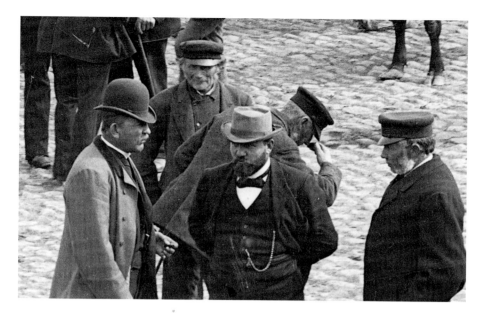

6.8 · CATTLE MARKET, LUND, 1896
(*Lund University Library*)

the suggestions of a portrait photographer and so appear somewhat awkward. Some men put a casual hand on the hip, as if this is the quickest way of looking dignified when suddenly being photographed. Others put their hands in the trouser pockets, but not thrusting them deep down so as to look sloppy or aggressive, but unless the man is exceedingly relaxed or with a group of acquaintances, he will only put the hands down to his knuckles, the gesture being just as much about brushing aside the coat as disposing of the hands. The pulling-back of the overcoat is a not uncommon pose in this period, and the most conspicuous version of it is to put both arms behind the back but underneath the overcoat, thus lifting it slightly, as exemplified by a man in a Bagge photograph (figure 6.8). Some men hook their thumbs in the trouser or waistcoat pockets. It is a pose somewhere between the armhole-hooking and the hands-thrust-in-trouser-pockets pose, looking more youthful than dignified.

These observations show how many men were unwilling to be caught on camera without posing their hands appropriately, generally by raising one or both arms a little, to avoid the standing-to-attention pose that was so derided. Portrait photographers admonished, as we have seen, hanging or idle hands, and although it is tempting to interpret this tendency as a consequence of the influence of photography, it can be seen in earlier times as well. The development of the male suit coincided with emergent notions of dignity and character, creating opportunities for the embodiment of

The Waistcoat Pose 173

such ideals in everyday practice. Some men avoided the waistcoat pose, perhaps because that would make it too obvious that they were posing, and it seems that while the waistcoat pose was widely disseminated, it was also seen as a bit too conspicuous. The higher the hands were placed on the body, the clearer the aspirations toward looking dignified and grand, and thereby the more vulnerable one was to mockery.

THE OCCURRENCE OF THE POSE IN CARICATURE

The waistcoat pose is used in *Punch* with considerable frequency from roughly the mid-nineteenth century until around 1910. It is still seen occasionally in the 1910s, and was probably an adequate way of portraying a certain type of character as long as the waistcoat was in common usage. As a similar pose sometimes makes use of the jacket lapels instead of the waistcoat armholes, it had the potential to remain common until the second half of the twentieth century and the waning of the male suit's hegemony, but for some reason it loses its ubiquity during the First World War, after which it is referenced only occasionally in parodical contexts. Until then, however, it was a common way of depicting a man who was meant to be perceived as pompous or superior. But was the usage of the pose more complex then than it was to become?

In *Punch*, the waistcoat pose is most prominently used in the portrayal of superior or inflated gentlemen, or of cockneys being cheeky or insolent. In the former case, the mockery is directed at stuck-up older men who act superior but display stupidity, as in the cartoon entitled "What our artist has to put up with," in which a "Major Blunderbore" tells "Our Artist" a joke and asks why he does not laugh at it. "Because I told it you myself only last week – and *you* didn't laugh!" (figure 6.9).[14] In this picture, Major Blunderbore has an arrogant look that goes well with his hand pose and broad-legged stance, while the younger man imitates his pose but with an air of revenge rather than pride. Similar images of stuffy old men in club interiors fill the pages of *Punch* in this period, presumably making up good illustrations to which the writers could later add a humorous piece of dialogue. This stock character is in some forms a forerunner to the early twentieth-century caricature of the conservative old army man who refuses to give in to change, personified in the 1930s by the English cartoon character "Colonel Blimp."[15] *Punch* was a conservative magazine, and though the satire here is directed at men of age or conservative opinions, a look at similar cartoons shows that the humour derives from the bloated demeanour rather than a certain type.[16] The satirical gaze of *Punch* was directed at any person who acted haughtily or who involuntarily revealed stupidity while trying to appear superior. The cardinal sin was "overacting," simply

6.9 AND 6.10 · CARTOONS IN *PUNCH*, 1896
(*Lund University Library*)

because an inflated confidence could easily be punctured. Thus it shared a discourse of conduct reflected in much advice literature of the time.

That the waistcoat pose was associated with various types of men is illustrated by its quite frequent use in the representation of cockneys, especially in the *Punch* cartoons of Phil May. The 1896 cartoon entitled "The Anchor's Weighed" shows a pompous, whiskered man, his hat pushed back to the neck, who has positioned himself in the middle of a crowd of boat passengers to announce that the anchor has been weighed. The picture bears the subtitle "Sketched on an Excursion Steamer" and might have been drawn after a sketch made on the spot by May (figure 6.10). The mention of an excursion steamer would have signalled to contemporary readers what sort of people this drawing makes fun of, namely lower-class people unable to afford any other weekend excursion than a cheap and, apparently, overcrowded boat ride down a river or along a coastline. This is a typical example of lampooning the pastimes of the majority, an activity that the media still perform expertly. As we have seen earlier, Phil

May's cockney caricatures could be quite cruel, and there is no doubt that images like his contributed to the creation of a stereotype that started to live its own life in the popular culture. As other drawings of cockneys show, the representations contained certain key elements such as a kerchief tied around the neck and bell-bottomed trousers, but as will become clear in the next chapter, the popular image of the cockney was different from stereotypes of the rough impecunious male in other countries. The main difference was in the body language used to portray them. The cockney is often seen affecting pompous and superior poses, such as the waistcoat pose. The tramps of Albert Engström, to name a comparable stereotype from a different context, are often shown in similar attitudes, being cocky and insolent, but their poses are always slumped and they invariably use their trouser pockets to emphasize their social background. The stage version of this English stereotype was the music-hall cockney or coster character, portrayed by such renowned performers as Albert Chevalier and Alec Hurley, both of whom tended to be shown in the waistcoat pose when portrayed in their stage personas.

The connotations of the pose were complex, then, and when we look at caricatures from other countries, the connection to stereotypes is different. In the satirical journals from German-speaking countries, the waistcoat pose is conspicuously absent. It can be seen now and then, and as it occurred in German fiction of the time it seems to have had similar basic connotations as in England, but its rarity in cartoons might mean that it never acquired a strong connection with any continuous stereotype in the caricatures. In general, the posing of male characters in the drawings incline more toward akimbo poses or trouser-pocket poses. The body language is both more naturalistic and more extreme, as in a tramp slouching excessively while a man of refinement gestures elegantly, at the same time as more grim and grotesque aspects are accentuated. The pose does occur, of course, in the portrayal of a greedy Jewish moneylender in *Simplicissimus*, but it also appears in the picture of an aristocratic gentleman in *Fliegende Blätter*.[17] There is little consistency in the use of the pose, then, apart from a slight indication that it was associated with capitalist stereotypes.

This association existed, as we have seen, in Swedish fiction, but seems to have gained ground only in the first decades of the twentieth century, perhaps as part of a clichéd view of the *fin-de-siècle* past. The use of the waistcoat pose in Swedish cartoons from the late nineteenth century is not as rare as in Germany, but it is more consistent. It is seen in the portrayal of exceedingly stereotypical fat businessmen, like the one sitting in a railway compartment in a 1903 issue of *Kasper*. Here the presence of the cigar, thick watch chain, greasy moustache and round belly all go together

6.11 AND 6.12 · CARTOONS IN *KASPER*, 1903 (*left*) AND 1895 (*right*)
(*Lund University Library*)

to create a perfect stereotype (figure 6.11).[18] But, as in England, it is also seen in images of male confrontation, such as one in which a man in his dressing-gown, having tossed aside his morning paper, asks his nephew, man to man, "So, you and Gerda are happily married now?" whereupon the nephew replies, "Yes ... well, that is to say, *she* is happy, and *I* am married" (figure 6.12).[19]

The parodical aspect that the waistcoat pose was to acquire as it was increasingly seen as archaic or affected is visible in the nineteenth century as well, then, but since the pose was more commonly seen in everyday practice, the connotations were not as narrow as they were to become. In cartoons, however, the pose was often used to convey arrogance or self-assertion in characters who – from the perspective of the cartoonist and his audience – had no grounds for such attitudes, and in some contexts it became associated with certain types. In England, it had connections with the emerging cockney stereotype and in Sweden with the emerging capitalist stereotype, but examples where the pose is used with no particular purpose suggest that it was still too common a part of body language to be universally associated with these caricatures. And, indeed, in Austria and Germany, the link with certain types seems never to have been

established quite as strongly, and the stereotypes that were established in *Fliegende Blätter* and *Simplicissimus*, such as the Gigerl and the peasant (see chapter 7), became associated with other styles of body language.

STRIKING THE WAISTCOAT POSE

If we are to conclude with a few remarks on the people who actually performed the waistcoat pose in everyday practice, then the question arises as to whether the pose was common enough to communicate only a vague identity in its surroundings, or whether it retained a performative aspect strong enough to signal something very specific. This has to do with who performed the pose and in what context. The men in the Petticoat Lane film certainly do offer evidence of self-conscious role-playing, while the elderly gentleman on the Morecambe sea front is engaging in a self-presentation of a more discreet sort. He is an example of the stuffy old retired army man mocked in cartoons of the time, who performs the pose from a position of leisure and the dignity of old age, while the man in the flat cap in Petticoat Lane performs it as a more youthful statement of self-control, expressing a need to project to others in his surroundings a confidence he assumes will be noticed instantly. The containment and physical "togetherness" that this pose represents is further emphasized by the man in the cap, especially in the way he clenches his pipe between his teeth, and he stares into the camera, afraid that a flicker of the eyes will reveal his insecurity. There is a sense of self-comfort here, a level of public confidence that was generally denied women, whose poses expressed either retreat or insolence and seldom this type of relaxation. And yet it is a demonstrative relaxation, probably used more in public than in private, as it is not as natural a resting pose as putting hands in trouser pockets or holding the arms akimbo.

The pose is undeniably performative, and the contents of the performance are made up of a specific form of dignified masculinity that conceives of the masculine as pompous and burly rather than virile or sexualized. The back is straightened to the point of bending backward, as in the derided "Roman fall" pose, and the hands draw attention to the chest rather than the pelvis, as in trouser pocket poses. But, as mentioned earlier, the chord that one wishes to strike is one of diligence and thrift, which gives this definition of masculinity its logic. Interestingly, what some men viewed as a performance of diligence, others perceived as a performance of unwarranted confidence and arrogance, particularly in connection with businessmen and fat cigars. There is a vague lineage here between this pose and other bodily practices of related social situations. Historian Raphael Samuel, for instance, has pointed to the affinity between the popular working-class dance, the Lambeth Walk, and urban cultures of

bare-knuckle boxing and street dancing, which connects it once again to the worlds of street gangs and slum sociability.[20] At the same time, the respectability of the pose is confirmed by its occurrence in several portraits of distinguished men of the time, including John Singer Sargent's 1908 portrait of prime minister Arthur Balfour and Emil Österman's posthumous 1915 portrait of Alfred Nobel.

The main factors influencing the use of this pose have to do, then, with work ethic and age. The man striking this pose wants to appear diligent and experienced. The presence of the pipe in the side of the mouth of the man in Petticoat Lane is a telling sign. The pipe, too, illustrates the kind of experienced dignity that the pose wishes to convey. In several of the instances analyzed here, the waistcoat pose is accompanied by smoking, and the impression of the pose alters depending on whether the man is smoking a pipe or a cigar. There were different types of pipes for different types of people in the nineteenth century, but among working people there seems to have been a strong link between pipe-smoking and labour. Working men were depicted as having a pipe between their teeth all day, and plebeian cultures of smoking were deeply embedded in the traditions of sharing tobacco as a male ritual.[21] The frequency of the cheap eighteenth-century chalk pipe as an archaeological find is indicative of its long and common use among workers. Is the man in Petticoat Lane, consciously or unconsciously, announcing his affinity with the working class? To interpret his pose in so explicit a manner would do it injustice, but the purpose of his behaviour is to guide the perceptions of others in a certain direction. And his position at the front of the image that the cameraman is capturing is the position of a guardsman, a gatekeeper at the border between the world of the cameraman and the separate world he is filming. Had he been smoking a cigar, the image would have been something else entirely. Cigars were, of course, too expensive for most labouring men to smoke on a regular basis, and thus they became connected with other identities. However, the straight and protruding shape of both the pipe and the cigar help to underpin the message of the waistcoat pose as a statement of containment and confidence. The masculinity it conveys was never specific to any certain social group; rather, it suggests the presence of a general non-verbal language that said everything to a contemporary observer. Indeed, it said so much that to put it into words proves futile.

7

Case Study 5

HANDS IN TROUSER POCKETS

⋈ THE PURPOSE OF their intercourse is unknown, and yet it seems to be a matter of some delicacy, considering the way the man on the left leans forward with a pensive expression. The man on the right is carrying a sack, probably on his way to or from his daily labour. The location is Hötorget, the main food market of central Stockholm (figure 7.1). The three people in the picture appear to be stallholders rather than customers, and perhaps the man is carrying home a sack of potatoes – the surplus of today's sales. The woman is dressed in the same fashion as most of the other female stallkeepers caught in Erik Tryggelin's numerous photos from this market. The man on the left is wearing a curious brimless and peakless hat, suggestive of the tight-fitting fur hat worn at this time in northern Europe. It is his hands-in-pockets pose that is most plainly visible, and it is an example of a slouching pose taken in a situation defined by interaction between acquaintances. There is no discernible aggression in this pose, and it works as a way of signalling that one is available for conversation, that one is listening. Each man appears to be listening to or pondering what the other is saying, but their body language is assertive and imposing. The man on the left is standing quite close to the others, almost stepping into the middle of the circle they have created. The natural thing for him to do in this situation is not to take a step back and stand to attention, but to step forward and dominate the scene.

The year is 1904, the date 30 January. There is little to suggest that the men in the picture are aware that they are being photographed, and yet Tryggelin is standing so close to them with his camera that it seems as if

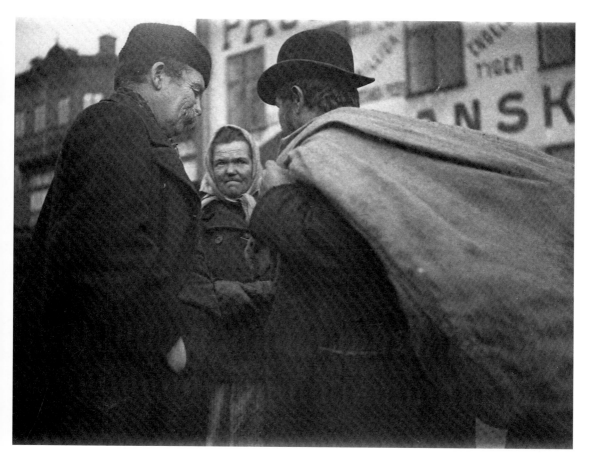

7.1 · SCENE FROM HAYMARKET, STOCKHOLM, CA 1900
(*Stockholm City Museum*)

he is hiding it somehow. The man in focus does not appear inclined to adjust his conduct to the fact that he is being observed, however, and it is just this indifference to his surroundings that his pose also communicates. Just as the injunction to stand up straight is commonplace in many historical periods, the admonition against hands in pockets is a staple of etiquette books from both the early modern and modern period. As fashion historian Hannah Carlson has observed, the act of posing with hands in trouser pockets became increasingly accepted among the more progressive factions of the middle class toward the end of the nineteenth century. It was still, however, associated by many with the "swaggering, performative masculinity of the rough," and only when noted artists and poets depicted themselves in more slouching poses were the ideals truly challenged.[1] But what of the "roughs" who had been striking these poses as part of their habitual body language for centuries?

Considering slouching poses as something new to the late nineteenth century means ignoring the possibility that they might have played a vital role in self-presentations of the lower classes in previous centuries. Since peasants and labourers were commonly portrayed with "bad" posture in art since at least the seventeenth century, it is not too far-fetched to assume that slouching poses were accepted and perhaps even encouraged among certain social groups.[2] This is a risky conclusion, as the depiction of peasants was steeped in pictorial conventions, and the portrayal of the lower orders was not seldom tinged with a moralistic stance identifying such groups with vice and licentiousness.[3] The practice of sketching figures from life became common only in the last years of the sixteenth century, and it is from that period that we have the first examples of labourers (mainly shepherds) standing in various leaning or relaxing postures.[4] The development of slouching poses is conditioned also by the development of dress, and the nature of trousers was such that not until the latter half of the eighteenth century did they have pockets that accommodated hands, and even then the trousers were still so tight that the pockets could not encompass the entire hand, as seen in some satirical prints of the period.[5] Only in the latter half of the nineteenth century were trousers baggy enough to allow hands to be thrust *deeply* into pockets. This should not lead us to think that poses exuding a similar looseness were absent from earlier periods, but we can at least say the changes in the cut of trousers encouraged a new nonverbal culture of performance.

The design of pockets depended on who you were. Women did not normally have pockets in their dresses or skirts, but the phenomenon of "tie pockets" was not uncommon, whereby a couple of pockets hanging from a string were tied around the waist to hold necessary objects. Working men carried different things in their pockets than men who worked in offices or men who did not need to work. The items carried around by labourers or artisans – including tools and food or drink – demanded much more voluminous pockets than the wallets, notebooks, or calling-card holders of refined gentlemen, and the cut of trousers differed greatly between classes.[6] Caricatures generally depict poor or labouring men in baggy trousers and refined men in tight trousers. But the possession of pockets, while setting men apart from women, was also something that united men across class boundaries. The portrayal of both caddish aristocrats and rough labourers included the use of trouser pockets, indicating that such poses were associated with ignoble characteristics in all walks of life.[7] Such associations do not appear to have been completely dominant, however. Did men such as those in Hötorget think such poses were inappropriate? Or did they perhaps like the fact that some factions of society thought such postures were signs of degeneracy?

So far in these case studies we have investigated poses that oscillate between elegance or dignity and insolence or cockiness. The pose we shall be concerned with in this last case study can seldom be termed elegant. Or can it? For if we go beyond the discourses of written testimonial, it seems we must re-evaluate some of our notions about how poses like these were viewed at this time. Some examples of how they *were* viewed from a literate, well-to-do perspective may illustrate, perhaps, that such writings cannot shed any light on why some men (and some women) used such body language. So why is there such a chasm between the mentality of these writers and the practice of the people we will see in the photographs discussed below? Primarily, I think it is a distinction between discursive ideals and rituals of practice. Some of the people we will see performing the very poses that were derided in fiction might hypothetically agree with the contentions expressed there. But the trouser-pocket pose was not performed simply to provoke others. Presumably there was more to it than that. The men in Hötorget perform their poses in a specific way, which is both similar to and different from other instances of the pose. Their stance is less performative and self-conscious than that of men in other images. Thus, this photograph might constitute important evidence that this pose was part of a man's habitual body language when he was not trying to make a statement. So what we need to ask us is, on the one hand, just how performative and directed the use of this pose could be, and, on the other, to what extent it was it simply a suitable pose for a tired labourer. And where was the line between the two?

THE OCCURRENCE OF THE POSE IN STREET PHOTOGRAPHY AND FILMS

Photographer Per Bagge's ventures out in the town of Lund in the early 1900s were inconspicuous at best. In some of his postcard views, he managed to catch the perfect image of a street or a square with some imposing building in the background, most notably the cathedral. But when we look closely at several of his street views, we see what reactions his camera could elicit in some people. A view of the central street of Klostergatan (Convent Street) contains a large number of curious passersby who have paused to witness the event (figure 7.2). This includes everything from women carrying groceries to shop assistants emerging from their place of work to see what all the fuss is about. The most recurring aspect of these street views, however, are the groups of loitering men. In this particular shot, a group of boys has assembled in the middle of the street. There are five of them. One, standing slightly apart to the right, is dressed more neatly than the others in a starched collar and tie. He is probably an

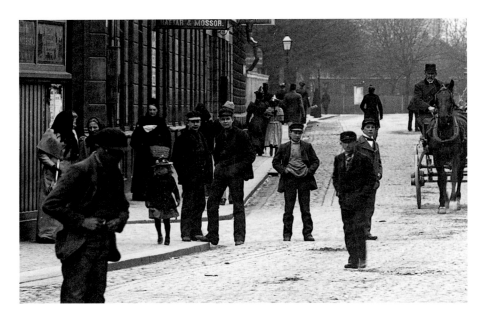

7.2 · KLOSTERGATAN, LUND, CA 1900
(*Lund University Library*)

errand boy of some sort and seems to be warily interacting with the other, more rough-looking, boys. Of these, the two to the left appear somewhat older and have a more confident and subversive look about them. They stare into the camera as if to say: "What are you looking at?" The tallest of the boys has assumed quite a demonstrative broad-legged stance, with one foot on the curb and both hands, which seem to be clenched into fists, thrust into his trouser pockets. The boy beside him turns the side of his body to us, a pose of dismissal. A bit out on the street stands the next boy, considerably younger, and therefore perhaps more eager to appear hostile. His way of acting does seem slightly exaggerated, or at least as if he is imitating the older boys. A similar impression is conveyed by the boy standing a bit closer to us, who seems to be approaching the photographer as if to ward him off.[8] In any case, all five appear quite enthralled by the presence of the camera, and their gaze is a bit perplexed at the same time as their instinct is apparently to present themselves in the way they wish to be perceived.

On the other side of the street, and at the other edge of the photograph, are a few other young men (figure 7.3) They are congregating with a couple of girls who appear to come from a similar social group. It is interesting to compare the conduct of the men with that of the women in the same situation. As noted earlier in other photographs, the presence of the men makes the women behave sheepishly and prudishly, their hand

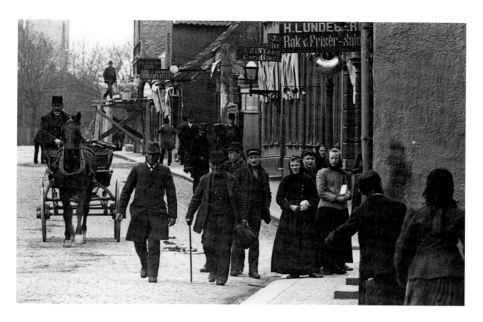

7.3 · KLOSTERGATAN, LUND, CA 1900
(*Lund University Library*)

positions betraying their subdued position in the current assembly, but there is also a lack of aggression in the encounter with the photographer. The behaviour of the three men standing with them is that of the protective or guarding male. They almost have the girls cornered, and the man at the front looks at the camera as if he has been unduly interrupted in the process of courtship. They might be acquaintances of the boys on the other side, but these men are a few years older. The impression they give is the same, though, and their poses have the same basic principles. First and foremost, hands in pockets. This gesture is actually quite complex, as it signals a certain interiority. The pocket, to paraphrase Robert Muchembled, is an interior space, and by using it, a person communicates both introspection (as in some portraits of the period depicting men deep in thought) and a warding-off of external involvement.[9] The main impression given by these men is one of intimidation, or deterrence. Don't come near, or else.

Other aspects of their appearance work toward the same goal. The man looking at us has his lapels turned up, as has one of the boys on the other side of the street. The leg position is mainly obscured in this particular photo, but their stance is broad-legged without exaggeration, with both feet firmly on the ground. The masculine message conveyed here is one of self-reliance and power, and a territorial reaction to the presence of the camera is suggested both by the confident stance and the hostile looks.

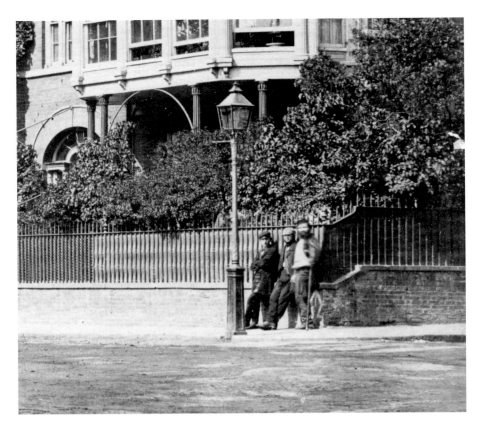

7.4 · LINDSEY ROW, CHELSEA, LONDON, 1860S
(*Royal Borough of Kensington and Chelsea Archives*)

Behaviour like this crops up frequently in the work of Bagge, as in that of other photographers of this time. In England, men acting in this stand-offish manner are extremely common in street photographs and film. One need only go to the footage from Petticoat Lane mentioned in the previous chapter to find them. But small differences in the way this behaviour is carried out become clear when we compare that of the boys in Lund with the men in Hötorget. The distinction has to do with where the photograph is taken and whether the photographer is encroaching on the depicted person's territory. The upright, interacting conduct of the hostile street boys contrasts with the laid-back appearance of similar men who are seen leaning against something. The three men in James Hedderly's photograph from Lindsey Row in Chelsea, taken some time in the 1860s, are really just a small detail in what is in effect a documentation of the street, taken at a time in the day when there is very little commotion among the dwellings of the wealthy (figure 7.4). Loafing about idly, they are possibly casual labourers who have found themselves without employment,

or workmen carrying out some sort of work nearby who have decided to take a break in the sunshine. Just as in the Per Bagge photo, they peer at the photographer with a certain wariness, but in this case the guarded and deterring attitude is created through reclining poses rather than upright or advancing ones. They wish to appear indifferent to the actions of the photographer, and an advancing manner might make them seem too unsure of themselves. Better to leer and demonstrate explicitly that they don't care by leaning back and trying not to interact with the camera.

These men do not make use of their trouser pockets, which shows that this mannerism is not necessary to create the effect of nonchalance and that the use of pockets could be supplanted by crossing the arms or putting one arm akimbo. However, the way two of the men lean on the wall creates a pose that draws some attention to the crotch in a fashion similar to poses that make use of trouser pockets. To a twenty-first-century viewer, the emphasis on the crotch seems negligible and harmless, but to a contemporary, this type of pose would instantly qualify these men as labourers or as unrespectable, as we will see. The third man, standing closest to us, is a bit blurred, but it does seem that he is missing one leg and is leaning on a crutch, and quite possibly his left arm is missing its hand or even its lower joint. His indistinct hat and coat might also be parts of an old military uniform, indicating that he is a crippled war veteran. The notion that they are idle and jobless becomes more likely the more one examines the picture, and their indifferent poses acquire their strength and aggression from the way they gaze straight at the camera. As in the previous photograph, it is this gaze, perhaps more than anything else, that defines the impression of hostility they give.

Was this type of slouching body language, then, something that certain men used when in the presence of outsiders, or wealthier people? Does it correspond to the "closed-up" and stern poses that one sees in some portrait photographs? In a way it does, of course, as it cannot be denied that this type of man signalled aggression toward the prying photographer, but while most historians limit themselves to interpreting this in terms of class conflict, it is vital to see it as part of something larger by comparing photographs like these to other types. By looking at photographs in which the people depicted are unaware of the photographer, or do not care about him, we can see how the attitudes conveyed by hostile poses recur in other forms in other types of situations.

Other Tryggelin photographs show the reclining poses of working men taking a break. Several of these exposures show them sitting on the steps of monuments, their elbows resting on their thighs, gazing out on the scenery. Others show them in interaction, or semi-interaction, standing together but not necessarily talking, just passing the time of day, lingering

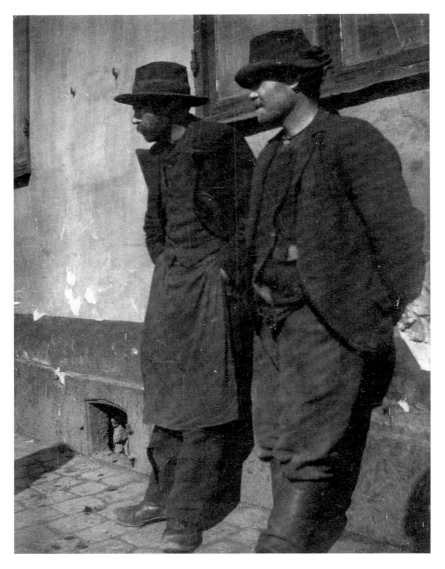

7.5 · CASUAL LABOURERS IN STOCKHOLM, CA 1900
(*Stockholm City Museum*)

in the pauses of a conversation (figures 7.5 and 7.6). In some cases, what we see are mere illustrations of posture rather than pose, which means that these are men who did not shy away from standing in a crouching or crooked posture in public view. But it seems that whenever someone puts a hand in the pocket, the body language instantly becomes more assertive and performative. These images, all from the years 1902 to 1904, bring us close to a microcosm of male interaction where the trouser-pocket pose is used to signal confidence and self-possession. The masculinity of this

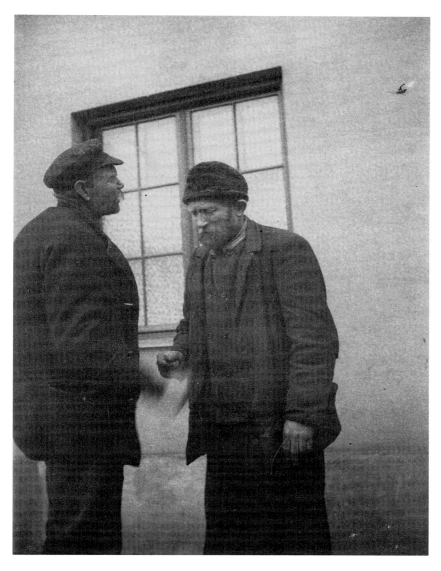

7.6 · STOCKHOLM STREET SCENE, CA 1900
(*Stockholm City Museum*)

world has established this type of pose as the norm, and it is difficult to find men from this walk of life posing in ways that give the opposite impression. In the encounter with "outsiders" this body language was emphasized, but it also existed in its own right among these men.

But who were the men that had this type of body language, and how distinctly did they delineate themselves as a homogeneous group? It is evident that hulking or slouching poses dominated in the all-male interaction of manual labourers or other groups of impecunious men, and

that, as we shall see, the stereotype of such groups cultivated that notion, but was this body language exclusive to those groups? When we consider photographs of larger gatherings of men, from which we have many to choose, then the difficulty of comparing the body language in men from different classes becomes apparent, since gatherings of people from various backgrounds tend to result in greater conformity of appearance. In the slightly more rural atmosphere of the cattle-market pictures of Per Bagge, it is the down-to-earth sturdiness of the farmer or labourer that tends to set the tone even for the suited businessman or aristocrat, but in similar pictures from large cities, although places like the cattle market existed there, too, the tone is set by the requirement for the formal suit rather than working clothes. Photographs of urban gatherings are a good illustration of how late nineteenth-century city life brought about a certain conformity in dress across social divisions. The people seen appear to come from varying backgrounds, but they are all dressed in their Sunday best. The conformity is limited to the basic three-piece suit and hat, and the multiplicity of hat types, coat types, and varieties of neckwear sets the men apart in detailed and multi-layered ways, but these men all aspire to the look of the city clerk rather than the shepherd or the costermonger. Their poses are also of the slouching-but-suave type that blurs the boundary between the stallkeepers at Hötorget and the dandy of the promenade.

The difference between an elegant pose and a rough pose is seldom very large. In the films of Mitchell and Kenyon, for instance, it also becomes clear that the phenomenon of the weekend promenade, which has been closely linked by some historians to an upper-middle-class or aristocratic culture, was something clearly indulged in by people from all walks of life.[10] It was only a matter of putting on a suit and a flowery hat. The various arenas of self-presentation in the turn-of-the-century world were subject to situational distinctions rather than social ones. At the same time, however, there is a difference, and the difference is in the details. The man in Hötorget would never be mistaken for a toff. It was clearly possible for a toff to put his hands in his trouser pockets – and deep into them at that! – but he did not do so in the most public of situations. He did so in all-male congregations, and preferably indoors. A manual labourer or junior clerk, however, was more free to indulge in relaxing poses in public. But the distinction was often extremely detailed. Placing *one* hand in the pocket was more than acceptable for a gentleman, as evidenced both by instances in street photography and, furthermore, its frequency in studio portraits. Putting hands in trouser pockets up to the knuckles was another way of making the pose appear slightly more respectable. The unrespectability of the trouser-pocket pose and its relations was conditioned by the sheer "letting go" of the body, of relaxing muscles to the point

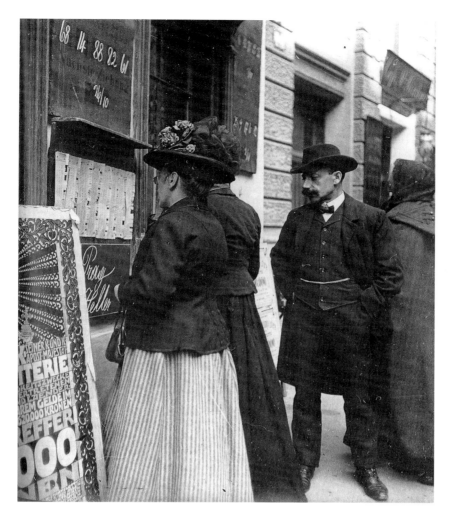

7.7 · IN FRONT OF THE LOTTERY OFFICE. VIENNA, 1900S
(*Wikimedia Commons*)

where the hands were deep in pockets, the posture bent, the shoulders slumped, and both feet firmly on the ground instead of in contrapposto. From another point of view, however, this was exactly what was aspired to.

It is not difficult to find images of men who combine the trouser-pocket pose with a suited appearance. Three interesting examples might suffice. First, there is the man in the Emil Mayer image who is standing in the street examining the board outside a lottery office (figure 7.7). This situation hardly suggests that he is a wealthy man, and yet he is well dressed in a neat suit, not-too-worn-out shoes, a watch-chain, and a wide-awake hat. If he is not rich, at least he aspires to a certain respectability. And yet he strolls about the streets in quite a nonchalant manner, redolent of

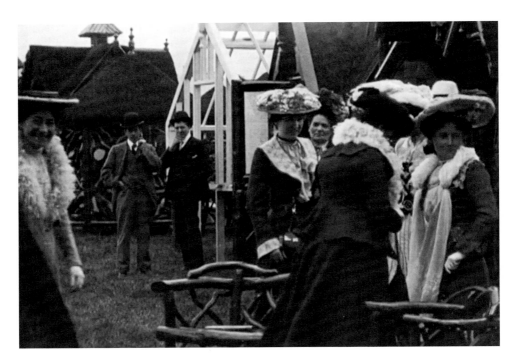

7.8 · STILL FROM FOOTAGE MADE AT THE GREAT YORKSHIRE SHOW
IN LEEDS, 1902 (*courtesy of the British Film Institute*)

the casual labourer rather than the distinguished gentleman. His possible
awareness of the camera suggests that he strikes this pose not as part of a
private moment of relaxation, but as part of a performance of noncha-
lance, but the difference is nebulous. If he had been brandishing a stick,
his appearance would have corresponded better to the stereotype, but as
it is he undermines the dignity of his getup by his lounging manner. The
question is whether others in his surroundings perceived him in this way.
Did they see instantly that this was not a real gentleman, or were they
aware that even a gentleman could walk with his hands in his pockets
while strolling by himself in a busy street?

The most common type of man seen in street photographs and films of
this era is perhaps the man who is dressed like a gentleman but acts like a
labourer. The terms "gentleman" and "labourer" are practical shorthands
that would have been used in some contexts in this time, but they are really
inaccurate, for these men are neither. In the Mitchell and Kenyon footage
from the fair at Leeds, we see two men standing in the background smok-
ing cigars while they look bemusedly at the camera (figure 7.8). They both
have one hand tucked into a trouser pocket, and their poses seem slightly
self-conscious and adjusted for the benefit of the camera. In what category

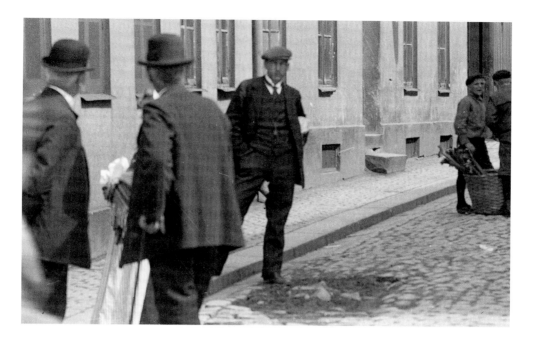

shall we place these two? They are probably at the fair doing business, and are possibly linked in some way with agriculture, which means they have dressed up for the occasion. Their comportment hardly differs from that of street boys and manual labourers, but the situation and appearance are altered. It is tempting to perceive them as working-class men who have changed appearances only for the day, but in this attire the identity they aspire to is more complex. One is reminded of the "swell" culture mentioned in chapter 3, and its combination of overtly elegant gentleman-like attributes and the conduct and bearing of the rough and masculine loafer.

Another illuminating example of this type of practice can be retrieved from a Per Bagge photograph of a busy street scene, in which a man in a suit and flat cap is standing a bit out of the way, but appears to be interacting with the camera (figure 7.9). His pose is guarded, to say the least, but it would be an overinterpretation to say that he has altered his pose because of the camera. He stands waiting while two gentlemen and a lady chat next to him and two little boys behind him argue over a basket of what appear to be vegetables. He rests his right foot on the curb and pockets at least one hand while holding a bundle under one arm. It is a simultaneously private and assertive pose. The external aggressiveness hides something other than the states of mind of the gang of insolent

boys. It is just a pose of private introspection, a bit like that of the man in the Mayer photo. In spite of his public position, he refrains from the cocky pose of the men in Leeds and a more elegant waistcoat pose. The degree of performativity here, as in many similar poses we have seen, is not as overt as in instances were the depicted individuals interact actively with the camera or make explicit poses, but there is a whiff of a more mundane and routinized type of self-presentation in which the cultural influences of the time are transformed into a semi-conscious template for practice, ingrained in the body.

THE OCCURRENCE OF THE POSE IN CARICATURE

The use of a slumped or lounging posture in caricatures of the late nineteenth and early twentieth centuries is mainly connected to the depiction of three basic stereotypes: tramps, peasants, and criminals. Looking at this from a generalized perspective, it is evident that an urban middle-class outlook dictates the depiction of society in these cartoons. To leave it at that would be dull, and would leave out all manner of factors that complicate the picture of this age, but it is nonetheless a good starting point for a revision of the established notion. Looking more closely at these three stereotypes, it becomes clear that they build on aspects that we have already identified in photographs, and by considering cartoonists' depictions of characters that are less easily categorizable, the contemporary attitude to this body language and its use in various situations becomes more perceptible.

We might start with a few examples of the established stereotypes to see how the conception of these types was transformed into pictorial conventions. In the Swedish journals *Söndags-Nisse* and *Kasper*, it was common to portray tramps and labourers, either in interaction with one another or in confrontation with a member of the wealthy classes. In the latter case, this often took the form of an encounter between a gentleman or lady on holiday in the Stockholm archipelago and a local fisherman who responds to their arrogance or lack of knowledge with a snide remark. In one such illustration, a fisherman mistakes the fashionable hat of a visiting Stockholm lady for a sou'wester and points out that she has it on back to front.[11] In another cartoon, this one by Albert Engström, the tourist, dressed in the bohemian fashion familiar to the artist, questions the fisherman about the safety of the waters, to which the old man replies that he knows every bucket of water in the entire archipelago (figure 7.10). The contrast between the two types is marked here, mainly through their differing postures, the stylish townsman bending backward, looking suave and nonchalant, and the old sea dog crouched, his hands deep in

7.10 · CARTOON IN *SÖNDAGS-NISSE*, 1890S
(*Lund University Library*)

his trouser pockets. The cultural stereotypes are somewhat hidden behind the fact that the contrast is also that between two age-group stereotypes, but the contrast recurs in other cartoons often enough to establish it as a social stereotype as well.[12]

The portrayal of Stockholm street types generally makes use of the slouching trouser-pocket pose, and the use of trouser pockets is often emphasized, as in the image of a newspaper boy trying to sell a paper to a passing shoemaker with the pretext that he will get some sense, whereupon the shoemaker retorts, "You who have so many papers are still stupid" (figure 7.11).[13] The pose of the boy is typical of the way down-and-out casual labourers are depicted. The hands in the pockets is not the only archetypal ingredient: the leg stance is also characteristic, and even though wealthier men may be portrayed with one or even both hands in their pockets, the slouch and broad-legged stance seldom accompanies the gesture. Examples of how this stereotypical pose becomes more

7.11 · CARTOON IN *SÖNDAGS-NISSE*, 1896
(*Lund University Library*)

7.12 · CARTOON IN *PUNCH*, 1883
(*Lund University Library*)

complicated when we move away from the most basic low-life stereotype are found in English cartoons of the same period. A scene involving an artist and a dashing elegant dandy standing next to one another looking at the former's latest work illustrates a more layered notion of distinction. The dandy has one hand in his trouser pocket while the other holds up a cigarette, and he stands in an aesthetic contrapposto that identifies him as a man of refinement (figure 7.12).[14] The artist is posed with both hands in his trouser pockets and his legs wide apart, which is clearly meant to set him apart from the other man. This pose distances him from the exaggerated flamboyance of the dandy, but it does not quite make him look like a slouching labourer. There are details that hinder him from being viewed in such a way, mainly in the straightness of his posture and the lack of a prominent pelvis. The flagrant pelvis is one of the key distinctions of the period, and it is found in both the newspaper boy in the previous cartoon, and just as noticeably in the man in the Hötorget photograph.

Apart from this aspect, it seems that men of refinement could be portrayed in almost any pose. A *Fun* cartoon of two swells at the club shows one of them leaning languidly on the mantelpiece while the other is

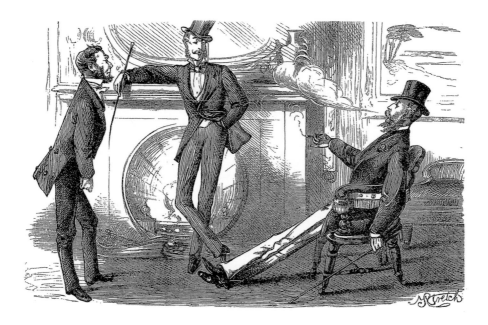

slumped into a chair with his legs stretched out (figure 7.13).[15] The swell, or his Continental equivalents, was, as we have seen, one of those stereotypes that reveal to us the complicated web of social distinctions and notions of comportment current in the late nineteenth century. One reason why swells could be depicted in more expansive poses than other characters is that they were seen as a socially transgressive group, their pedigree seldom corresponding to their aspirations. This is apparent in a *Simplicissimus* cartoon in which a slouching and sloppy man wearing a colourful but messily tied necktie and a pair of flamboyant but baggy trousers, and carrying a stick under his arm, is talking to a tramp-like character (figure 7.14). The image is entitled "Der Emporkömmling" – "The Upstart" – and it is clear that this is a rough and unrefined man trying to add some elegance to his otherwise shabby getup.[16] In all the journals consulted, we see swells and upstarts posed both in elegant walking-stick poses and slouching trouser-pocket poses. The ban on a prominent pelvis does not appear to have followed as clear a dividing line in real life as it did in cartoons, which give us a glimpse of the tension between the discourse of print media and the conduct codes of everyday practice.

The occurrence of poses with pocketed hands is of course most frequent in pictures of men, but they do also occur in depictions of women, which reveals that the depiction of women in this context contained something

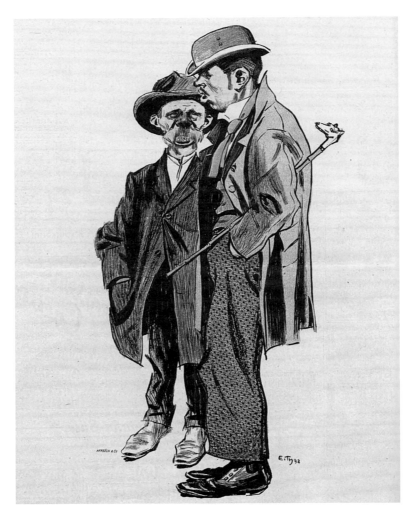

7.14 · CARTOON IN *SIMPLICISSIMUS*, 1898
(*Lund University Library*)

more than the expected delicate stereotype. In some cases, the trouser-pocket pose is associated with men to the extent that it is used to portray the way emancipated women become masculinized, as in the *Fliegende Blätter* cartoon entitled "A Victim of Emancipation" (figure 7.15). Here a young student stands before his mother, who explains that she cannot send him any more money. "Have you lost the money?" he enquires worriedly. "No," comes the reply, "but now I study myself!" The most eye-catching thing in this illustration is the way the woman is portrayed, her hands thrust into the pockets of baggy trousers that have the appearance of a divided skirt, her hair standing on end, and a cigar in her mouth. The face, although partly obscured, looks contorted, and is similar to other

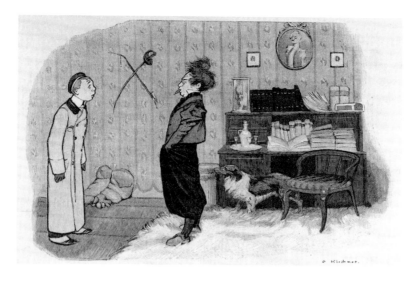

depictions of emancipated women in which their perceived ugliness was exploited.[17] She is surrounded by items that would have been interpreted as masculine at the time, including a sabre on the wall, a decanter on the table and, of course, piles of books.[18] But only very few cartoons mocked women in this cruel way, and we only need to go a decade forward in time to find that the depiction of women with expansive body language is well established. This is two-sided, as the increasing bodily freedom of women often appears connected to an increased sexualization, but when we come up to the time of the First World War, *Punch* especially is fond of making leering remarks on how women's entry into the labour market has made them defeminized.[19]

As was noticed in the akimbo pose chapter, however, there was also a way of portraying women that, while not exactly allowing them as expansive a body language as men, showed them in the role of the straight character or the normal observer of something or someone humorous, representing the outlook of the artist and thus, indirectly, the reader. When women play this role in cartoons, it is apparent from their general attractiveness and elegant but unshowy dress that this is how we are to perceive them, and the presence of akimbo poses throughout the period under study shows that female body language, although existing under different expectations, could be expansive. The relative lack of women performing trouser-pocket poses is, foremost, a sign that women seldom had pockets on their clothes. Toward the end of the nineteenth century, however, this started to change and pockets on travelling coats and similar items of

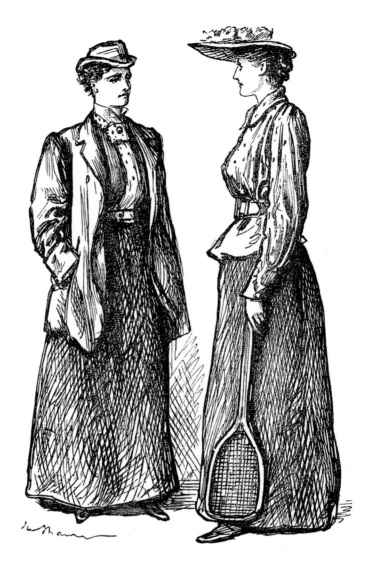

7.16 · CARTOON IN *PUNCH*, 1891
(*Lund University Library*)

clothing became common. The masculine connotation of a woman's use
of trouser pockets persisted in spite of this, as shown by a *Punch* cartoon
from 1891, in which a woman has put on a man's hat and coat, prompting
her friend to comment that "it makes you look like a young man, and that's
so effeminate!" (figure 7.16).[20] The cartoon is an acerbic comment on the
emerging fashion among women to assume items of clothing considered
male, but here the cartoonist manages to mock mannish women and un-
manly men at the same time. The expansive pose available to women in

7.17 · CARTOON IN *PUNCH*, 1896
(*Lund University Library*)

this discourse was the akimbo pose, and only in rare instances is a trouser-pocket pose used without acidic comment, as in a *Punch* cartoon from 1896 (figure 7.17).[21]

Mainly, then, the trouser-pocket pose was used to signal certain established social stereotypes, and to emphasize the masculinity of the character, but although the lines here are more clear cut than in street photographs, there are interesting gray areas. This manifests itself mainly in the trouser-pocket poses of socially uncategorizable men, borderline

characters such as artists or clerks. By identifying the stereotypes and the possible subcultures that they referenced, we might glimpse more clearly what messages these poses were meant to get across in various situations.

<div style="text-align:center">STRIKING THE TROUSER-POCKET POSE</div>

The stereotypes invoked in the cartoons discussed here revolve around occupational identities as well as identities connected to the division between town and country and the suggestion of juvenile delinquency. Therefore it might be pertinent to consider what potential connections there are between the performative poses and such identities. When the poses are taken up into the repertoire of caricatures, they acquire a jocular dimension that was not there to begin with. The most established types that were referred to when using this type of body language included, in the English context, those of the cockney or the hooligan, in Sweden that of the *kväsare* or *kväsarkvanting*, and in the German context the *Pülcher* and the *Girgl*. Let us look at these types in turn to investigate their meaning.

The character of the Pülcher emerged as a stereotypical version of the young street criminal in a south-German and Austrian context. The Vienna writer Friedrich Schlögl described the Pülchers as an assembly of "runaway apprentices" and "ragged, unemployed ne'er-do-wells" who "push themselves into the crowds at markets, shop windows and tramway stops and let their hands sink into strange pockets." The term was a dialectical distortion of the word *Pilger*, meaning originally "pilgrim" but also used to denote tramps and vagabonds. The Pülcher was the aimlessly wandering down-and-out of the Germanic city and was a popular motif for images in the popular "urban types" series of photographs or caricatures produced in many European cities around the turn of the century. In most depictions, the Pülcher is seen with his hands deep in his trouser pockets and a cigarette butt in the corner of his mouth. The character was most often the subject of drawings or paintings, and the photographs of alleged Pülchers that exist tend to be staged. In photographer Otto Schmidt's series of *Wiener Typen*, the Pülcher is enacted by a dressed-up model posing in a suitable pose.[22] The subcultural origins of the stereotyped Pülcher is to be searched for among the annals of crime and moral panic, wherein occasional stirrings of plebeian assertive youth culture can be traced. Journalistic commentators of city life identified the Pülcher as the more self-conscious and vain type of street youth, often brandishing a cigar and straw hat and combing his hair in a certain style (see chapter 8).

Alongside the distinctly urban street types, it was also popular, especially in the south-German and Austrian context, to make fun of rural dwellers on a visit to the big city. In such cases, the peasant – sometimes

7.18 · PEASANT CARICATURES
IN *FLIEGENDE BLÄTTER*, CA 1900

7.19 · CARTOON IN *STRIX*, 1899
(*Lund University Library*)

referred to as Girgl after the nickname of the legendary Bavarian poacher
Georg Jennerwein – was always depicted with a specific body language:
a bad posture, a wide, bow-legged stance, and the hands either hanging
awkwardly by the sides or plunged into trouser pockets. These characters
were easily recognizable by being dressed in the traditional garb of their
home region, commonly known as *Tracht*, recognizable by the numerous
buttons on their waistcoats and jackets as well as by their broad-brimmed
hats (figure 7.18). In *Simplicissimus* especially, the farmer is used in contrast
to the largely urban themes of the cartoons, whether he is approached by
a prostitute or stumbles into a *Bierstube*. A curious convention of these
drawings is to exaggerate the farmer's thin and bandy legs, which perhaps
were seen as being emphasized by the narrowness of the trousers. This
allows the cartoonists to dwell on the unsophisticated position of farmers'
legs, making them bowed or crooked, and often making them look as if
they are placed quite far from each other (figure 7.19).[23] This is one of the

ways in which the perspective of the cartoons views provincialism as the negation of all that is civilized and modern, even though the farmer is sometimes placed into cartoons to pierce the self-absorbed bubble of the smug city-dweller. Along with the depiction of tramps in both Swedish and German cartoons – but especially in the German examples – the depiction of the Germanic farmer is the clearest demonstration of how the slouching, crouched body language was associated with baseness and lack of sophistication in the conventions of popular print media, in much the same way as it was associated with Jews and non-European minorities.[24]

This perspective constitutes a distortion of the people it reacted to, but the images also suggest that there was a difference in comportment between urban and rural people. This difference also appears to have divided the urban low-life Pülcher from the rural farmer, the performative and cocky air of the former lacking in the conduct of the latter. A similar distinction in Swedish cartoons is particularly apparent when we glance through Albert Engström's own journal *Strix* from the late 1890s. Here the emergence of stock characters – especially the Kolingen figure discussed in chapter 3, concretizes the perceptual division between the urban homeless man, whose occasional congregation with other urban classes of people makes him assume elegant gestures, and the farmer, who epitomizes the no-nonsense attitude of country dwellers toward city types. From the point of view of cartoons, the farmer might even be said to be defined by his innate lack of performativity or affectation. Compared with the subcultures of the city, then, rural cultures seem a bit more distant, and the performative cultures of the provinces glimpsed in some of the unusual studio portraits seen in chapter 2 are beyond the scope of these artists.

The urban subcultures are discernible, however, and when we look at Swedish cartoons of the 1890s, factions other than that of the grilljanne emerge. The most concrete character invoked in uses of the trouser-pocket pose was perhaps that of the Stockholm street gang youth, commonly termed kväsare or kväsarkvanting and associated with certain districts, most notably Kungsholm and Norrtull. These groups have been described by ethnologists as "territorially recruited street-fighting groups," and their culture seems to have revolved largely around fights between gangs. Judging from some accounts, it appears that the gang culture permeated much of the life of manual labourers in both cities and the countryside.[25] Some cartoons of lower-class youths in the journals consulted explicitly portray such gang members, making use of certain details in their appearance to mock their efforts at being intimidating. An Engström cartoon shows a gang of young men (some mere boys) who stand in a specific pose with hands in trouser pockets, shoulders pushed back, pelvis pushed forward, and the legs bowed inward so that the feet point outward (figure 7.20).

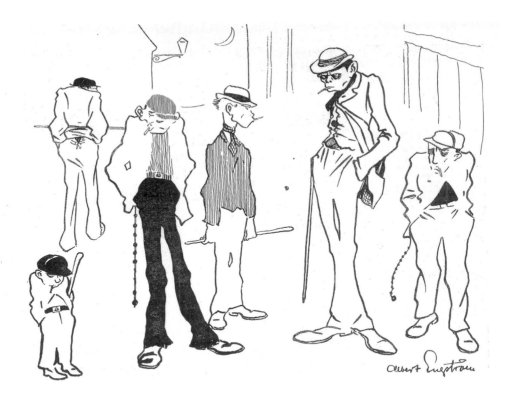

7.20 · CARTOON IN *STRIX*, 1899
(*Lund University Library*)

This gives them a threatening stance that was presumably appreciated by the cartoonist, who could revel in the s-curve created by these men's bodies. The caption identifies them as gang members from Ersta, a seedy part of Stockholm's working-class Södermalm district, and the leader is given the cue: "Considering that no people are out tonight and we are too few to fight each other, I hereby dissolve the meeting." Other cartoons, particularly those by Arthur Högstedt published in *Strix* in 1898 alongside the lyrics of his "Parade March of the Kungsholm Gang," turn gang members into the stereotype of the kväsarkvanting (figure 7.21). The depiction of street-fighting gangs in Stockholm, Vienna, and London follows the same patterns, expressing bafflement at their unique customs and way of dressing, and invariably emphasizing their slouched trouser-pocket poses (figure 7.22).[26]

Although it is evident that cartoons and journalistic writings identifying some of these types or subcultures are guilty of bundling together what in reality may have been only vague groupings, when we look at the body language through the prism of these stereotypes we can glimpse the messages of their poses. In this instance, the body language is highly

7.21 · CARTOON IN *STRIX*, 1898
(*Lund University Library*)

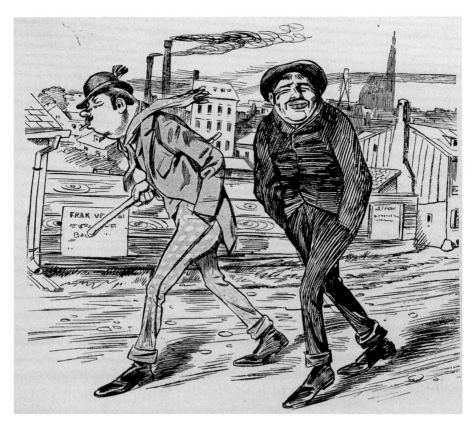

7.22 · CARTOON IN *SIMPLICISSIMUS*, 1903
(*Lund University Library*)

masculinized, and the trouser-pocket pose was appropriated in perform-
ances where men – often young men – congregated and paraded before
one another and before members of the opposite sex. The pose thereby
acquires a sort of heterosexual air, and similarly to other poses was used in
the act of male-female courtship. The tropes referenced to achieve an im-
pression of rugged masculinity had to be assembled from various contexts
that would have embraced the same masculine ethos. Whereas the waist-
coat pose used gestures reminiscent of those of a bare-knuckle fighter, the
trouser-pocket pose emphasized laziness and indifference rather than a
readiness to act. Both attitudes were used to form a bodily ideal that ran
counter to the elegance and restraint of etiquette discourse, but at the
same time its message of staunch indifference, of guarding one's right to
do no work, was an aspect that crossed social boundaries.

PART THREE

8

Observations on Urban Body Language I

STREET TYPES IN THE PERIODICAL PRESS

⅛ THE WIDE SCOPE OF the pictorial material examined in the previous chapters has allowed us to appreciate the complexity and patterns of public body language in the urban realm. In each case study, the pose that we have traced has, through the contextualization of caricatures, become linked to a certain stereotype of the period. The various poses clearly had complex meanings for the people of the time, but the detection of associations between specific poses and corresponding stereotypes helps to bring us closer to an understanding of their contemporary connotations. Avoiding the concretizing framework of such associations would force us to dive into a sea of potential identities and prejudices. Instead, the impulse behind and reception of a certain body language in a certain time is best understood by a limited investigation of the type with which it was associated and the most relevant contexts in which it was referenced. In some sense, we might run the risk of disregarding the potential variety of meanings a pose had in favour of a study of one or some of its meanings, but hopefully such a study will in the end indirectly bear light on the complexity of the pose as well.

The five poses studied in the previous chapters became associated with certain public roles or subcultural identifications. These associations were mainly the result of a general perception of the pose that was representative of its audience rather than its performers, but by looking closely at the associations it is possible to get closer to the incentive of the pose and

thus acquire a clearer picture of the nonverbal culture it was part of. To perform a certain pose or gesture always conveyed a certain message and a certain identification. Even though the performer did not consciously intend to play the part of a swell when leaning on his walking-stick, for instance, he acted within a sphere of cultural preconceptions in which such a pose was liable to be interpreted along those lines. The increasing dissemination of stereotypes linked with a certain type of dress and behaviour also meant that individuals would have performed certain poses with an awareness of how they would be perceived – and often of how they were ridiculed in the media. In this constant flux of everyday practice, journalistic comment, media exposure, and subcultural consolidation, it is difficult to distinguish between independent agency among members of a subculture and the derision of the same behaviour in print – which in turn would often have influenced everyday practice. The best we can hope for is, perhaps, a clearer insight into the practice and its connotations, regardless of the source of its impulses.

In this chapter, we will look more closely at the attitudes to and descriptions of certain regularly occurring stereotypes in turn-of-the-century media, focusing on the way their body language is portrayed. Considering the geographical scope of this study, it has not been possible to distinguish all the types and subcultures that the photographic examination have brought to the fore. Instead, I will focus this chapter on three general types of people often associated with the street context: forthright women, rough and slouching men, and various forms of dandies. The material considered comprises articles from periodicals – particularly light or conversational stories on specific aspects of urban public life, in German referred to as *feuilletons* – and, to a lesser extent, eyewitness accounts in diaries or essays.

Behind the type, then, lurks a complex and far from homogeneous everyday nonverbal culture, but the stereotyped version sheds light on its distinguishing marks and its logic. The many descriptions of public body language found in newspaper columns from the relevant time and places certainly constitute an outside perspective on the performances of the observed people, but as the nonverbal culture that we are trying to grasp has very little by way of corresponding verbal formulations, we must recruit these outsiders and try to extract their observations without reproducing their prejudices. This approach is inspired by Peter Burke who, in his study of cultures of performativity in early modern Italy, divided his sources into "insiders" and "outsiders." Both perspectives are needed in a study of communication in history, Burke claims, as "insiders are rarely conscious of their own cultural codes," taking "for granted much of what the historian most wants to discover." Therefore, outside observers can be

used as "an anthropologist's field-notes," provided that the historian detects the inaccuracies and biases of the reports.[1] A note of warning should be added to this concerning the often critical outlook that the outside view is coupled with in the material consulted here. Although a study of body language cannot ignore attitudes to and perceptions of it, it is essential that the opinions be separated from the observations.

This outside perspective will also be appropriated in the next chapter, in which we focus on the portrayal of street types in stage comedy, looking especially at reviews and newspaper accounts of English music-hall performers where the behaviour and body language connected to the types become tangible. The conclusions of both that chapter and this will then be summed up in chapter 9.

FORTHRIGHT WOMEN: SHOPGIRLS, STALLKEEPERS, AND STREET GIRLS

In June 1861, solicitor Arthur Munby made note of a labouring woman, carrying a sack from a nearby warehouse, who stopped to rest near London Bridge. Munby describes her in his diary entry as "a tall, strongly built wench of twenty or so" wearing "an old gown of nameless material," a white apron and "muddy masculine boots." Then he explains in detail how she stood while resting: "[S]he stood against the wall, her feet planted wide apart on the pavement, and one stout but pallid arm akimbo, and the other resting with its wrist upon her hip, the large bony hand, yellowed with grease and oil, falling free in a clumsy ease. So she stood; now rolling from side to side, now hitching up her shoulders, now rubbing the back of her hand across her nose or mouth: every action and posture rude and ungainly, but full of loose and supple strength."[2] Munby's description is steeped in phrasings that reveal his personal fascination with working women, but beyond that we can also view this passage as a snapshot of a woman in the street who is quite unaware of being the centre of attention. Munby emphasizes the masculinity of her body language, thus almost inadvertently illustrating how expansive body language occurred among working women even in public, although this woman is in a special state when Munby sees her and might not have carried herself in the same way if seen on her day off.

The distinctions that Munby makes in his observations of women in the streets are sometimes very traditional. He considers the behaviour of a group of unemployed women lying in the grass in St James's Park, "one flat on her face, another curled up like a dog with her head between her knees; another with her knees bent under her, and her cheek on the ground," to be "ungainly, and unfeminine, and bestial," and at one point he compares

the "languid perfumed ladies" he sees "strolling elegantly" through Hyde Park with a milkwoman who passes by, "moving heavily along," "large and burly." But although his outlook is aloof, his sympathies are mostly on the side of the weaker party, and he records with scorn the derisory remarks of a well-off woman of his acquaintance concerning servant maids: "She refused to believe that any such woman could by possibility be refined in nature ... [T]heir faces might be pretty and their manner modest, but within, they were full of baseness & vulgarity."[3] Munby here gives us an example of how the female ideal of conduct could be put into words, a "modest manner" being the hallmark of a refined woman. But Munby thoroughly disagrees, and his diary entries show that a modest manner could often be far from the reality.

In July 1861 Munby visited Crystal Palace, where he came upon a group of men and women in a nearby park playing a game called "Kiss in the Ring." Munby became one of the participants when "a young woman next me link[ed] her hand in mine with much simplicity, whereby I became part of the circle." He observed that the women were mainly made up of "shop girls and servants" and notes that "the behaviour of the girls ... varies with their character," but while some acted shyly when about to be kissed, offering one cheek, "the greater number approach with simple frankness, look full in your face, and expect to be kissed upon the mouth." Among the girls, he especially noticed "a tall buxom wench, a servant maid from Islington" who threw herself into the proceedings "with great vigour and abandon." He continues: "It was the satisfaction, in a rude & sensuous kind, of a long repressed and half unconscious desire: to be let loose, from the solitude of her kitchen where no followers are allowed, into a circle of young men prepared for unlimited kissing – quel bonheur!"[4] Although no details are given of the girls' body language, the lack of inhibition in their conduct is evident, regardless of whether it should be interpreted along the lines that Munby chooses. We are allowed a brief glimpse of a situation and a type of Victorian women beyond decorum.

Munby made a similar observation when he took a train in a third-class compartment, deliberately wishing to "learn the ways of the working classes." Next to him sat "a rosy country wench" who quickly broke the ice with the young men sitting around her and started to speak in a "frank simple way" about herself, "laughing at [the men's] mild jokes with fresh openmouthed unrestrained laughter." Observing this scene, Munby cannot keep himself from exclaiming in his diary: "What an artifical product the modern lady is! Is not *this* type of woman, also, valuable & interesting?"[5] This delight in the unrestrained behaviour of women from the lower classes comes from a man who is bored with the decorous conduct of women from the world that he himself inhabits. The women he describes

seem to be more prone to resorting to uninhibited backstage-like behaviour, unmindful of the rules of etiquette governing well-mannered society. Interestingly, he uses the epithet "modern" to describe the lady of refined society, and presumably distances himself from most other people of his background in preferring the frank manner of a working woman.

The distinction Munby makes is clear to himself, but when we isolate the behaviour he describes from his interpretations, we see that unrestrained behaviour is not exclusive to working women or shopgirls. A friend of the author William Makepeace Thackeray, Munby often visited the Thackeray family and found many opportunities to comment on the forthright behaviour of the daughters. But the conduct of one of them, Annie, who, "all lithe and tremulous" throws herself into discussions "with the impulse of thought and strong feeling," Munby interprets along slightly different lines, viewing her as "artless," "intense" and "spirituelle," words that he would not use for his milkmaid acquaintances.[6] At one point he compares a woman he meets at a soirée with the working women he knows, considering her "a refined type of that character which is so noble in low life," but adding that "in a drawingroom creature, such selfasserting strength looks somewhat masculine and out of place: whereas the form it takes in working women is simply heroic."[7]

The stereotypes of lower-class labouring women might have had an implicit aim to clump together heterogeneous groups and social categories, but the depictions of the stereotypes could never entirely ignore the variations of reality. One aspect that is often apparent from descriptions of female street types is age, and in descriptions of a young coster girl there are always verbal indications that distinguish her from a middle-aged or elderly coster woman. Among the Viennese street types, there is a clear distinction between the flower girls, habitually portrayed as young and attractive, and the market-stall women – *Standelweiber* – seen in numerous contemporary illustrations and paintings as middle-aged, fat, and burly. The division exists also in English and Swedish contexts. The Viennese version of the market woman dates back to the late eighteenth century, when writer Johann Pezzl described her as "a type of impudent, rude, forthright, sly, rough, slanderous woman who, year in, year out, blockades every street and alleyway, every square, every nook and cranny."[8] A hundred years later, the discourse surrounding the *Wiener Typen* had softened, as many of them were viewed with nostalgia for *Alt-Wien*, that is, the period before Vienna started to grow into a modern metropolis.[9] The Standelweib was then portrayed by feuilletonist Vinzenz Chiavacci in the shape of a fictional woman called "Frau Sopherl vom Naschmarkt," whom Chiavacci used to comment on various current issues in the voice of a woman "of the people." This character became popular because of the instant

recognizability of her persona to the readership of Vienna, who were customers at the various vegetable stalls at the still-functioning Naschmarkt. Chiavacci described her as having "a rounded and well-founded figure with a face beaming with coarse health ... a mouth, from whose furrows it is evident that it is in constant motion ... a mixture of liveliness and good humour expressed in all her motions ... As a true child of nature, she is never stumped to find a pithy word to say on all matters, and to elucidate the issues of the day with her resolute sayings and an outlook characterized by coarse humour."[10] Some of the attributes of this character are based on popular perceptions of the female market-stall keeper: her robust and large frame, her constant gossiping and chattering, and her way of speaking as if being completely confident about all matters, which in Chiavacci's hands turns her into a form of modern oracle.

In the majority of pictorial representations of Frau Sopherl, and other Standelweiber, she is shown with her arms akimbo, and this pose was the gestural synonym of the characterization of the type in feuilletons. This self-confidence and tendency to speak her mind and take up space seems to have been closely associated with women from a certain work group, but also of a certain age and of a certain corpulence. As we will see, young women who assumed this behaviour of confidence and outspokenness were more often dismissed or seen as vulgar. Rare testaments such as that of Arthur Munby show that such behaviour was not absent among young lower-class women, or even middle-class women, but in literary discourse this conduct was accepted only when the woman had been stripped of some of her femininity, or perhaps even her sexuality. The Standelweib was a desexualized woman, her character mostly resembling that of a man – in an Austrian context, particularly stereotypes of burly mustachioed men who viewed the world from behind the table at the Bierstube – while younger women, even those who worked in the street markets, were not allowed the same freedom of speech and body language. But, outside of the literary discourse, the silence was not unbroken.

Beyond Munby's accounts, the conduct and body language of impecunious women is extremely difficult to ascertain, and we are at the mercy of a few scraps here and there, especially in newspaper articles or letters that complain about such behaviour. The late nineteenth-century vogue for articles recounting excursions into the slums of various cities provide us with a few brief statements. "In one dirty, squalid street in Middlesbrough," we are told, for example, "ill-kempt women, with their arms akimbo, loiter all day long."[11] Interestingly, this writer chooses to mention the arm poses of these women. Another similar report from Newcastle briefly mentions "batches" of women running up and down a certain street, "with handkerchiefs on their heads, gowns tucked up, and arms akimbo; some running

in to the Albion Inn for a refresher on the way to the quay."[12] Another article has the reporter accompanying a policeman on the trail of a murderer, and among the gothic details is a dark alleyway where, in the doorways of the houses, there "lolled, now two, now three, and more young girls, with their arms akimbo, humming vulgar ditties peculiar to this particular class of neighbourhood."[13] From these passages we should not be led to believe, however, that the arms akimbo pose was exclusively associated with low and disreputable women in back streets. In fact, the phrase "her arms akimbo" can be found in numerous children's stories from late-Victorian boys and girls magazines, in an age long before the pose became associated with Pippi Longstocking.[14] But the noting of the pose in these articles demonstrates that it was associated with female defiance and boldness. To the most conservative of writers, the akimbo pose was considered a faux-pas, and it is occasionally advised against.[15]

But what makes this pose both a mark of female unrespectability and of an attractive form of sternness is the outlook of the writers. In fiction and cartoons, we see respectable women with their arms akimbo, and their pose is accepted because of who they are, while if a low woman encountered in a rough neighbourhood adopts the pose, it is commented on as an indelible mark of her low social status. The akimbo pose was, then, as it had been for centuries and will always be, a common pose that everybody could perform, but at the same time it can be imbued with specific meanings. Disregarding the interpretation of the pose made by the quoted article writers, it can be seen as a piece of body language used as part of a performance. An illustrative case from reality was reported from one of the London police courts in 1889, when a "fashionably dressed young woman" with the name of Dolly Wilson was arrested in Piccadilly, charged with disorderly conduct. A police constable had spotted her at one o'clock in the morning when she "paraded the thoroughfare with arms akimbo, and pushed every gentleman who came near to her either against the shutters or into the roadway." After a while an elderly man approached her, whereupon Miss Wilson allegedly "skipped up to him and laughingly said, 'You're a nice old fellow, ain't you? Stoop down, and I'll play leap-frog.'" This prompted the constable to walk up to the woman and arrest her. The newspaper report claimed that she had been charged with disorderly conduct before, but while before the magistrate she stood "with downcast eyes," her demeanour much changed from when she was in the street, and begged for forgiveness.[16]

Dolly Wilson's behaviour in Piccadilly was a snippet of a situational context in which she acted according to standards that are seldom apparent in Victorian records. Parading down the pavement with her arms akimbo, she acted with a considerable amount of bodily expansiveness

that even working-class women were denied, and her bold and impulsive "skipping" up to the old gentleman, inviting him to play leap-frog with her, broke every rule of politeness and civility in the book. Except this was as far from "the book" as one could get. Since Wilson confessed in court that she could not remember the details, it is possible that she was under the influence of drink, but this does not contradict the fact that she was acting within a mindset that encouraged this forwardness. A similar case concerns two women whom a policeman caught "singing and shouting at the top of their voices, and abusing every man who passed by them." The uproarious behaviour of the two women continued in the courtroom, where they were reported as "skipping" into the dock and as laughing loudly when they recognized their friends in the audience. When the magistrate fined them ten shillings, one of the women reportedly put her arms akimbo and started to dance, saying: "Oh, bless me, ten bob! I shall go mad."[17]

In 1890s Stockholm, young women from the lower strata of society were given the epithet *tjinona*, a word that emerged from street slang and found its way into newspaper accounts of city life. An account of a journalist's visit to Gröna Lund, an amusement park in central Stockholm popular among the lower classes, contains a brief snapshot of such a girl standing in the ticket queue: "In the crowd of crushing youths stands a 'tjinona' with red lips and red cheeks squeezed into the middle of the throng. Boys are teasing her from all directions, but she bites back with clever retorts, sharp as the crack of a whip."[18] A more specific term was the *kväsarynka*, a word used alongside the male versions *kväsarkvanting* or *kväsargrabb* to denote a young girl from a poor background who was part of some form of gang. Another article makes an attempt at describing both the male and female members of such gangs, applying a somewhat distanced ethnographical perspective. The "kväsarynka," says the writer, "is a girl between thirteen and eighteen years old, [who] appears shabby and dirty, in a low-cut dress, a large round hat over the blond hair, a braid down the back and a fringe on the forehead that she curls with a nail heated by the flame of a candle. She lives on sandwiches and coffee, beer, porter, lemonade and soda. The kväsarynka comes from a working-class home, the father being a metal worker, mason or something similar, and she herself works in a tobacco or stocking factory. At night when the factory closes, she takes her broad-brimmed hat and goes down to Kungsträdgården."[19]

The article describes the kväsarynka as a loose and lecherous girl. Kungsträdgården is a park in central Stockholm where people from various classes promenaded, and the writer goes on to describe how she draws the attention of some elderly gentleman "to whom dirt and depravation constitutes a certain delicacy," but the lewdness is portrayed as a result of

the girl's behaviour rather than that of the men she attracts, and the writer describes how she "expresses her desires by lifting her wet, torn skirts by a clumsily indecent gesture, and hums to herself a snippet of some Viennese waltz." The unrestrained conduct that women from this category are associated with is interpreted as lustful and lecherous to the outsider, who is unaccustomed to such practice. Accounts of the kväsare subculture mainly pay attention to the male members, and these descriptions will be studied in the next section, but the fringe (bangs) as a female hair fashion recurs, which is an interesting counterpart to the "Whitechapel fringe" mentioned in a London court case we will see later. There are also some indications that girls played quite a prominent role in the street gang formations of the Stockholm slums, occasionally being identified as leaders.[20]

An article describing a journalist's visit to a "workers' variety show" reports on an audience consisting primarily of what the writer calls "gang boys" and *kväsarjäntor*, that is, kväsar girls. The behaviour of the young women is both uproarious and coquettish. When four young girls from, the writer estimates, "better worker families" enter the locality and encounter a group of boys, we are told that "even though the girls did not appear particularly cheeky, they greeted the boys with familiarity: Hello there, boys." As the two groups try to get acquainted with awkward questions, however, they start to giggle nervously. The behaviour of the same people in the auditorium is loud and riotous. "One form of entertainment appeared to be the rolling of the programmes into cones that were thrown down on other people's heads from the balcony. The whistling and cigarette smoking was something that also the girls indulged in." The following description of the show is filled with horrified remarks at the whistling and stamping of both men and women in the audience. The moralistic tone of the piece emerges eventually, and the article ends in a sermon on the vices of working-class entertainment, but the behaviour that the journalist reacts to fits in well with the unrestrained behaviour of the kväsarynkor glimpsed elsewhere.[21]

Surviving accounts of lower-class dancing and courting in Vienna from the same period provide us with slightly more sympathetic insights. On the periphery of central Vienna is the large Prater park, a popular entertainment venue for members of all classes around the turn of the century. The hotspot of the park was the Wurstelprater, an amusement park especially popular among labourers, particularly the so-called *Ziegelböhm*, the "brick Bohemians" – men and women, primarily from Bohemia, who had moved to Vienna to work in the Wienerberg brickworks.[22] The key text concerning the Wurstelprater is the book of the same name first published in 1911 containing texts by the feuilletonist Felix Salten and the photographs of Emil Mayer. The photographs were produced independently of

Salten's texts, and I have made use of them here, but Salten's short essays on various aspects of Prater life illuminates what sorts of activities the park was associated with and how it was observed. Much of the book is devoted to the different types of entertainment offered at the Prater, from freak shows to puppet shows for children, but some chapters are devoted to aspects that we have previously identified in Mayer's images, namely the congregation and courtship rituals of young men and women from the lower classes. At the dance halls of the Prater were to be found women who had moved from the provinces to gain employment as servants and men who had come to join the army. Mayer's photographs show young men in uniform and girls in patterned dresses brought from their native land and looking quite rural in the Viennese environment.

Salten describes poetically how the provincial youths from Bohemia or the Alpine regions come to these venues to meet others like them, to feel at home, and how they "rotate with stiff backs and short bodies" in the dance. The young men are divided into those in uniform – "alert, powerful, aggressive in their straightforward joy, like young bulls" – and those in the "Sunday clothes of artisans and factory workers," whose "expressions and character have been decolourised by alcohol and the wickedness of the city." The girls, having lived a couple of years in Vienna, shed the naive personality of their rural background – much to the sorrow of the sentimental Salten – and exchange their coloured headscarves for fashionable hats "of improbable elegance."[23] In Salten's depiction, the simple background of the Prater lovebirds cannot be truly escaped, and so whatever efforts they make to achieve respectability or imitate bourgeois behaviour are ultimately futile. This picture derives from Salten's anti-urbanism and idealization of rural culture, but in his tableaux the resulting description is one of condescension. The men adopt "noble manners" and the women indulge in coquetry, but the roughness of the men dominates the portrayal and the "young girls of the people" cannot hide their "cheeks fresh and bright from the air of the fields of their homeland" and their arms suntanned from working outdoors.[24]

Salten had already reported from the *Fünfkreuzertanz* ("five-penny dance") of the Wurstelprater in an earlier book, in which he painted a lively picture of the abandon with which these young couples threw themselves into the dance, as if "in a fit of extreme rage, or even a kind of rhythmic frenzy."[25] A more sexualized account of young women at a dance can be found in another piece in the same volume, which describes the types of women Salten observes on a dance floor at one of the new types of dancing establishments in Vienna. The piece centres on "young girls who dance" and identifies various types. "Some are talented, and some are without skill. Some are full of grace, and some are utterly helpless.

Some are bashful, indeed ill at ease, and some, on the other hand, are very saucy." He observes a young girl who "hurls herself into the resounding foam of the fandango, hurls herself with an enthusiastic gesture into the flood of the high-spraying music, like a swimmer who cheerfully jumps from a diving board into the clear water." The descriptions identify expressions of vanity, arrogance, and coyness. There is one whose dance conveys her "silly vanity" when she "shows with unbelievably false affectation and with terribly misplaced haughtiness how she imagines her stylishness and seductiveness." Next to her is a girl who expresses her "devil-may-care attitude, her utter mendacity and greediness" and "her laziness and sloppiness" through "her carelessly studied, faulty step." Finally, there is the "neat little thing" with a "provincial demeanor" whose style of dancing betrays "her willingness to become at any moment a nursemaid or seamstress" and her "innate fondness for dust wiping and window cleaning."[26]

Representations of young women in Viennese literature around the turn of the century made use of an established set of archetypes associated with terms like *das süße Mädel* ("the sweet lass") or *Wiener Fräulein* ("Vienna young lady").[27] The poetical and stylized portrayal of the dancers obscures whatever observation of reality that Salten's piece is based on with literary tropes, but beyond this we can see the astonishment of the male observer at the abandon and freedom of movement displayed by these young women. We are left to guess at the social background of the women who were to be found on these dance floors – with the possible exception of the provincial girl – but the context and type of venue point to a lower-middle-class clientele. Certain phrases are particularly interesting, such as the "carelessly studied, faulty step," which implies a deliberate performativity designed to express indifference and affectation rather in the fashion of the male dandy (see below). Parallel to this is the "haughtiness" and "stylishness" observed in the other girl. The culture of brashness inherent in these women's behaviour is all the more emphasized by being contrasted with the awkward provincial girl, who is said to move with "simple expressions" and "good-natured gestures."

Although cases that are given space in the newspaper constitute to some extent extreme versions of the expansive conduct that women in the street could make themselves guilty of, these examples demonstrate how some records allow us a glimpse of a largely undocumented world of behavioural standards. When Salten's lively dancers are placed alongside the burly and akimbo-posing Viennese *Standelweib*, for instance, a pattern of public female forthrightness and outspokenness emerges. But what were the conditions of this nonverbal culture? Is it to be seen as the expression of specific urban subcultures, or as a practice that, although indulged in by a majority of women, was not well documented because it did not fit the

ideal? The admonitions concerning expansive female body language that come to light whenever this topic is studied in a nineteenth-century context would certainly have been present or at least known even to women lower down the social scale, but the evidence suggests that it was considered a matter of what situation you were in. If Dolly Wilson had been suddenly invited to dine with nobility, she would probably have known that she could not act in the drawing room the way she did in Piccadilly on a Friday night. We cannot be sure of this, of course, but the fact that she acted with much less confidence in court shows that she was aware of the difference in situation. The two women in the second court case, however, acted in exactly the same way when they were in court as when they were in the street in Whitechapel, and they even denied having been drunk when charged by the constable. These women cannot be equated with the "fashionably dressed" Dolly Wilson, however. Wilson seems to have come from a slightly more prosperous background than the two Whitechapel women, who were described as appearing "without bonnets, and wearing white aprons, their foreheads being decorated with the Whitechapel fringe." The fringe suggests a street-gang affiliation, and the somewhat aggressive and abusive attitude of these women springs from a much more impoverished background than the exuberance of Dolly Wilson.

◁ OF ALL THE BEHAVIOURS disparaged in Victorian periodicals, coquetry stands out as a recurring object of criticism. While the female conduct mentioned so far has forthrightness and boldness in common, coquetry is in a category of itself, but although its body language was often shy and delicate, its connotations were certainly not the antithesis of the forthright woman. Coquetry was commonly seen as despicable and unsuitable, and was frequently connected to women who were far too frivolous or vain or who consciously used their own beauty to attract men. This was of course considered a threat to the hegemonic notions of masculinity and femininity often promoted in the media, but, as Ellen Bayuk Rosenman has observed, the condemnations of coquetry can be seen as "a kind of cover story that conceals deeper fears about gender roles and heterosexuality, and above all about female agency, autonomy, and eroticism."[28] Glimpses of a type of behaviour that can be equalled to the behaviour denounced as coquetry are found in some of the texts we have consulted and can be especially linked to the shy poses of chapter 4. Although no explicit links can be established between these poses and the discourse of coquetry, the subject is highly relevant for its frequency in the sources and is a vital context for the study of shy and restrained female conduct.

"Coquetry," wrote the American suffragist Tennessee Claflin in an English newspaper, "is an elastic term which includes a multiplicity of prac-

tices more or less tinged with deceit." Claflin further explains the term as "pretended or affected liveliness" and "insincere efforts to be pleasing, attractive, or alluring."[29] At the core of the coquette's manners seems to be an affected modesty, innocence, and coyness, which suggests a certain body language, the details of which the reader is unfortunately often left to imagine herself. The coy body language mentioned in journal accounts is often seen as indicative of the immaturity and "silliness" of young girls. One example is giggling. A report from Paris praises the "well-mannered and well-dressed" nature of the French crowd in comparison with the "London young women, with hideous feathers and repellent ulster" and the "giggling shop-girls."[30] "Be temperate in everything," advises the conservative *Girl's Own Paper*, "take a cold tub every morning, leave your window very wide open at the top every night, and eat good food in moderation, so shall you be strengthened morally and physically, and able to enjoy life and society without simpering, laughing or giggling at every silly thing spoken or done." Giggling and laughter is banished for being a threat to beauty, since "laughing too much wrinkles the face, [and] excitement of any kind has the same effect."[31] The associative link between coquetry and giggling is made in an advice column that states: "[A] girl who will be giggling and smiling at every young man she meets, whether she knows him or not, is not a fit wife for a man who wants a quiet home."[32]

The subject of coquetry dates back to at least the eighteenth century, when the term was applied to both men and women. By the late nineteenth century, however, it had become firmly connected to the behaviour of seductive and unseemly young women.[33] The stereotype is often employed as a character obstructing the path of the hero of bourgeois novels, but, as noted, it is increasingly seen in accounts of everyday urban practice. In Viennese feuilletons, it is used mainly to characterize the women observed in coffeehouses, especially the female cashier who was a constant object of desire for the male visitors of the cafés, and who crops up in several accounts of the coffeehouse culture as an idealized and attractive young woman in a world of men. In this idealized version, she has much in common with the character of the barmaid in English writings on the public house.[34] In one of his brief sketches, feuilletonist Peter Altenberg encounters one such creature: "A young woman with aristocratically delicate hands sat at the cash register. I said to her with my eyes: 'Sweetest cashier —' And: 'One ought to be allowed to purchase you as well ——.'"[35] There were numerous arenas in the cities of this period where female exposure to the male gaze was accepted as a natural part of the scene.

Toward the end of the nineteenth century, young girls acquired an increasingly separate identity and culture, which was expressed and cul-

tivated through the proliferation of girls' magazines that catered to a socially varied readership. Sally Mitchell has observed how the image of the young girl promoted in such publications portrayed her as strong-willed, independent, and outgoing, indicating the existence of a female subculture that contrasted with the discourse of domesticity and discipline promulgated through other channels. Mitchell does not look to everyday interaction to verify the existence of such a culture outside of literature, but she is still adamant that the common ideals of this sphere "had a cultural reality."[36] In the nonverbal interaction studied in this book, we have taken a few steps closer to revealing the everyday form of such a girl culture. The coexistence of assertive and shy poses illustrates that there was a template of conduct among young women that oscillated between modes of coyness and open displays of brashness. Signs of this can be found among both working-class girls and lower-middle-class girls, and perhaps even higher up the social scale. A fuller study is required to sort out the various subcultures that might have evolved among groups of women in separate social spheres – factory girls, office girls, shop girls, rich girls, etc. – but common traits dominate the observations we have made. As we will see in the next chapter, the popular culture of the period distributed forthright female role models that might have influenced young women's self-conception.

SLOUCHING MEN: KVÄSARE, PÜLCHERS, AND LOAFERS

The stereotypical working-class man was associated, as we have seen, with a certain body language, but the observations of these types of men also provide us with glimpses of the group identities or subcultures that they lived among. Unfortunately, such identities became tangled up with the prejudicial gallery of street types that writers habitually referred to when writing about urban life, and we need to distinguish one from the other when examining the traces of the subcultural connotations of their body language. It might be said that the larger the city, the farther from actual street subculture was the street type portrayed in writing. In London, the stereotype of the lower-class man might be connected to epithets such as "the cockney," or in a more jocular discourse, "'Arry."[37] Corresponding stereotypes in Vienna and Stockholm made more specific links with criminality. In Vienna, Pülcher was a word used broadly of rough men hanging about in the streets, but the word connected them to the petty criminal.[38] In Stockholm, the aforementioned kväsarkvanting was the word used of the street gang member, and to some extent the term entered common usage to refer to a young man from the slum areas of the city, but it did not become as widely used or as representative of an entire social class as

"cockney." This discrepancy may of course have had to do with the varying degrees of commonality in the different urban regions. London slum dwellers may have developed some sense of belonging to a more coherent group than the corresponding groups in smaller cities.

In Stockholm, the smallest of the cities in focus here, there does not seem to have emerged any very explicit stereotypical denomination of labouring men. The most recurring types that referred to lower-class men were the kväsarkvanting and the *koling*, both denoting very concrete types: street gang members and harbour porters, respectively. Therefore it might be that these terms and the descriptions of the types they referred to contain something of the subculture that existed within these groups. The caricature of the kväsare or kväsarkvanting, portraying him as slouching, with hands in pockets and shoulders drawn up, corresponds quite closely with written descriptions as well. The character became such a fascination for contemporary Stockholmers that a couple of pamphlets describing their subculture and, especially, their unique jargon, were published. In these the kväsarkvanting is described as "a funny devil, always dressed in a jacket, probably because he mostly walks with his hands thrust down into his pockets, which makes it easier for him to pull up his shoulders, all with the aim of looking as wide-shouldered as possible."[39] The other pamphlet describes his walk as "resembling that of a tilting duck, the hands pushed down into the trouser pockets, the shoulders bent and the head stretched forward, like a bull ready to charge."[40]

The illustrations that accompanied published songs parodying the kväsarkvanting sometimes depicted them while they were dancing, and from some of the accounts of the kväsarkvanting subculture it appears that a particular form of dancing played an important part. The pamphlet writers describe the movements with quite a bit of sarcasm: "The girl keeps her arms twined around the neck of the boy, and he lets his rest on her shoulders, while they lean their heads together and push out their backs into an arch, and in this position they then stand and jump towards each other like a pair of rams."[41] The article on the Gröna Lund amusement park includes a somewhat more sympathetic description of their way of dancing: "The boy puts his hands on the shoulders of the tjinona, they flap a couple of times with the elbows as if they were attempting to fly and then all of a sudden the whole throng sets in motion. Rocking to and fro a few times, they thereafter twirl around all at the same time as if someone pulled at them with a string ... They throw themselves into their dance, closing their eyes every time they twirl, squeezed tightly together, holding on to each other as if they had a vise around their waists ..., and with their sometimes fast, sometimes slowly gliding feet, they stir up a cloud of dust that glimmers above their heads in the last beams of the setting sun."[42]

Although we only ever view the kväsar culture from the outside, and not seldom in terms that are distanced and even hostile, it is difficult not to get the impression of a rather tangible collective culture among them. The fashions, the hair, the body poses, the walk, even their own way of dancing go together to create a distinctive form of expression. It is perhaps a symptom of the observing writers that the male members of this culture are devoted the most attention, but it does seem that the female members played a prominent and domineering role within their ceremonies. What emerges as most vital to our study, though, is of course the very distinct body language that is described in passing in most of the accounts of the kväsarkvanting. The drawn-up shoulders, slouching gait and, not least, the hands thrust into the pockets are all elements of a performance of rough masculinity that is at the heart of this subculture. This masculinity was certainly not limited to the men who identified themselves as members of this culture, as has been made clear by the photographic investigation, but the way it is used in the context of this culture – associated with street fighting, courting, dancing, and general licentiousness – connects it to a code of toughness that hardly fits into a world of discipline or civility.

Similar in nature is the German-language term Pülcher, which seems to have been used of the rough-looking casual labouring man hanging about the streets in general. In Berlin the term *Eckensteher* was appropriated for such men, and it illustrates perhaps in itself how such men were perceived, although being a common element to the urban fabric, the Eckensteher – usually a synonym for porters waiting on street corners for work – came to be seen as a picturesque and eccentric addition to the type gallery.[43] The Pülcher, however, had more criminal associations. In a volume of the *Grosstadtdokumente* project – a series of books on various topics of urban daily life and the underworld, initially encompassing Berlin but eventually also Vienna – there is a concise characterization of the type. The book is entitled *Wiener Verbrecher – Vienna Criminals –* and the Pülcher is dealt with briefly as the most petty of lawbreakers. The text describes him as "a scavenger and loafer rather than a criminal" but estimates that he is introduced into crime through his "idleness, alcoholism, and violent nature." The piece also mentions a distinctive way of dressing that features bell-bottomed trousers, a short coat, a hat angled over one ear, and the hair worn above the ears, combed forward and smoothed down with wax – all of which suggests a delimited subculture with clear identifying marks. The Pülcher's doings are described as "hanging about" in the outer suburbs of the city, behaving in a generally threatening manner and perpetrating petty thefts. "Once a day," however, "they make a visit to the inner city" with the purpose of watching the changing of the guards at the imperial palace and then follow the band as it marches down the Ringstrasse, often

in such a way that the police have to be called in and the area cordoned off.[44] The attitude toward this type of people is outright hostile in this text, but the brevity and generalization of the description implies that the writer is clumping together semi-criminals with other young men in varying states of desperation.

In depictions of most impecunious young men who were not associated with any specific skilled labour, idleness and slouching are key elements of the portrait. The Pülcher is found, according to a newspaper feuilleton, in the Wiener Wald (the woods outside the city), where "the young, work-shy lads lounge about all day, waiting for a favourable opportunity to commit some roguish misdemeanour."[45] The same terminology crops up frequently in English newspapers. Sometimes it is in the form of letters to the editor complaining about some particular location where men "loiter at the street corners for the want of a better place to go," or where men "standing in groups" are "allowed to block the pavement."[46] One angry letter-writer who has visited a London dockyard even observes that the dock workers adopt a certain gait – the "dockyard step" – the moment they arrive at work, suddenly walking much more slowly and "apathetically" so as to get as little work done as possible. The writer suggests the appointment of someone who can "make those slothful, idle, lazy bipeds that one meets idling about in all parts of our dockyards to 'move on.'"[47] Besides such letters, there are of course numerous reports from the slums making more explicit criminal associations with the "slouching, shirtless grimy fellow standing at the corner, eye[ing] us with ... a furtive, sinister glance."[48] A similar discourse developed around the Stockholm street porters, who were stereotypically seen "standing lazily about the street corners" in the words of the famous poet Gustaf Fröding.[49] A letter to the editor of *Aftonbladet* complains that the porters have taken to assembling in large groups on the pavement of the most heavily trafficked streets of the city, "completely obstructing the passage of passersby," and "if you should tell them, even in the most polite manner, not to obstruct the road, you run the risk of exposing yourself to a diatribe of abusive remarks and mockeries."[50]

The loafing and slouching that so many commentators bring to the fore suggests something beyond a mere condescending dismissal of the lower classes. If we strip these accounts of all evaluative dimensions concerning idleness, delinquency, and lack of morals, we see traces of a way of carrying oneself, a norm of interpersonal indifference and a standard of stern masculinity governing the social life of both skilled labourers and casual labourers waiting for a job to come along. The fact that all observations of this type of behaviour come from public places indicate a performative dimension to it, directed both at other members of the same group and at

passersby from other social backgrounds. It is therefore difficult to distinguish between the internal ritual behaviour of the group and the external manifestations of one's subcultural identity, and there barely seems to be any such distinction in the way these men behave. The kväsarkvanting seemed to adopt his style of walking and raising his shoulders in most situations, and his unique way of dancing was performed in front of outsiders. Naturally, a form of pride is essential to this behaviour, and the foundation of it is a display of extreme confidence. Apparently, for the kväsarkvanting, any sign of weakness or wavering would undermine all attempts to gain respect.

AVATARS OF THE DANDY

Stockholm newspapers of the 1890s occasionally contained observational pieces, similar to the German feuilletons, that consisted of brief descriptions of various urban phenomena, including tram rides, dance establishments, parks, variety theatres, and so on. Through a survey of these, focusing on the 1890s (when the genre thrived), a notion of what types of people were on the Stockholm streets at this time quickly emerges. These groups were, as indicated by other sources, generally clumped into specific stereotypes that spread from newspaper to newspaper, obscuring somewhat the actual street life observed, and supplanting it with a slightly fictionalized and categorized version. It is still possible, however, to extract the basic manifestations of street culture through a close examination of these types.

The types frequently referenced can be divided into the groups described earlier in this study. They include the dandy, the working-class ruffian, the working girl, and various types of elegant or snobbish lady or gentleman. Of the first category, the most frequently occurring embodiment is the aforementioned grilljanne, first established in the weekly *Figaro*, but quickly picked up by the more conventional daily press. The grilljanne corresponds almost directly with the German *Gigerl* and the English "masher." The depictions focus on the dandyism of his attire, the raucousness of his conduct, and the forthrightness of his flirtation, of which the last, according to newspaper accounts, is generally displayed at theatres and music halls. The grilljanne's dress is often described in extraordinary detail, and some aspects of his clothing have a bearing on the grilljanne's body shape and body language. The stereotypical grilljanne wore a short, double-breasted jacket, and over that an "even wider and shorter" yellow overcoat, a high and stiff shirt collar, a cravat "tied in the manner of a ship's mate," and baggy, wide-striped trousers folded at the bottom, and carried a thick cane much too short to be a walking aid.

This attire, which must have been exaggerated somewhat in these mocking descriptions, had the effect of making the grilljanne look much wider from behind at "the part where the birch is applied on unruly little boys" than at the shoulders, giving him a silhouette that would have differed from that of the kväsarkvanting, who emphasized his shoulders and wore bell-bottomed trousers. To the writers in *Figaro*, this way of dressing is incomprehensible, partly because "a really respectable young gentleman would never dress that way, either in Paris, London, Hamburg or Berlin," and partly because it is "neither fashionable nor modern."[51]

Although further comments on the grilljanne in *Figaro* state that he dresses in Viennese style, and the editor admits to having been called a grilljanne himself, the condemnation of this subculture is consistently acidic. The dismissal is founded on the belief that the grilljanne is a parvenu who dresses the way he thinks real gentlemen dress, but is actually a semi-criminal with connections to prostitution and even to a much publicized murder case that was said to have begun in a session of drunken revelry at Jones Grill.[52] There is a constant undertone of uncertainty and defensiveness in the critique that reveals, on the part of the outsider, a fear of social anarchy; for the grilljanne himself, though, it suggests an ironic, self-contained style. He knows his style is not a patch on aristocratic fashion, but neither does he wish it to be.

Because the articles in *Figaro* rarely contain any direct observations of the grilljanne, their practice was somewhat tangled up in the reviewer's ironic language. The term was taken up by daily newspapers, however, especially when reporting on the raucous behaviour of such men in variety theatres, where they were said to conduct themselves with little restraint. According to one account, they were in the habit of "interrupting the performance, shushing and applauding at the wrong moments, address[ing] the performers in a mocking tone and throw[ing] sugar lumps at them, which among these men is considered witty."[53] At another incident, a group of grilljannar, "while shouting unarticulately, bombarded the stage after the end of the performance with bottles and glasses for nearly half an hour, making it virtually lethal to be on the stage at that time."[54] The interesting thing about most reports on grilljanne culture is how newspapers at either end of the political spectrum want to view the grilljanne as an expression of their opponent's side. An article in the leftist *Aftonbladet* writes of them as "upper class" and claims that grilljannar are "not lost individuals from the bottom of the social scale but mostly snobs from its top," while *Figaro* bases most of its critique on the "fake gentility" of these men, looking upon them as men from the working or lower-middle class who bought their fancy clothes on credit. There were surely both impecunious upstarts and rowdy aristocrats in Stockholm nightlife at this

time, but *Figaro*'s version is supported by newspaper notices, such as one about a "gang of so-called grilljannar" who had lived beyond their means, taking supper at fine restaurants and requisitioning carriages, and were now summoned to court for liquidation.[55]

This stereotypical grilljanne upstart and dandy had clear parallels in the English context. The words "swell" and "masher" may not have been completely synonymous to the Victorians, and the latter word seems to have been more short-lived, perhaps denoting something more akin to a passing fashion in male appearance. Both words were used to describe young dandies, however, and although "swell" was often used as a label for a "bona fide" respectable and well-dressed man, it was frequently used in connection with men who wanted to be, rather than were, swells. An elaborate description of the type in an 1886 book entitled *Tempted London* by an anonymous author refers to the "young men in evening dress" who populate variety theatres on late evenings as "mean-minded little snob[s]" and "don their evening dress for the sole purpose of impressing the poor wretched creatures whom they meet with the idea that they fill a better position in life than they really do." According to the writer, these men are under the impression that the other elegantly dressed gentlemen frequenting the same establishments are "genuine," not realizing that "the men they see are little better than themselves." Thus, the men that even the author initially calls swells are soon stripped of their status, and the whole scene is one of one man imitating another, who in turn is imitating the first, and none of them are "real swells." These youths are instead portrayed as "the loafers of the West End, the sons of the big shopkeepers, the smaller members of the Stock Exchange, the livery-stable keepers, the West End wine-bar proprietors, and all those men who, daily brought into contact with gentlemen, fancy they have only to assume the feathers to become counterparts of the bird."[56]

In short, what the author sees is a lower-middle-class phenomenon, an expression of social ambition and a Victorian counterpart to what in the 1990s was termed "the wannabe." Apart from the gaudy dress of these young men, what strikes the observer is their body language, which although only mentioned in passing, becomes an essential part of the characterization. They "loaf" and "swagger about with their hats on the back of their heads and their coats thrown open, and big cigars protruding from their lips." Apart from the age difference, the author could be describing the man in the Mitchell and Kenyon film with his thumbs in his waistcoat. The same comportment is described by other authors who seem to be referring to similar "fake swells." George Augustus Sala makes a brief mention of the gamblers of Regent Street in his book *Twice Round the Clock* in 1859, men who posed as aristocrats, dressed extravagantly in "great white coats, shiny hats, and mosaic jewellery," and who "very nearly

succeeded, by adopting, to drive out" the fashion of wearing a moustache. Sala has little respect for this group of men, and he explains with contempt how "they used to swagger about, all lacquered, pomatumed, bejewelled, and begrimed." Their conduct is defined by its aimlessness and idleness, coupled with a mock-aristocratic arrogance, "skulking, with a half sheepish, half defiant stride up and down Regent Street."[57] The discourse that Sala and the anonymous author are tapping into can be found in several other texts, some dating to the earlier part of the nineteenth century. Dickens describes in one of his essays a type of character "who hang[s] about the stage-doors of our minor theatres in the daytime," and the cocked hat, "swagger" and "conscious air" of this category of men is traceable to the eighteenth-century rake or *sprätthök*.[58] But, looking beyond the language with which this type is presented, we glimpse a confident, arrogant, and subversive way of carrying oneself that seems to have been standard practice among the dandies who dressed above their station and congregated in more respectable surroundings than they might have come from.

The creation of the Viennese Gigerl stereotype is usually attributed to the essayist Eduard Pötzl, who, in a series of feuilletons first published in various Austrian journals and then assembled in book form, gave a concrete shape to the term, which was floating around Vienna at the time in reference to new male fashions and preconceived notions about the type of young men who slavishly followed the new dandyist trends.[59] The question of the Gigerl's counterparts in reality is blurred somewhat by the enormous popularity and spread of the character in media, resulting in various merchandise and several theatrical pieces, and the research tends to focus on the discursive aspect of the Gigerl, thus leaving the question of its reality more or less unanswered. Looking beyond the stereotyping, however, there are aspects in the descriptions of the Gigerl that smack of responses to observed public behaviour. Thus Pötzl portrays the way the Gigerl walks down the street: "With a stooping head and the thick cane fumbling in front of him, the Gigerl negotiates the street. He is a heel walker, for his shoes have barely any heels. His gaze tired and bored, he flatters himself by considering himself jaded."[60] The Gigerl style was characterized by a monocle, large collar, thick cane, short coat, and pointed shoes. The shoes, according to Pötzl, lacked heels, thereby influencing the Gigerl's gait. Pötzl uses the word *Fersengeher* – heel walker – and this description may account for some of the caricatures of Gigerls in which a somewhat slouching walk is emphasized. Such a walk does not fit with the elegant aspirations of the dandy mentioned elsewhere, but Pötzl pays more attention to the Gigerl's "spleen" than to his elegance.

The movement patterns of the Gigerl as portrayed by Pötzl suggests something unsophisticated, almost simian, and yet the character was associated with one or two areas in Vienna where "promenading" was con-

ducted at leisure times: the Wurstelprater and the Sirk-Ecke. The latter was the more exclusive venue of the two, but it was also associated with the Gigerl, thus acquiring an air of pretension among writers who wanted to remain aloof to city life. The Sirk-Ecke was the corner of Kärntner Strasse and Ringstrasse, where the renowned Café Sirk was located, and where the so-called *Korso* – the promenade – began. Pictorial representations of this spot, such as Maximilian Lenz's painting of 1900, show a street of well-dressed middle-class men and women greeting each other as they go along. But the unassuming surface hid an emotive social debate that was going on in the papers, at least. To the more radically minded, this place and its people was the essence of bourgeois pretension and superficiality. In an article commenting on a rumoured price increase on top hats, the Viennese *Arbeiter-Zeitung*, after beginning the piece with the statement: "The top hat is the symbol of the bourgeoisie," speculated jokingly that "perhaps the Ringstrasse Gigerls will decide to protest against the price increase, in the same way as the proletarians protested against an increase in the price of sausages. But it would be a much more pleasant sight to see the gentlemen strutting down the Korso in old and shabby silk hats."[61]

But the apprehensions connected to the Sirk-Ecke and Korso could be tied to any type of social malice. A short poem entitled "Korso" in the satirical journal *Kikeriki* goes as follows:

> How they strut! In finest dress
> From London and Paris tailors!
> Swedish kid gloves, Russian lacquer,
> Bedecked with jewels! But what do they eat?
> On your way home you might see them all
> At Löwy's kosher sausage deli![62]

The fancy men and women *stolzieren* down the Korso now become the target of anti-Semitism, as the anonymous writer sardonically notes that they can all be seen on their way home dropping by the kosher deli, turning the derision of the dandy into a mockery of Jewish social climbing. Anti-Semitism was common in Viennese satirical journals of this period, and especially in *Kikeriki*, where it was often mixed with or expressed similarly to the mocking of Bohemian immigrants. At the same time as these groups were seen as traditional ingredients in Viennese life, they were ridiculed, not seldom with a large dose of contempt.[63] *Kikeriki* stands out in that it sometimes mixes its anti-Semitic undertone with the heckling of the Gigerl.[64] In most other periodicals, Jews are ridiculed separately from the stereotypes of the Gigerl or the Pülcher. It seems that the Jewish stereotype worked on a different level, expressing other sentiments, although, as

Lars M. Andersson notes in his study of Jewish caricature in Sweden, the Jewish caricature often represented the urban, and anti-Semitism could be a way of criticizing what was viewed as negative aspects of urban life.[65] Andersson notes that Jewish characters were often portrayed as dandified upstarts, but with the emphasis on a critique of capitalist mercantilism rather than social mobility and fashion.

Whoever the butt of the joke was, the perception of the people assembling at the Korso and Sirk-Ecke was of a collective theatricality that was becoming easier and easier to make fun of. But its foundation was, at the end of the nineteenth century, still the aristocratic scene that it had been for decades. The Ringstrasse that constituted the Korso had been built in the 1860s to replace the city's medieval walls, and its role is demonstrated by the emphasis put by historians of the city on self-presentation as a key aspect of Viennese society.[66] And while the scorn of the *Arbeiter-Zeitung* probably hides a distaste for the ceremony of the Korso, the poem in *Kikeriki* shows that a criticism of what went on there was often founded in a will to "protect" the ceremonies from unwanted social actors. It is perhaps within this logic that the criticism of the Gigerl fits, pointing to the ways in which his attempts to appear sophisticated and elegant only end in demonstrations of his parvenu character and affectation.

◁ THE CLOSE ASSOCIATION between areas of public display and performative ways of behaving is a commonplace in the turn-of-the-century European city. Vienna and London are especially distinct examples. In London, the "Piccadilly Lounger" became a label for the type of semi-respectable man who spent too much time in the entertainment establishments around Piccadilly, particularly the popular Criterion Bar, which was frequented by "the man who dons evening dress simply to be seen here by his friends."[67] These men were considered to have a special way of walking, dubbed the "Piccadilly crawl" by the press, that was thought to be affected and flamboyant. One writer describes it thus: "It consists of putting out the left leg manfully, as if for a mile race, and drawing the right slowly along, not dragging on the ground, but as if the hip joint were a little out of order."[68] The term was picked up by the authors of music-hall songs, and accounts of music-hall acts claim that several performers made their own impersonations of this eccentric gait, although it is difficult to acquire a vivid picture of exactly how it looked.[69] Nevertheless, it illustrates the link between affected body language and urban spaces that became areas of display, showing both how certain places encouraged a very distinct type of behaviour and how body language easily acquired performative dimensions as a result of the emerging nature of certain spaces.

9

Observations on Urban Body Language II

STAGE-COMEDY STOCK CHARACTERS

BODY LANGUAGE IN ENGLISH MUSIC-HALL CHARACTERS

In English music-hall entertainment, the variation of the acts could be considerable, and yet a closer look reveals several recurring features. These features derived largely from what can be called a narrowly defined set of stock characters, of which the artists made their more or less individual interpretations. The main part of these were impressions of stereotypes that were meant to be depictions of street characters, types that the audience would recognize from their everyday lives. These characterizations were presumably exaggerated, but many commentators of the day made note of how well the performers reproduced traits that could be seen in the street. In contemporary descriptions of such characters, we can see a reflection of the mannerisms of the street and how they were perceived at the time.

Female performers had quite a large array of roles to choose from. Some were very successful with their male impersonations, of which more below, while others saw fit to parody either the pretentious manner of the aristocratic lady or the rough ways of the working-class woman. Of the latter variety, the so-called "coster girl" emerged as a recurring character in many acts. As mentioned in earlier chapters, the costermonger class of impecunious labourers in Victorian England constituted a group of people to whom, because they make their living on the street, a specific culture and an unrefined demeanour were commonly attributed. An interesting

description of how such a character could be performed, and what music-hall critics thought about it, can be seen in a review from the trade journal *The Era* in 1892. The review considers the artist Katie Lawrence, whose performance is "true to life" and not "spoilt by an aggressive, exaggerated, or complicated and unnecessary exhibition of vulgarity, which is unfortunately so common an ingredient in the portraiture of street life." The reviewer seems to have a low opinion of coster impersonations, and he goes on to complain about "some ladies on the music hall stage [who] are apt to think that artistic ends are best served by making the coster-girl of the footlights a shouting, abusive young virago, whose language and manners constitute a libel on her class."[1]

It is evident from this and other reviews in *The Era* that the coster act was seen as, at best, catching something of the way people behaved in the street. The reviewer in this case seems eager to protect the coster class from the humiliation of overly vulgar impersonations, and the fact that Lawrence's "restrained" performance is considered "true to life" is noteworthy. Such respect is not always present, however, as in the notice of another similar performance, on which the reviewer remarks: "We should like all the 'Arrys in London to see her in this character, and to learn how ridiculous they are."[2] Imitating the accent of the cockney, 'Arry and 'Arriet were common terms denoting stereotypical English lower-class members. But what did the performers do that was considered so "true to life"? We must rely on undetailed and fleeting descriptions to get a picture of this. For instance, the performance of a sketch "written in the coster lingo" in which two actors play a cockney couple is reviewed thus: "Miss Roma's volubility and assumed temper reproduce with great fidelity the manners of the lower classes in London life, and Mr W.S. Laidlaw happily catches the walk and mannerisms of the humble trader and barrow-owner."[3] Although the behaviour of the performers is described in passing, we can see what they used to portray their characters, and what the reviewer recalled as typical of "the lower classes in London." As for the female part, "volubility" and "assumed temper" typifies the coster woman's conduct, stressing the outspokenness and irritability perceived as a trait of that type, while the description of the man pays particular attention to his gait.

Overall, body language or mannerisms are not mentioned as frequently in descriptions of female coster characters as in descriptions of their male counterparts. The little we can extract, however, is revealing. Reviewers seem to prefer a restrained and sentimental interpretation of the coster girl character, dismissing attempts at making her too vulgar. Beyond such typical reservations, however, notable performers such as Kate Carney could be applauded for their credibility: "Miss Carney must surely have been a close student of coster life so cleverly does she impersonate the

hard-working folk who earn a livelihood at the street stall."[4] Maybe the critics took a female performer more seriously when they were not distracted by her looks. The successful artist Louie Freear was frequently spoken of as unattractive, but in a report on the successes of her visit to America, the writer notes: "Miss Freear is distinctively English and Cockney. This queer old-young woman, with her feet incased in huge shoes which are yet not suggestive of burlesque – so lifelike is her shuffling gait – with her small figure, her big hands, – and the expression of mingled innocence and shrewdness on her little pinched face, might have stepped out of the pages of Nevinson's stories of London low life."[5] This account shows, perhaps, how female coster acts could be as outlandish as male ones.

However, for more specific descriptions of the performances we must resort to the fuller reports on male performers. Among these, reviews of two of the most famous interpreters of the coster character, Gus Elen and Albert Chevalier, are so explicit as to be quite instructive. "Mr Gus Elen's coster delineations," writes one reviewer, "impress one with the idea that they are careful studies from life. The slouching figure with the discontented expression of face seems to be familiar enough, and the grim humour which is a leading characteristic of every one of this popular artist's stage creations is no less effective than the admirable make-up."[6] This flattering description would probably have delighted Elen himself, who is said to have kept a notebook in which he carefully made notes on how to act and behave when performing his songs, modelling his gestures and expressions on people he had observed in real life.[7] Elen's performance style seems to have been quite unique in its slightly more naturalistic mannerisms, but the slouching posture is recognizable in the stereotypical coster character as we have seen it in other forms. Both the posture and the "discontented expression of face" are still visible in filmed performances of Elen's songs made forty years later, and they seem to build on a slight exaggeration of the seemingly angry and loud-mouthed conduct of the habitual street seller.

A somewhat more nuanced interpretation seems to have been the forte of Albert Chevalier, who was widely considered to portray a more sentimental coster.[8] Contemporary reviews made mention of "the gestures, the facial action, and the walk" of his rendering as being "very similar to those of the London coster."[9] This appraisal is tantalizing, but what were the gestures, and how did he walk? Another report describes, in one of his acts, "the peculiar gestures and antics of the London coster, the manipulation of his 'cady,' the protruding lip, and the inevitable slouching 'walk-round.'" As for the protruding lip, it is difficult to say whether this was widely considered to be characteristic of the coster, but the pulling down of the "cady" – the hat – over the eyes and the slouching walk seem to have

been recognizable to the audience. The reviewer further testifies that in the reviewed performance Chevalier "gave the familiar twist and wriggle."[10] All this is a poor substitute for filmed performances, which in the case of Chevalier, sadly, do not survive. The term "walk-round" betrays, perhaps, the fact that the review is an assessment of one of Chevalier's American appearances, as this term was more common in late nineteenth-century America, where it denoted some sort of brief dance made at the beginning or conclusion of a variety act and seems mainly to have been associated with blackface minstrels.[11] Its occurrence in a piece on Chevalier suggests that his gait had been stylized into some sort of clown-like walk, possibly a precursor of sorts to the famous walk of Charlie Chaplin's tramp character. That it was an exaggeration of reality might perhaps be inferred from the mention of the "twist and wriggle," but the descriptions also give us an idea of how actual people in the street were perceived. A similar walk-round might be the walk that Elen executes in a film of him singing the number "'Arf a Pint of Ale" from 1931, in which he walks round in a circle between each verse, his knees pointing slightly outward and his body bent forward.

Maybe Gus Elen's somewhat aggressive and rowdy style caught something of a signature behaviour among London costermongers. We have seen that men of the lower classes generally were seen to have a slouching gait, but the music-hall caricatures encourage us to ask just how slouching it was, and whether this way of walking could be seen as performative in any way. At the same time, the music-hall context should also be considered as something that might have influenced everyday behaviour. The extremely deep and pronounced way in which some music-hall performers seem to have put their hands in their pockets, for instance, could be seen as a reflection of the demonstratively hard-natured and rough demeanour of the man in the street. The slouching walk that so many reviewers of *The Era* make note of is also something that we have noted in the photographic material, and which has a performative side to it. Historians of the music hall have described the music-hall performance as a complex exchange in which an artist mocks the very types of people who often made up the audience, while the audience laugh at themselves but also at those among them whose behaviour they see as more risible than their own; meanwhile, these distinctions are barely detectable to the outsider or in hindsight.[12] In this way, the music-hall performance both mocked the ways of the lower orders and elevated them to something conscious and clearly defined, thereby perhaps assisting the audience in their formation of a social identity.

When the music-hall performer Ben Nathan was interrupted in his act at the London Pavilion by a heckler, he got his own back by announcing

to the audience, "I will now give you an imitation of the gentleman who has just interrupted me." According to the newspaper report, he did this by "adopting the style, pronunciation, and gait of the coster."[13]

⫷ THE OTHER STOCK CHARACTER of the music hall that is relevant to us is, of course, the swell. There is no need to repeat the details concerning the dress and context of the swell or the masher already described, but reviews of music-hall interpretations of the character of the swell can help to illustrate the body language connected to it and how the body language described by writers was enacted on stage. A word often connected with the behaviour of the swell character is "swagger," which can be used to denote both a way of walking and a general bearing. In an unfavourable review in *The Era* of the performance of one "Mr Phillips," for instance, the critic states that it is not sufficient for performers to "put their faith in a low-crowned hat, a walking cane, a short, tight-fitting coat, a fast style of dress generally speaking, and a swagger supposed to be characteristic of the 'swell.'"[14] Although the artist in this particular case might have been deficient as regards talent, these are attributes that other reviewers point out as emblems of the character. In one review, the portrayal of a masher is described as having "a good deal of outside swagger but a good deal of inside sham." Here the term "swagger" is used to mean merely "confidence" or "conceit," and the continuing description underlines the nature of the masher or swell as a counterfeit gentleman: "Inside his portmanteau, where he professes to carry his clean linen, he has nothing but rags, and underneath his waistcoat there are rags too."[15]

The connection of swagger with gait is also made, however, as in a few notices on the male impersonator Vesta Tilley's performances in America. Here, the third synonym of swell and masher – "dude" – is coming into use, when the reviewer writes of "the swell swagger and the 'dudish' walk" of Tilley's performance as "affectations that can be seen on Broadway any afternoon."[16] Vesta Tilley made her name as an impersonator of male dandies, and the cross-dressing aspect of her artistry tended to make her body language slightly exaggerated, thereby illustrating some of the conceptions surrounding male elegance and flamboyance. In photographs she is often depicted with a walking-stick, one hand held suavely in the trouser pocket, a monocle in the eye. Other reviews of her performances speak of her portrayal of a "sham aristocrat," a "Piccadilly Johnny,"[17] and a "chappie" – all labels for the dandified men who appeared in the elegant venues of London but were not always as wealthy as they wanted to seem. "They are all types that one may see in London's streets every day," writes one critic, "and we are all more or less familiar with them."[18]

There is no doubt that, to many, "the modern swell's conceited strut about the stage" that one *Era* reviewer mentions reflected a practice that

could be seen in real life, and it is not far-fetched to associate the conduct and gait described in these reviews with the body language observed earlier in this book, especially in connection with the walking-stick pose. This becomes evident from a quick study of the preserved images of the various music-hall performers, most of which can be seen on the covers of sheet music. The associations of the music-hall impersonations with real-life types could sometimes be quite concrete. Vesta Tilley's "Piccadilly Johnny" character, writes one reviewer, "with his scrupulously neat, well-groomed appearance, might be seen any day in Bond-street or Rotten-row; and the would-be City swell, who poses as a nobleman, is exactly the sort of young man to be found on Margate Pier in the summer."[19] We recognize here the descriptions and social associations found in the accounts of George Augustus Sala and others, in which the assumed elegance of men who are not of as illustrious a background as aristocrats is viewed with disdain and mockery. But this indicates a vital context for the elegant male body language that we have studied earlier. Poses making use of a walking-stick, or other gestures and movements that aimed at some form of grace or sophistication, were performed within a situation where certain movements had certain connotations. The men who dressed and behaved in the way parodied in the music hall cannot have been oblivious to the way their conduct was perceived, and so although the written record suggests that swagger was seen as a bad thing, the pictorial record, along with the reactions seen in the written record, are strong indications that there were groups of men – perhaps even a certain subculture – who saw swagger and strutting as something positive.

However, there are indications that the simplistic dismissal of the swell as a "sham aristocrat" was not the whole picture. As we have seen, the word "swell" could also be used of a "genuine" gentleman. And when the music-hall reviews refer to such places as Bond Street or Piccadilly, the connotations for the readership would not only have been pretentiousness. The "military swell" was a common term for those former army men who, either in uniform or in a smart suit, lived on their military past, especially as a means of attracting women. One of Vesta Tilley's acts was described as an "English militiaman, with his 'penny cane and bad cigar,' strutting and posing."[20] The "military swell" could also be synonymous with the "Piccadilly lounger," the impecunious young man who had learned to dress well and carry himself in the army but now lived an idle life indulging in superficial pleasures.[21] But the connotations of the term "lounger" were not as negative and as plebeian as for the term "loafer," which also implied idleness and hanging about the street. "Lounger" was a word used for the quite respectable men and women who strolled in the parks or the streets that had become showcases for the rich and famous, such as Pall Mall or Regent Street. As one reads the numerous magazine articles on these areas

of London, it is difficult to keep track of the class distinctions. A general scepticism toward men dressed up and acting with an overconfident air is combined with a matter-of-fact noting of the presence of respectable, even noble, men and women in the same places.[22] This social mix was of course well known to the people who appeared in these places, and the uncertainty concerning whether the man one was talking to was really a gentleman was taken advantage of. This, everyone seems to have been aware of, but the existence of gathering places like these appears to have been necessary enough for people to continue visiting them.

As we have seen, the term "swagger" could be connected both to the swell type and to rougher characters. Does this suggest a kinship between the two, or simply that swagger was associated with masculinity in a broad sense? Probably a bit of both. The swell was often regarded with as much disdain as the Pülcher, and the arrogant conduct of both types elicited the same critical terminology. But both dandy characters and working-class characters seem to have built much of their confidence and performativity on a sort of unbridled manliness, albeit channeled in quite different ways, and the strutting, arrogant walk, even though it might have looked different to an observer, was a result of the self-presentation of both groups. "Swagger is found among pretty nearly all classes of society," states one of the few contemporary articles that addresses the phenomenon directly, adding with irony, "but it prevails mostly among very young men, because, of course, they have done so much more to be proud of than anyone else, and are, consequently entitled to more respect." The article goes on to inform the reader that swagger is best carried out accompanied by "a gushing suit of clothes," and if you cannot afford one you can always get it on credit. "Most young men can put on quite a lot of swagger in a suit of clothes that really belongs to their tailor." The next requisite is a walking stick, "which must be held at the wrong end to let people see that you know what it is meant to be used for." But the most central aspect of swagger is of course the walk. "In walking, you roll yourself from side to side with every step; and as you swing your arms about in the air, that stick will describe pleasant little circles around you, and enable you to take up more room on the pavement. This sets you off much better, especially if the street is at all crowded; and, besides, it gives other people the idea at once that the whole of that side of the street really belongs to you, and that you are letting them have the use of it temporarily."[23]

The somewhat clumsy and overly explicit irony of the piece reveals the author's own frustration with actual encounters with this type of men, but the humour would not have worked if he could not rely on readers' own experiences of this behaviour. Here the swagger is closely associated with the swell or masher, and the expansiveness of the body language is appar-

ent. The description of the walking stick is interesting. The carrying of a walking stick under the arm or in such a way that it became completely distanced from its origins as a walking aid seems to have been a practice indulged in by dandies from varying cultures. It especially became a commonplace in cartoon depictions of the grilljanne in Stockholm, and judging from such images it became common practice to carry the short and thick cane by holding it sticking up from one's pocket. When the accessories of dandyism strayed too far from their practical aspect they became open to criticism from an established discourse that was critical to all forms of unnecessary flamboyance and finery.

STREET TYPES IN AUSTRIAN AND SWEDISH STAGE COMEDY

The Swedish- and German-speaking worlds had variety shows similar to the English music hall, but their characters were somewhat more stylized and intermingled with other forms of entertainment when compared with the English stock characters. German and Austrian variety around the turn of the century contained both popular entertainments directed at the masses, which had the nature of circus performances, and the much-researched high-brow cabarets, which played an important role in the modernist circles. The variety entertainers who acquired material from daily life were mainly the *Volkssänger*, a type of performer originally seen as a singer of traditional songs but whose role evolved into that of popular urban entertainer and comedian. The genre was most vibrant in Bavaria and Austria, and many of the most illustrious Volkssänger worked in Vienna.

The most famous among these was perhaps Edmund Guschelbauer, who was especially popular among the suburban cafés and Prater venues where he regularly performed. His stout frame and round cheeks made him perfect for the role of *der alte Drahrer*, the jolly old man who advocated the hedonistic lifestyle of Old Vienna. A more versatile performer was Josef Modl, who had a wide range, playing everything from the stereotypical *Wiener Hausmeister*, complete with apron and broomstick, to the Gigerl, which of course was a stock character here as well.[24] Other famous singers included Johann Fürst, who according to the contemporary writer Friedrich Schlögl had the ability to capture the soul of the simple people he performed in front of. "He could strike notes that were encapsulated within the heart of every Viennese."[25] Female performers were initially not allowed, but beginning in the 1860s several women became very successful as Volkssänger. The most renowned among them was Emilie Turecek, who became known as "Fiaker-Milli." Her stage persona was highly sexualized,

and she performed both in theatres and private workers' balls dressed in a jockey outfit with tight-fitting short trousers and a riding whip.[26]

Although the way the Volkssänger were described implies a close affinity with the lifestyle and subcultures of the city, the nature of the genre was much more traditional and backward-looking than the English music hall, since the tradition of the Viennese *Volksstück* – popular theatre – stretched back to the eighteenth century.[27] Performers do not appear to have adopted roles through clothing and behaviour in the same way as the English comedians, preferring to appear in formalized clothes that did not contain explicit references to any particular type. When evening dress was not used, traditional folk costume with lederhosen and Tyrolean hat was not uncommon. The references to types were in the lyrics of the songs, and here the conventions seen in the previous chapter were reproduced. One song establishes a scene of a strutting Gigerl:

> A Gigerl goes strutting on the Ring - daradl didl.
> Then a strange man comes walking - daradl didl dadl dum.
> The Gigerl thinks oh I know him - daradl didl.
> That was his tailor, hence he scarpered - daradl didl dadl dum.[28]

The well-worn joke about the dandy who owes his tailor money is dusted off once more. Phenomena of modern or urban life could not be avoided in the *Wienerlieder*, but the form and ideals of the genre were traditional. The nostalgia and hindsight that could be glimpsed in the *Wiener Typen* discourse recurs here with more fervour. Austrian historians Wolfgang Maderthaner and Lutz Musner consider the Wienerlied genre a "culture of transition" in its inherently rural and idyllic nature, contrasting against the urban environment in which it was performed. The Volkssänger's "use of resistance, subversion, and irony against the rationality of modernity" contributed in forming "a myth of community before this dissolved in the anonymity of metropolitan life."[29] But, alongside the nostalgia, the popularity of genres such as this must also be a sign of an enduring folk culture with a more rural character. In the English music hall, this popular culture did not have as vibrant and concrete a rural culture to pick its cultural codes from, and so there it was more readily absorbed by the older urban culture that prospered in industrial cities. Austrian and Bavarian folk culture and folk costume contained certain explicit attributes that, while long since stripped of their original meaning, were reappropriated and are still being used in many modern contexts.

The most prominent stock characters of the Wienerlied genre were the Drahrer and the *Fiaker*, represented respectively by two of the most famous songs: *Weil i a alter Drahrer bin* and *Das Fiakerlied*. The Drahrer was

quite a stereotyped character with a symbolic rather than realistic core. The Fiaker was the Viennese cab driver who, rather than inspiring caricatures by stage comedians, actually often turned into a performer himself, as numerous Fiakers, often seen waiting at the doors of theatres to take the audience home after the show, were found to have good singing voices and transformed themselves into so-called *Fiakersänger*.[30] Unfortunately, we can only guess at the performance styles and body language of the Volkssänger – unlike in the English context, we lack concrete descriptions – but it is apparent that phenomena of urban life were picked up in this form of entertainment as well. The difference is that the established form of Viennese variety entertainment did not feature the explicit caricatures of the English music hall.

Swedish variety entertainment started to grow toward the very end of the nineteenth century, its main venues being in Stockholm. Initially, the theatres hired foreign performers to attract an audience, but by the 1890s an independent Swedish variety scene had emerged. A large part of this scene was, as in the Austrian case, of a nationalistic character with performers in folk costume doing parodies of peasants. This rural comedy was soon joined by performances referencing more urban topics, although the variety genre was consistently viewed as a low and vulgar form of art and was thus devoted very little space in the press.[31] Besides the peasant caricaturists, of whom there were many, the performers given the most attention were probably Sigge Wulff and Anna Hofmann. Both artists had stage personas that fit well within the picture of stage comedy we have acquired so far.

The peasant caricaturists shaped a genre of comedy that lived on well into the twentieth century: *bondkomik* (literally, "peasant comedy" but in extended use related to "ham acting") and *bondkomiker* (peasant comedians) being regular ingredients in variety at least until the mid-twentieth century, after which the genre became increasingly nostalgic. The comedians generally had stage names that emphasized their rural origins – Skånska Lasse, Jödde i Göljaryd, Olle i Skratthult – and they made fun of the dialect and backwardness of rural people, but scholars have debated whether the caricatures were scornful or affectionate, as it is likely that the audiences were to a large extent made up of rural visitors to the urban venues.[32] Photographs of these performers suggest that they made extensive use of exaggerated mimicry in their portrayals of dumb peasants, and by appealing to frames of reference familiar to the audience, they simultaneously made fun of and signalled solidarity with them.

The female performers were generally categorized under the French-sounding term *chansonettes* and appeared in a standardized form of stage costume, mostly consisting of evening dresses or, in some cases, male

white-tie and tails. These performances were viewed by reviewers as tasteful and elegant, although they seem to have contained sexual innuendo enough to allow the artists to embody gender norms while at the same time challenging them. The expectations placed on female variety artists obstructed most attempts at comic characterization in the shape of type caricatures. Comedy derived from sarcastic comments on gender norms and the Swedish version of the English "Ta-ra-ra-boom-de-ay!" became very successful.[33] The most renowned chansonette was Anna Hofmann, who specialized in seductive and flirtatious performances until her established position in the world of variety allowed her to take on other roles. When she played the role of "Fia Jansson" in the 1900 revue *The Gilded Ocarina* (*Den förgyllda lergöken*), the character and the song "Do you know Fia Jansson?" ("Känner du Fia Jansson?") quickly became emblems of popular culture. The role was a caricature of the cocky lower-class girl from the Södermalm slums of Stockholm and appears to have struck a chord with its audience.[34]

Next to the chansonette and the bondkomiker, the grilljanne was probably the most widespread variety character in 1890s Stockholm. This stereotype was turned into a stage character virtually single-handedly by Sigge Wulff, a young artist who rose to fame extremely quickly in the early 1890s and enjoyed a very brief period of popularity before dying from tuberculosis at the age of twenty-two in 1892. The unprecedented success of Wulff's work and the sudden nature of his departure left the audience hungry for more of the same, and several imitators soon sought to fill the gap he had left behind, including one performer who appeared at one of Stockholm's most renowned variety theatres after having bought all of Wulff's original stage costumes.[35] Wulff's showpiece was his impersonation of the grilljanne "Kalle P," a character that quickly entered popular culture and became a synonym of contemporary dandyism. Wulff's characterization was not completely original, however, as he had been inspired by a very popular German comedian named Littke-Carlsen, who toured around Europe with his elegant gentleman stage persona.[36] Littke-Carlsen is often referred to in contemporary accounts as a "dance comedian" and in some instances he is called a Gigerl, performing "side-splitting dandy types and gentleman caricatures" with a type of comedy that was more refined and toned down than what most audiences were accustomed to.[37]

The background to Wulff's grilljanne impersonation complicates the picture of the grilljanne as a subculture unique to Stockholm. This illustrates perhaps most clearly the processes that we have glimpsed repeatedly in this and the preceding chapter, in which a constant interplay of everyday subcultural role-playing and mediated popular stereotyping shapes and reshapes self-identities and tropes of popular culture. It seems to be

an unavoidable consequence of a mediated culture that popular mocking of certain types of people – which appears to represent a general attitude to these people in the period – coexists with the prominence of the subculture or the identity that is the target of the mockery.

CONCLUSIONS: THE INTERMINGLING OF SUBCULTURE AND TYPE

The stereotyping of people in the urban public realm reflects the associations of demeanour and deportment that flowed through popular culture around the turn of the twentieth century. The limited investigations that we have made in this chapter into expressions of such associations provide us with a basis, then, for identifying both some of the potential messages that the studied poses would have contained as well as the various contexts that would have shaped public body language in the age of early modernity. The phenomenon of stereotyping has been linked to the emergence of urban modernity and the objectification of strangers in the growing urban crowd. In one of the rare book-length studies devoted to the subject, Michael Pickering takes his inspiration from the canon of urban sociologists, including George Simmel and Richard Sennett, to identify stereotyping in urban environments as a symptom of urban contingency and commingling, the "other" being in our midst.[38] The more specific subject of the "urban type" or "street type," however, has been seen as more of a nostalgic or idyllic character. Austrian ethnologist Jens Wietschorke identifies the discourse of types as something that reinforces social hierarchies in times of perceived social flux, but he also considers it a part of urban folklore, thereby revealing more complex dimensions in the interplay between representation and performance in the creation and recreation of urban types.[39] The pioneering ethnographer Orrin Klapp distinguished between the stereotype and the social type, noting that "[t]he stereotype is conceived as being in error whereas the social type is in a sense true."[40] Wietschorke speaks of both "folklorization" and "self-folklorization," noting that in urban types we are dealing with "a constant interweaving of medial templates and performative practices: a circulation between street and stage, text and image, social relations and adaptations in popular culture."[41]

The individual agent could thus be seen to take an active part in the making of the type that he or she was associated with. This might, however, not be a question of a person consciously playing the role of a Pülcher, for instance, but rather of acting to fit in with the group he wants be a part of, or impudently acting or overacting the way he knows his prejudiced surroundings will expect of him because of his appearance. Klapp notes

that "a person may think of himself as a tough guy or a good Joe or a smart operator; seeing himself in such a role, he will reject suggestions and group-memberships inconsistent with his self-type and, conversely, he will seek those which build up his self-type."[42] This view is reminiscent of the work of Goffman, who remarked on the tendency of individuals to act according to expectations or according to the requirements of a group.[43] The body language that has been commented on most frequently in the texts consulted in this chapter comprises a concise list of gestures and poses: the arms akimbo pose among women; the slouching, tilting, hands-in-pockets posture of the ruffian; the lazy lounging poses of labourers and porters; and the swagger and strutting gait of various types of dandies. The question is to what extent this body language can be tied to more concrete forms of "self-typing."

The clearest example of a behaviour that signals a group or type identity is perhaps that of the "fake swells" of Regent Street with their "half sheepish, half defiant stride" and their "conscious air." The establishment of an affected or conscious way of walking among certain groups, especially various forms of dandies, is a recurrent theme in the texts we have looked at, and it surfaced in the heel-walking of the Gigerl and in the Piccadilly crawl. Although the descriptions probably exaggerate it, the level of detail and repeated mentions suggest that these men accompanied their very particular way of dressing with a way of carrying themselves that would be certain to distinguish them from others. A slang dictionary published in 1889 explains the term "Piccadilly crawl" as "a languid walk much affected about ten years ago."[44] The conveyance of indifference, haughtiness, and distinction appears to have been key to this way of behaving, and when the gait is related to the contexts that can be ascertained, namely the nature of the places where it was performed, the clothes it was coupled with, and the arrogance that the performers exuded, then the body language comes across as indicative of a self-contained subculture built on a display of self-possession and elegance. It is as if the appearance of elegance and wealth is more important than the actuality of it, in contrast to what is said in advice manuals. The performance is also exaggerated to the point where it is almost a parody of a rich man, and it seems that the behaviour was consciously stylized in defiance of the restrained and sensible conduct codes that were around at the time.

10

Everyday Body Language and Its Contexts

CONCLUDING REMARKS

⊰ NOT EVERYONE AT THE TURN of the twentieth century was a "type" or a conscious member of a subcultural group. The adoption of certain gestures or poses is a semi-conscious aspect of a wider and more complicated combination of role-playing and adaptation to social conventions, but, as the previous chapter illustrated, every pose and gesture had its connotations. It is challenging to combine the notion that people conduct their bodies in a natural and biologically controlled way with a cultural history of poses that suggests nobody could do anything in public without implicitly referring to a specific subtext; however, restricting our focus to the most performative instances of body language, it is apparent that there was a formation of subtexts with specific meanings through the mediation between social group interactions and the exposition of mass media images. In this chapter, I will try to distinguish the various formative contexts of the period in order to give us a wider picture of how everyday practice was shaped by its circumstances and, drawing on the observations of the previous two chapters, perceive what the aspired identifications of that practice looked like. What had the most influence on behaviour at the turn of the century – the media, or the local culture of one's everyday surroundings? Lastly, I will draw on this overview and the observations of the previous chapters to make some concluding remarks on what distinguishes the body language of everyday publicity from that of posed portraits.

The period in focus brought changes to the self-perception and self-consciousness of a larger number of people in Western society than ever before. Photography has been credited with much of this change, and is often portrayed as part of a wider mental transition to modern notions of subjectivity.[1] It is natural to assume the important role of photography in a book such as this, which deals with it so much, but it probably took some time before photography had an impact on everyday behaviour. Toward the end of the nineteenth century, amateur photography started to become more common and to creep into private life. Whereas it had initially been a ritual connected with a special situation – that of dressing up and going to the photographer's studio – it was now something that could be done in private.[2] This meant that the private self also became objectified and codified as a role to a larger extent. Performing was no longer just about the dignified and well-mannered role of the *carte de visite*. The conduct of the private sphere was now also a performance.

But photography was part of something much larger that brought about this change. The growing availability of printed media in the latter half of the nineteenth century carried with it an immense array of potential influences on people's behaviour that cannot be surveyed in its entirety. Through the juxtaposition of photographs and cartoons in the case studies, we have, however, partly revealed how periodical illustration took its cues from daily life and how certain instances of body language that resisted the judgmental gaze of satire indicates a strong connection between bodily cues and identity formations in public interaction. Considering that the press needed to appeal to their readership of average men and women, it is curious to note the often judgmental attitude to phenomena of the day found in periodicals, but the discourse was more complex than that. Media historians have stressed the paradoxical development toward a more "personalized form of address" in order to appeal to as large an audience as possible, imitating, as it were, the intimate tone of the village gossip to an urban public whose sense of commonality was dwindling.[3] This might partly explain the emergence of publications catering to specific groups of readers based on political opinions, class, or cultural preferences. A majority of the media around the turn of the century adopted a viewpoint they thought corresponded to the mindset of the newspaper-reading upper-middle class, who had the money and the reading habits necessary to buy periodicals on a regular basis. At the same time, commodity culture resulted in the coexistence of apparently contrary messages, combining the exhortations of restraint and discipline with encouragements of display and excess in fashion and self-presentation.[4]

The aforementioned *Girl of the Period Miscellany* grew out of a rebuke toward young women who behaved in unsuitable and forthright ways, but became a satire on the moralism that had coined the term "Girl of the Period" and portrayed girls who indulged in both "feminine" activities such as shopping and more liberated and male-coded practices such as hunting or sporting.[5] Correspondingly, journals directed at male readers could support a variety of different masculinities, ranging from the uproariously flamboyant and predatory *The Masher: A Journal for Gentlemen*, published in only a few issues in 1883, which promoted a decadent lifestyle of drinking and flirting, to the openly gay discourse of *The Artist*, which hid its content in wordplay that was apparent to anybody who understood its code.[6] The majority of printed material from the nineteenth and early twentieth centuries upheld conventional and conservative notions about gender, class, and conduct, but this study shows if nothing else that challenges to these notions existed outside of the press, and so it is in the margins of the written world that we must look for contexts of the forthright behaviour that was common in the period. The study of the emerging comic strip genre has become something of a labour historian's media history in that it tends to emphasize – possibly overemphasize – the working-class and subversive aspects of this type of fiction. David Kunzle has argued that comic strips could allow themselves to be more rebellious and subversive by passing as children's fare even though adults also read them.[7]

It has been suggested that the proliferation of periodicals toward the end of the nineteenth century was a reflection of the new urban experience, especially the illustrated magazines and the multitude of content of various types assembled side by side.[8] Alongside the jumbled and crowded nature that was customary in various types of periodicals and readerships, different journals catered to different people. Thus, divisions of identity were created at the same time as the common traits of periodicals created correspondences in identity. The affinities that were established through print culture were fluid and multi-faceted. An individual might identify with the messages of several different channels with diverse and perhaps even incompatible values, thus inscribing multiple identifications.[9] The late nineteenth century was also the first time in history when people could become exposed to images and messages that they did not actively choose to take in, simply by traversing the public sphere. The abundance of advertisements on omnibuses, hoardings, and sandwich-board men, together with the close encounters with people from various walks of life and of various cultural affiliations, made it impossible not to become affected by the dissemination of fashions, social and occupational identities, and clashes of conduct codes.[10] Historians have concluded that this condition resulted in a suppression of the most glaring and diverse outer

appearances, triggering a conformity in fashion and ways of behaving.[11] In this study, we have seen that such superficial conformity coexisted with more subtle signals of individuality and flamboyance.

The period from around 1880 until the First World War has been designated as the first period of lower-class leisure, when labourers and other impecunious work groups had more free time and more money to spend on entertainment.[12] This affected both the content of popular culture and the social geography of the public realm. The changes in popular culture have been charted to some extent, and scholars have especially identified the importance of comic-strip journals such as *Ally Sloper's Half-Holiday* and variety entertainments whose visual spectacles presaged the introduction of cinema,[13] but only recently have the connections between new popular cultures and everyday practice been addressed. Media studies of the institutionalization of cinema in local communities show how new forms of media such as the moving image were implemented by adopting existing structures of entertainment and business, and how the lower-class or rural audiences of early cinema initially saw this medium in terms of earlier forms of itinerant entertainment, gradually adapting their perspective from a primary predilection for broad comedy to the introduction of classical drama.[14] New types of leisure activities emerging in the early twentieth century, both in Britain and on the Continent, were essentially continuations of popular cultures of the late nineteenth century, being both publicizations of middle-class activities and commercializations of working-class activities that mediatized previously local or situated cultures.[15] Although many driving forces came from business imperatives and authorities, the process was dependent on the taste of the broad audience. Thus, the bodily ideals and conceptions that were disseminated had complex connotations.

The depiction of women as objects of male desire could be channelled through many different media, not least that of advertisement posters, which were one of the most prolific and accessible avenues of publicity in the growing contemporary celebrity culture. The use of idealized female figures in posters is generally associated with the French context and the advertising of the café-concert dancers in the works of artists such as Toulouse-Lautrec and Jules Chéret. These images served to establish a mental connection between the female body and cultures of leisure and consumerism, but the conjunction of this medium with a time of changing gender roles also meant that the depictions of active and dominant women that were uncontroversial in advertisements for department stores or commodities introduced an expansive female body language into the popular culture of the time, making the audience more used to unrestrained female conduct through a sphere other than that of contested suffragette

politics.[16] The increasing tolerance of women using the akimbo and other expansive poses in public that we see toward the end of our period of study was thus a consequence of an expanding dissemination of such poses in popular culture, especially spreading to the cultures of practice of the middle classes.[17] Lower down the social scale, women were not, presumably, in as great a need of mediated role models to increase the effrontery of their conduct, although the popularity of female variety and music-hall artists would have affected notions of identity in such spheres as well.[18]

Young women in the late nineteenth century years lived under the influence of several forthright women who appeared both on stage and in the media, as noted in the previous chapter. Although the late nineteenth century in some ways constituted a preamble to the growing celebrity culture of the early twentieth century, there was hardly a celebrity culture before the turn of the century that introduced personalities in ways as full and unavoidable as film stars would later establish. Advertisers had not yet begun to make use of entertainment figures in their campaigns, and the celebrity status of a singer or a dancer was still much like the identity of a sideshow curiosity or a mountebank.[19] On the other hand, there is little doubt that variety performers enjoyed quite an elevated status, especially among the urban lower classes. This was probably a larger phenomenon in England, where certain music-hall entertainers became household names, although it has been fervently discussed whether these artists should be considered working-class role models, or icons created through carefully manipulated publicity campaigns.[20] The simple backgrounds of music-hall performers were often emphasized in articles, suggesting a plebeian appeal, but also a developed knowledge among the artists of how to market themselves. The personas of entertainers catering for the lower classes were not wholly defined by working-class ideals or attributes, however, and music-hall performers could promote both respectability and licentiousness. In the case of female performers, however, the energy and forthrightness of their acts were in themselves signs of both sexual objectification and a female culture of outspoken behaviour more widespread than one might think. Writings on female stage performances in the *fin-de-siècle* tend to contrast these with the passivity and weakness of feminine ideals at the time, but this picture ignores the underlying, and perhaps somewhat hidden, culture of female effrontery that we have detected here.[21]

More essential than the immediate contact between audience and performer was probably the depiction of performers on billboards and in pamphlets and magazines. Exposure to printed images was rapidly becoming more and more overwhelming over the course of the nineteenth century, and most types of images, from flyers and advertisements to broadsides and commodity labels, contained images of human figures

that mediated mentalities surrounding the body. By the end of the nine-teenth century, such images were available to virtually everybody in Euro-pean society, and although this exposure decreased the farther one lived from the cities, the distribution of periodicals and advertising made rural dwellers part of this culture as well.[22] Although the reproduction of photo-graphs in the press began in the 1860s, it was not to become widespread until the 1890s, a fact that plays down the importance of photography as a shaping factor in everyday conduct. Rather, it is the place photography would take in the current media landscape that prompted, in the words of Helena Wright, "the dissemination of photography's syntax into other media."[23] So, even though it is difficult to make specific claims about the influence of a certain media channel on the way people behaved in every-day life, it cannot be denied that the subjection to mass media images was by the time of the turn of the century quite all-encompassing throughout Western Europe.

But the images and values disseminated by modern media were not im-posed on a world completely devoid of other mentalities and ideals. There-fore, it is also necessary to consider what people did with the media images that reached them. The study of scrapbooks and photo album collages is a growing field of research that illustrates the way middle-class women cre-atively appropriated and adapted external material within their own per-sonal sphere.[24] On a more plebeian level, links between what people read and how they behaved were mostly made in moralist debates surrounding popular reading matters such as "penny dreadfuls," the cheap instalment fictions that became popular especially among young boys in the latter half of the nineteenth century. In this case, penny dreadful readership was associated with crime rates, but from the perspective of the readers, these pamphlets contained enticing stories of colonial adventure, detec-tives and pirates.[25] Besides infusing a sense of escapism and a longing for travel in their readers, these fictions replaced earlier cheap books on fig-ures derived from folklore and history with themes of crime and love that appealed more directly to the readers' yearnings, and their settings were more recognizable to their intended audience.[26] Alongside written fic-tion, fads and crazes introduced through music and the stage seeped in to people's everyday lives. Popular songs such as "Ta-ra-ra-boom-de-ay" and "The Lambeth Walk" in England or the "Calle P" songs of Sigge Wulff in Sweden became points of reference in street jargon and youth interaction, and the phenomenon of street dancing became common in working-class neighbourhoods.[27]

In many ways, then, popular culture came closer and closer to the world of its audience. Is it thus possible to presume that, taken together, innov-ations such as photography and cheap print allowed a greater number of

people to look upon representations of themselves and people like themselves, which in turn created a parallel, "fictitious" version of their own reality? The fact that the production of idealized media images and popular fiction exploded, together with the increasing propensity for realism and portrayals that lay close to the lived reality of readers and spectators, might have contributed in shaping a modern sense of everyday performativity.

EVERYDAY INFLUENCES ON EVERYDAY IDENTITY

Behaviour in public places, the focus of inquiry in this book, can be said to be shaped by both "situationally active" and "situationally non-active" factors. This means that the way a person behaves in a certain situation is potentially conditioned both by the norms and conventions that usually define such a situation and by the values, role models, and ideals that have already been fostered within that person and that have come to her through the images, books, and other influences that she has been exposed to over a long time. These two aspects are closely interrelated, but to identify their characteristics it is helpful to consider them in turn. Having looked at some of the potential mass media influences that may have shaped a person's behaviour around the turn of the twentieth century, we now turn to the everyday influences. These have surfaced continually throughout this study, and given our choices of photographic material, certain – hopefully representative – spaces have become relevant. The spaces referred to are mainly spaces of leisure – parks, promenades, markets – but the people observed in these places have come from all walks of life – stallkeepers, servants, porters, schoolgirls, office workers, etc. I will conclude this chapter by considering the specific subcultural nonverbal behaviour observed through this investigation, but first it is necessary to look at some of the main conditions of appearing in urban public spaces of this period.

Moving about in urban public space in the late nineteenth century was conditioned by territoriality, social divisions, and assumptions about spatial authority. Where you went and how you were perceived there depended on who you were. Or who you appeared to be. Manipulating perceptions could be easily achieved by adopting fashions that emulated other social groups, and the resulting movement and anonymity of cities meant that conduct and appearances were increasingly situational, transient, and performative.[28] Some people took advantage of this transience, but others did not, and so there were both groups of people who adopted a dress that did not reflect their social background in order to blend into strange areas of the city, and people who had no need to hide their social belonging when visiting other areas. Examples of the latter may be various types of labourers who worked in prosperous areas, such as porters,

drivers, and builders. But even these groups adopted, as we have seen, a behaviour that was in some ways performative, as they needed to communicate their identity and their attitude to their surroundings. This communication perhaps became even more important and thus even more explicit when they visited strange areas. The condition for this behaviour was the increasing awareness of urban spectatorship in the public street.

The late nineteenth-century street has frequently been described by historians as a place of spectatorship in which women participated according to the conditions imposed by men and subjected themselves to an immodest male gaze. Lately, scholars have stressed that this picture is one-sided, and that women enjoyed a greater freedom of movement and publicity than has been acknowledged. Lynda Nead has called the late-Victorian metropolis a "world of scopic promiscuity, where the exchange of looks is constant and potent." In an article published in 1862, conservative English writer Eliza Lynn Linton remarked that women can go about the streets without being harassed or stared at only by acting in a modest and discreet manner, slipping "through a crowd unobserved" like a "gray moth." Writings like this were certainly reactions to women negotiating the public streets more and more freely, not only being the object of a male gaze but also actively participating in the exchange of glances.[29] This culture of impression management corresponds with notions that we have observed here concerning the effrontery and coquetry of female public conduct among both lower-class and middle-class women. Restrained body language could signal both actual feelings of inferiority or vulnerability, and more self-conscious strategies for encouraging pity or sympathy in the surroundings. This and more male modes of flamboyance or flirting would have been influenced by current norms of courtship or male-female interaction. Coexistent with a more dominant discourse of spectatorship was an interactive culture of spectatorship in which men and women looked at each other.

The culture of urban courtship and flirting among young men and women often contained quite specific rituals, both in the lower and the upper middle classes, even though the structures differed considerably. The restrictive and organized manner of courting that was the ideal among wealthy urban dwellers was contrasted by a permissive youth culture found both in the impecunious spheres of the large cities and among the farmers of the province. In rural Sweden, a strictly delimited period of youth, from the time of church confirmation at the age of about fifteen until marriage, was a time of relative sexual liberty, and rural youths engaged in barn dancing and the ritualized practice of "night courtship," whereby the young men of the village went on a nightly round to the local young women to allow the girl to choose one of them to let into her house

and share her bed with, fully dressed in a platonic but physically intimate ceremony in which the parties could "try out" their respective proposed fiancées.[30] Although this practice does not seem to have lived on in urban areas, night courtship is an illustrative example of how lower-class courtship was both physically expressive and governed by regulations. A corresponding example from the English Victorian and Edwardian city is the culture of the "monkey parade," in which the young men and women of working-class neighbourhoods would parade along the area's central street and look each other up and down in order to pick out a suitable partner. This ceremony was generally accompanied by dressing up – both among men and women – and other social indulgences such as singing.[31]

But this culture of flirting was not limited to the lower classes, as people at the time and some later historians have assumed. The monkey parade had counterparts in the parks and promenades, and there are indications in contemporary descriptions of these venues that the class distinction between them was not as clear-cut as one might think. But, more to the point, the aspirations and motivations of the participating flirters were the same, and a display of masculinity and femininity characterized all of the various arenas. The nineteenth-century city offered numerous types of places where flirting and courting could go on – parks, amusement establishments, local transport, museums, shops – and, for the labouring classes, there were many opportunities for interaction, such as that between patrolling policemen and chambermaids, or servant girls going on errands to the butcher, baker, or grocer.[32] The hidden nature of homosexual interaction sadly obscures it from most of the sources used here, but even in the overtly heterosexual courtship rituals there was a range of conceptions of masculinity and femininity, from the effeminate dandy to the rough and rugged lounger, from the coquettish girl to the brash and forward "rasper."

Expressions of everyday popular culture were numerous in this period, and it is difficult to chart their influence on conduct, but on a general level a number of striking aspects can be noted. As mentioned above, the culture of muscular masculinity has been detected in highly varied parts of *fin-de-siècle* culture, from militarism and religion to public schools and working-class street fighting. Numerous scholars have connected shifts and anxieties in masculinity to the changes in social life that occurred during this period.[33] Above all, perhaps, the attention to superficial appearances was the factor that created the types of displays we have seen in this study, and which brought to the fore conflicting performances of ruggedness and elegance. Similarly, the performances of young women oscillated between coquettishness and brashness through a number of vague but time-specific roles, including that of the shop girl, office girl,

and street girl. In public appearances, then, the tension between respect-ability and frivolity was tangible, but to the people of the time it may not necessarily have been contradictory.

CONCLUSIONS: EVERYDAY PERFORMATIVE PRACTICES AND THEIR OBJECTIVES

With the preceding contextualizations, it is now possible for us to sketch a more concrete overview of how individuals could use their body language to perform roles in turn-of-the-century streets, and what subcultural iden-tities lay behind everyday practices. The poses that formed the starting point of our investigation were sometimes assumed in ways that lay close to their stereotypical forms, but they were often tweaked in some way to correspond with the individual's self-presentation. There were "ideal types" of various poses, postures, and gestures that were spread mainly through print culture but also through their adoption in everyday life. The perform-ance of the poses studied here suggests that everyday practice both – and sometimes perhaps simultaneously – adhered to and tactically adjusted externally imposed ideal types of bodily practice. The tactics of body lan-guage that emerged through the defiantly "incorrect" performance of a pose had subcultural inclinations, but also conformed to the ideals repre-sented by the pose's ideal type.

The question then presents itself whether the ideal type sprang from a dominating discourse or whether it was simply the most regular form of the pose. This is a question to which no certain answer can be pro-vided, but the occasional criticism of some of the poses as early as the eighteenth century shows that even a pose that was representative of a bodily ideal in one time could have been decried as pompous or uncivil-ized only a few decades earlier. Body language changes both quickly and slowly. On a general and distanced level, the changes are barely visible over centuries, but close up, the changes in detail from one decade to the next are apparent. The way the holding of the long skirt in a manner resembling an akimbo pose became necessary for women negotiating the late nineteenth-century street is an example of how a practice founded in necessity became imbued with new meaning, both objectifying the pub-lic woman and symbolizing her self-assumed independence. The various ways in which a man could carry his walking-stick, some more indicative of subculture than others, similarly demonstrates how varying perform-ances of poses in different times held potent meanings. Fashionable styles of walking, such as the Piccadilly Crawl or the Alexandra Limp, are also examples of short-lived body language cultures whose connotations were quickly forgotten in a few years.

As Connerton noted, the repertoire of gestures and poses accessible to a human being is always limited. But the limitations are cultural more than physical, which suggests that bodily conventions are deep-seated and change slowly. Therefore, any historical study of body language focusing on a specific period cannot avoid making observations that say something about the specific period and about a more long-term process. Akimbo arms, contrapposto, and other stances we have not explored, such as crossing the feet at the ankles with the unsupported foot held sideways and resting lightly on the toe, signalled certain things in the 1890s, but were at the same time the same poses with the same basic messages as they had conveyed perhaps as much as a century or even two centuries before. What we can chart, then, are mainly very vague and unverbalized agreements about how people interpret a pose, and it is always difficult to separate time-specific interpretations from interpretations that might have been the same had we analyzed the pose in an earlier or later period. It also makes it difficult to locate the border between a natural and a contrived pose in a certain time.

What Connerton and Gilman tell us is that the dichotomy of positively charged upright posture versus negatively charged slouching posture is a basic assumption in Western culture. Having acknowledged this, however, we can add nuances to the picture. Although an assertive slouching posture would always contain an element of opposition or subversion, we can see that the tacit norms of everyday practice were more permissive. In the encounter with a prying photographer, a male labourer would often pose aggressively with his pelvis protruding, but in a leisurely or unguarded moment just about anybody, even in the nineteenth century, would allow himself or herself a looser posture than the ideal permitted. What might have started out as a consciously oppositional behaviour could also develop into an unreflected convention among certain groups or in certain situations. Upper-class men in the lounges of gentlemen's clubs, upper-middle-aged women interacting at a street market, or young women hobnobbing among intimate friends are some examples that complicate the picture.

The correlation between convention and discreet but, in their time, glaring bodily tactics suggests a world where agency and noncompliance adapted itself to modern anonymity and conformity rather than being suppressed. All the poses we have examined more closely are ambivalent: some are more elegant and others more provocative, but all have the potential to send out completely different messages depending on how they are carried out. What this shows is that public conduct was a battleground between differing conceptions of a limited set of bodily tropes. The body and clothing set the boundaries for what movements were possible, and

so conflicting factions had to struggle for the prerogative of a certain pose or gesture. The conflicts were often resolved by resorting to petty details – it was *how* you performed a pose that mattered, rather than *what* pose you performed. There was thus a conflict between discursive behavioural ideals, mainly expressed in writing, and the nonverbal ideals shaped through practice. Both sides would have claimed that they were aiming at expressing things such as elegance, grace, or attractiveness, but they had discrepant definitions of such concepts and how they should be expressed, the discursive definition emphasizing restraint and classical posture, the practised ideal emphasizing expansiveness and a commanding presence.

Many of the poses we have looked at confirm the established picture of the mentality of this period – signalling alertness, elegance, thrift, delicacy, grace. But looking at the way it was performed in everyday life allows us to adjust that established picture by seeing how the mentality incorporated instances of exaggeration, irony, flirting, and ostentation. More to the point, the blueprint of the mentality was never reproduced in complete correspondence with real life. The real-life version of the *belle époque* was based on everyday tactics and constituted a more unruly, disparate, and creative reappropriation of the principles of the blueprint. In the tactical navigation of the scene of emerging modernity it was necessary to play a role befitting the ideal, but one that was balanced by situational flexibility, resulting in a behaviour that passed from one role to the next depending on the situation. Everyone identified with a particular role, or "self-type," and communicated this identification foremost in their clothing, but there is always a discrepancy between the person one wanted to be and the person one could not help being.

The blueprint, the ideal types, existed perhaps only on paper, but they were real ideals in the sense that people aspired to them in their everyday behaviour. These aspirations resulted in what Goffman would call formalized displays of identity. However, the various ritual and cultural practices that contributed in shaping public conduct and street performativity were intermingled to such an extent that it is almost impossible to disentangle them and draw borders between them. Neither is this necessary, for they did not constitute separate compartments in the culture of practice at the time. Instead, the culture of everyday practice that we have studied here comes across as an amalgamation of overtly conflicting prescriptive and permissive notions, combining respectability and subversiveness. The culture of practice was neither bourgeois nor working-class at its core, apart from the socially stratified ideals behind certain public roles. The public sphere was a place of both ostentation and leisure. Work was conducted in the street, but constantly we see roadworkers or porters striking a leisurely pose between physical efforts. Most of the poses in focus here illustrate

the combination of performativity and the need for relaxation that everyday public places induced. One was always in public and therefore always in need of conveying one's identity.

I have refrained from using the word "role" too much as a term for the aspired performances detected in public, simply because I assume that the performances we have observed must be taken as something more than just the playing of roles. People identify with these performances – even if they are very much performances – to an extent that calling them roles would rob them of the performers' belief in them. Taking inspiration from the social-type theory developed by Wietschorke and his talk of "self-folklorization," we might term the aspired performances "self-typing," since it has become clear from the studies here that many people in their everyday practice aimed at imitating or emulating ideals or types that they had been fed with either through their social life or – as might have been increasing – through popular media. They wanted to express themselves as members of a diffuse and invisible collective. Sometimes this collective was distinct enough to be termed a subculture, but often the aspirations were quite vague. If – for the sake of clarity – we wish to identify the self-types that the body language in focus here seems to have aspired to, then the list can be made simple: the walking-stick poses aspired to a "dandy self-type" or a "gentleman self-type" (the unclear border between these two caused, as we have seen, much consternation); the withdrawing female poses, when at their most self-conscious, aspired to a "coquette self-type"; female akimbo poses aspired to a "brash girl self-type"; the trouser-pocket pose aspired to a "lounger self-type"; and the waistcoat pose aspired to a "proud" or "self-made self-type." These terms are rather approximate in order to encompass as wide a scope of behaviour as possible, but thereby I think they correspond with the level of exactness that most everyday conduct aims at. Some conduct is more precise, and the "lounger self-type" could in such cases be called a "cockney subculture" or a "*kväsare* subculture," and the "dandy self-type" could be called a "masher subculture." In other cases, it could be much less precise, conceding that everyday practice is not always performative, or at least not self-consciously performative. It should also be noted that these self-types can overlap, various types of poses connecting to one self-type, several self-types making use of one pose performed in slightly varying ways, etc.

What the self-typing shows is that people in the late nineteenth and early twentieth centuries were not as interested as their counterparts a century later in expressing individuality. Their notion of individual expression was to a large extent bound up in collective identities. The conditions and form of public conduct had undergone vital changes since the premodern period, most notably the waning of solid occupational or social roles as

a result of the increasing social mobility and anonymization that accompanied democratization and urbanism. This meant that the way people dressed and behaved had become homogenized. Social distinctions were thus made on a more detailed level, training people to observe how one wore one's jacket or what type of gait one had.[34] This state also affected body language, making a rather limited set of bodily tropes the accepted poses of the majority of people. At the same time, however, homogeneity in dress and appearance meant that movement, posture, and pose were the only means that people had left to convey something more specific about who they were. And it seems that when many things were evolving towards homogeneity and a subdued personal expression in public life, body language thrived and became one of the main arenas for social mobility, if not in actuality then at least in aspiration.

A more direct study of the emergence of modern mass media and its impact on human behaviour – if such a study is possible – might have shown the influence that the dissemination of social ideals or types had on everyday practice. A recurring observation about this is that media contributed in distributing upper-class ideals and making them visible as something that could be attained by the lower orders. Less considered is the possibility of the opposite – that media distributed lower-class types and made them aspirational for the upper strata. The cockney caricatures of *Punch* were hardly ideals for the readers who laughed at them, but the increasing tolerance of expansive and lounging body language, in both women and men, might have been helped by media images, at least in the first decades of the twentieth century. Innovations in conduct are seldom, if ever, introduced through overt and norm-challenging practices. Instead, those groups who have an intentional goal of instituting new forms of behaviour often find that they must do this by initially clothing it in the guise of established norms, while overt expressions of the new conduct can often be conveyed quite without opposition in other arenas, such as advertising and popular culture. Thus, for instance, "New Women" cyclists were obliged to don the external appearance of respectability for their culture to become accepted, and the earliest expressions of a forthright and expansive female conduct is mainly found in the dance advertisement posters and music-hall performances that had no concrete ideological agenda and were often acting out of an interest in profit or entertainment; ironically, these arenas facilitated the aims of the more criticized women's movements.[35] Historians of dress have also demonstrated how cues in nonverbal behaviour such as clothing can introduce subversive or original messages more easily than verbal culture, and that the innovations pioneered nonverbally often take hold unconsciously. This is possible thanks to the more vague and implicit nature of nonverbal culture, and a novel way

of dressing, for instance, may at first be an unspecific or playful whim that eventually takes on a social message as the nonverbal symbols "change to correspond with changing definitions of social roles and structures."[36]

Most of the male poses in this time exude some sort of containment, a confidence expressed physically by displaying complete control of one's body, elegant gestures, and hands close to and often high on the body. In this way the body techniques almost become the message, the message being that "I am in complete control of myself" or "I am my own man" or "I am a world unto myself." But there are also the slouching poses or female akimbo poses, which are more about addressing the surroundings with aggressive messages of "Keep out!" "What are you looking at?" "You want a piece of me?" These poses are adapted to a world of looking, a world where one's picture can be taken at any minute. The adaptations made are either accepting, making oneself look as elegant as possible for the close-up, or insubordinate and obstinate, using body language as a sort of weapon. In both cases, the body language is appropriated and infused with attitudes symptomatic of the time. In some sense, it is a climax of the development that started in the early-modern period toward elegant poses expressing civilization and self-control: the renaissance elbow, the walking-stick choreography, etc. This is the type of performative pomposity that was to be deconstructed in the twentieth century and connected to self-delusional oppressive Western hegemony.

The upright posture that we often associate with the nineteenth century and the poses of *carte de visite* portraits was not as hegemonic as one might think. As Gilman has shown, it emerged in the early modern period from militarism and court culture, coexisting with the carnivalesque and rowdy culture that was not necessarily its opposite.[37] In the nineteenth century, it was made the ideal of numerous cultural expressions (militarism, etiquette, dancing, sports) but it was simply a discourse that still lived alongside the expansive and rowdy behaviour that some recent historians have called the customary mentality, the indulgence in violent and disruptive forms of entertainment that the culture of respectability allowed.[38] The hegemony of the upright posture was to be finally undermined after the Second World War, when militarism could no longer claim its honourable basis, but already in the nineteenth century the expansive body language started to establish itself as the ideal of the "cool" and the progressive. During the twentieth century it would strengthen more and more its hegemonic position in Western popular culture, especially gaining support in the latter half of the century, when youth culture and challenges to the restrained manners of earlier generations started to become accepted. Now, the culture of gentlemanliness and etiquette have been consigned to the status of subculture.

Coda

THE DECLINE OF THE GRACEFUL IDEAL, OR
HOW HITLER BECAME RIDICULOUS

⫷ I BEGAN THIS BOOK WITH the picture of nineteenth-century body ideals that we generally encounter in books and representations of the period. A study of body language around the turn of the twentieth century cannot avoid considering the ideals of reserved and civilized behaviour that are so intimately associated with that time. We know, however, that these ideals constitute little more than a "discourse," a general mentality penetrating various levels of society in terms of obligations and standards, but that at the same time are not always consistent with how people ultimately choose to behave. The surveys of the first two chapters described this discourse in ways that corresponded with how it could be expressed in other spheres, such as law, politics, or philosophy. But the closer we moved to sources that captured the body language of everyday practice rather than of the ideal, the less relevant this discourse became.

A discursive analysis of written material can never grasp the whole nature of a historical period. Studying texts – especially those that are taken to express ideals or discourses – will always produce a one-sided picture that underestimates the role of everyday interaction and the influence of "ordinary people" (meaning people who were not writers or journalists) on the spirit of the age. Both the working-class housewife, the well-dressed but struggling shopgirl or junior clerk, and the well-off but obscure young heir at the margins of society had ways of thinking and behaving that cannot be represented by analyzing George Gissing, Karl Kraus, or August Strindberg. The division between discourse and everyday practice is

never absolute, of course, and in the case studies we noticed frequently how everyday practice often implicitly referred to, or made allowance for, various discursive notions about the body. But the aim of this study was to investigate how people used body poses in expressing themselves in everyday life, and in order to answer this, everyday practice must be allowed to take up more space than the discourse.

Doing a historical study on something purely nonverbal is bound to be an experiment, and it is difficult to say what the outcome of it will be, or even if the results will be as concrete as in a more conventional study. The case studies of street photography do not lend themselves as easily to general conclusions about the period, but the picture they collectively assemble certainly balances the discursive picture. A focus on everyday practice reveals how the "tactics" of people's everyday behaviour play a part in reshaping discursive influences and changing the ideals of conduct. As we have seen, everyday practice is seldom an outright rebellious opposition to the disciplining discourses, or a submissive compliance with the ideals of the discourse, but something in between, constantly adapting to various circumstances and the definition of a certain situation. In almost all cases, the body language we have observed follows quite collective norms rather than being individualized, but the norms are adapted more to the conditions of interpersonal contact in the public sphere than to the standards of portrait poses. All everyday behaviour is extroverted, or at least directed at an audience with the aim of getting across a message. In many of the poses studied, flirting and courtship were the purpose, and when the situation was not an outright male-female encounter, then a sense of display was present all the same.

But the display and performativity were not always about flirting. They were also a matter of asserting an identity to people from other groups. In this endeavour, elegant and restrained bodily ideals clashed with expansive and slouching poses, turning the public realm into a battleground between conflicting notions of masculinity and femininity. To some extent this was a clash between people of differing social backgrounds who wished to assert their own identities and belongings when confronted by people from other backgrounds in the public sphere, but, at the same time, expansive body language cannot be ascribed to just a certain group of people. The groups that were more prone to expansive poses in public were often those that had a wider definition of what the private sphere encompassed, but it seems that the ubiquity of public appearance also made it virtually impossible for people from all walks of life to avoid public expansiveness. So, while the nineteenth century to some degree saw a wider distribution of the civilized, upright ideal, the growth of the urban public

realm simultaneously meant that a certain amalgamated conduct norm emerged, subduing the most violent gestures but encouraging a rough and thick-skinned exterior.[1]

But what happened to this development in the twentieth century? Many scholars have considered the twentieth century as the century of informalization after the civilizing process. Chief among these theorists is Cas Wouters, who in an attempt to chart the continuation of Elias's civilizing process into the twentieth century has proposed that manners have grown less rigid and formal and that interpersonal relations have grown more flexible and less hierarchical.[2] Wouters has been backed up in this Elias-inspired thesis by English sociologist Stephen Mennell in a work on the role of informalization in modern American society.[3] Similarly, English historians such as Martin Wiener and Mark Girouard have noted the decline of manners and of the gentlemanly ideal from around the First World War until the 1970s, which would probably correspond with the popular notion that people were much more relaxed and liberated by the end of the twentieth century than at the beginning of it, and, more nostalgically, that manners have declined and no one holds the door open for a stranger anymore.[4] This line of reasoning has been criticized by scholars who point to the possibility that "shifts in formality and informality might be turns of the wheel of fashion" and that new forms of self-presentation require just as much grooming and preparation as old ones.[5] Old areas of self-control have been replaced with new ones, and historian Peter Stearns has remarked that the twentieth century actually ushered in increased anxiety over conduct as the external support made up by Victorian moralism was replaced by internal impulses.[6]

Although some of the observations made here might be seen to support the notion of informalization, I believe that, when taken together, the evidence of late nineteenth and early twentieth-century street photography points to a different picture. What we have seen here is certainly that *fin-de-siècle* behaviour was much more outgoing and expansive than the stereotypical view of the age accounts for, but also that the loose and easy body language that can be seen to grow more common and start to establish itself as accepted body language was not more informal than the upright and disciplined body language. To view a slouching man as more natural than a straight-backed man would only be to apply the biased outlook of our own period to a phase of history. The modern search for authenticity that many theorists speak of leads only to new forms of performativity.[7] We think that a loose posture is more natural than a straight posture simply because that is the ideal of our own time. In fact, what the evidence suggests is that one ideal of acting natural was supplanted by another ideal of acting natural. The Victorians did not think one should

be unnatural. To them, a straight back and graceful gestures were the embodiment of natural behaviour. And the slouching posture that began, perhaps, as an ideal among labouring men, was – and is – just as much a performative ideal as the upright posture.[8]

What we glimpse in the period in focus here, then, is how a loose body language starts to establish the strong position it would eventually have in the late twentieth and early twenty-first centuries. In the late nineteenth century, we are still a long way from hip-hop culture and slackers, but the culture of the "new girl" and the masher, and the hopelessness with which respectable culture tried to stave them off, are the first stages on the way. As pointed out by Marcus Collins, however, respectability and manners held quite a strong position well into the twentieth century.[9] The process that finally undermined it must in some way be connected to some of the major events of that century, which brings me to the subheading of this chapter. Before the Second World War, a man like Adolf Hitler could still attract the admiration and trust of a majority of people. After the war, at least in the parts of the world that had been deeply affected by this ex-perience, the militaristic pomposity and inflated self-importance of a man like Hitler were a joke. Comedy of the postwar era derived many laughs from mocking the behaviour and body language of the German dictator, continuing in a tradition that had emerged both inside and outside Ger-many during the war.[10] Of course, this hypothesis should not be taken too far. A respect and belief in leaders – military and otherwise – continued even in the allied countries in the latter half of the twentieth century, and the mocking of pompous leaders is a recurring aspect of cultural history, but this development and other parallel trends on a more everyday level must have contributed to paving the way for a hegemony of youth and counter culture from rock 'n' roll via hippie and punk culture to the age of hip-hoppers, slackers, and The Dude.[11]

We like to think of ourselves as being at, or close to, the end of a pro-gression toward natural and liberated behaviour, but one need not make a deep study of the past to be reminded that history only evolves, it does not progress. This superior attitude toward history sometimes risks affecting even the academic study of history, when we fail to consider the divers-ity of a historical period and rely too much on one aspect of it. This is sometimes done with the nineteenth century, when sources derived from the literate sections of society are used to form a general picture of the period. In this book, I have tried to give due attention to the unwritten side of things, to the nonverbal or to the parts of life that are often silent in conventional histories of the age. This has indicated that the histor-ical study of nonverbal communication is difficult and requires a different methodology than the use of written sources, but it has definitely shown

that a discursive analysis of the written material can never grasp the whole nature of a historical period. Whenever historians allow their notion of a period to be shaped in disregard of everyday interaction and unwritten culture, then the picture they paint will be incomplete and biased. In all historical ages, everyday life and the doings of ordinary people have had a considerable impact upon the current culture and mentality. To believe otherwise is only wishful thinking.

Appendix

BIOGRAPHICAL NOTES ON THE MAIN PHOTOGRAPHERS INCLUDED IN THIS STUDY

PER BAGGE, 1866–1936

Swedish photographer, based in Lund, who made his living primarily as a portrait photographer. Around the turn of the century he began to document the streets of Lund, taking an increasing interest in the changing urban scene in the early twentieth century.

SAMUEL COULTHURST, 1867–1937

Manchester-based photographer who took part in the Manchester photographic survey to document the city for historical and social reasons. Coulthurst was originally a bookseller who became a member of the Manchester Amateur Photographic Society. In the 1880s, the Society decided to photograph "old buildings and picturesque nooks" that were threatened by demolition. Coulthurst made use of a hand-held "detective camera" so as not to draw attention to himself. Some accounts claim that he went around disguised as a rag and bone merchant with his camera hidden on a cart.

PAUL MARTIN, 1864–1944

French-born amateur photographer who moved to England when young. In the early 1890s he acquired a Fallowfield "Facile" camera, which was camouflaged to look like a brown paper parcel carried under the arm. In

this way he began taking pictures of people in his spare time, mainly in the London markets and at seaside towns.

EMIL MAYER, 1871–1938

Bohemian-born lawyer who lived most of his life in Vienna. Mayer taught himself photography and was a member of several local amateur photographic societies, eventually becoming president of the Wiener Amateur-Photographen-Klubs. He also published several articles and books on technical aspects of photography. Most of his work was undertaken with a hand-held camera in the streets of Vienna. In 1938, Mayer and his wife committed suicide after the Nazi annexation of Austria.

LINLEY SAMBOURNE, 1844–1910

English cartoonist, draughtsman, and book illustrator famous for his drawings for *Punch*. He took up photography initially as an aid to his drawing, but during the last decade of his life he began to photograph young women, mainly in the streets surrounding his London home, but also when holidaying by the seaside. He made use of a concealed camera, and the purpose and ethics of these images have been debated.

AUGUST STAUDA, 1861–1928

Austrian photographer born in Bohemia. He was working as a clerk when he was taught the art of photography by his uncle. In 1885 he opened his own studio in Vienna. He worked mainly as an architectural photographer, giving most of his attention to the old buildings of Vienna that were threatened by new urban developments. Although the subject of the images is the architecture, many contain portraits of the local inhabitants.

ERIK TRYGGELIN, 1878–1962

Artist and photographer born and based in Stockholm. Tryggelin made his name as a realist painter among the generation of artists who emerged after late nineteenth-century naturalism but before the establishment of modernism. Tryggelin's art is completely focused on depictions of Stockholm life, and at an early stage he began to use photography to gain inspiration for his paintings. Tryggelin's images are close-up photos of people in the street, and it is likely that he used an easily concealed detective camera to take pictures of people unawares.

Notes

ABBREVIATIONS

BFI British Film Institute
LUL Lund University Library
MA Manchester Archives
RBKC Royal Borough of Kensington and Chelsea Archives
SCM Stockholm City Museum
SFI Swedish Film Institute
WM Wien Museum

INTRODUCTION

1 The most influential works relative to bodily discipline include Norbert Elias, *The Civilizing Process: The History of Manners and State Formation and Civilization* (Oxford: Blackwell, 1994) and Michel Foucault, *Discipline and Punish: The Birth of the Prison* (New York: Vintage Books, 1975). Overviews include Anupama Rao and Steven Pierce, eds, *Discipline and the Other Body: Correction, Corporeality, Colonialism* (Durham, NC: Duke University Press, 2006) and Michael Sappol and Stephen P. Rice, eds, *A Cultural History of the Human Body in the Age of Empire* (Oxford: Berg, 2010).

2 Work on premodern carnival culture is extensive. For the nineteenth century, see Robert D. Storch, ed., *Popular Culture and Custom in Nineteenth-Century England* (London: Croom Helm, 1982) and John Carter Wood, *Violence and Crime in Nineteenth-Century England: The Shadow of Our Refinement* (London: Routledge, 2004). On sexuality, see Peter Gay, *The Bourgeois Experience: Victoria to Freud*, 5 vols (Oxford: Oxford University Press, 1984–1998). On alcohol, see Gina Hames, *Alcohol in World History* (London: Routledge, 2012).

3 Extensive research has been carried out on topics such as dress, tattoos, and dance, to name a few examples.

4 Lytton Strachey, *Eminent Victorians* (London: Chatto and Windus, 1926 [1918]), vii.

5 On the overrepresentation of verbal perspectives in Victorian history, see Peter K. Andersson, "How Civilized Were the Victorians?," *Journal of Victorian Culture* 20, no. 4 (2015): 439–52.

6 Discussions of this approach can be found in Liz Wells, ed., *Photography: A Critical Introduction* (London: Routledge, 2015) and *History and Theory* 48, no. 4 [theme issue: Jennifer Tucker, ed., *Photography and Historical Interpretation*] (2009).

7 See especially the work of Alan Trachtenberg (see chapter 2, note 34, in this volume) and Christopher Pinney (see note 50 below), but also Elizabeth Edwards's consideration of photography as a material practice in her study *The Camera as Historian: Amateur Photographers and Historical Imagination, 1885–1918* (Durham, NC: Duke University Press, 2012).

8 Leading theorists of the gaze are Rosalind Krauss, W.J.T. Mitchell, Hal Foster, and Allan Sekula.

9 Martin Jay, "Cultural Relativism and the Visual Turn," *Journal of Visual Culture* 1, no. 3 (2002): 262–78. Jay's view is mirrored by Andy Grundberg: "Photographs are no longer seen as transparent windows on the world, but as intricate webs spun by culture." Andy Grundberg, *Crisis of the Real: Writings on Photography, 1974–1989* (New York: Aperture, 1990), 101.

10 Joel Eisinger, *Trace and Transformation: American Criticism of Photography in the Modernist Period* (Albuquerque: University of New Mexico Press, 1995), 269. I use the term "postmodernism" here in full realization of its heterogeneous nature. My motivation for using it comes from Geoffrey Batchen's characterization of the "consistent view of the photograph [that] has come to occupy the center stage of critical debate" as "postmodern." Geoffrey Batchen, *Burning with Desire: The Conception of Photography* (Cambridge, MA: MIT Press, 1997), 5.

11 On the material turn in general, see Tony Bennett and Patrick Joyce, eds, *Material Powers: Cultural Studies, History and the Material Turn* (London: Routledge, 2010). On the material turn in Victorian studies, see Jennifer Sattaur, "Thinking Objectively: An Overview of 'Thing Theory' in Victorian Studies," *Victorian Literature and Culture* 40, no. 1 (2012): 347–57. On the spatial turn, see Ralph Kingston, "Mind Over Matter? History and the Spatial Turn," *Cultural and Social History* 7, no. 1 (2010): 111–21, and Peter Bailey, "Adventures in Space: Victorian Railway Erotics, or Taking Alienation for a Ride," *Journal of Victorian Culture* 9, no. 1 (2004): 1–21.

12 On this debate, see Joyce Appleby, Lynn Hunt, and Margaret Jacob, *Telling the Truth About History* (New York: Norton, 1994), 261, and Richard J. Evans, *In Defence of History* (London: Granta, 1997), especially 76–80 on the vital distinction between facts and evidence.

13 Jennifer Tucker, "Entwined Practices: Engagements with Photography in Historical Inquiry," *History & Theory* 48, no. 4 (2009): 1–8.

14 See Geoffrey Batchen, "Seeing and Saying: A Response to 'Incongruous Images,'" *History & Theory* 48, no. 4 (2009): 26–33.

15 Elizabeth Edwards, *Raw Histories: Photographs, Anthropology and Museums* (Oxford: Berg, 2001), 20.

16 Julia Peck, "Performing Aboriginality: Desiring Pre-contact Aboriginality in Victoria, 1886–1901," *History of Photography* 34, no. 3 (2010): 214–33.

17 Ruth Rosengarten, "Exhibition Review: Performing for the Camera," *Photography & Culture* 9, no. 2 (2016): 187–91.

18 One historian who seems to share my reservations about the pessimistic view of photographic evidence is Peter Burke. See his *Eyewitnessing: The Uses of Images as Historical Evidence* (London: Reaktion Books, 2001), 24–5.

19 Marianne Hirsch, *Family Frames: Photography, Narrative, and Postmemory* (Cambridge, MA: Harvard University Press, 1997), 6.

20 Beth Muellner, "The Photographic Enactment of the Early New Woman in 1890s German Women's Bicycling Magazines," *Women in German Yearbook* 22 (2006): 167–88.

21 Reflecting on the desire of some street photographers to be invisible, Geoff Dyer mentions American photographer Walker Evans's trick of putting a lens on the side of his camera, allowing him to photograph people unaware while he appeared to be pointing his camera in another direction. *The Ongoing Moment* (London: Abacus, 2005), 12–13.

22 See Colin Westerbeck and Joel Meyerowitz, *Bystander: A History of Street Photography* (London: Little Brown Books, 1994) and Clive Scott, *Street Photography: From Atget to Cartier-Bresson* (London: I.B. Tauris, 2007).

23 Scott, *Street Photography*, 60.

24 On the potential of street photography for the study of pedestrians and on rejections of the "decisive moment" school, see Joe Moran, *Reading the Everyday* (Abingdon: Routledge, 2005), 88–93.

25 Penny Tinkler, *Using Photographs in Social and Historical Research* (London: SAGE, 2013), 37. For uses of photography in ways that combine critical theory with a consideration of the motif, see Stephen Brooke, "Revisiting Southam Street: Class, Generation, Gender, and Race in the Photography of Roger Mayne," *Journal of British Studies* 53, no. 2 (2014): 453–96, and Jane Hamlett, "'Nicely Feminine, Yet Learned': Student Rooms at Royal Holloway and the Oxford and Cambridge Colleges in Late Nineteenth-Century Britain," *Women's History Review* 15, no. 1 (2006): 137–61.

26 Tinkler, *Using Photographs in Social and Historical Research*, 41.

27 Meir Wigoder, "Some Thoughts about Street Photography and the Everyday," *History of Photography* 25, no. 4 (2001): 368–78. Carol Armstrong has expressed wariness concerning what she calls the "automatism" of street photography, stressing that the conscious agency of the photographer and the lack of control of exactly what happens in front of the camera are "thoroughly interlocked." I would argue that this analysis pertains more to artistic street photographers from the 1920s onward than to the pioneers of the genre at the turn of the century. Carol Armstrong, "Automatism and Agency Intertwined: A Spectrum of Photographic Intentionality," *Critical Inquiry* 38, no. 4 (2012): 705–26.

28 Sander L. Gilman, "'Stand Up Straight': Notes Toward a History of Posture," *Journal of Medical Humanities* 35, no. 1 (2014): 57–83.

29 See Christine Walther, *Siegertypen: Zur fotografischen Vermittlung eines gesellschaftlichen Selbstbildes um 1900* (Munich: Königshausen & Neumann, 2006) and Fiona Kinsey, "Reading Photographic Portraits of Australian Women Cyclists in the 1890s: From Costume and Cycle Choices to Constructions of Feminine Identity," *International Journal of the History of Sport* 28, nos. 8–9 (2011): 1121–37.

30 Anja Petersen, *På visit i verkligheten: Fotografi och kön i slutet av 1800-talet* (Stockholm: Symposion, 2007); Solfrid Söderlind, *Porträttbruk i Sverige 1840–1865* (Stockholm: Carlsson bokförlag, 1993); Peter Larsen, *Ibsen og fotografene: 1800-tallets visuelle kultur* (Oslo: Universitetsforlaget, 2013).

31 Kenneth L. Ames, "Posture and Power," in *Death in the Dining Room and Other Tales of Victorian Culture* (Philadelphia: Temple University Press, 1992).

32 See Jan Bremmer and Herman Roodenburg, eds, *A Cultural History of Gesture: From Antiquity to the Present Day* (London: Polity Press, 1991) and Michael J. Braddick, ed., *The Politics of Gesture: Historical Perspective* (Oxford: Oxford University Press, 2009).

33 Marcel Mauss, "Techniques of the Body," republished in *Sociology and Psychology: Essays* (London: Routledge, 1979).

34 Maurice Merleau-Ponty, *Phenomenology of Perception* (London: Routledge, 1962) and *The World of Perception* (London: Routledge, 2008).

35 Pierre Bourdieu, *Outline of a Theory of Practice* (Cambridge: Cambridge University Press, 1977).

36 David Swartz, *Culture and Power: The Sociology of Pierre Bourdieu* (Chicago: University of Chicago Press, 1997), 26.

37 Nick Crossley, "Body Techniques, Agency and Intercorporeality: On Goffman's *Relations in Public*," *Sociology* 29, no. 1 (1995): 133–49.

38 Erving Goffman, *Gender Advertisements* (London: Macmillan, 1979), 1.

39 Paul Connerton, *How Societies Remember* (Cambridge: Cambridge University Press, 1989).

40 Herman Roodenburg, *The Eloquence of the Body: Perspectives on Gesture in the Dutch Republic* (Zwolle: Waanders, 2004).

41 Gareth Williams, "Popular Culture and the Historians," in *Making History: An Introduction to the History and Practices of a Discipline*, ed. Peter Lambert and Philipp Schofield (London: Routledge, 2004).

42 David Matsumoto and Hyi Sung Hwang, "Cultural Influences on Non-verbal Behavior," in *Non-verbal Communication: Science and Applications*, ed. David Matsumoto, Hyi Sung Hwang, and Mark G. Frank (London: SAGE, 2013); Christoph Wulf and Jörg Zirfas, eds, *Die Kultur des Rituals: Inszenierungen, Praktiken, Symbole* (Munich: Wilhelm Fink Verlag, 2004); Barbara Korte, *Body Language in Literature* (Toronto: University of Toronto Press, 1998), 27.

43 Adam Kendon, *Gesture: Visible Action as Utterance* (Cambridge: Cambridge University Press, 2004).

44 The division was originally introduced by Edward T. Hall in *The Hidden Dimension* (New York: Anchor Books, 1969). The terms "expressive" and "reserved" are from Matsumoto and Hwang, "Cultural Influences on Non-verbal Behavior."

45 Allan Mazur, "Interpersonal Spacing on Public Benches in 'Contact' vs. 'Noncontact' Cultures," *Journal of Social Psychology* 101, no. 1 (1977): 53–8; Martin S. Remland, Tricia S. Jones, and Heidi Brinkman, "Proxemic and Haptic Behavior in Three European Countries," *Journal of Non-verbal Behavior* 15, no. 4 (1991): 215–32; Martin S. Remland, Tricia S. Jones, and Heidi Brinkman, "Interpersonal Distance, Body Orientation, and Touch: Effects of Culture, Gender, and Age," *Journal of Social Psychology* 135, no. 3 (1995): 281–97.

46 See Matsumoto and Hwang, "Cultural Influences on Non-verbal Behavior" and David Matsumoto and Hyi Sung Hwang, "Non-verbal Communication: The Messages of Emotion, Action, Space, and Silence," in *The Routledge Handbook of Language and Intercultural Communication*, ed. Jane Jackson (London: Routledge, 2012).

47 Michel de Certeau, *The Practice of Everyday Life* (Berkeley: University of California Press, 1984).

48 John Fiske, *Understanding Popular Culture* (London: Routledge, 2010), 18. When speaking of popular performativity, the highly influential work of Judith Butler might be inspiring, but it is not excessively helpful in that it does not consider individual agency in the way I wish to do here. Butler's most relevant notion for the present discussion is probably that of "subversive bodily acts." However, discrepant or deviant practices in everyday life are seldom explicitly or self-consciously subversive. Judith Butler, *Gender Trouble: Feminism and the Subversion of Identity* (New York: Routledge, 1999).

49 See, for instance, Rosalind Crone, *Violent Victorians: Popular Entertainment in Nineteenth-Century London* (Manchester: Manchester University Press, 2012); Karl Bell, *The Legend of Spring-Heeled Jack: Victorian Urban Folklore and Popular Cultures* (Woodbridge: Boydell Press, 2012); Wolfgang Maderthaner and Lutz Musner, *Unruly Masses: The Other Side of Fin-de-Siècle Vienna* (Oxford: Berghahn, 2008); Mike Huggins, *Vice and the Victorians* (London: Bloomsbury, 2016); Lynn Abrams, *Workers' Culture in Imperial Germany: Leisure and Recreation in the Rhineland and Westphalia* (London: Routledge, 1992).

50 Ginzburg's method is highlighted by photographic historian Christopher Pinney as a helpful way of analyzing pictorial material. See "Introduction: How the Other Half …," in *Photography's Other Histories*, ed. Christopher Pinney and Nicolas Peterson (Durham, NC: Duke University Press, 2003), 6–8. See also Burke, *Eyewitnessing*, 32–3.

51 On opera mimicry in the nineteenth century, see Mary Ann Smart, *Mimomania: Music and Gesture in Nineteenth-Century Opera* (Berkeley: University of California Press, 2004). On bullfighting posture, see Reza Hosseinpour, *Making Sense of Bullfighting* (Seville: Punto Rojo Libros, 2014), 98–9.

CHAPTER ONE

1 *The Habits of Good Society: A Handbook for Ladies and Gentlemen* (London: J. Hogg and Sons, 1859), 282, 309.

2 John H. Young, *Our Deportment, or the Manners, Conduct and Dress of the Most Refined Society* (Detroit: F.B. Dickerson & Co, 1884), 30.

3 Michael Curtin, "A Question of Manners: Status and Gender in Etiquette and Courtesy," *Journal of Modern History* 57, no. 3 (1985): 395–423; Cas Wouters, *Informalization: Manners and Emotions since 1890* (London: SAGE, 2007), 23; John Tosh, "Gentlemanly Politeness and Manly Simplicity in Victorian England," *Transactions of the Royal Historical Society* 12 (2002): 455–72.

4 Emilie Flygare-Carlén, *Jungfrutornet* (Stockholm: P.B. Eklunds förlag, 1869), 7.

5 *Svenska turistföreningens årsskrift* (Stockholm: Wahlström & Widstrand, 1892), 134.

6 Richard Jefferies, *Field and Hedgerow: Being the Last Essays of Richard Jefferies* (London: Longmans, Green and Co., 1900), 89.

7 See, for instance, Hannu Salmi, *Nineteenth-Century Europe: A Cultural History* (Cambridge: Polity Press, 2008), 79.

8 See Timothy J. Gilfoyle, "The Urban Geography of Commercial Sex: Prostitution in New York City, 1790–1860," *Journal of Urban History* 13, no. 4 (1987): 371–93.

9 Stephen Marcus, *The Other Victorians: A Study of Sexuality and Pornography in Mid-Nineteenth Century England* (London: Weidenfeld & Nicolson, 1966), 77–84.

10 Michelle Perrot, ed., *A History of Private Life IV: From the Fires of Revolution to the Great War* (Cambridge, MA: Harvard University Press, 1990), 174, 341; Peter K. Andersson, *Streetlife in Late Victorian London: The Constable and the Crowd* (Basingstoke: Palgrave Macmillan, 2013), 205, 246n103.

11 The lack of social outlets for women often led to mental illness. See Karin Johannisson, "Dårskap och kultur. Om heliga flickor," in *Mänskliga gränsområden: Om extas, psykos och galenskap*, ed. Lars Bergquist and Johan Cullberg (Stockholm: Natur & Kultur, 1996).

12 Jenny Birchall, "'The Carnival Revels of Manchester's Vagabonds': Young Working Class Women and Monkey Parades in the 1870s," *Women's History Review* 15, no. 2 (2006): 229–52; Andersson, *Streetlife in Late Victorian London*.

13 Quoted in Karen Volland Waters, *The Perfect Gentleman: Masculine Control in Victorian Men's Fiction, 1870–1901* (New York: Lang, 1997), 21.

14 Lotta Holme, *Konsten att göra barn raka: Ortopedi och vanförevård i Sverige till 1920* (Stockholm: Carlsson bokförlag, 1996); Angela Wichmann, "The Historical Roots of the *Gymnaestrada*: National Gymnastics Festivals in Nineteenth-Century Europe," in *Power, Politics and International Events: Socio-Cultural Analyses of Festivals and Spectacles*, ed. Udo Merkel (London: Routledge, 2014).

15 Sander L. Gilman, *Seeing the Insane: A Cultural History of Madness and Art in the Western World* (New York: John Wiley & Sons, 1982), 207, 230; Michelle Perrot, ed., *A History of Private Life IV*, 664–7.

16 David Yosifon and Peter N. Stearns, "The Rise and Fall of American Posture," *American Historical Review* 103, no. 4 (1998): 1057–95; Ute Frevert, ed., *Militär und Gesellschaft im 19. und 20. Jahrhundert* (Stuttgart: Klett-Cotta, 1997), 219.

17 Mary Mosher Flesher, "Repetitive Order and the Human Walking Apparatus: Prussian Military Science versus the Webers' Locomotion Research," *Annals of Science* 54, no. 5 (1997): 463–87.

18 Valerie Steele, *The Corset: A Cultural History* (New Haven: Yale University Press, 2001), 13.

19 Ibid., 36.

20 Brent Shannon, *The Cut of His Coat: Men, Dress, and Consumer Culture in Britain, 1860–1914* (Athens: Ohio University Press, 2006), 118.

21 Barry Emslie, *Speculations on German History: Culture and the State* (Rochester, NY: Camden House, 2015), 119–20; J.A. Mangan, *Manufactured Masculinity: Making Imperial Manliness, Morality, and Militarism* (London: Routledge, 2012); Sverker Sörlin, "Nature, Skiing, and Swedish Nationalism," *International Journal of the History of Sport* 12, no. 2 (1995): 147–63.

22 Dror Wahrman, *The Making of the Modern Self: Identity and Culture in Eighteenth-Century England* (New Haven: Yale University Press, 2004).

23 Ibid., 318.

24 See ibid., 101, 103, 113–17; George L. Mosse, *The Image of Man: The Creation of Modern Masculinity* (Oxford: Oxford University Press, 1996), 5, 61, 97–8; Salmi, *Nineteenth-Century Europe*, 112–23.

25 Norbert Elias, *The Civilizing Process: The History of Manners and State Formation and Civilization* (Oxford: Blackwell, 1994), 445–6.

26 Michael Rosen, *Dignity: Its History and Meaning* (Cambridge, MA: Harvard University Press, 2012), 31–5. See also Phillip Anthony O'Hara, *Encyclopedia of Political Economy* (London: Routledge, 1999), 471.

27 Charles Taylor, *Sources of the Self: The Making of the Modern Identity* (Cambridge: Cambridge University Press, 1989), 15.

28 Charles Taylor, *Philosophical Arguments* (Cambridge, MA: Harvard University Press, 1995), 226–30.

29 Matthew McCormack, *The Independent Man: Citizenship and Gender Politics in Georgian England* (Manchester: Manchester University Press, 2005), 37–44.

30 Glynne Wickham, "Gladstone, Oratory and the Theatre," in *Gladstone*, ed. Peter J. Jagger (London: Hambledon Press, 1998).

31 Mangan, *Manufactured Masculinity*, 156; Gertrud Pfister, "Cultural Confrontations: German *Turnen*, Swedish Gymnastics, and English Sport – European Diversity in Physical Activities from a Historical Perspective," *Culture, Sport, Society* 6, no. 1 (2003): 61–91.

32 See John Kucich and Dianne F. Sadoff, eds, *Victorian Afterlife: Postmodern Culture Rewrites the Nineteenth Century* (Minneapolis: University of Minnesota Press, 2000); Asa Briggs, "Victorian Values," in *In Search of Victorian Values: Aspects of Nineteenth-Century Thought and Society*, ed. Eric M. Sigsworth (Manchester: Manchester University Press, 1988); Eric J. Evans, *Thatcher and Thatcherism* (London: Routledge, 2013), 154.

33 See Bernhard Giesen, *Intellectuals and the Nation: Collective Identity in a German Axial Age* (Cambridge: Cambridge University Press, 1998), 111.

34 See Jonas Frykman and Orvar Löfgren, *Culture Builders: A Historical Anthropology of Middle-Class Life* (New Brunswick, NJ: Rutgers University Press, 1987).

35 Wouters, *Informalization*; Cas Wouters, "How Civilizing Processes Continued: Towards an Informalization of Manners and a Third Nature Personality," *Sociological Review* 59 (2011): 140–59.

36 See Sander L. Gilman, "'Stand Up Straight': Notes Toward a History of Posture," *Journal of Medical Humanities* 35, no. 1 (2014): 57–83, and Christopher J. Smith,

"A Tale of Two Cities: Akimbo Body Theatrics in Bristol, England, and Spanish Town, Jamaica," *American Music* 33, no. 2 (2015): 251–73.

37 On these types of topics, see Mike Huggins, *Vice and the Victorians* (London: Bloomsbury, 2016); Rosalind Crone, *Violent Victorians: Popular Entertainment in Nineteenth-Century London* (Manchester: Manchester University Press, 2012); Wolfgang Maderthaner and Lutz Musner, *Unruly Masses: The Other Side of Fin-de-Siècle Vienna* (Oxford: Berghahn, 2008).

38 Stefan Richter, *The Art of the Daguerreotype* (London: Viking, 1989), 5.

39 Elizabeth Anne McCauley, *A.A.E. Disdéri and the Carte de Visite Portrait Photograph* (New Haven: Yale University Press, 1985), 11–13, 41–2.

40 Lara Perry, "The Carte de Visite in the 1860s and the Serial Dynamic of Photographic Likeness," *Art History* 35, no. 4 (2012): 728–49.

41 Peter Burke, "The Renaissance, Individualism, and the Portrait," *History of European Ideas* 21, no. 3 (1995): 393–400.

42 Perry, "The Carte de Visite in the 1860s"; Marilyn F. Motz, "Stockholm: Natur & Kultur Visual Autobiography: Photograph Albums of Turn-of-the-Century Midwestern Women," *American Quarterly* 41, no. 1 (1989): 63–92; John Plunkett, "Celebrity and Community: The Poetics of the *Carte-de-Visite*," *Journal of Victorian Culture* 8, no. 1 (2003): 55–79.

43 This theory is developed in Crary's two famous but debated books, *Techniques of the Observer: On Vision and Modernity in the Nineteenth Century* (Cambridge, MA: MIT Press, 1990) and *Suspensions of Perception: Attention, Spectacle, and Modern Culture* (Cambridge, MA: MIT Press, 1999).

44 Severe criticism of Crary's sweeping theories has been formulated primarily by W.J.T. Mitchell. See his *Picture Theory: Essays on Verbal and Visual Representation* (Chicago: University of Chicago Press, 1994), 19–24.

45 Vanessa R. Schwartz and Jeannene M. Przyblyski, "Visual Culture's History: Twenty-first Century Interdisciplinarity and its Nineteenth-Century Objects," in *The Nineteenth-Century Visual Culture Reader*, ed. Vanessa R. Schwartz and Jeannene M. Przyblyski (New York: Routledge, 2004). This characterization is inspired by Walter Benjamin's "The Work of Art in the Age of Mechanical Reproduction," reprinted in the same volume.

46 Giorgio Agamben, "Notes on Gesture," in *Means Without End: Notes on Politics* (Minneapolis: University of Minnesota Press, 2000).

47 This view was established by Pierre Bourdieu, and few scholars have had the idea that he could be wrong. See Pierre Bourdieu, *Photography: A Middle-Brow Art* (Cambridge: Polity Press, 1990), 113, 172; Steve Edwards, *The Making of English Photography: Allegories* (University Park: Pennsylvania State University Press, 2006), 75.

48 See Mette Mortensen, *Kampen om ansigtet: Fotografi og identifikation* (Copenhagen: Museum Tusculanum Press, 2012).

49 Michael L. Carlebach, *Working Stiffs: Occupational Portraits in the Age of Tintypes* (Washington: Smithsonian Institution, 2002), 47–52.

50 John Ibson, *Picturing Men: A Century of Male Relationships in Everyday American Photography* (Chicago: University of Chicago Press, 2002), 51–8.

51 Wolfgang Kaschuba, "Protest und Gewalt: Körpersprache und Gruppenrituale von Arbeitern im Vormärz und 1848," in *Transformationen der Arbeiterkultur*, ed. Peter Assion (Marburg: Jonas Verlag, 1986).

52 Diana Crane, *Fashion and Its Social Agendas: Class, Gender and Identity in Clothing* (Chicago: University of Chicago Press, 2000); Anna Hedtjärn Wester, *Män i kostym: Prinsar, konstnärer och tegelbärare vid sekelskiftet 1900* (Stockholm: Nordiska museets förlag, 2010).

53 See Anne Maxwell, *Colonial Photography and Exhibitions: Representations of the 'Native' and the Making of European Identities* (London: Leicester University Press, 1999), 13.

54 James Faris, "Navajo and Photography," in *Photography's Other Histories*, ed. Christopher Pinney and Nicolas Peterson (Durham, NC: Duke University Press, 2003). Cf. Stephen Sheehi's recent analysis of Middle Eastern portrait photography as simultaneously nationalistic and westernized. *The Arab Imago: A Social History of Portrait Photography 1860–1910* (Princeton: Princeton University Press, 2016).

CHAPTER TWO

1 For the details of the development of portrait photography, see John Hannavy, ed., *Encyclopedia of Nineteenth-Century Photography* (London: Routledge, 2007). For a general overview of the history of portrait photography, see Ben Maddow, *Faces: A Narrative History of the Portrait in Photography* (Boston: New York Graphic Society, 1977) and Graham Clarke, ed., *The Portrait in Photography* (London: Reaktion Books, 1992).

2 On the rise of photographic journals, see the entries "British Journal of Photography," "Photographische Correspondenz," and "Books and Manuals about Photography" in Hannavy, *Encyclopedia of Nineteenth-Century Photography*.

3 Noel E. Fitch, "Recollections of an Amateur Photographer in Portraiture," *Photographic News*, 21 March 1862.

4 Elizabeth Anne McCauley, *A.A.E. Disdéri and the Carte de Visite Portrait Photograph* (New Haven: Yale University Press, 1985), 41.

5 Herman Hamnqvist, "Den fotografiska posen," *Fotografisk tidskrift* 11, no. 160 (1898).

6 Hugh Brebner, "Beauty of Pose, Proportion, and Feature in Portraiture," *British Journal of Photography*, 28 January 1887.

7 Hermann Vogel, *Handbook of the Practice and Art of Photography*, trans. Edward Moelling (Philadelphia: Benerman & Wilson, 1871), 286–90.

8 Hans Spörl, "Porträttet," *Fotografisk tidskrift* 15, no. 211 (1902). Translation of German article from *Allgemeinen Photographen-Zeitung* 8, no. 45.

9 A. Kaudern, "Likhet och dess betydelse för det fotografiska porträttet," *Svensk fotografisk tidskrift* 8, nos. 87–90 (1918).

10 Charles H. Davis, "Suggestions for Portrait Photography," *British Journal of Photography*, 10 February 1922.

11 H.A., "Porträtt-tagning," *Svenska fotografisamfundets tidskrift* 1, no. 3 (1904).

12 *Råd för alla, som ämna låta fotografera sig, angående sättet att kläda sig, placering m. m.; äfvensom råd i allmänhet om hårets, läpparnes, tändernas och hyns vård och skötsel* (Stockholm, 1859), 8.

13 William Lake Price, *A Manual of Photographic Manipulation*, facsimile of 1868 original, published in London (New York: Arno Press, 1973), 155.

14 Articles on posing from the early twentieth century promote the same basic notions of composition that can be found in earlier pieces. See "Porträttposering," *Svenska fotografisamfundets tidskrift* 1, nos. 7, 8, 9, 10 (1904); "Om posering," *Svensk fotografisk tidskrift* 11, no. 123 (1921).

15 "Porträttposering."

16 "Om posering."

17 "Porträttposering."

18 Vogel, *Handbook of the Practice and Art of Photography*, 288.

19 G.G. Mitchell, "Photographers and Sitters," *British Journal of Photography*, 16 May 1884.

20 Lake Price, *A Manual of Photographic Manipulation*, 169.

21 A.W., "Photographic Portraiture," *Once A Week*, 31 January 1863.

22 Quoted in Ellen Maas, *Die goldenen Jahre der Photoalben: Fundgrube und Spiegel von gestern* (Cologne: DuMont, 1977), 77.

23 See Jennifer Green-Lewis, *Framing the Victorians: Photography and the Culture of Realism* (Ithaca, NY: Cornell University Press, 1996).

24 See Daniel A. Novak, *Realism, Photography, and Nineteenth-Century Fiction* (Cambridge: Cambridge University Press, 2008), 4.

25 Jennifer Tucker, *Nature Exposed: Photography as Eyewitness in Victorian Science* (Baltimore: Johns Hopkins University Press, 2005), 33. See also Green-Lewis, *Framing the Victorians*, 156–9, 230–1.

26 See Novak, *Realism, Photography, and Nineteenth-Century Fiction*, 47, 140–1.

27 Geoffrey Batchen, "Dreams of Ordinary Life: Cartes-de-visite and the Bourgeois Imagination," in *Photography: Theoretical Snapshots*, ed. J.J. Long, Andrea Noble, and Edward Welch (London: Routledge, 2009).

28 See Ursula Peters, *Stilgeschichte der Fotografie in Deutschland 1839–1900* (Cologne: DuMont, 1978), 56.

29 The general picture of portrait poses given here is an amalgam of surveys in Gisèle Freund, *Fotografi och samhälle* (Stockholm: Norstedts, 1977); Peters, *Stilgeschichte der Fotografie in Deutschland 1839–1900*; Robert Pols, *Family Photographs, 1860–1945* (Richmond, UK: Public Record Office Publications, 2002); and Solfrid Söderlind, *Porträttbruk i Sverige 1840–1865* (Stockholm: Carlsson bokförlag, 1993), as well as studies of select collections of studio photographs from the mid-nineteenth century to the first decades of the twentieth century.

30 "Posing for the camera," in *The Oxford Companion to the Photograph*, ed. Robin Lenman (Oxford: Oxford University Press, 2005).

31 This is a difference that Erving Goffman also detects in late-twentieth century advertisements. Erving Goffman, *Gender Advertisements* (London: Macmillan, 1979), 29.

32 Peters, *Stilgeschichte der Fotografie in Deutschland*, 266. See also ibid., 59, and Pols, *Family Photographs, 1860–1945*, 67–8.

33 Freund, *Fotografi och samhälle*, 60.

34 See Alan Trachtenberg, *Reading American Photographs: Images as History from Mathew Brady to Walker Evans* (New York: Hill and Wang, 1989), 27–8. See also John F. Kasson, *Rudeness & Civility: Manners in Nineteenth-Century Urban America* (New York: Hill and Wang, 1990), 93–100.

35 *Svenskt porträttgalleri*, ed. Albin Hildebrand (Stockholm: Tullberg, 1895–1913).

36 Anja Petersen, *På visit i verkligheten: Fotografi och kön i slutet av 1800-talet* (Stockholm: Symposion, 2007), 31.

37 Ibid., 30–2.

38 Peters, *Stilgeschichte der Fotografie in Deutschland*, 264.

39 Petersen, *På visit i verkligheten*, 30.

40 Pols, *Family Photographs, 1860–1945*, 70.

41 Fred E.H. Schroeder, "Say Cheese! The Revolution in the Aesthetics of Smiles," *Journal of Popular Culture* 32, no. 2 (1998): 103–45.

42 Batchen, "Dreams of Ordinary Life."

43 See John Tagg, *The Burden of Representation: Essays on Photographies and Histories* (Basingstoke: Palgrave Macmillan, 1988), 36.

44 Novak, *Realism, Photography, and Nineteenth-Century Fiction*, 132.

45 Cf. the difference between Disdéri's formulaic strict posing and his rival Félix Nadar's "impromptu poses." Roger Cardinal, "Nadar and the Photographic Portrait in Nineteenth-Century France," in Clarke, ed., *The Portrait in Photography*. See also Fulya Ertem, "The Pose in Early Portrait Photography: Questioning Attempts to Appropriate the Past," *Image & Narrative* 7, no. 14 (2006), http://www.imageandnarrative.be/inarchive/painting/fulya.htm.

46 Illustrative examples of the former include Swedish artist Hanna Hirsch Pauli's portrait of her colleague Venny Soldan-Brofeldt (1887), in which the subject is sitting on the studio floor with her legs stretched out before her and her mouth open. See Anna Lena Lindberg, "The Space of Possibilities: Hanna Hirsch Pauli's Portrayal of Venny Soldan," in *Women Painters in Scandinavia 1880–1900*, ed. Jorunn Veiteberg (Copenhagen: Kunstforeningen, 2002). Another example is German painter Lovis Corinth's portrait of his poet friend Peter Hille (1902). See Peter-Klaus Schuster, Christoph Vitali, and Barbara Butts, eds, *Lovis Corinth* (Munich: Prestel, 1996), 146.

47 On the routine depiction of rural and working people, see Karen Sayer, *Women of the Fields: Representations of Rural Women in the Nineteenth Century* (Manchester: Manchester University Press, 1995) and Susan Waller, "Rustic *Poseurs*: Peasant Models in the Practice of Jean-Francois Millet and Jules Breton," *Art History* 31, no. 2 (2008): 187–210.

48 Susan P. Casteras, "Pre-Raphaelite Challenges to Victorian Canons of Beauty," *Huntington Library Quarterly* 55, no. 1 (1992): 13–35; Julie F. Codell, "Expression Over Beauty: Facial Expression, Body Language, and Circumstantiality in the Paintings of the Pre-Raphaelite Brotherhood," *Victorian Studies* 29, no. 2 (1986):

255–90; J.B. Bullen, *The Pre-Raphaelite Body: Fear and Desire in Painting, Poetry, and Criticism* (Oxford: Clarendon Press, 1998), 9.

49 Lucy Hartley, "Putting the Drama into Everyday Life: The Pre-Raphaelite Brotherhood and a Very Ordinary Aesthetic," *Journal of Victorian Culture* 7, no. 2 (2002): 173–95.

50 Kathleen Spencer, "Purity and Danger: *Dracula*, the Urban Gothic and the Late Victorian Degeneracy Crisis," ELH 59, no. 1 (1992): 197–225; Svante Lovén, "Den lockande avgrunden: Senviktoriansk skräckgotik och hoten mot den borgerliga identiteten," in *Nationell hängivenhet och europeisk klarhet: Aspekter på den europeiska identiteten kring sekelskiftet 1900*, ed. Barbro Kvist Dahlstedt and Sten Dahlstedt (Eslöv: Symposion, 1999); John Paul Riquelme, "Oscar Wilde's Aesthetic Gothic: Walter Pater, Dark Enlightenment, and *The Picture of Dorian Gray*," *Modern Fiction Studies* 46, no. 3 (2000): 609–31.

51 Cf. Goffman's discussion of models "guying" the portrait pose. Goffman, *Gender Advertisements*, 17.

52 On itinerant and village photographers, see A.E. Linkman, "The Itinerant Photographer in Britain 1850–1880," *History of Photography* 14, no. 1 (1990): 49–68, and Colin Harding, "Sunny Snaps: Commercial Photography at the Water's Edge," in *Art and Identity at the Water's Edge*, ed. Tricia Cusack (London: Routledge, 2012).

53 Ulrich Keller, "Introduction," in *August Sander: Citizens of the Twentieth Century. Portrait Photographs 1892–1952*, ed. Gunther Sander (Cambridge, MA: MIT Press, 1997). The contention is comparable to the statement of anthropologist Margaret B. Blackman in her study of photographs of the indigenous people of British Columbia: "Regardless of how else it might be viewed, an historical photograph must be recognized as the outcome of an interaction between photographer and subject matter." Margaret B. Blackman, "'Copying People': Northwest Coast Native Response to Early Photography," *BC Studies* 52 (Winter 1981): 86–112.

54 Geoffrey Pearson, "Perpetual Novelty: Youth, Modernity and Historical Amnesia," in *Youth in Crisis? 'Gangs,' Territoriality and Violence*, ed. Barry Goldson (London: Routledge, 2011), 20–37.

55 "Postcard," in Hannavy, *Encyclopedia of Nineteenth-Century Photography*.

56 On masculine performance in the working classes, see Peter Bailey, "'Will the Real Bill Banks Please Stand Up?' Towards a Role Analysis of Mid-Victorian Working-Class Respectability," *Journal of Social History* 12, no. 3 (1979): 336–53, and Ying S. Lee, *Masculinity and the English Working Class: Studies in Victorian Autobiography and Fiction* (London: Routledge, 2007).

57 See Jennifer M. Green, "'The Right Thing in the Right Place': P.H. Emerson and the Picturesque Photograph," in *Victorian Literature and the Victorian Visual Imagination*, ed. Carol T. Christ and John O. Jordan (Berkeley: University of California Press, 1995).

58 The collection contains about 230 images of navvies working on the railroads of England in the 1890s. All images are available in digitized form from http://imageleicestershire.org.uk. Further studies of workers' portraits have also been conducted at the Museum of English Rural Life, Reading, UK.

59 See images L1006, L1154, L1431, L1435, L1819, L2353, L2762, L9490, http://imageleicestershire.org.uk.

60 J.A. Mangan, *Athleticism in the Victorian and Edwardian Public School* (Cambridge: Cambridge University Press, 1981), 166–7.

61 Ibid., 31, 175.

62 See Cornelia Kemp and Ulrike Gierlinger, *Wenn der Groschen fällt ... Münzautomaten – gestern und heute* (Munich: Deutsches Museum, 1989), 348; Gabriele Chiesa and Paolo Gosio, *Dagherrotipia, ambrotipia, ferrotipia: Positivi unici e processi antichi nel ritratto fotografico* (Brescia: Youcanprint, 2012), 177–80, and Ann-Sofi Forsmark, *Stockholmsfotografer: En fotografihistoria från Stockholms stadsmuseum* (Stockholm: Stockholmia förlag, 2012), 88–9.

63 That being said, the physical contact between the sitters may be compared with that of some family photographs. See Geoffrey Batchen, "Individualism and Conformity: Photographic Portraiture in the Nineteenth Century," *New York Journal of American History* 66, no. 3 (2006), 10–27.

64 Trachtenberg, *Reading American Photographs*, 56–7.

INTRODUCTION TO THE CASE STUDIES

1 Photographic collections that have been consulted include the Victoria and Albert Museum and the London Metropolitan Archives in London, the Wien Museum and Albertina Museum in Vienna, and the Stockholm City Museum.

2 See Vanessa Toulmin, Simon Popple, and Patrick Russell, eds, *The Lost World of Mitchell & Kenyon: Edwardian Britain on Film* (London: BFI Publishing, 2004).

3 For more information on the history of cartoon and caricature, see Edward Lucie-Smith, *The Art of Caricature* (London: Orbis, 1981) and Carl G. Laurin, *Skämtbilden och dess historia i konsten* (Stockholm: P.A. Norstedt, 1908).

4 Robert Muchembled, "The Order of Gestures: A Social History of Sensibilities Under the Ancien Régime in France," in *A Cultural History of Gesture: From Antiquity to the Present Day*, ed. Jan Bremmer and Herman Roodenburg (London: Polity Press, 1991), 132.

5 On the qualifications for selecting subjects for case studies and the indispensable interplay between content analysis and the researcher's "local knowledge," see Gary Thomas and Kevin Myers, *The Anatomy of the Case Study* (Los Angeles: SAGE, 2015), 56–7.

6 Mary Cowling, *The Artist as Anthropologist: The Representation of Type and Character in Victorian Art* (Cambridge: Cambridge University Press, 1989).

CHAPTER THREE

1 *Bilder från Jönköping*, 1911, SFI, http://www.filmarkivet.se.

2 "Le Ring," Catalogue Lumière no. 274, filmed in the summer of 1896, http://stadtfilm-wien.at/film/144/.

3 For a brief historical sketch on walking sticks, see Joseph Amato, *On Foot: A History of Walking* (New York: New York University Press, 2004), 89.

4 See John F. Kasson, *Rudeness & Civility: Manners in Nineteenth-Century Urban America* (New York: Hill and Wang, 1990), 121.

5 Diana Crane, *Fashion and Its Social Agendas: Class, Gender and Identity in Clothing* (Chicago: University of Chicago Press, 2000), 35–7.

6 Katherine Lester and Bess Viola Oerke, *Accessories of Dress: An Illustrated Encyclopedia* (Mineola, NY: Dover Publications, 2004), 392.

7 *Oxford English Dictionary*, http://oed.com.

8 Ariel Beaujot, *Victorian Fashion Accessories* (Oxford: Berg, 2012), 120–30.

9 Thorstein Veblen, *The Theory of the Leisure Class: An Economic Study of Institutions* (London: Macmillan & Co, 1912 [1899]), 265.

10 See Andrew Wilton, *The Swagger Portrait: Grand Manner Portraiture in Britain from Van Dyck to Augustus John 1630–1930* (London: Tate Gallery, 1992) and Arline Meyer, "Re-dressing Classical Statuary: The Eighteenth-Century 'Hand-in-Waistcoat' Portrait," *Art Bulletin* 77, no. 1 (1995): 45–63.

11 A particularly manifest example is found in Mitchell and Kenyon's film *Panoramic View of Morecambe Sea Front*, in which a man is seen twirling his umbrella excessively about one minute into the footage (BFI).

12 Illustrative examples of such assemblies can be found in many collections from small-town photographers, especially Per Bagge's photos from turn-of-the-century Lund, Sweden (LUL), but also Oscar Heimer's photos from Stockholm SSME 030008S (SCM), Linley Sambourne photo ST/PR/5-0215/91 (RBKC), and August Stauda photo HMW 27363 (WM). See also Jürgen Grothe, ed., *Berlin: Photographien von Waldemar Titzenthaler* (Berlin: Nicolai, 1987), 39, 65, 93, and Heinrich Zille Winfried Ranke, *Photographien Berlin 1890–1910* (Munich: Schirmer/Mosel, 1975), 113.

13 Another photo by Stockholm photographer Severin Nilson from the Humlegården park in the 1890s contains a gentleman striking a very conscious pose in the background while women play with their children in the foreground. Reproduced in Ann-Sofi Forsmark, *Stockholmsfotografer: En fotografihistoria från Stockholms stadsmuseum* (Stockholm: Stockholmia förlag, 2012), 112.

14 Seen in Martin Friedman and Henning Bender, *The Frozen Image: Scandinavian Photography* (New York: Abbeville Press, 1982), 79.

15 See images no. 1877 (man on curb to the right), 2476 (second labourer from left), and 2044 (man in hat next to cyclist in middle of road), Per Bagge Collection (LUL).

16 For clear examples of the former, see August Stauda images HMW 27205 and 27001 (WM).

17 Coulthurst's Manchester images were produced as part of a "Photographic Survey of Manchester and Salford by the Members of the Manchester Amateur Photographic Society" 1892–1901 and are held at Manchester Archives (MA).

18 See Sambourne images "21 June 1907" in photo album "London Streets, vol. 1" and "17 Sept 1906" (Folkestone) in "Seaside Album" (RBKC). See also Per Bagge, image no. 2462 (LUL).

19 See Samuel Coulthurst image MO8838 (MA) and a man who crosses the street in the Lumière film from Ringstrasse, Catalogue Lumière no. 274.

20 "Sword Exercise for the Streets of London," *Fun*, 19 October 1861; "Lecture Concerning Umbrellas," *Pick-Me-Up*, 9 November 1889; "The Walking-Stick Fiend," *Fun*, 7 August 1894.

21 "Against the Law," *Chums*, 8 August 1894.

22 "Ett tidslyte att bortarbeta," *Vågbrytaren: Nykterhetsvännernas julkalender* (Stockholm: C. Thunström, 1899), 37–42. The article also mentions "eating with the fork" and wearing trousers folded at the bottom.

23 "Carrying a Stick," *Pick-Me-Up*, 3 May 1890.

24 The cartoon is included in James Thorpe, *Phil May* (London: Art & Technics, 1948).

25 On this gesture, see Joan Wildeblood and Peter Brinson, *The Polite World: A Guide to English Manners and Deportment from the Thirteenth to the Nineteenth Century* (Oxford: Oxford University Press, 1965), 268.

26 See also *Fliegende Blätter* 118, no. 3017 (1903): 255; *Söndags-Nisse*, 19 March 1882, 48; *Simplicissimus* 6, no. 3 (1901): 21.

27 As in *Söndags-Nisse*, 1 October 1882, 159; 2 December 1894, 4; 29 April 1894, 4.

28 Helmer Lång, *Kolingen och hans fäder: Om internationell vagabondkomik och Albert Engström* (Lund: Gleerup, 1966).

29 Albert Engström, *Mitt liv och leverne* (Stockholm: Vårt hem, 1928).

30 Peter Bailey, *Popular Culture and Performance in the Victorian City* (Cambridge: Cambridge University Press, 1998), 101–5.

31 Similar representations of the music-hall *lion comique* are found on the covers of the song sheets "After the Opera" and "Pretty Little Flora" by George Leybourne, "It's a Sprahtin'!" sung by Gus Elen, and "The Dandy Coloured Coon," sung by Eugene Stratton (see later in this chapter), included in the Spellman Collection of Victorian Music Covers, University of Reading. Accessible online at http://vads.ac.uk.

32 See also sheet cover for "Burlington Bertie from Bow," which shows Ella Shields dressed as a man.

33 On the "Grecian Bend," see *Punch*, 2 October 1869, 132, and 16 October 1869, 154. On the "Alexandra Limp," see Kate Strasdin, "Fashioning Alexandra: A Royal Approach to Style 1863–1910," *Costume* 47, no. 2 (2013): 180–97. "The Roman Fall" was written and performed by Arthur Lloyd, circa 1878.

34 Michael Pickering, "Eugene Stratton and Early Ragtime in Britain," *Black Music Research Journal* 20, no. 2 (2000): 151–80.

35 Bailey, *Popular Culture and Performance*, 119–22.

36 See *Simplicissimus* 7, no. 21 (1902): 163; *Farbror Mårten*, no. 3 (1891): 3–4; *Söndags-Nisse*, 8 April 1894, 5; 11 March 1894, 4; *Larks!*, 15 May 1893, 20; 22 May 1893, 32.

37 *Farbror Mårten*, no. 4 (1891): 1.

38 See *Söndags-Nisse*, 18 March 1894, 3, and *Punch*, 19 February 1896, 101.

39 See, for instance, *Kasper*, 18 July 1891, 4; 17 September 1892; 14 April and 16 June 1894; *Fliegende Blätter* 115, no. 2841 (1900): 14.

40 *Kasper*, 17 November 1894, 4.

41 Ellen Moers, *The Dandy: Brummell to Beerbohm* (London: Secker & Warburg, 1960), 215.

42 http://www.duden.de.

43 Georg Simmel, *Simmel on Culture: Selected Writings* (London: SAGE, 1997), 194. Original version: "Zur Psychologie der Mode: Soziologische Studie," *Die Zeit: Wiener Wochenschrift für Politik, Volkswirtschaft, Wissenschaft und Kunst* 5, no. 54 (1895): 22–4.

44 Janet Stewart, *Fashioning Vienna: Adolf Loos's Cultural Criticism* (London: Routledge, 2000), 135.

45 See Björn Ivarsson Lilieblad, *Moulin Rouge på svenska: Varietéunderhållningens historia i Stockholm 1875–1920* (Linköping: Linköpings universitet, 2009), 146–56, and Theodor Hjelmqvist, *Förnamn och familjenamn med sekundär användning i nysvenskan* (Lund: Gleerup, 1903), 79–82.

46 Emil Norlander, *Rännstensungar och storborgare: Stockholm under ett halvsekel* (Stockholm: Åhlén & Åkerlunds förlag, 1924), 187.

47 Hjelmqvist, *Förnamn och familjenamn*, 80.

48 *Fliegende Blätter* 96, no. 2444 (1892): 193; 99, no. 2514 (1893): 120. See also 102, no. 2599 (1895): 183; 99, no. 2510 (1893): 87; 100, no. 2550 (1894): 226.

49 See *Larks!*, 15 May 1893, 20; 29 May 1893, 37; 26 August 1893, 136. See also *Funny Wonder*, 12 August 1893; *Illustrated Chips*, 14 January 1893.

50 Michelle Ann Abate, "When Clothes Don't Make the Man: Sartorial Style, Conspicuous Consumption, and Class Passing in Lothar Meggendorfer's *Scenes in the Life of a Masher*," *Children's Literature Association Quarterly* 37, no.1 (2012): 43–65.

51 See cartoons in *Fun*, 20 September 1876, 126; 11 July 1883, 20; *Punch*, 7 December 1882.

52 Brent Shannon, *The Cut of His Coat: Men, Dress, and Consumer Culture in Britain, 1860–1914* (Athens: Ohio University Press, 2006), 154.

53 See Christopher Breward, *The Hidden Consumer: Masculinities, Fashion and City Life, 1860–1914* (Manchester: Manchester University Press, 1999) and Ying S. Lee, *Masculinity and the English Working Class: Studies in Victorian Autobiography and Fiction* (London: Routledge, 2007), 57.

54 George L. Mosse, *The Image of Man: The Creation of Modern Masculinity* (Oxford: Oxford University Press, 1996), 35–6.

55 See especially John Tosh, *Manliness and Masculinities in Nineteenth-Century Britain: Essays on Gender, Family, and Empire* (New York: Pearson Longman, 2005), 41, and James Eli Adams, *Dandies and Desert Saints: Styles of Victorian Masculinity* (Ithaca, NY: Cornell University Press, 1995).

56 J.A. Eklund, "Om öfversitteri," *Svensk Tidskrift*, vol. 5 (1895).

57 Fredrik Svenonius, "Råd för vandringslystna ungdomar," *Svenska Turistföreningens årsskrift* 6, no. 84 (1888).

58 Richard Gustafsson, "De blixtrande ögonen," *Svenska Familj-Journalen* 3, no. 7 (1864): 205–6.

59 See Arlene Young, *Culture, Class, and Gender in the Victorian Novel: Gentlemen, Gents, and Working Women* (Basingstoke: Macmillan, 1999), 63.

60 David Scobey, "Anatomy of the Promenade: The Politics of Sociability in Nineteenth-Century New York," *Social History* 17, no. 2 (1992): 203–27; Cameron White,

"Promenading and Picknicking: The Performance of Middle-Class Masculinity in Nineteenth-Century Sydney," *Journal of Australian Studies* 30, no. 89 (2006): 27–40.

CHAPTER FOUR

1 This argument has been made most clearly by the German artist Marianne Wex in her book *Let's Take Back Our Space: "Female" and "Male" Body Language as a Result of Patriarchal Structures* (Hamburg: Frauenliteraturverlag Hermine Fees, 1979).

2 Per Bagge Collection, no. 939 (LUL).

3 Ibid., no. 2450 (LUL).

4 Erving Goffman, *Gender Advertisements* (London: Macmillan, 1979), 57–82.

5 For examples, see Jane Ashelford, *The Art of Dress: Clothes Through History 1500–1914* (London: National Trust, 1996), 96–7.

6 Joaneath Spicer, "The Renaissance Elbow," in *A Cultural History of Gesture: From Antiquity to the Present Day*, ed. Jan Bremmer and Herman Roodenburg (London: Polity Press, 1991), 100.

7 The lap area of Mrs Andrews is actually unfinished, suggesting that she was meant to be portrayed holding something, possibly a dog or a piece of embroidery.

8 Lynda Nead, *Myths of Sexuality: Representations of Women in Victorian Britain* (Oxford: Blackwell, 1988), 29.

9 Carl Størmer's pictures are in the collections of Norsk Folkemuseum, Oslo, and are available online at http://oslobilder.no.

10 Ariel Beaujot, *Victorian Fashion Accessories* (Oxford: Berg, 2012), 40.

11 "Chitchat on Fashions for September," *Godey's Lady Book and Magazine*, September 1878, 268.

12 Temma Balducci, "*Aller à pied*: Bourgeois women on the streets of Paris," in *Women, Femininity and Public Space in European Visual Culture, 1789–1914*, ed. Temma Balducci and Heather Belnap Jensen (Farnham: Ashgate, 2014).

13 *Cassell's Household Guide*, vol. 4 (London: Cassell, Petter, and Galpin, 1869), 186.

14 John H. Young, *Our Deportment, or the Manners, Conduct and Dress of the Most Refined Society* (Detroit: F.B. Dickerson & Co, 1884), 145. See also "Etiquette in Walking, Riding, and Driving," *Girl's Own Paper* 5 (1883): 474–5.

15 An identical way of walking is seen in a film from the Opernring in 1911, produced by Pathé Frères and held by Filmarchiv Austria. It can be accessed at http://www.youtube.com/watch?v=OgkIbVwFTGg.

16 For good examples, see Enno Kaufhold, *Heinrich Zille: Photograph der Moderne* (Munich: Schirmer/Mosel, 1995), plate 126; Roy Flukinger, Larry Schaaf, and Standish Meacham, *Paul Martin: Victorian Photographer* (London: Fraser, 1978), plate 56; Linley Sambourne, Holland, France, Belgium Album (RBKC); Jürgen Grothe, ed., *Berlin: Photographien von Waldemar Titzenthaler* (Berlin: Nicolai, 1987), 67, 69.

17 See Flukinger et al., *Paul Martin*, plates 32, 56–7.

18 Per Bagge, images no. 9 and 2533 (LUL); Flukinger et al., *Paul Martin*, plate 10.

19 Stauda image no. HMW 30092/1 (WM). For other examples, see Peter K. Andersson, *Streetlife in Late Victorian London: The Constable and the Crowd* (Basingstoke: Palgrave Macmillan, 2013), 195, and Oscar Heimer, photos SSME029999S, SSME029 782S (SCM).

20 On the depiction of women in eighteenth-century caricature, see Cindy McCreery, *The Satirical Gaze: Prints of Women in Late-Eighteenth Century England* (Oxford: Clarendon, 2004).

21 This is best demonstrated in *Simplicissimus* 1, no. 22 (1896): 8; 2, no. 38 (1897): 301; 2, no. 50 (1897): 397; 4, no. 22 (1899): 176; and *Fliegende Blätter* 106, no. 2686 (1897): 26.

22 Judith R. Walkowitz, "Going Public: Shopping, Street Harassment, and Streetwalking in Late Victorian London," *Representations* 62 (Spring 1998): 1–30.

23 See *Simplicissimus* 3, no. 5 (1898): 36; 4, no. 11 (1899): 88; 6, no. 20 (1901): 153; *Söndags-Nisse*, 1 August 1897, 3; *Punch*, 13 May 1876, 196; 15 November 1879, 219.

24 See also, for instance, *Punch*, 4 November 1876, 197.

25 See *Punch*, 17 May 1905, 352.

26 See also *Söndags-Nisse*, 16 April 1882, 63.

27 *Fliegende Blätter* 106, no. 2686 (1897): 26.

28 *Punch*, 5 May 1883, 208; 8 February 1890, 71.

29 See *Punch*, 5 April 1890, 167; 29 November 1890, 258; 2 December 1890, 291; 14 March 1891, 126; *Kasper*, 14 March 1891, 4; *Simplicissimus* 8, no. 5 (1903): 35. The primness of the muff is emphasized in the painting *Winter 1882* by Spanish painter Francesc Maniera.

30 Laura Engel, "The Muff Affair: Fashioning Celebrity in the Portraits of Late-eighteenth-century British Actresses," *Fashion Theory* 13, no. 3 (2009), 279–98.

31 Iris Marion Young, *On Female Body Experience: "Throwing Like A Girl" and Other Essays* (New York: Oxford University Press, 2005), 31–2.

32 See Lise Shapiro Sanders, *Consuming Fantasies: Labor, Leisure, and the London Shopgirl, 1880–1920* (Columbus: Ohio State University Press, 2006).

33 Kristine Moruzi, "Fast and Fashionable: The Girls in *The Girls of the Period Miscellany*," *Australasian Journal of Victorian Studies* 14, no. 1 (2009): 9–28.

34 Sally Mitchell, *The New Girl: Girls' Culture in England, 1880–1915* (New York: Columbia University Press, 1995).

35 On contemporary female stereotypes, see Lise Shapiro Sanders, *Consuming Fantasies*; Katherine Mullin, "The Shop-Girl Revolutionary in Henry James's *Princess Casamassima*," *Nineteenth-Century Literature* 63, no. 2 (2008): 197–222; Helena Forsås-Scott, *Re-writing the Script: Gender and Community in Elin Wägner* (London: Norvik Press, 2009); Carole Elizabeth Adams, *Women Clerks in Wilhelmine Germany: Issues of Class and Gender* (Cambridge: Cambridge University Press, 1988); Elfriede Wiltschnigg, *Das Rätsel Weib: Das Bild der Frau in Wien um 1900* (Berlin: Reimer, 2001). Unfortunately, virtually all books on this group of women deal with literature and politics, and very little of their everyday spheres and subculture has been investigated.

36 Margaret Beetham, *A Magazine of Her Own? Domesticity and Desire in the Woman's Magazine, 1800–1914* (London: Routledge, 1996); Kate Flint, *The Woman Reader 1837–1914* (Oxford: Clarendon, 1993), 162–70.

CHAPTER FIVE

1 Film no. 236, Catalogue Lumière.

2 Mitchell and Kenyon, film no. 571: Great Yorkshire Show at Leeds 1902, Mitchell and Kenyon Collection (BFI).

3 As opposed to religious portraits, where the piety that was to be conveyed called for more restrictive body language.

4 Joaneath Spicer, "The Renaissance Elbow," in *A Cultural History of Gesture: From Antiquity to the Present Day*, ed. Jan Bremmer and Herman Roodenburg (London: Polity Press, 1991), 84–128; Thomas A. King, "Performing 'Akimbo': Queer Pride and Epistemological Prejudice," in *The Politics and Poetics of Camp*, ed. Moe Meyer (London: Routledge, 1994), 20–43.

5 Andrew Stewart, "Hellenistic Freestanding Sculpture from the Athenian Agora, Part 1: Aphrodite," *Hesperia* 81, no. 1 (2012): 267–342.

6 Guillemette Bolens, "Arms Akimbo: Kinesic Analysis in Visual and Verbal Art," in *Visual Rhetoric and the Eloquence of Design*, ed. Leslie Atzmon (Anderson, SC: Parlor Press, 2011).

7 Fritz Graf, "Gestures and Conventions: The Gestures of Roman Actors and Orators," in Bremmer and Roodenburg, *A Cultural History of Gesture*, 49.

8 On the limitations of advice manuals as a historical source, see Marjorie Morgan, *Manners, Morals and Class in England, 1774–1858* (Basingstoke: Macmillan Press, 1994), 8–31.

9 Didier Aubert, "The Doorstep Portrait: Intrusion and Performance in Mainstream American Documentary Photography," *Visual Studies* 24, no. 1 (2009): 3–18.

10 See photographs by Oscar Heimer from the slums of Stockholm, nos. E26125, E29999, E29819, E29782 (SCM).

11 Christian Brandstätter, Franz Hubmann, *Damals in Wien: Menschen um die Jahrhundertwende. Photographiert von Dr. Emil Mayer* (Vienna: Verlag Christian Brandstätter, 1995), 136.

12 Bill Jay, *Victorian Candid Camera: Paul Martin 1864–1944* (Newton Abbott: David and Charles, 1973), 55.

13 The mentioned hidden-camera images of Oslo photographer Carl Størmer also provide good insight into the discrepancies between promenade body language and hurried body language.

14 *E.J. Bellocq: Storyville Portraits*, ed. John Szarkowski (New York: Museum of Modern Art, 1970); Gordon Baldwin, *Eugène Atget: Photographs from the J. Paul Getty Museum* (Los Angeles: J. Paul Getty Trust, 2000), 66.

15 On nineteenth-century nude photography, see Alison Smith, *The Victorian Nude: Sexuality, Morality and Art* (Manchester: Manchester University Press, 1996), 55–62.

16 Phil May Sketchbook, circa 1896, Manuscript collection no 92, Manuscript, Archives and Rare Book Library, Emory University.

17 *Punch*, 7 January 1903, 15. Another depiction of the coster stereotype is in one of the "London Types" prints by artist William Nicholson, published in 1898.

18 *Söndags-Nisse*, 3 October 1897.

19 For a matronly cook, see *Fliegende Blätter* 118, no. 3018 (1903): 272; *Punch*, 21 November 1896, 244; 17 April 1897, 186.

20 *Kasper*, 4 January 1896.

21 Illustrative examples are found in *Punch*, 4 July 1896; 25 January 1899, 42; and *The Phil May Album*, ed. Augustus M. Moore (London: Methuen & Co, 1900), 85.

22 *Fliegende Blätter* 108, no. 2740 (1898): 53.

23 *Söndags-Nisse*, 21 November 1897.

24 See examples in *Kasper*, 28 November 1891; 7 January 1893; 14 and 28 February 1903; *Söndags-Nisse*, 4 October 1896, 15 August and 26 September 1897; *Fliegende Blätter* 108, no. 2742 (1898): 72; 112, no. 2845 (1900): 70; 112, no. 2846 (1900): 75; *Punch*, 11 January 1896, 21.

25 See *Punch*, 11 March 1876, 87; 29 November 1890, 263; 10 October 1896, 179; *Fliegende Blätter* 118, no. 3012 (1903): 193; *Kasper*, 10 January 1891, 6; 17 January 1891; 7 February 1891, 2.

26 *Fliegende Blätter* 118, no. 3018 (1903): 264.

27 On the perception of smoking women, see Hugh Cockerell, "Tobacco and Victorian Literature," in *Ashes to Ashes: The History of Smoking and Health*, ed. Stephen Lock, Lois A. Reynolds, and E.M. Tansey (Atlanta, GA: Rodopi, 1998), 98, and Penny Tinkler, *Smoke Signals: Women, Smoking and Visual Culture* (Oxford: Berg, 2006).

28 See *Kasper*, 17 January 1903, 3; *Söndags-Nisse*, 10 October 1897; *Fliegende Blätter* 112, no. 2846 (1900): 84; *Simplicissimus* 3, no. 5 (1898): 36.

29 See Robert C. Allen, "'The Leg Business': Transgression and Containment in American Burlesque," *Camera Obscura* 8, no. 2 (23) (1990): 43–69.

30 See *Kasper*, 30 January 1892, 5; 29 July 1893, 3; *Punch*, 18 May 1895, 231.

31 *Punch*, 24 April 1907, 305.

32 *Simplicissimus* 2, no. 2 (1897): 16.

33 Female cyclists are portrayed in *Simplicissimus* 6, no. 9 (1901): 67; 8, no. 3 (1903): 25; *Punch*, 18 July 1896, 35; *Söndags-Nisse*, 24 October 1897.

34 Susan C. Shapiro, "The Mannish New Woman: *Punch* and Its Precursors," *Review of English Studies* 42, no. 168 (1991): 510–22.

35 Shapiro takes the drawing in *Punch*, 15 June 1895, 282, as an example, but has neglected other portrayals of "new women" in the same volume: 5 January 1895, 6; 27 July 1895, 42. These portrayals have nothing to suggest that the new woman was perceived as different in appearance from other women.

36 *Simplicissimus* 3, no. 28 (1898): 221.

37 See *Punch*, 17 October 1896, 184.

38 See Kevin Moore, *Jacques Henri Lartigue: The Invention of An Artist* (Princeton: Princeton University Press, 2004), 109. See also the French artist Henry Somm's

1885 sketchbook held by The Art Institute of Chicago. A digitized version is accessible at http://www.artic.edu/aic/resources/resource/2651.

39 David Price, "A Cancan Too Far," *History Today* 46, no. 12 (1996): 5–7.

40 Bailey, *Popular Culture and Performance*, 175–93.

41 Melissa Ballanta, "'Ta-ra-ra-boom-de-ay': Lottie Collins' Act and the Not-so-Modern Girl," *Nineteenth-Century Theatre and Film* 37, no. 1 (2010): 3–13.

42 Marika V. Lagercrantz, "Anna Hofmann: En sedesam förförerska på varietéscenen," *Tidskrift för genusvetenskap* 17, no. 2 (1997): 26–38.

43 Otto Schneidereit, *Paul Lincke und die Entstehung der Berliner Operette* (Berlin: Henschel Verlag, 1974), 35.

44 Smith, *The Victorian Nude*, 115–20.

45 See Timothy J. Gilfoyle, "The Urban Geography of Commercial Sex: Prostitution in New York City, 1790–1860," *Journal of Urban History* 13, no. 4 (1987): 371–93.

46 See especially Brandstätter and Hubman, *Damals in Wien*, 52–3, 73.

47 Ibid., 148–9.

CHAPTER SIX

1 Mitchell and Kenyon, no. 571 (BFI).

2 *Petticoat Lane* (1903), catalogue no. 15326 (BFI).

3 Jane Ashelford, *The Art of Dress: Clothes Through History 1500–1914* (London: National Trust, 1996), 64, 92.

4 William Henry Merle, *Melton de Mowbray: or, the Banker's Son*, vol. 1 (London: R. Bentley, 1838), 24.

5 "Cheltenham," *The Satirist, and the Censor of the Time*, 11 September 1836.

6 Charles Dickens, *Great Expectations* (London: Chapman and Hall, 1861), ch. 22, and *The Mystery of Edwin Drood* (London: Chapman and Hall, 1870), ch. 4.

7 Fritz Reuter, *Dörchläuchting* (Leipzig: Max Hesses Verlag, 1910 [1866]), ch. 4.

8 Thomas Mann, *Buddenbrooks* (Berlin: S. Fischer Verlag, 1901), ch. 8.

9 Harry Martinson, *Bollesagor* (Stockholm: Albert Bonniers förlag, 1983), 234.

10 Sigfrid Siwertz, *Pagoden* (Stockholm: Bonnier, 1954), 209.

11 Roberta E. Pearson, *Eloquent Gestures: The Transformation of Performance Style in the Griffith Biograph Films* (Berkeley: University of California Press, 1992), 46.

12 Brian Girling, *Images of London: East End Neighbourhoods* (Stroud: The History Press, 2009), 89. My thanks to Brian Girling for his kind permission to reprint the photograph.

13 Christopher Oldstone-Moore, "The Beard Movement in Victorian Britain," *Victorian Studies* 48, no. 1 (2005): 7–34.

14 *Punch*, 11 August 1896, 85.

15 See Lawrence H. Streicher, "David Low and the Sociology of Caricature," *Comparative Studies in Society and History* 8, no. 1 (1965): 1–23.

16 See also *Punch*, 2 September 1876, 97; 15 February 1890, 75; 27 February 1897, 106; 8 March 1905, 163; 17 May 1905, 352; 3 April 1907, 247.

17 *Simplicissimus* 2, no. 2 (1897): 12; *Fliegende Blätter* 89, no. 2243 (1888): 35.

18 *Kasper*, 10 January 1903, 2.

19 Ibid., 2 February1895, 4.

20 Raphael Samuel, *Theatres of Memory: Past and Present in Contemporary Culture* (London: Verso Books, 2012 [1994]), 395.

21 Matthew Hilton, *Smoking in British Popular Culture 1800–2000* (Manchester: Manchester University Press, 2000), 47–51.

CHAPTER SEVEN

1 Hannah Carlson, "Idle Hands and Empty Pockets: Postures of Leisure," *Dress* 35, no. 1 (2008): 7–27.

2 It is actually difficult to find slouching peasants in the works of, for example, Pieter Bruegel the elder, but in the seventeenth century the mocking portrayal of peasants becomes more direct, and images of drunken or reeling peasants are common in the paintings of, for instance, Adriaen Brouwer and Adriaen van Ostade.

3 See Hans-Joachim Raupp, *Bauernsatiren: Entstehung und Entwicklung des bäuerlichen Genres in der deutschen und niederländischen Kunst ca. 1470–1570* (Niederzier: Lukassen, 1986) and Keith Moxey, *Peasants, Wives and Warriors: Popular Imagery in the Reformation* (Chicago: University of Chicago Press, 1989).

4 See John Oliver Hand, J. Richard Judson, William W. Robinson, and Martha Wolff, *The Age of Bruegel: Netherlandish Drawings in the Sixteenth Century* (Cambridge: Cambridge University Press, 1986), 142, 264.

5 Some of these are reprinted in Carlson, "Idle Hands and Empty Pockets."

6 Barbara Burman, "Pocketing the Difference: Gender and Pockets in Nineteenth-Century Britain," *Gender & History* 14, no. 3 (2002): 447–69.

7 Christopher Todd Matthews, "Form and Deformity: The Trouble with Victorian Pockets," *Victorian Studies* 52, no. 4 (2010): 561–90.

8 Or are they bullying the boy in the curious pose who is in the foreground?

9 The paraphrase is from Carlson, "Idle Hands and Empty Pockets," who is referring to Muchembled's chapter in Jan Bremmer and Herman Roodenburg, eds, *A Cultural History of Gesture: From Antiquity to the Present Day* (London: Polity Press, 1991).

10 See John K. Walton, "The Seaside and the Holiday Crowd," in Vanessa Toulmin, Simon Popple, and Patrick Russell, eds, *The Lost World of Mitchell & Kenyon: Edwardian Britain on Film* (London: BFI Publishing, 2004).

11 *Kasper*, 2 July 1892.

12 See also *Kasper*, 23 May 1891; 18 March 1893; *Söndags-Nisse*, 18 October 1896; *Fun*, 9 August 1882, 55.

13 *Söndags-Nisse*, 12 April 1896.

14 *Punch*, 21 April 1883, 183.

15 *Fun*, 5 March 1870, 12.

16 *Simplicissimus* 3, no. 33 (1898): 264.

17 See Patricia Marks, *Bicycles, Bangs, and Bloomers: The New Woman in the Popular Press* (Lexington: University Press of Kentucky, 1990).

18 *Fliegende Blätter* 110, no. 2789 (1899): 21. See also *Punch*, 13 June 1896, 282.

19 See *Punch*, 31 January 1917, 76; 22 August 1917, 145.

20 *Punch*, 26 September 1891, 147.

21 *Punch*, 17 October 1896, 184.

22 *Wiener Typen. Klischees und Wirklichkeit*, ed. Wolfgang Kos (Vienna: Christian Brandstätter Verlag, 2013), 318.

23 *Simplicissimus* 3, no. 12 (1898): 94; 2, no. 50 (1897): 395; 3, no. 1 (1898): 8; 3, no. 27 (1898): 211; 3, no. 20 (1898): 155.

24 Cf. Lars M. Andersson, *En jude är en jude är en jude: representationer av "juden" i svensk skämtpress omkring 1900–1930* (Lund: Nordic Academic Press, 2000), 86–109. As is visible from the material presented by Andersson, however, Jews could be depicted in various mocking ways, both as dandies and shabby characters.

25 Mats Hellspong and Orvar Löfgren, *Land och stad: Svenska samhällstyper och livsformer från medeltid till nutid* (Lund: Gleerup, 1974), 338–9.

26 See Geoffrey Pearson, *Hooligan: A History of Respectable Fears* (London: Macmillan, 1983) and Andrew Davies, *The Gangs of Manchester: The Story of the Scuttlers, Britain's First Youth Cult* (Preston, UK: Milo Books, 2009).

CHAPTER EIGHT

1 Peter Burke, *The Historical Anthropology of Early Modern Italy: Essays on Perception and Communication* (Cambridge: Cambridge University Press, 1987), 15–24.

2 Quoted in Michael Hiley, *Victorian Working Women: Portraits from Life* (London: Gordon Fraser, 1979), 11.

3 Quotes from Derek Hudson, *Munby: Man of Two Worlds* (London: Abacus, 1974), 199, 166–7.

4 Ibid., 103–4.

5 Ibid., 93.

6 Ibid., 231.

7 Ibid., 219.

8 Johann Pezzl, *Skizze von Wien* (Graz: Gugitz/Schlossar, 1923 [1786–90]), 211.

9 Klara Löffler, "Das Standelweib im Ensemble der Volkstypen: Das Feuilleton als Ort der Verwienerung," in *Wiener Typen: Klischees und W Schwartz irklichkeit*, ed. Wolfgang Kos (Vienna: Christian Brandstätter Verlag, 2013).

10 Vinzenz Chiavacci, *Wiener vom Grund: Bilder aus dem Kleinleben der Grosstadt* (Vienna: Prochaska, 1888), 177.

11 "Middlesbro' Immorality," *Northern Echo*, 25 August 1882.

12 "Northern Streets," *Newcastle Courant*, 5 November 1880.

13 "In Search of the Coram-Street Murderer," *Standard*, 6 January 1873.

14 This estimation is based on a search for the phrase in several magazines directed at young boys and girls, including *The Girl's Own Paper*, *The Boy's Own Paper*, *Little Folks*, *Boys of England*, *Our Little Dots*, and *Kind Words for Boys and Girls*.

15 See Christopher Breward, "Femininity and Consumption: The Problem of the Late Nineteenth-Century Fashion Journal," *Journal of Design History* 7, no. 2 (1994): 71–89.

16 "A London Street Scene," *Derby Daily Telegraph*, 13 May 1889; "Gleanings," *Birmingham Daily Post*, 13 May 1889. Although the event took place in London, I have not been able to find any reports of it in the London papers.

17 "Drunk and Disorderly Charge," *Illustrated Police News*, 6 February 1892.

18 "På Gröna Lund," *Svenska dagbladet*, 24 May 1899.

19 "Ur gatspråkets mysterier," *Svenska dagbladet*, 24 April 1898.

20 "'P.K.' På fängelsets tröskel," *Svenska dagbladet*, 4 August 1897.

21 "En afton på en 'arbetarevarieté,'" *Svenska dagbladet*, 17 December 1895.

22 Wolfgang Slapansky, *Das kleine Vergnügen an der Peripherie: Der böhmische Prater in Wien* (Vienna: Picus Verlag, 1992).

23 *Felix Salten: Wurstelprater. Ein Schlüsseltext zur Wiener Moderne*, ed. Siegfried Mattl, Klaus Müller-Richter, and Werner Michael Schwarz (Vienna: Promedia, 2004), 71–81.

24 Ibid., 77, 104–7.

25 Felix Salten, "Fünfkreuzertanz," in *Das österreichische Antlitz: Essays* (Berlin: S. Fischer Verlag, 1910), 54.

26 Felix Salten, "Nachtvergnügen," in ibid., 85–96. English translation from *The Vienna Coffeehouse Wits, 1890–1938*, ed. Harold B. Segel (West Lafayette, IN: Purdue University Press, 1993), 184–5.

27 These archetypes are often connected to the writings of Arthur Schnitzler. See Eva Ludwiga Szalay, "From Bourgeois Daughter to Prostitute: Representations of the 'Wiener Fräulein' in Kraus's 'Prozess Veith' and Schnitzler's *Fräulein Else*," *Modern Austrian Literature* 33, nos. 3/4 (2000): 1–28.

28 Ellen Bayuk Rosenman, "Fear of Fashion; or, How the Coquette Got Her Bad Name," ANQ 15, no. 3 (2002): 12–21. See also Maria Ioannou, "Beautiful Stranger: The Function of the Coquette in Victorian Literature," unpublished PhD thesis, University of Exeter, 2009.

29 "Coquetry," *Hampshire Telegraph and Sussex Chronicle*, 10 April 1897.

30 "Paris and the Exhibition," *Hearth and Home*, 26 April 1900.

31 "Some Plain Hints on Health and Happiness," *Girl's Own Paper*, 1 December 1900.

32 "Miss Chips' Chatter," *Illustrated Chips*, 14 August 1897.

33 Shelley King and Yaël Schlick, "Refiguring the Coquette," in *Refiguring the Coquette: Essays on Culture and Coquetry*, ed. Shelley King and Yaël Schlick (Lewisburg, PA: Bucknell University Press, 2008), 13–14.

34 Peter Bailey, "Parasexuality and Glamour: The Victorian Barmaid as Cultural Prototype," *Gender & History* 2, no. 2 (1990): 148–72.

35 Segel, *Vienna Coffeehouse Wits*, 132.

36 Sally Mitchell, *The New Girl: Girls' Culture in England, 1880–1915* (New York: Columbia University Press, 1995), 3.

37 Patricia Marks, "'Love, Larks, and Lotion': A Descriptive Bibliography of E.J. Milliken's "'Arry" Poems in *Punch*," *Victorian Periodicals Review* 26, no. 2 (1993): 67–78.

38 See Michaela Lindinger, *Außenseiter, Sonderlinge, Femmes Fatales: Das "andere" Wien um 1900* (Vienna: Amalthea Signum Verlag, 2015).

39 *Stockholms kväsagrabbar och kväsarynkor* (Stockholm, 1892), 3.

40 *Kväsargrabbar och kväsarfjällor, deras seder och bruk: En bild ur storstadslifvet* (Stockholm, 1902), 3.

41 *Stockholms kväsagrabbar och kväsarynkor*, 6.

42 "På Gröna Lund," *Svenska dagbladet*, 24 May 1899.

43 Olaf Briese, "Eckensteher: Zur Literatur- und Sozialgeschichte eines Phantoms," *Internationales Archiv für Sozialgeschichte der deutschen Literatur* 37, no. 2 (2012): 239–88.

44 Emil Bader, *Wiener Verbrecher: Grosstadtdokumente Band 16* (Berlin: H. S. Nachfolger, 1905), 14–6.

45 "Aus dem Wiener Walde," *Wiener Montags-Post*, 30 August 1909.

46 "The Working Men's Club," *The Times*, 15 April 1863; "Where are the police?," *The Times*, 11 October 1866.

47 "Our Dockyards," *The Times*, 29 January 1859.

48 "Life in London," *Licensed Victuallers' Mirror*, 24 February 1891.

49 Gustaf Fröding, "När banan blir färdig," *Ungdomsdikter* (Stockholm: Bonnier, 1917).

50 "Trottoirer och stadsbud," *Aftonbladet*, 16 April 1868.

51 "Grilljannens, dekadansfjantens yttre fägring," *Figaro*, 26 September 1891.

52 See articles in *Figaro* 1891–1894.

53 "Sju grilljannar," *Figaro*, 24/31 October 1891.

54 "Pöbelupptåg," *Aftonbladet*, 1 October 1896.

55 "En hel liga s. k. 'grilljannar,'" *Svenska dagbladet*, 17 March 1896.

56 Anonymous, *Tempted London: Young Men* (London: Hodder and Stoughton, 1889), 198–200.

57 George A. Sala, *Twice Round the Clock* (London: Houlston and Wright, 1859), 154.

58 Charles Dickens, *Sketches by Boz: Illustrative of Every-Day Life and Every-Day People* (London: Chapman & Hall, 1839), ch. 11.

59 Peter Payer, "Nigerl und Gigerl: Zur Geschichte zweier Feuilleton-Stars von Eduard Pötzl," in Kos, *Wiener Typen*.

60 Eduard Pötzl, *Rund um den Stephansturm: Ausgewählte humoristische Erzählungen, Skizzen und Studien* (Leipzig: Reclam, 1888), 187–9.

61 "Die Angströhren werden theurer," *Arbeiter-Zeitung*, 29 November 1895.

62 "Korso," *Kikeriki*, 25 February 1906.

> Wie sie stolzieren! In feinsten Kleidern
> Von Londoner und Pariser Schneidern!
> Schwedisch die Handschuhe, russisch der Lack,
> Juwelenbeladen! Doch wie speist der Back?
> Am Heimweg könnt ihr sie treffen alle
> In Löwys koscherer Würstelhalle!

63 Moritz Csáky, *Das Gedächtnis der Städte: Kulturelle Verflechtungen – Wien und die urbanen Milieus in Zentraleuropa* (Vienna: Böhlau, 2010), 262–3.

64 See *Kikeriki*, 25 July 1895; 20 February 1896; 4 June 1896.

65 Andersson, *En jude är en jude är en jude*, 88–90. See also Michaela Haibl, "Sichtbarkeit und Wirkung: 'Jüdische' Visiotype in humoristischen Zeitschriften des

späten 19. Jahrhunderts," in *Jewish Images in the Media*, ed. Martin Liepach, Gabriele Melischek, and Josef Seethaler (Vienna: Austrian Academy of Sciences Press, 2007), 61–84.

66　Tag Gronberg, *Vienna: City of Modernity, 1890–1914* (Bern: Lang, 2007), 37. See also Carl E. Schorske, "The Ringstrasse, Its Critics, and the Birth of Urban Modernism," in *The Nineteenth-Century Visual Culture Reader*, ed. Vanessa R. Schwartz and Jeannene M. Przyblyski (New York: Routledge, 2004).

67　"London Night by Night," *Pick-Me-Up*, 3 January 1891.

68　"Ladies' Column," *Berrow's Worcester Journal*, 28 February 1891.

69　According to an advertisement in the *Liverpool Mercury* of 21 September 1869, the actor Howard Paul incorporated an imitation of the Piccadilly crawl into his act.

CHAPTER NINE

1　"The London Music Halls," *The Era*, 18 June 1892.

2　Ibid., 30 June 1883.

3　Ibid., 15 January 1898.

4　"Empress, Brixton," *The Era*, 31 December 1898.

5　"Miss Louie Freear," *The Era*, 8 July 1899.

6　"The London Music Halls," *The Era*, 6 February 1897.

7　See Adrian New, "The Zola of the Halls," *The Times*, 19 December 1970. Strangely, no music-hall historian seems to know what has become of this valuable piece of material, and everyone who mentions it refers to this *Times* article in which it is described in detail.

8　Derek B. Scott, "Song Performance in the Early Sound Shorts of British Pathé," in *The Sounds of the Silents in Britain*, ed. Julie Brown and Annette Davison (Oxford: Oxford University Press, 2013).

9　"Albert Chevalier in America," *The Era*, 11 April 1896.

10　Ibid., 4 April 1896.

11　See entry in *Oxford English Dictionary*, http://oed.com.

12　Peter Bailey, *Popular Culture and Performance in the Victorian City* (Cambridge: Cambridge University Press, 1998), 119–20.

13　"Music Hall Gossip," *The Era*, 14 March 1891.

14　"The London Music Halls," *The Era*, 31 October 1869.

15　Ibid., 17 March 1888.

16　"Vesta Tilley in New York," *The Era*, 16 October 1897. See also "Vesta Tilley's American Triumphs," *The Era*, 30 April 1898.

17　"Miss Vesta Tilley in London," *The Era*, 25 July 1896.

18　"Vesta Tilley's American Triumphs," *The Era*, 2 April 1898.

19　"The Tivoli," *The Era*, 4 July 1896.

20　"Vesta Tilley in New York," *The Era*, 16 October 1897.

21　"Monsieur Detaille," *The Graphic*, 25 May 1895.

22　See, for instance, "Mr John Leech's Gallery of Sketches in Oil," *Baily's Monthly Magazine*, 1 July 1862; "Lord Carington," *Baily's Monthly Magazine*, 1 June 1873;

"Life in London," *Licensed Victualler's Mirror*, 10 April 1888; "The Man About Town," *The Country Gentleman*, 10 May 1890; "Tales of the Town," *Licensed Victualler's Mirror*, 16 September 1890.

23 "Very Swagger," *Pick-Me-Up*, 3 November 1900.

24 On Guschelbauer, see Ernst Weber, "Schene Liada – Harbe Tanz: Die instrumentale Volksmusik und das Wienerlied," in *Wien, Musikgeschichte: Volksmusik und Wienerlied*, ed. Elisabeth Theresia Fritz and Helmut Kretschmer (Vienna: Lit, 2006), 131. On Modl, see Georg Wacks, *Die Budapester Orpheumgesellschaft: Ein Varieté in Wien 1889–1919* (Vienna: Holzhausen, 2002), 19–20; obituary in *Neuigkeits Welt-Blatt*, 3 March 1915.

25 Friedrich Schlögl, *Wiener Blut: Kleine Culturbilder aus dem Volksleben der alten Kaiserstadt an der Donau* (Vienna: Hartleben Verlag, 1893), chapter 26.

26 Weber, "Schene Liada – Harbe Tanz," 192.

27 Kenneth Birkin, *Richard Strauss: Arabella* (Cambridge: Cambridge University Press, 1989), 42–3.

28 Wacks, *Budapester Orpheumgesellschaft*, 109.

> Ein Gigerl tut am Ring stolzieren – daradl didl.
> Da kommt ein fremder Herr spazieren – daradl didl dadl dum.
> Das Gigerl denkt uje den kennt er – daradl didl.
> Das war sein Schneider darum rennt er – daradl didl dadl dum.

29 Wolfgang Maderthaner and Lutz Musner, *Unruly Masses: The Other Side of Fin-de-Siècle Vienna* (Oxford: Berghahn, 2008), 88.

30 Weber, "Schene Liada – Harbe Tanz."

31 Björn Ivarsson Lilieblad, *Moulin Rouge på svenska: Varietéunderhållningens historia i Stockholm 1875–1920* (Linköping: Linköpings universitet, 2009), 27.

32 Ibid., 158–60.

33 Ibid., 161–7.

34 The only writings on Hofmann are Marika V. Lagercrantz, "Anna Hofmann: En sedesam förförerska på varietéscenen," *Tidskrift för genusvetenskap* 17, no. 2 (1997): 26–38, and Marika V. Lagercrantz and Lotte Wellton, *Känner du Fia Jansson ...*, exhibition catalogue (Stockholm: Stockholm City Museum, 1998). Neither of these texts discusses the Fia Jansson character.

35 Ivarsson Lilieroth, *Moulin Rouge på svenska*, 146–52.

36 Norlander, *Rännstensungar och storborgare*, 186–7.

37 See reviews in *Sport und Salon*, 19 April 1900; *Grazer Tagblatt*, 18 April 1900.

38 Michael Pickering, *Stereotyping: The Politics of Representation* (Basingstoke: Palgrave Macmillan, 2001), 203–18.

39 Jens Wietschorke, "Urbane Volkstypen: Zur Folklorisierung der Stadt im 19. und frühen 20. Jahrhundert," *Zeitschrift für Volkskunde* 110, no. 2 (2014): 215–42.

40 Orrin E. Klapp, "Social Types: Process and Structure," *American Sociological Review* 23, no. 6 (1958): 674–8.

41 Wietschorke, "Urbane Volkstypen."

42 Klapp, "Social Types."

43 Erving Goffman, *The Presentation of Self in Everyday Life* (London: Penguin, 1990 [1959]), 37, 44–7, 83–5.

44 Albert Barrère, *A Dictionary of Slang, Jargon and Cant* (London: Balantyne Press, 1889), 127.

CHAPTER TEN

1 Geoffrey Batchen, *Burning with Desire: The Conception of Photography* (Cambridge, MA: MIT Press, 1997), 62; Patricia Holland, "'Sweet it is to Scan ...': Personal Photographs and Popular Photography" in *Photography: A Critical Introduction*, ed. Liz Wells (London: Routledge, 2004), 113–58.

2 Cf. Bill Kovarik, *Revolutions in Communication: Media History from Gutenberg to the Digital Age* (New York: Bloomsbury, 2016), 159–60.

3 Corey Ross, *Media and the Making of Modern Germany: Mass Communications, Society, and Politics from the Empire to the Third Reich* (Oxford: Oxford University Press, 2008), 17; *Nineteenth-Century Media and the Construction of Identities*, ed. Laurel Brake, Bill Bell, and David Finkelstein (Basingstoke: Palgrave Macmillan, 2000), 2–3.

4 Kay Boardman, "'A Material Girl in a Material World': The Fashionable Female Body in Victorian Women's Magazines," *Journal of Victorian Culture* 3, no. 1 (1998): 93–110.

5 Kristine Moruzi, "Fast and Fashionable: The Girls in *The Girls of the Period Miscellany*," *Australasian Journal of Victorian Studies* 14, no. 1 (2009): 9–28; Christopher Breward, "Femininity and Consumption: The Problem of the Late Nineteenth-Century Fashion Journal," *Journal of Design History* 7, no. 2 (1994): 71–89; Sharon Marcus, "Reflections on Victorian Fashion Plates," *differences: A Journal of Feminist Cultural Studies* 14, no. 3 (2003): 4–33.

6 On *The Artist*, see Laurel Brake, "'Gay Discourse' and *The Artist and Journal of Home Culture*," in Brake et al., *Nineteenth-Century Media and the Construction of Identities*. The obscure *The Masher* has, to my knowledge, not yet been explored by scholars.

7 David Kunzle, *The History of the Comic Strip, 2: The Nineteenth Century* (Berkeley: University of California Press, 1990), 4–5.

8 Ibid., 6; Peter Fritzsche, *Reading Berlin 1900* (Cambridge, MA: Harvard University Press, 1996); Erik Edoff, *Storstadens dagbok: Boulevardpressen och mediesystemet i det sena 1800-talets Stockholm* (Lund: Mediehistoriskt arkiv, 2016).

9 See Mary Lester, "Local Newspapers and the Shaping of Local Identity in North-East London, c. 1885–1925," *International Journal of Regional and Local Studies* 5, no. 1 (2009): 44–62.

10 Cf. David M. Henkin, *City Reading: Written Words and Public Spaces in Antebellum New York* (New York: Columbia University Press, 1998).

11 See John F. Kasson, *Rudeness & Civility: Manners in Nineteenth-Century Urban America* (New York: Hill and Wang, 1990), 93–100, 124.

12 See Roger Sabin, "Comics versus Books: The New Criticism at the Fin de Siècle," in *Transforming Anthony Trollope: Dispossession, Victorianism and Nineteenth-Century Word and Image*, ed. Simon Grennan and Laurence Grove (Leuven: Leuven University Press, 2015), 109.

13 See Peter Bailey, *Popular Culture and Performance in the Victorian City* (Cambridge: Cambridge University Press, 1998), 47–79; André Gaudreault and Philippe Marion, "A Medium Is Always Born Twice ... ," *Early Popular Visual Culture* 3, no. 1 (2005): 3–15; Dan North, "Illusory Bodies: Magical Performance on Stage and Screen," *Early Popular Visual Culture* 5, no. 2 (2007): 175–88.

14 Denis Condon, "'Brightening the Dreary Existence of the Irish Peasant': Cinema Transforms Leisure in Provincial Ireland," *Early Popular Visual Culture* 11, no. 2 (2013): 126–39; Rosalind Leveridge, "'Proud of Our Little Local Palace': Sidmouth, Cinema, and Community 1911–14," *Early Popular Visual Culture* 8, no. 4 (2013): 385–99.

15 Lynn Abrams, "From Control to Commercialization: The Triumph of Mass Entertainment in Germany 1900–25?," *German History* 8, no. 3 (1990): 278–93. See also Karl Christian Führer, "Auf dem Weg zur 'Massenkultur'? Kino und Rundfunk in der Weimarer Republik," *Historische Zeitschrift* 262, no. 3 (1996): 739–81.

16 Catherine Pedley-Hindson, "Jane Avril and the Entertainment Lithograph: The Female Celebrity and *Fin-de-siècle* Questions of Corporeality and Performance," *Theatre Research International* 30, no. 2 (2005): 107–23; Ruth E. Iskin, "The Pan-European Flâneuse in Fin-de-Siècle Posters: Advertising Modern Women in the City," *Nineteenth-Century Contexts* 25, no. 4 (2003): 333–56.

17 Cf. Rae Beth Gordon, *Dances with Darwin, 1875–1910: Vernacular Modernity in France* (Farnham: Ashgate, 2009) on the influence of Darwinism and African dance on the gestures and dances of the French café-concert stage.

18 Cf. Rachel Teukolsky, "Cartomania: Sensation, Celebrity, and the Democratized Portrait," *Victorian Studies* 57, no. 3 (2015): 462–75.

19 Thomas Richards, *The Commodity Culture of Victorian England: Advertising and Spectacle, 1851–1914* (Stanford: Stanford University Press, 1990), 84.

20 Barry J. Faulk, *Music Hall and Modernity: The Late-Victorian Discovery of Popular Culture* (Athens: Ohio University Press, 2004), 46.

21 See Catherine Hindson, *Female Performance Practice on the Fin-de-Siècle Popular Stages of London and Paris: Experiment and Advertisement* (Manchester: Manchester University Press, 2007), 36–44, and Jane R. Goodall, *Performance and Evolution in the Age of Darwin: Out of the Natural Order* (London: Routledge, 2002), 190.

22 On the distribution of images in the nineteenth century, see Lena Johannesson, *Den massproducerade bilden: Ur bildindustrialismens historia* (Stockholm: Carlsson bokförlag, 1997) and Vanessa R. Schwartz and Jeannene M. Przyblyski, *Nineteenth-Century Visual Culture Reader* (New York: Routledge, 2004).

23 Helena E. Wright, "Photography in the Printing Press: The Photomechanical Revolution," in *Presenting Pictures*, ed. Bernard Finn (London: Science Museum, 2004). See also Gerry Beegan, *The Mass Image: A Social History of Photomechanical Reproduction in Victorian London* (Basingstoke: Palgrave Macmillan, 2008).

24 On photocollage, see *Playing with Pictures: The Art of Victorian Photocollage*, ed. Elizabeth Siegel (Chicago: Art Institute of Chicago, 2009) and Patrizia di Bello, *Women's Albums and Photography in Victorian England: Ladies, Mothers and Flirts* (London: Ashgate, 2009). On scrapbooks, see Johan Jarlbrink, "En tidningsläsares

dagbok: Allan Holmströms klipp och läsvanor 1877–1962," in *Presshistorisk årsbok* (Stockholm: Svensk presshistorisk förening, 2010) and Ellen Gruber Garvey, "Scissorizing and Scrapbooks: Nineteenth-Century Reading, Remaking, and Re-circulating," in *New Media, 1740–1915,* ed. Lisa Gitelman and Geoffrey B. Pingree (Cambridge, MA: MIT Press, 2003).

25 John Springhall, "'Pernicious Reading'? 'The Penny Dreadful' as Scapegoat for Late-Victorian Juvenile Crime," *Victorian Periodicals Review* 27, no. 4 (1994): 326–49.

26 Ronald A. Fullerton, "Toward A Commercial Popular Culture in Germany: The Development of Pamphlet Fiction, 1871–1914," *Journal of Social History* 12, no. 4 (1979): 489–511; John Phillip Short, "Everyman's Colonial Library: Imperialism and Working-Class Readers in Leipzig, 1890–1914," *German History* 21, no. 4 (2003): 445–75.

27 On the complicated history of the Lambeth Walk, see Samuel, *Theatres of Memory,* 394–5. References to street dancing are found in Melissa Ballanta, "'Ta-ra-ra-boom-de-ay': Lottie Collins' Act and the Not-So-Modern Girl," *Nineteenth-Century Theatre and Film* 37, no. 1 (2010): 3–13, and Tom Scriven, "The Jim Crow Craze in London's Press and Streets, 1836–39," *Journal of Victorian Culture* 19, no. 1 (2014): 93–109.

28 Works that present this view include Jonathan Raban, *Soft City* (London: Harvill Press, 1974) and Karen Halttunen, *Confidence Men and Painted Women: A Study of Middle-class Culture in America, 1830–1870* (New Haven: Yale University Press, 1982). For a discussion of this contention, see Peter K. Andersson, *Streetlife in Late Victorian London* (Basingstoke: Palgrave Macmillan, 2013), 139–63.

29 Lynda Nead, *Victorian Babylon: People, Streets, and Images in Nineteenth-Century London* (New Haven: Yale University Press, 2000), 66–7, 71.

30 Orvar Löfgren, "Från nattfrieri till tonårskultur," in *Fataburen* (Stockholm: Nordiska museet, 1969).

31 Birchall, "The Carnival Revels of Manchester's Vagabonds."

32 Francoise Barret-Ducrocq, *Love in the Time of Victoria: Sexuality and Desire Among Working-Class Men and Women in Nineteenth-Century London* (London: Penguin, 1992), 75–81.

33 See Halttunen, *Confidence Men and Painted Women,* and Ibson, *Picturing Men.*

34 Kasson, *Rudeness & Civility,* 80–6, 92–9; Mary Cowling, *The Artist as Anthropologist: The Representation of Type and Character in Victorian Art* (Cambridge: Cambridge University Press, 1989).

35 Pedley-Hindson, "Jane Avril and the Entertainment Lithograph."

36 Diana Crane, "Clothing Behavior as Non-Verbal Resistance: Marginal Women and Alternative Dress in the Nineteenth Century," *Fashion Theory* 3, no. 2 (1999): 241–68. Crane's idea of non-verbal behaviour is inspired by feminist scholar Joan Cassell's writings on the unconscious behaviour of feminists.

37 Gilman, "Stand Up Straight." Cf Peter Burke, *Popular Culture in Early Modern Europe* (Farnham: Ashgate, 2009 [1978]).

38 Crone, *Violent Victorians*, 265–8. Crone concludes that violent entertainment changed from actual violence to representations of violence during the nineteenth century.

CODA

1 Expansive and nonchalant behaviour is often associated by sociologists with youth gangs and groups connected to the street. See Elijah Anderson, *Code of the Street: Decency, Violence, and the Moral Life of the Inner City* (New York: W.W. Norton & Co, 1999) and Jonathan Ilan, *Understanding Street Culture: Poverty, Crime, Youth and Cool* (Basingstoke: Palgrave Macmillan, 2015).

2 Cas Wouters, *Informalization: Manners and Emotions since 1890* (London: SAGE, 2007).

3 Stephen Mennell, *The American Civilizing Process* (Cambridge: Polity Press, 2007).

4 Martin J. Wiener, *English Culture and the Decline of the Industrial Spirit, 1850–1980* (Cambridge: Cambridge University Press, 1981); Mark Girouard, *The Return to Camelot: Chivalry and the English Gentleman* (New Haven: Yale University Press, 1981). For more popular studies on manners, see Henry Hitchings, *Sorry! The English and Their Manners* (London: John Murray, 2013) and Mark Caldwell, *A Short History of Rudeness: Manners, Morals, and Misbehavior in Modern America* (New York: Picador, 1999).

5 Randall Collins, "Four Theories of Informalization and How to Test Them," *Human Figurations* 3, no. 2 (2014), https://quod.lib.umich.edu/h/humfig?page=home.

6 Peter N. Stearns, *Battleground of Desire: The Struggle for Self-Control in Modern America* (New York: New York University Press, 1999).

7 See Giselinde Kuipers, *Good Humor, Bad Taste: A Sociology of the Joke* (Berlin: De Gruyter Mouton, 2015), 38.

8 In relation to this, cf Lynn M. Voskuil, *Acting Naturally: Victorian Theatricality and Authenticity* (Charlottesville: University of Virginia Press, 2004). Randall Collins speaks of a status reversal in social interaction wherein "popular styles of dressing-down and informal codes of interaction represent the adoption of manners of lower, subordinate groups by the higher." Although this is putting it a bit more class-distinguished than I would myself, Collins's descriptions of how street gang styles are adopted by the middle class in the twentieth century is a comparable phenomenon. Collins, "Four Theories of Informalization."

9 Marcus Collins, "The Fall of the English Gentleman: The National Character in Decline, c. 1918–1970," *Historical Research* 75, no. 187 (2002): 90–111.

10 See Rudolph Herzog, *Dead Funny: Telling Jokes in Hitler's Germany* (New York: Melville House, 2011) and Kathleen Stokker, *Folklore Fights the Nazis: Humor in Occupied Norway, 1940–45* (Madison, NJ: Farleigh Dickinson University Press, 1995).

11 For reflections on the phenomenon of "coolness," see Daniel Harris, "Coolness," *The American Scholar* 68, no. 4 (1999): 39–49.

Index

"Afternoon Crawl, The," 91–2
age. *See* old age; youth
"Alexandra Limp," 92, 256, 283n33
Altenberg, Peter, 223
appearance: and behaviour, 21, 25–8,
 161, 185–6, 245–6; concern for, 69,
 76, 96, 101, 255; conformity of, 42–3,
 55, 190, 249–50, 260; and gender,
 45–6, 54, 58, 161, 185, 260, 288n35;
 natural, 36–40, 59; and social roles,
 26, 47, 51–8, 65, 72, 134, 193, 230
arrogance, 103, 121, 149, 153, 167, 174,
 177–8, 194, 221, 231, 240, 246
art movements: impressionism, 49;
 Pre-Raphaelite movement, 48–9
Austrian Volkssänger: Edmund
 Guschelbauer, 241; Josef Modl, 241;
 Emilie Turecek, 241–2

Barthes, Roland, 6, 8
beards, 172
behaviour: and appearance, 21, 25–8,
 161, 185–6, 245–6; and audience,
 7–8, 162, 167, 170, 227, 233, 237,
 253; and culture, 13–14; and gender,
 23, 58, 73, 105–6, 110, 123, 129, 133,
 160–1, 184–6, 213–24, 251; ideals, 23,
 114, 126, 160, 258, 262–3; and media,
 247–52, 260; natural, 7, 12, 16, 36,
 61, 265; and social roles, 23, 72, 96,
 102–3, 135, 156, 179, 214–24, 235,
 237–8, 246, 258, 262, 299n1. *See also*
 body language; performativity
bicycling, 8, 153, 260, 288n33
billboards, 251
black dandy. *See* "coon" (derogatory)
 caricature
Bloomsbury group, 28
body language: akimbo, 133–4, 158–61,
 217–18; gait, 73–4, 91–2, 104, 112–13,
 115–17, 233, 236; militaristic, 10,
 17, 24, 25, 28, 43, 255, 261, 265;
 naturalness, 10, 21, 30, 32, 36–40,
 48–9, 160, 165, 176, 236, 257, 264–5;
 nonchalance, 42, 45, 85, 102, 187,
 191–2, 194, 299n1; pose, 35–47, 67–8;
 posture, 10, 21, 24–5; relaxed, 38, 52,
 76–7, 106, 110–11, 117, 120, 138; rigid,
 38, 55, 57, 170; study of, 13–14. *See
 also* contrapposto; extremities: legs;
 slouching
body parts. *See* extremities
Bourdieu, Pierre, 11

cameras: hand-held, 53; hidden, 8, 16,
 109–10, 271n21
cartoons, 16, 86–94, 98–102, 121–6,
 146–58, 174–7, 194–202, 204–6
Chaplin, Charlie, 237
Chiavacci, Vinzenz, 215–16
cigar, 94, 97, 162, 170, 176, 178–9, 192,
 198, 202, 230, 239

cigarette, 138, 151, 152, 196, 202, 219
cinema, 250
civilizing process, 26–7, 29, 264
class. *See* social distinction
clothing: corsets, 25, 92, 109; dresses,
 45, 108, 113, 117, 121, 123, 131, 144,
 160, 182; hats, 46, 53, 79, 97, 106,
 113, 190, 200, 202, 226, 231–2, 236,
 242; jackets, 97–9, 156, 163, 165, 174,
 204, 225, 228, 260; skirts, 83, 106,
 109, 113, 115–17, 121–6, 132, 144, 153,
 160, 182, 256; suits, 55, 61, 75, 83, 94,
 165, 167, 173, 174, 190–1, 239–40; ties,
 57, 197, 228, 243–4; trousers, 58, 75,
 77, 89, 97, 99, 172–3, 176, 180–208,
 226, 228–9; waistcoats, 74, 162–79;
 worker, 56–7, 75
cockney, 146–7, 149, 163, 165, 174–7,
 224–5, 235–6, 259–60
contrapposto, 57, 77, 86–9, 196
"coon" (derogatory) caricature, 92
coquetry, 115, 222–3
corsets, 25
cycling, 153

Daguerreotype, 30
dancing, 158, 178–9, 219–21, 225–6,
 237, 252
dandy types, English, 92, 96, 99–103,
 230–1, 238–40. *See also* "coon" (dero-
 gatory) caricature
de Certeau, Michel, 14
Degas, Edgar, 49
Dickens, Charles, 166, 231
dignity, 21, 27–8, 168–72
Disdéri, André-Adolphe-Eugène, 30,
 36, 46
dress, development of, 113, 165–6, 172,
 181–2

elegance, 45, 51–2, 71–2, 75–7, 79,
 83–4, 88–9, 93–5, 98, 100–4, 110,
 112–13, 123, 238–9, 246, 261
Elen, Gus, 236, 237
Elias, Norbert. *See* civilizing process
Engström, Albert, Swedish artist,
 89–90, 176, 194–5, 205
Era, The (journal), 235, 237–8

etiquette manuals, 21–3, 113–14
extremities: arms, 37–8, 45, 55, 117,
 131–53, 170, 216–18; feet, 37, 39, 45,
 205, 257; hands, 40, 45, 55, 57–8, 71,
 74, 77, 106, 108–9, 115, 117, 126, 153,
 162–3, 165, 168, 172–4, 180–205; legs,
 37–8, 77, 88, 156, 204. *See also* body
 language: akimbo

femininity, 25, 129, 216, 255
Figaro (journal), 97–8, 228–30
film (motion pictures), 66, 69–72,
 132–4, 138, 140, 144, 152, 162–5,
 167–8, 170–1, 178–9, 190, 192, 236–7,
 250–1, 282n11, 282n19, 285n15
Fliegende Blätter (magazine), 66, 98,
 123, 149, 151, 176, 178, 198–9, 203
flirting, 73, 88, 104, 123, 153, 159,
 254–5, 263
Flygare-Carlén, Emilie, 22
Fröding, Gustaf, 227

gait, kinds of: "Alexandra Limp," 92,
 256, 283n33; clown-like, 237; dock-
 yard step, 227; "Grecian Bend," 92,
 283n33; heel walking (*Fersengeher*),
 231, 246; Piccadilly crawl, 233, 246,
 256, 294n69; "Roman Fall," 92, 178,
 283n33; shuffling, 236; slouching,
 21, 226, 236, 237; strolling, 73, 77;
 swaggering, 58, 73, 230–1, 238–40,
 246
gaze, the, 6, 47, 137; male, 161, 223,
 254; satirical, 103, 174, 248
gender norms and expectations, 26,
 45; for men, 33, 54–5, 58; for women,
 73, 105–30, 151–6, 222, 244, 250
gent. *See* dandy types
gentlemanliness, 24–5, 73, 93–4, 98,
 192, 229, 261
Gigerl, 96–7, 231–3, 242, 246
girl culture, 129–30, 160–1, 218–19,
 223–4
"Girl of the Period," 129
Goffman, Erving, 11, 108, 258
grace, 17, 22–3, 39–40, 47, 50, 71, 76,
 83, 85, 117, 239, 258, 265
"Grecian Bend," 92, 283n33

grilljanne, 94, 97–8, 228–30
Grosstadtdokumente, 226–7
gymnastics, 24

hairstyle, 218, 219, 226
Hitler, Adolf, 265
Hofmann, Anna, Swedish singer, 159, 244
human body, history of, 3–4, 10, 12
Hunt, William Holman, 48

idleness, 74, 102, 104, 168, 172, 187, 226–7, 239. *See also* lounging; slouching
Industrial Revolution, 16, 25–6, 33
informalization, 29, 264

Jay, Martin, 6
Jefferies, Richard, 22–3

labourers, 22, 32–3, 54–8, 75, 89, 182–3, 188–90, 194–6
laziness, 24, 102, 104, 208, 221, 227, 246
leisure. *See* idleness
Linton, Eliza Lynn, 254
London: Chelsea, 186; Hyde Park, 214; Piccadilly, 217, 233, 238–9, 246; Regent Street, 230–1
Loos, Adolf, 97
lounging, 21, 83, 102, 153, 194, 239, 246, 259–60. *See also* idleness; slouching
Lumière Company, 144
Lund, Sweden, 105–7, 135–6, 140–1, 183–5

magazines, 16, 65–6, 103, 174, 217, 224, 249, 251. See also *Fliegende Blätter*; *Punch*; *Simplicissimus*
maids. *See* servants
Manchester, 81–2, 138
Mann, Thomas, 166
manners, 15, 22, 29, 223, 261, 264–5, 299n4
masculinity, 28, 33, 58, 178–9, 198–9, 226–7, 255
masher. *See* dandy types

Mauss, Marcel, 10
May, Phil, English cartoonist, 86, 146–9, 175–6
Merleau-Ponty, Maurice, 10
militarism, 24, 28, 239, 261, 265
Millais, John Everett, 48
monkey parades, 255
muffs, 125–6, 286n29
Munby, Arthur, 213–15
Munch, Edvard, 49
music-hall entertainers, British: Albert Chevalier, 236–7; Lottie Collins, 159; Gus Elen, 236; Vesta Tilley, 238

newspapers, 15, 96, 103, 212–13, 216, 218, 227, 228–30, 248
New Woman, 154–6, 288n35

old age, 72, 170, 172, 178

parody, 87, 98, 225, 234, 246
peasants, 202–4, 243, 290n2
performativity, 7, 11, 33–4, 54, 61, 205, 240, 258–9, 264–5, 273n48. *See also* Goffman, Erving
periodicals, 249–50
photobooths, 58–60
photographers: Eugène Atget, 146; Per Bagge, 66, 76–7, 81, 105–6, 135–6, 138–41, 167–9, 173, 183–5, 193; E.J. Bellocq, 146; Henri Cartier-Bresson, 9; Samuel Coulthurst, 66, 81–2, 138–9; Paul Martin, 66, 80, 82, 119; Emil Mayer, 66, 79, 114–15, 137–8, 191; Linley Sambourne, 66, 109–13, 129, 140, 142; August Sander, 50–1; Napoleon Sarony, 48; August Stauda, 66, 75–6, 121, 135–6; Erik Tryggelin, 66, 83–4, 116–17, 140, 143–5, 180–1, 187–9
photography: as historical source, 7–8; daguerreotype, 30; history of, 29–34, 53; portraiture, 30–4, 35–66; study of, 5–9; tintype, 33, 52. *See also* portraits
pipes, 179
pockets, 45, 57–8, 75, 77, 94, 156, 165–6, 172–3, 180–208, 225–6

pompousness, 71, 92, 98, 165–6, 174, 176, 178, 256, 261, 265

portraits: *carte de visite*, 30–2, 43–4, 46–8, 50–1, 53–4, 61, 261; door-step, 135–7; paintings, 48–9, 74, 179, 279n46; portraiture, 10, 30, 34, 37, 39–40, 42, 46–7, 53, 60–1, 108; studio, 30, 43, 47, 51–3, 56–8, 74, 109, 278n29

prostitutes, 146, 156–8

Punch (magazine), 66, 86, 99, 127, 146–7, 149, 153–4, 160, 174–5, 196, 199–201

respectability, 29, 104, 114–15, 134, 156, 190–1, 256, 265

"Roman Fall," 92, 178, 283n33

Rousseau, Henri, 49

Sargent, John Singer, 179

satirical journals, 66, 86–7, 98, 123–6, 146–58, 160, 174–7, 194–201, 232–3

self-consciousness (awkwardness), 32, 38, 51, 61, 69–71, 162, 172

servants, 120, 131, 149–50, 214

sexuality, 254–5, 269n2; men's, 146, 171, 178, 208; women's, 123, 130, 146, 149, 159, 160, 199, 216, 241–2, 251

shop girl, 129, 223–4

shyness, 117, 120, 123, 125, 214, 222. *See also* coquetry

Simmel, Georg, 96–7

Simplicissimus (magazine), 66, 87, 122–4, 153, 155–7, 176, 178, 197–8, 204, 208

sincerity, 21–2

skirts, 83, 106, 113, 115–17, 121–6, 132, 144, 153, 160, 256

slouching, 56–8, 75, 104, 180–2, 187, 195–7, 205–6, 224–8, 236–7, 263–5

smoking, 179. *See also* cigar; cigarette; pipes

snobs and snobbery, 71, 85, 89, 93, 95–6, 98, 103, 221, 229–30

social Darwinism, 10, 28

social distinction, 15, 22–3, 32–4, 40–2, 73–4, 89–93, 102–4, 134, 158, 190, 197, 215, 240, 251, 255, 260

stage entertainment, forms of: bond-komik, 243–4; music hall, 234–41; Volkssänger, 241–3

standing, 24, 43, 45, 55, 57, 75, 77, 80, 98

stereotypes. *See* types

Stevenson, Robert Louis, 49

Stockholm: Gröna Lund, 218, 225; Hötorget, 180, 182–3; Kung-strädgården, 218; Norrmalmstorg, 97

Strachey, Lytton, 4, 17, 28

street gangs, 202–8, 224–8

street markets, 138–40, 148, 215–16

swagger, 73, 230–1, 238, 240. *See also* body language; gait

swell. *See* dandy types

theatre, 17, 159, 228–31, 242–4

tramps, 89–90, 92, 176

types, 46, 68, 92, 99, 138, 176–7, 202, 212–13, 215, 225, 245–6, 259–61

umbrellas, 73, 83–5, 94, 113, 121–2, 132, 282n11

vanity, 202, 221, 222

Veblen, Thorstein, 73–4

Victorian values, 28

Vienna: Prater, 138, 219–20; Ring-strasse, 226, 232–3; Sirk-Ecke, 232

waistcoats, 165–6

walking. *See* gait

walking-sticks, 72–4, 84–5, 241

Whitechapel fringe. *See* hairstyle

Wilde, Oscar, 48, 49

Winckelmann, Johann Joachim, 27

working class. *See* labourers

Wulff, Sigge, Swedish singer, 97, 244

Young, Iris Marion, 128

youth, 51–2, 79, 96–8, 100–1, 112, 113–14, 129, 137, 159, 214–24. *See also* girl culture